The
Artist's
Complete Guide

BARRON'S

Original title of the book in Spanish: *Guía completa para el artista*
© Parramón Ediciónes, S.A., febrero 2004
Published by Parramón Ediciónes, S.A., Barcelona, Spain

Translated from the Spanish by Michael Brunelle and Beatriz Cortabarria

Authors: Parramon's Editorial Team
Editor in Chief: Maria Fernanda Canal
Photography: Nos & Soto
Text and Coordination: David Sanmiguel
Book Design and Layout: Vicenç B. Ballestar, Marta Bru, Carlant, Marta Duran, Miquel Ferrón, Mercedes Gaspar, Gabriel Martín, Esther Olivé de Puig, Esther Rodríguez, David Sanmiguel, Esther Serra, and Yvan Viñals
Production Director: Rafael Marfil

All inquiries should be addressed to:
Barron's Educational Series, Inc.
250 Wireless Blvd.
Hauppauge, NY 11788
www.barronseduc.com

International Standard Book No. 0-7641-5813-9

Library of Congress Catalog Card No.: 2004107405

Printed in Spain
9 8 7 6 5 4 3 2 1

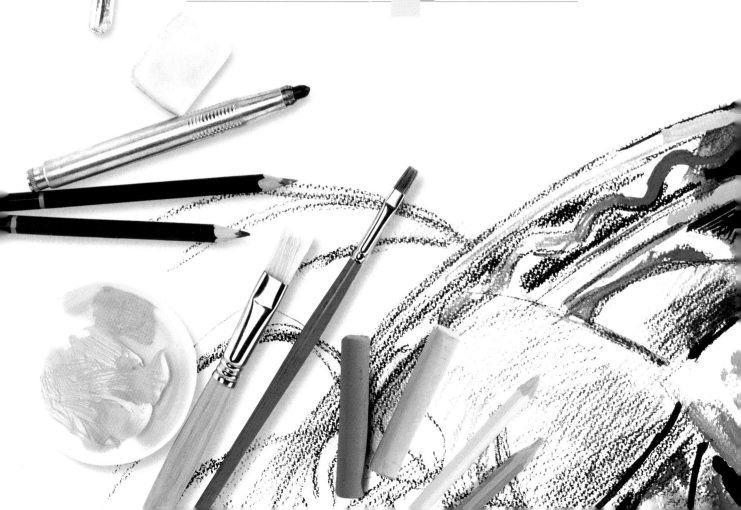

The Artist's
Complete Guide

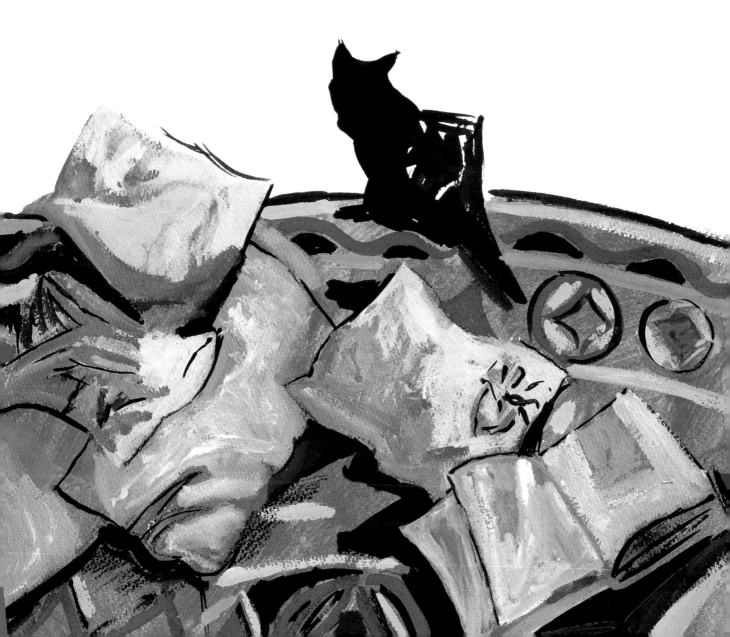

CONTENTS

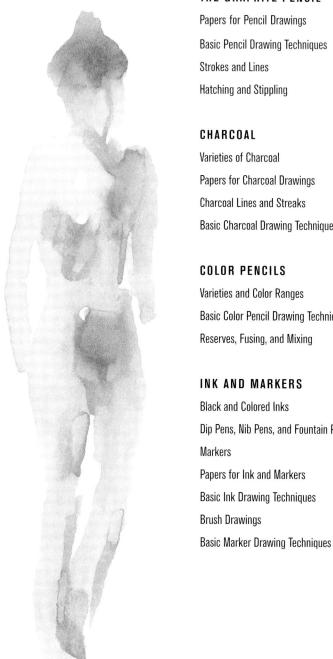

DRAWING
Materials and Methods

DRAWING
Basic Techniques

Step-by-Step Exercises

PAINTING
Materials and Painting Media

PAINTING
Basic Techniques

PAINTING TECHNIQUES
Artistic Themes

Drawing and Painting:
Activities Within Everyone's Reach

Artistic work, like any other human activity, can benefit from talent but mainly depends on interest and practice. The objective of this book is to encourage that interest and guide the reader through the many techniques and drawing and painting media.

The *Complete Guide for the Artist* contains all the basic teachings on drawing and painting, theory and practice, with the intention of including all the means that will allow the reader to develop his or her artistic abilities. This book assumes that the amateur has no previous knowledge or training, making it a very useful manual for beginners as well as for professional artists and art teachers.

The theoretical concepts are explained in an easy-to-understand manner, and the large number of illustrations helps in their assimilation. The contents are closely related to the practice of art, and the reader will see and understand their almost immediate application to particular processes, techniques, and subject matter.

All painting and drawing materials have a place in this book, from pencils and drawing papers to the modern acrylic colors for artists, including every artistic technique. This contains not only a complete explanation, but also comments, advice, and suggestions about the use of the tools, their selection based on the preferences of the readers, and the advantages and disadvantages of each.

In this guide, each and every one of the relevant aspects of how to draw and paint are put into practice by professional artists who apply their knowledge and experience in each detailed demonstration. The result is a volume created solely to put a very useful and inspiring book about the practice of painting and drawing into the hands of the reader.

"The more you dominate the technique the less you have to worry about it."

Pablo Picasso

DRAWING

DRAWING

Materials and Methods

Drawing, an essential part of any artistic endeavor, is the only solid foundation upon which a creative work can be based. The most important aspects of drawing are covered in this chapter: the materials and methods. The materials range from the humblest pencil to the most sophisticated ink pen, including all the typical art instruments (charcoal, ink pens, brushes, etc.).

We consider drawing methods to be the basic techniques and the graphic means by which something that has been attentively observed is applied to the paper with clarity and precision. All of the aspects of drawing materials and methods are studied here so the reader will be able to find a satisfactory answer to any possible concern.

Graphite is a substance that is used to make the lead of a pencil. It is the simplest drawing medium and also the cleanest. Pencil can be used to draw on almost any surface; the greasy nature of graphite makes it very long lasting and it does not require a fixative, although in certain cases that is advisable.

The pencil is used to draw lines and to do work based on shading. The lead-gray color is always the same for all types of graphite. Only its intensity changes: lighter for the hard lead and darker for the soft lead pencils.

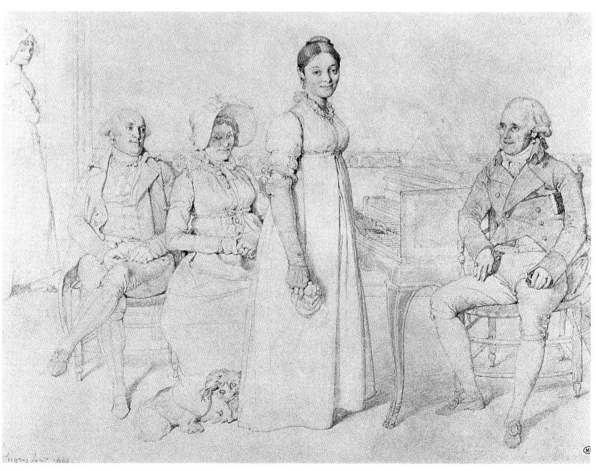

Jean Auguste-Dominique Ingres (1780–1867), *The Forestier Family.*
A work of great detail and precision created with a hard graphite pencil.

The softer leaded pencils are the ones that make a dark, intense line, as well as the ones that wear out the most with use.

METAL POINTS

Graphite for drawing is also called lead. This name comes from the metal points that were used as drawing media before the appearance of graphite. They could be gold, copper, silver (a brown line in all three cases), or lead (a gray line). This image is a drawing by Perugino done in silver point.

Varieties

The different line intensities that can be made by graphite depend on its hardness. The softer the lead, the more intense and dark the line will be. The hardness is specified by a number and letter printed at the top end of the pencil; the letters B and H indicate the hardness (B for soft pencils and H for hard ones). The most used variations are the medium hard and soft ones. The hard leads are appropriate for making careful drawings and for the first shading of a work, whereas the softer ones are used for emphasizing the darkest parts. Graphite is also available in cylindrical, square, or hexagonal sticks of various hardness and thickness (the thinnest ones can be inserted into a holder).

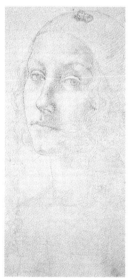

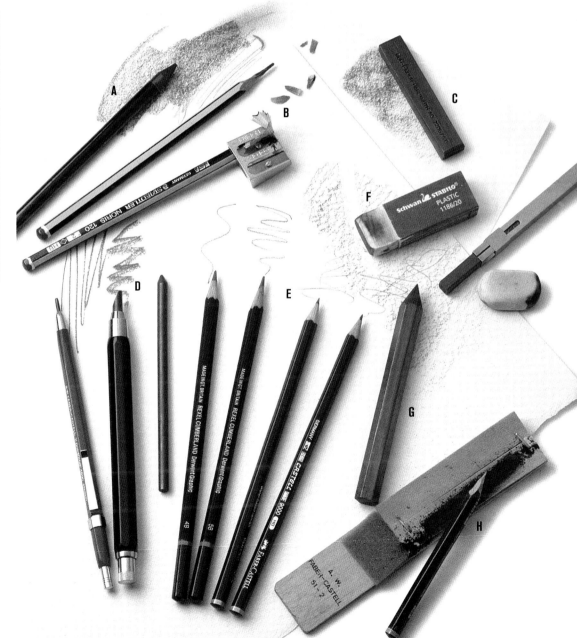

Tools for drawing with graphite: graphite stick with plastic sheath (A); pencils sharpened with a blade or pencil sharpener (B); flat graphite stick (C); holders with refillable leads (D); set of pencils with leads of different hardness (E); plastic and rubber erasers (F); hexagonal graphite stick (G); sanding stick for pointing leads (H).

Papers for Pencil Drawings

One of the advantages of the pencil is that it can be used on almost any surface, and therefore, on practically every kind of paper. However, special papers made for drawing are logically the most appropriate.

A distinction should be made between regular-quality papers made of wood pulp, created with molds by machines, and high-quality papers that contain a high percentage of rags and are manufactured with special care. High-quality paper is expensive; therefore all manufacturers supply papers of intermediate quality. Good papers are distinguished by the presence of the name or mark of the manufacturer in one of the corners or margins of the sheet, embossed or with a traditional watermark that can be seen when the paper is lighted from behind. Among the different professional qualities, pencil drawing paper is made with satin, smooth, medium, and laid surfaces (the latter a rough surface of evenly spaced lines).

Each paper favors certain results and hinders others. In general, the rougher the surface, the less the amount of realistic detail that can be applied by the artist.

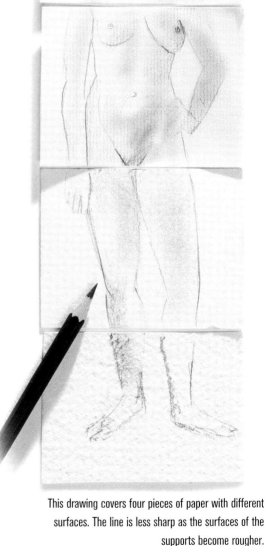

This drawing covers four pieces of paper with different surfaces. The line is less sharp as the surfaces of the supports become rougher.

Satin, Smooth, and Rough Papers

Satin papers with a barely perceptible texture are hot pressed to accentuate the smoothness. They allow the creation of a wide range of grays, and give very good results when graphite lines are rubbed and blended. Smooth papers are also appropriate for working with graphite pencils, and so are some laid papers. These lightly textured papers show off the strength of the line and allow greater chiaroscuro contrasts than satin paper. Very rough papers (watercolor paper, for example) are not very appropriate for pencil drawings; the stroke does not cover the surface and the gray areas look like black and white dots. Furthermore, the hardness of the lead leaves visible impressions on the sheet.

Certain drawing paper textures can be seen in pencil drawings that have a lot of shading.

Small sketchbooks are ideal for carrying in a pocket, and the pages work very well for pencil drawings.

The best papers for drawing with graphite are those with a smooth or moderately textured surface. The rougher they are, the less fluid the drawing's lines will be.

Basic Pencil Drawing Techniques

The basic techniques for drawing in pencil include lines, blending, and eventually, the erasing of lines. To draw a line correctly, the pencil must first be held the right way. When grasping it like a writing instrument, held near the point, it is easier to control details and the precision of the line, but the sense of the whole is lost and it is nearly impossible to dominate the overall drawing. By holding the pencil lower, with the end inside the hand, large strokes can be made with greater control; this is the right way to proceed when beginning to work.

The line is different depending on how the graphite is applied to the paper, with the point, the edge, or the flat side.

Holding the pencil like a drawing instrument allows perfect control of the line for detailing and shading very small areas.

Grasping the pencil from the end, like you would hold a walking stick, helps reach the whole drawing area and makes it easier to control the width and intensity of the lines.

CLEANING THE PAPER

After each erasure, the crumbs should be removed with a fan or soft brush. It is very important that the finished work have no traces of them because they continue absorbing and erasing the part of the drawing they are on, causing the lines to fade.

Blending

Soft graphite with an intense tone can be blended with blending sticks to create grays and gradations without any trace of lines. However, most artists usually blend directly with a finger to keep better control of the gradations. If blending is constantly done with the fingers, the paper always ends up getting dirty. Many artists solve this problem by placing a piece of paper under their hand while they draw, to keep it from touching and smudging the paper.

Dirt and smudges caused by the natural grease of the graphite in contact with the skin can be avoided by placing a piece of paper under the hand.

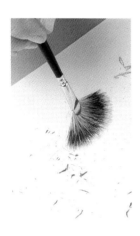

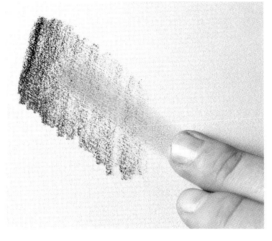

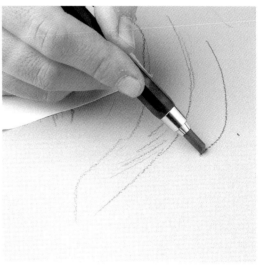

A piece of paper can help control the area that is being erased, protecting the nearby areas.

Graphite can be blended with the fingers. The blending creates an area of gradated tones without lines.

Erasing

Graphite is easily removed with rubber erasers, which should be more or less soft according to the leads being used. A dirty eraser will smear the paper; to avoid this it should be cleaned by rubbing it on a separate sheet before use. If the details that are to be erased are very small, a piece of eraser can be cut off and the corners used. In cases where the drawing is very advanced, a piece of paper can be placed directly below the detail that must be erased so no other areas of the drawing are affected.

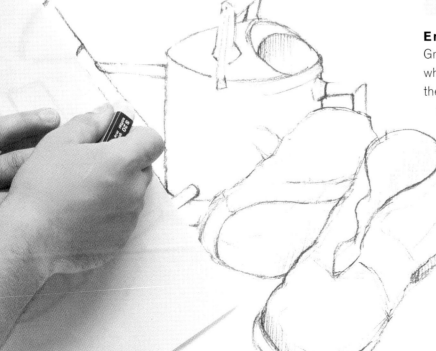

Strokes and Lines

The line drawing is only one way of making a pencil drawing, a work whose value lies in the intention of the line, in its width and inflection. A more shaded style would have to include loose strokes to create the values of forms and volumes. If a great amount of shading is desired, hatching can be used, which is merely the accumulation of ordered lines. These techniques are very simple and are not difficult to learn.

Drawing Lines

The angle of the pencil is critical to the quality of the line. The more it is angled, the wider it will be. Generally, in pencil drawings based exclusively on lines, the artist must constantly modify their width to create variety and avoid the cold monotony of an unchanging line. The decision about where to increase the thickness and intensity of the line depends on the nature of the subject. It is important to practice drawing lines to develop fluid strokes, without repeated or broken areas. A slight imprecision in the outline of the form is preferable to continually correcting the direction of the line, which betrays insecurity.

Pencil lines should be sure and unhesitating. A straight line is made by drawing quickly and surely; otherwise it will be an accumulation of uncertain lines.

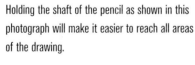

Holding the shaft of the pencil as shown in this photograph will make it easier to reach all areas of the drawing.

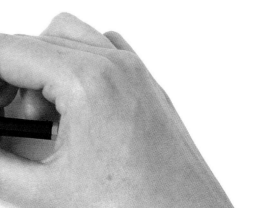

A slight imprecision in the outline of a form is preferable to continually correcting the direction of the line, which betrays insecurity.

WORKS IN PENCIL

Traditionally, the pencil was used for making notes from nature and drawing sketches for works of a larger scale. Many artistic techniques are required for making a preparatory drawing, and that drawing is almost always done with a pencil. This is because the pencil is the quickest, simplest, and most direct medium for artistic work, yet it is not considered to be of lesser importance by working professionals.

Controlling the Line

Anyone learning to draw in pencil should experiment with different varieties of lines and learn their graphic qualities. An exercise as simple as making a series of parallel lines of the same length and angle is the first step toward acquiring skill in drawing. This exercise can be developed with a series of curved, rounded, spiral, or zigzag lines.

Drawings of outlines of forms should be done with a sure hand, to create the strength and determination in the lines that best define the forms of the figures.

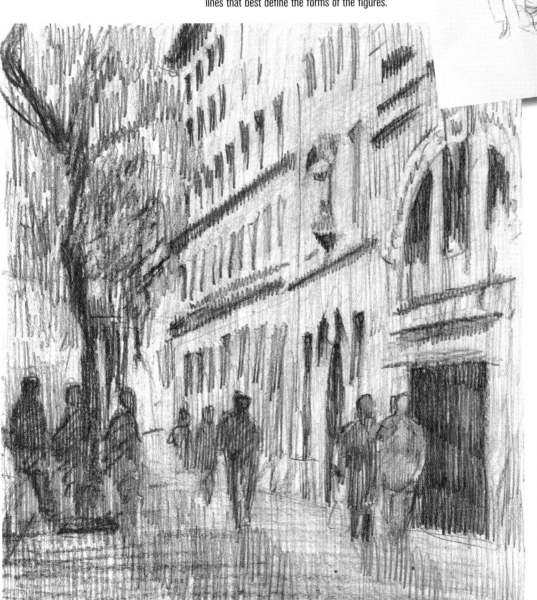

Gabriel Martín made this drawing with a single pencil. The different shadows and the linear values result from different ways of putting the point to the paper.

Hatching and Stippling

Hatching is an ordered accumulation of lines that is often used for shading or indicating surfaces and textures. They can be composed of lines that are perpendicular, diagonally crossed, spiral, etc. It is most important to create hatch areas of even density—in other words, a homogenous fabric. Once this is achieved, you can begin practicing hatching of increasing and decreasing densities, very useful for creating areas of shadow.

Hatching can be used to systematically create light and shadow, accurately graduating the different intensities.

Four very simple hatches that can be used for practice, in an attempt to create a homogenous "fabric" of lines.

At the right, a drawing by Gabriel Martín, combining the different hatches. The different tonal intensities result from the uneven density of each hatch line.

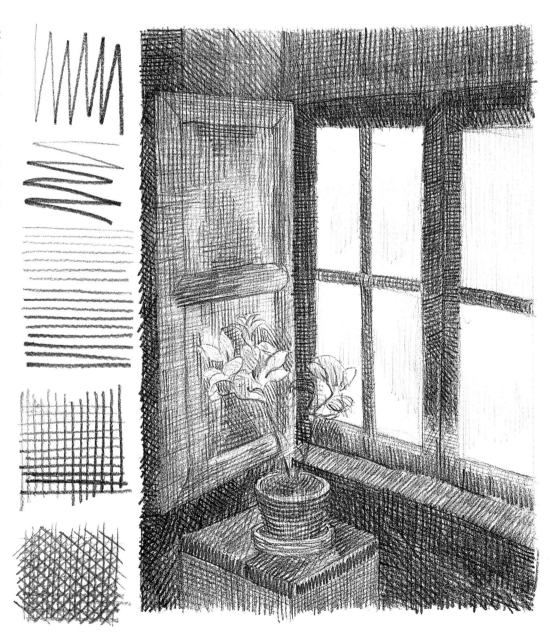

THE DIVISIONIST TECHNIQUE

Pointillism, or Division-ism, was a technique in-troduced at the end of the 19th century by Georges Seurat, an Im-pressionist painter who decided to experiment with the effect produced by applying pure, un-mixed color in small dabs. The coloration of his works creates a curious optical mixture effect; what seem to be areas of solid color are, in reality, separate dots.

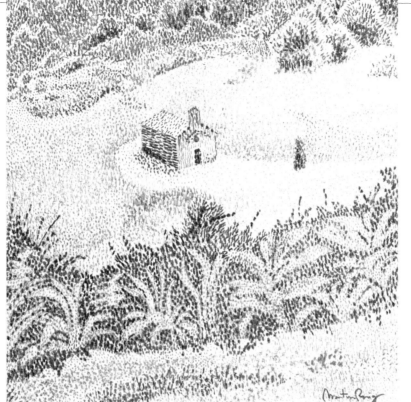

This drawing by Gabriel Martín was created with the stippling technique, emphasizing the different tonal areas without using any lines or hatching.

Hatching

Parallel hatching is achieved by drawing parallel lines very close together to create a totally unified area. This tone will be more or less dark, depending on how tight the hatching is and the intensity of the lines in it. Parallel hatching can also produce a blended effect when the lines start out being very light and little by little become more intense, or vice versa. Artists usually create hatching with quick zigzag lines placed in the shaded areas of the drawing. The density of the hatching depends on the intensity and number of lines.

This stippling creates surfaces with different textures and luminosity. It is worthwhile to patiently practice these and other variations.

Stippling

Stippling is applied in very detailed works to create delicate contrasts between different areas of the drawing. Its application is as simple as patiently building up small pencil dots of different intensities and densities (the greater intensity and density of the dots, the darker the area).

Charcoal is vegetable carbon, and its use dates back to the origins of humans. Cave paintings contain pulverized vegetable charcoal (slightly agglutinated, probably with saliva); this was their principal artistic technique, and its endurance through the centuries is the best proof of the permanence and durability of this medium. Just like pencil, charcoal drawing does not require any auxiliary media, but unlike pencil, it can render more artistic and spontaneous results when used in any format, from small works to large-scale compositions.

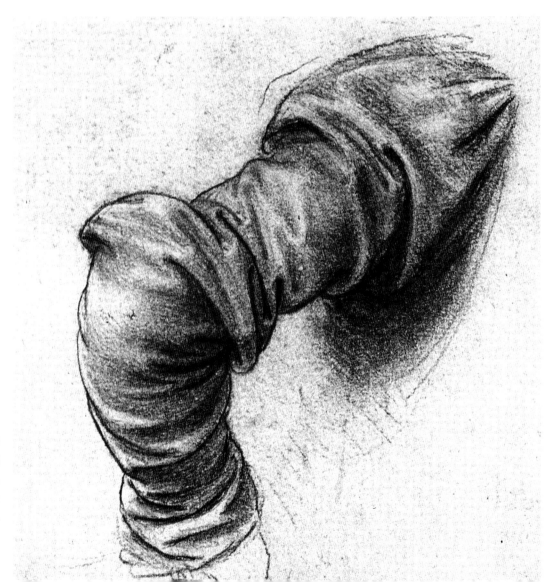

Leonardo da Vinci (1452–1519), *Study for Saint Peter's Right Arm,* 1503. Windsor Castle Library (Windsor, England).

A PREDECESSOR OF CHARCOAL

The great masters of the Renaissance habitually worked with a predecessor of charcoal called black stone. This mineral substance (not vegetable, like modern charcoal) made a very dark gray line that could be quite precise if the artist sharpened the "stone" to a good point. In this illustration is a drawing in black stone by Paolo Veronese.

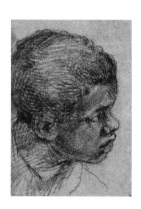

Charcoal is the most ancient of all drawing media. Cave paintings are, in a way, charcoal drawings.

Characteristics

Charcoal is a substance that is dry to the touch and makes a matte and very dark gray, almost black, line. Since it is composed of fine, carbonized particles, it can be applied to the support (usually paper) and can create a great variety of different gradations and blended grays. The finish of a charcoal drawing greatly depends on the paper that is used. The rougher it is, the more intense the lines, because more particles will have been lodged in the indentations of the paper. Charcoal is a completely natural product that contains no agglutinate to bind it; therefore it is necessary to fix the drawing so that the particles do not come off over time. Vine charcoal sticks are thin twigs of willow, linden, or walnut that are carefully selected to avoid knots and imperfections. The size and thickness of the twigs are reflected in the resulting charcoal, the thickest being the most expensive.

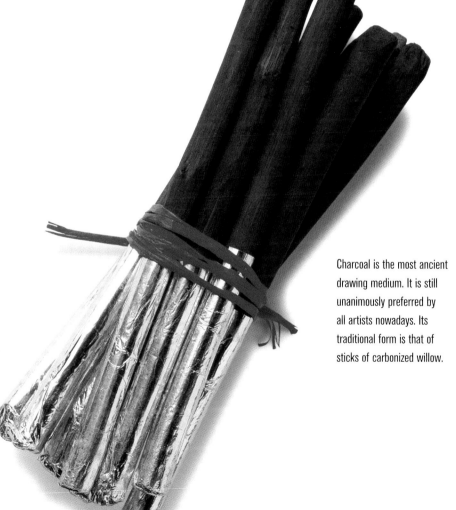

Charcoal is the most ancient drawing medium. It is still unanimously preferred by all artists nowadays. Its traditional form is that of sticks of carbonized willow.

Varieties of Charcoal

Charcoal is sold in different widths, from a stick barely 2 mm in diameter to about 3/4 inch (2 cm), and its price varies according to width. Its quality depends on selecting the best twigs, which should be as straight as possible and without knots, as well as the carbonization process, which must be uniform and complete. Vine charcoal is the best quality but is not inexpensive. Excellent quality charcoal sticks formed in molds from powdered charcoal are also available and are less expensive than vine charcoal. This new system allows some manufacturers to sell varieties of different hardness.

The diverse forms of charcoal are adapted for different uses. They make a characteristic dark, matte line, which is more or less intense depending on the density of the stick.

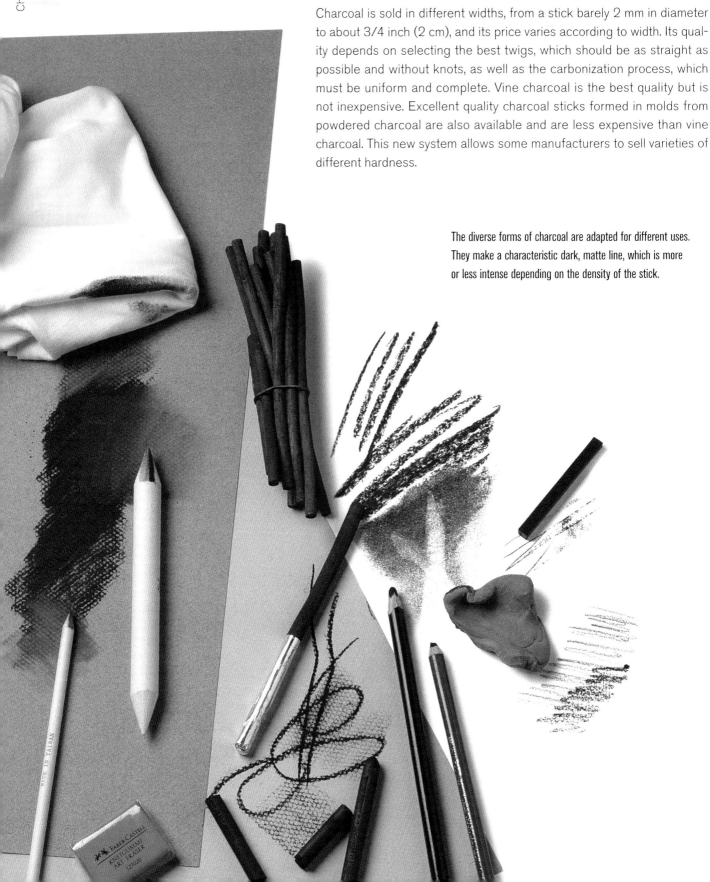

Compressed Charcoal

Special charcoal bars that are compressed and bound with a small amount of clay can also be found on the market. These bars are perfectly regular cylinders about 1/4 inch (6 or 7 mm) and are halfway between pastel and charcoal. Their line is quite a bit darker, denser, and more velvety than that of charcoal, and they are available in four levels of hardness.

CHARCOAL POWDER

Some artists use powdered charcoal for creating soft blending and gradations on large-scale works. It is applied with a cotton ball impregnated with powder and is a common technique used in art schools. It is sold in jars, although the artist can make it by finely grinding the bits and pieces of vine charcoal that are too small to be used for drawing.

The charcoal pencil can be used by itself or in combination with charcoal sticks. Its line is more precise and more uniform than that of the sticks. Furthermore, its point can be sharpened.

Charcoal Pencils

Some manufacturers make pencils with charcoal leads, with a little agglutinate to give them consistency so they can be sharpened. They can be very useful for small-scale works that require fine, uniform lines. These pencils are usually used in combination with regular charcoal sticks.

A selection of compressed charcoal and charcoal pencils. Such sets supply almost all varieties of charcoal needed by artists.

Compressed charcoal sticks are made of very finely ground carbon powder with a binder and mixed with clay. This results in a drawing tool that makes a very intense and velvety line.

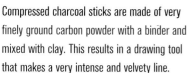

Papers for Charcoal Drawings

The best papers for drawing with charcoal are rough, since the texture of the support is what retains the carbon particles. A charcoal line is barely visible on smooth paper. The rougher the paper, the darker the lines, since the paper retains a greater quantity of charcoal. But excessive texture makes it difficult to blend lines, so it is necessary to find a compromise between the strength of the line and ease of manipulation.

Laid papers (mentioned in the section on pencil drawing) give excellent results, as does paper commonly used for drawing. Generally, glossy paper, smooth paper, and heavily textured watercolor paper should be avoided.

It is most comfortable to use drawing pads of medium quality and price, as long as the paper's surface is not too smooth. It is also possible to use wrapping paper (tan color in the picture), which is quite inexpensive and very useful for large-scale sketches.

Charcoal highlights the texture of the paper; some textures will make the lines look like they have gradations of value.

HANDMADE PAPER

Suppliers of fine art materials usually have a variety of papers made by hand. They have a characteristic deckled (irregular) edge on all sides, which shows that they were made one sheet at a time. They usually have a rough surface, but they are perfectly good for drawing with charcoal. They are expensive papers meant for work that requires a very special finish.

Paper for Sketching

Charcoal is the most popular medium for sketches and studies for important works because it is easy to use and can be worked quickly on large formats. Artists prefer to use inexpensive paper for making such studies because they encourage loose and relaxed work. One of the most economical and recommended options is kraft or wrapping paper. This brown paper is sold in rolls of 30 feet (10 m) or more, with a surface suitable for working with charcoal and a color that combines well with the blacks and grays of the drawing. Because of its format this paper can be used for small sketches made on cutout sheets as well as large-size studies.

Four types of paper suitable for working with charcoal. Watercolor paper (A) is a heavy support that produces dynamic results. The texture of an Ingres-style paper (B) is ideal for charcoal drawings. Canson paper (C) is a little rougher but just as useful for works in charcoal. Finally, this medium-weight watercolor paper (D) has a medium texture and a pleasant roughness.

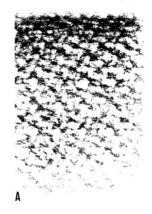

A

B

C

D

There are many charcoal drawing pads of all sizes on the market, from pocket size to studio size meant for very large drawings.

Charcoal Lines and Streaks

Unlike pencil, the entire length of a piece of charcoal may be used, opening up many different possibilities. Rotating the stick and varying the pressure on it will produce different lines and streaks. The lines can be varied as they are made, depending on whether one draws with the point, the edge, or the bevel that is formed by drawing (the stick is worn down as it passes over the paper). Finally, other effects can be created by rubbing the fingers or a rag over the lines and streaks.

Medium-width lines of varying intensity are made by drawing with the charcoal in the same way drawing is done with a pencil.

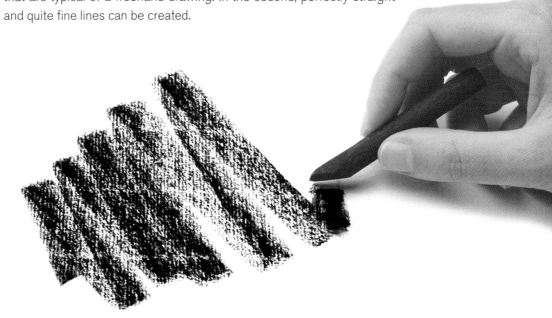

Applying Strokes

Strokes of charcoal can be made by drawing with the point of the stick, or with its side completely flat on the paper. In the first case the strokes tend to be the same width as the stick, and they show the movements that are typical of a freehand drawing. In the second, perfectly straight and quite fine lines can be created.

Drawing with the bevel creates a wider and more intense stroke than drawing with the point of the stick.

DRAWING ON FABRIC

The grays and blacks, the gradations and shading of charcoal take on a different quality when they are applied to fabric. The texture of fabric is very different than that of paper, and its rougher, less absorbent surface creates a cooler feeling to the tones. This aspect can favor some subjects such as still lifes, and, on occasion, portraits.

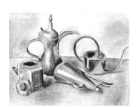

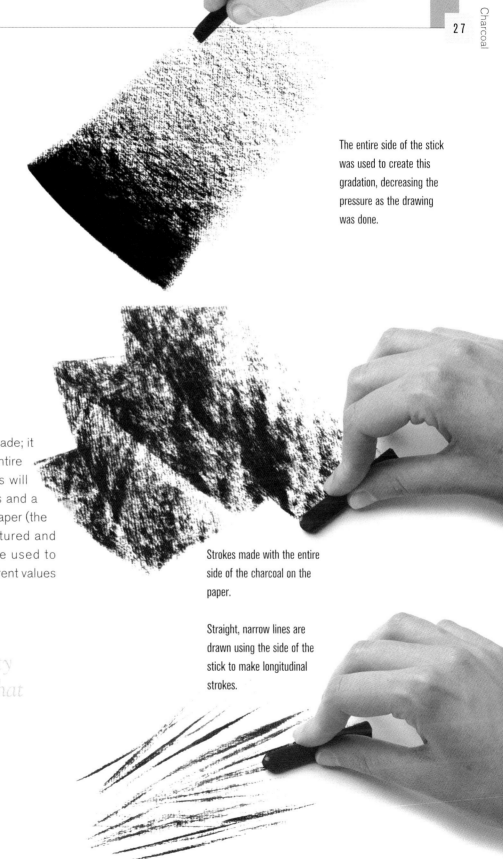

The entire side of the stick was used to create this gradation, decreasing the pressure as the drawing was done.

Strokes and Blending

Strokes of charcoal are very easily made; it is just a matter of drawing with the entire side of the stick on the paper. This will make large areas of very dark tones and a texture that depends on that of the paper (the rougher the support, the more textured and darker the color). Blending can be used to create atmosphere, unifying the different values of the drawing.

Strokes made with the entire side of the charcoal on the paper.

Straight, narrow lines are drawn using the side of the stick to make longitudinal strokes.

Charcoal creates velvety effects and a warmth that seems to contradict its almost black color.

Because it is a denser medium, charcoal can be used to create many more effects than pencil, including outstanding opportunities for detail work. It has an ample range of tones, from light gray to black, and an important factor is its ability to be spread, blended, and manipulated with the fingers. It is without a doubt "dirty," and therefore requires larger formats than that of pencils and more care in its use. Below are demonstrated the basic techniques of drawing with charcoal.

Blending

Charcoal can be blended with a blending stick or with the fingers, a reality that opens a wide range of possibilities to the artist. When blended, the tone of the charcoal lightens, and this is almost the only way of achieving gradations, since the change in intensity resulting from drawing with more or less pressure on the paper is barely noticeable.

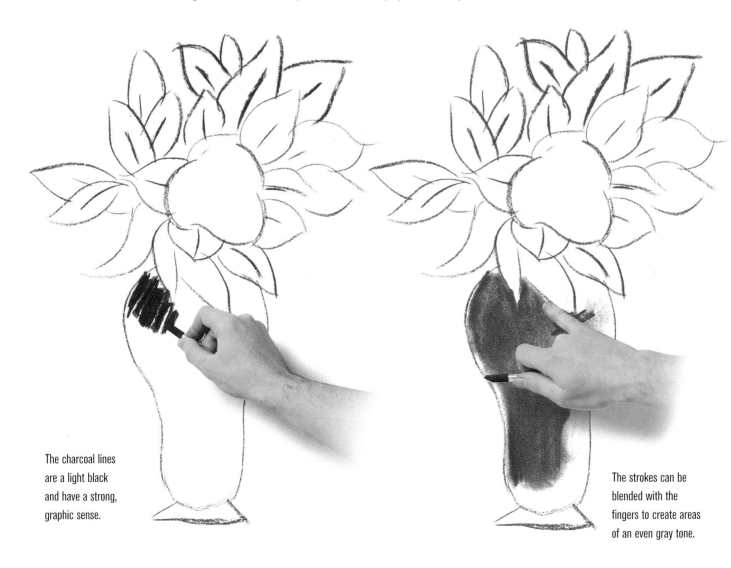

The charcoal lines are a light black and have a strong, graphic sense.

The strokes can be blended with the fingers to create areas of an even gray tone.

FIXING CHARCOAL

Charcoal should always be fixed when the drawing is finished because its particles have no adhesive power and will fall off the support little by little. An old fixing method consists of dipping the stick in linseed oil before drawing. However, this method works only for drawings with no blending. The best solution is to use an aerosol fixative to spray several light coats over the drawing, waiting for each to dry before applying the next one. This should be done until the charcoal will not come off when touched.

Erasing

Charcoal's limited ability to adhere makes it very easy to erase. Kneaded erasers (soft erasers that can be molded like clay) are necessary tools, since they not only correct errors but can also create highlights, restoring the color of the paper after having drawn on it. The eraser can also be used to draw; tones can be lightened and details created, and the lightest areas of a shadow in the drawing can be illuminated.

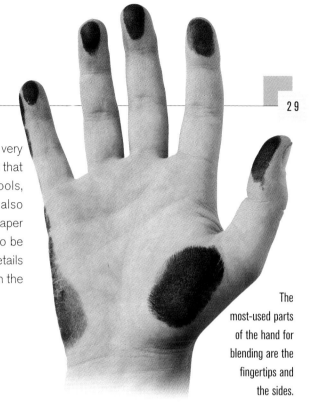

The most-used parts of the hand for blending are the fingertips and the sides.

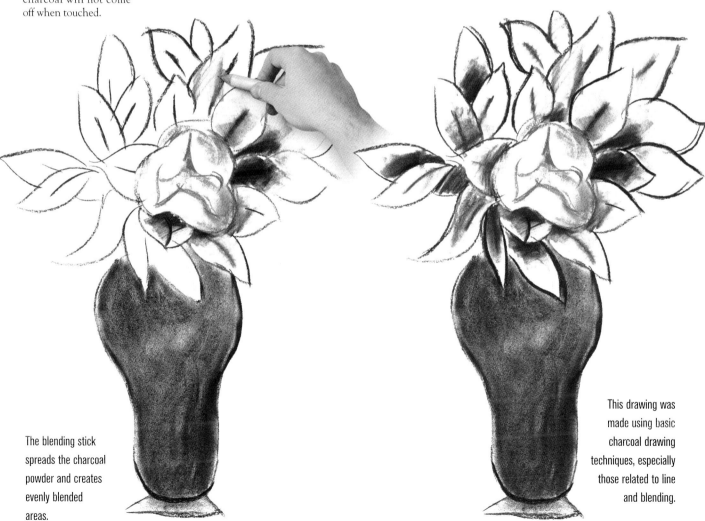

The blending stick spreads the charcoal powder and creates evenly blended areas.

This drawing was made using basic charcoal drawing techniques, especially those related to line and blending.

*F*ar from merely being a grade-school technique, color pencils have great potential as a drawing medium. A colored line can define forms, and at the same time define its color with an elegance, precision, and subtlety that is difficult to achieve with other media.

Ideal for illustration work, color pencils occupy a place halfway between drawing and painting that allows the artist to color while he or she draws.

Works created with color pencils should be considered to be on equal footing with those created with all other artistic techniques. The chromatic effects, the subtlety, and the shading of the lines are their main advantages. This drawing was done by Mercedes Gaspar.

Characteristics and Qualities

The leads of color pencils are made of pigments bound with a substance similar to clay, called kaolin, mixed with wax. Color pencils have less covering power than other drawing and painting media because of this material. The kaolin, which adds strength to the pigment and allows it to hold a point, keeps the pigment from spreading easily on the support, and is a limiting factor for the lines and areas of color.

The quality of color pencils depends on the quality and quantity of the pigment used in their manufacture. The best-quality pencils are those that incorporate the greatest amount of pigment, which result in drawing tools that create dense and precise lines.

Illustrations

Color pencils are particularly useful for illustration work. Thanks to their precise line, they can be used for minute details in illustrations that require realistic representations, whether done in pencil, watercolor, gouache, or airbrush.

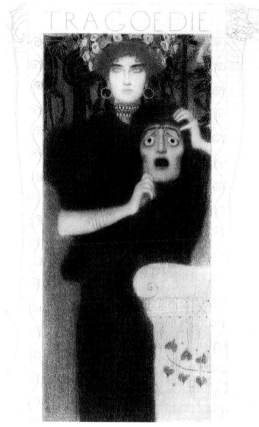

Gustav Klimt (1862–1918), *Drawing for an Allegory of Tragedy.* Color pencils can create results as interesting as any other artistic technique, and are especially useful for creating illustrations.

Color pencils are comfortable to use and give excellent results in small-format works.

Mixing is nearly impossible with color pencils, because once the line has been drawn, it can be changed only by erasing.

Varieties and Color Ranges

Color pencils for schoolchildren are sold in boxes of twelve. Their color range is very limited and the pencils are not usually sold individually. The major brands offer many sets, from boxes of twelve colors to luxurious cases with as many different tones as each manufacturer displays in its color chart (as many as 140 in some cases). These pencils are available individually through the catalogues that each company supplies to its customers.

Some manufacturers offer pencils of two different categories. The hard pencils are best for professional-quality work, since they can be sharpened more often and hold their points longer. The semi-hard (when speaking of color pencils there are no truly soft leads) are very useful for covering more or less large areas with uniform color. In addition to these there are watercolor pencils, a professional-quality variety whose line can be worked with a brush.

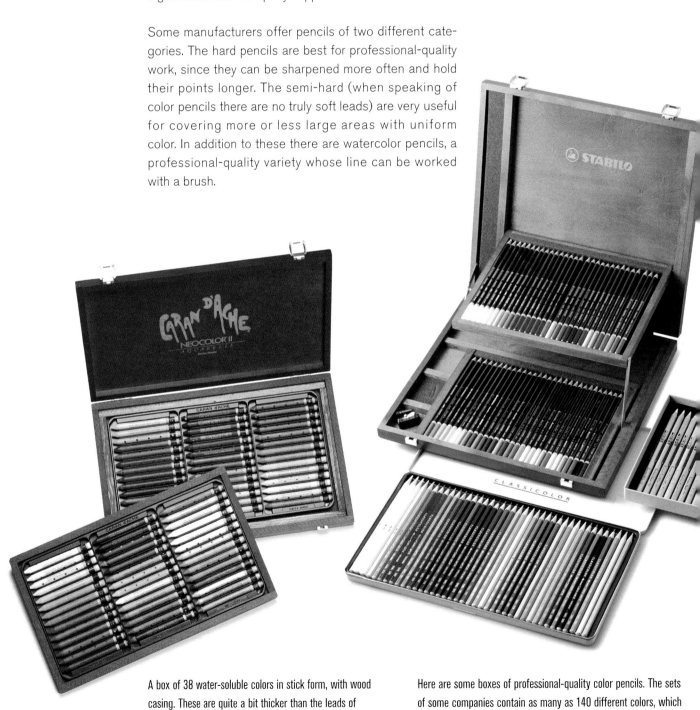

A box of 38 water-soluble colors in stick form, with wood casing. These are quite a bit thicker than the leads of conventional pencils.

Here are some boxes of professional-quality color pencils. The sets of some companies contain as many as 140 different colors, which may also be purchased individually.

SETS

The major manufacturers offer luxury cases with large selections of pencils. Normally, the reason to choose such sets is for the great variety. Artists who use color pencils usually develop specific preferences for particular colors as opposed to many others. These artists purchase their colors individually and choose from the selection of specific brands, since the colors from each manufacturer vary a little in luminosity and intensity. It should not be surprising that colors of the same name from two different brands will be slightly different.

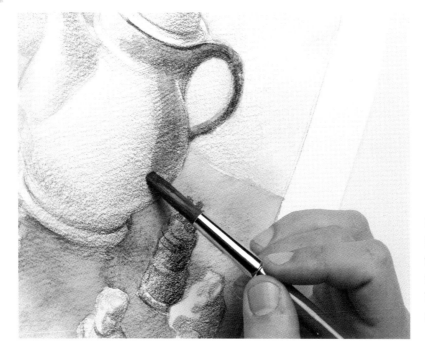

Normally, the water is applied in the final stages, when the work using conventional techniques is nearly finished. The water dissolves the lines and tends to darken the tones.

Watercolor Pencils

Some important brands offer a special variety of color pencils that are distinctive because they are water-soluble. The techniques needed for working with these pencils are exactly the same as for conventional pencils. The difference lies in the possibility of water coloring with the color, that is to say, to spread it by adding water with a brush to the already colored areas. Doing this almost completely eliminates any trace of lines on the paper, creating an effect similar to that of watercolor, although without its gloss and luminosity.

Color Sticks

Some manufacturers sell small sticks of water-soluble color in a wide range of tones. Since they are all color, these sticks can be used to work on projects that are larger than those normally attempted with this technique. Some brands make thin color leads about 1/16 inch (0.5 mm) that can be inserted into holders. The advantage of these leads is that a very fine and uniform line can be made that would be possible only with conventional pencils by constantly sharpening their points.

The lines of the watercolor pencils can be worked with brush and water, creating results close to those of watercolor.

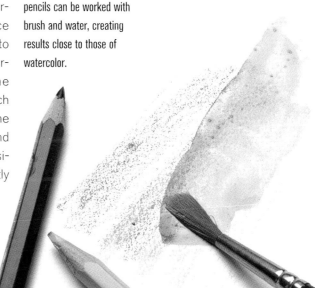

Basic Color Pencil Drawing Techniques

Compared with other drawing techniques, working with color pencils is a small-scale endeavor. Pencils cannot handle large formats and are best used when working with details, leaving aside the grand artistic effects required from charcoal, pastel, and ink. Within this limitation resides the interesting and undeniable charm of the technique, since it requires focused, delicate, and sensitive work.

Line and Color

Drawing with color pencils can be considered painting. The character of the color depends, of course, on the type of line that is used. Light colors are made using wide or narrow hatching and cross-hatching that does not cover the entire surface of the paper. The accumulation of lines can be quick and loose, or premeditated, by superimposing diagonal lines (which is a way to create a texture with a single color).

Shading with hatching is one of the best ways to achieve attractive and clean results when drawing with color pencils.

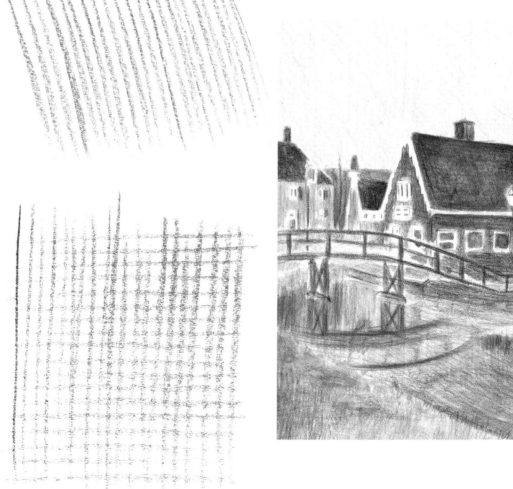

The logical size for work done in color pencil should be based on the normal range of movement of the wrist and the hand when drawing.

Color Pencils

35

Mixing Colors

Rather than mixing, we should be speaking of building up tones, since their physical mixing is not completely possible. The colors that result from superimposing tones are, of course, those that fall within color theory. The primaries—yellow, blue, and red—create the secondary colors when superimposed: orange (mixture of red and yellow), green (mixture of blue and yellow), and violet (mixture of red and blue). Artists use a wide range of colors besides the primaries to specifically avoid excessive mixing, but it is a rare drawing that does not require building up two colors to create a third. This mixing should follow a specific order: the lighter color must go over the dark one, because the lighter tones are not as dense and allow the base color to show through, which is necessary to create the new color.

These details from a color pencil drawing show how the different lines produce the optical effect of color mixing.

Overlaying and juxtaposing multicolor lines, without resorting to systematic hatching, is another optical mixing technique.

All the colors in this work by Marta Bru were created with optical mixes of different overlays or hatched color lines.

When mixing colors the lighter color must be applied over the darker one, and not vice versa.

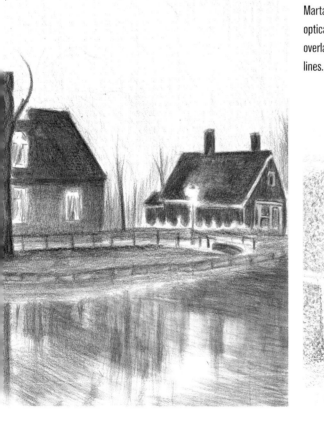

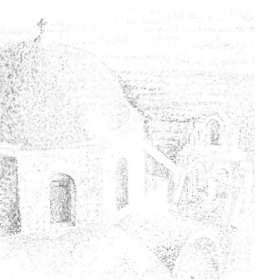

This work by Marta Bru demonstrates an original approach to color mixing; luminous color surfaces are created using dots of several colors.

Reserves, Fusing, and Mixing

Some drawing techniques are specific to color pencils and are derived from their special characteristics. In this section we explain the techniques of white reserves, fusing with a light color, and mixing colors using watercolor pencils. All these approaches enrich the range of artistic techniques for a medium that is much richer than it would seem at first glance.

Color Reserves

Shapes can be filled in using a darker color than that of the base color, making a reserve as is done in watercolor. This way of working requires imagining the effect beforehand, knowing that the base color must be quite light to maintain a lively richness of color. Filling in shapes over a dark color, no matter how many light colors are used, barely changes or enriches the tones of the first color.

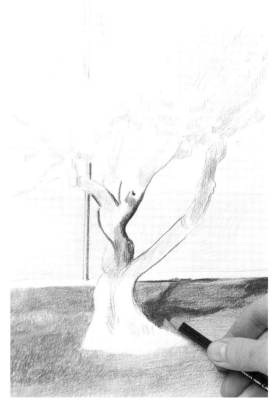

Reserving a color means painting around the outside of the shape. It is left white for a time while the exterior is colored in.

Fusing with Gray or Black

Color pencils have a peculiarity of their own, caused by their physical composition. This is the ability to fuse gray or white lines drawn over other colors. The slightly waxy consistency of the lead allows the gray or white lines to "dissolve." Some colors not only fuse, but even turn darker when they are covered with gray. This is a very useful technique whenever working with color pencils.

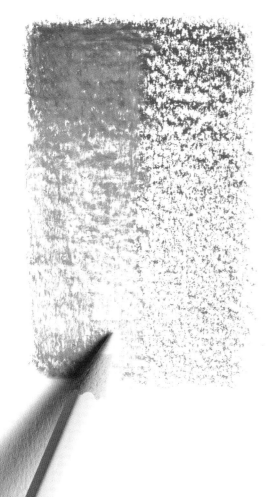

The white pencil is very useful: it fuses color lines and creates glossy surfaces that will contrast with the overall texture of the artwork.

A color pencil drawing should preserve the simplicity, freshness, and spontaneity that are inspired by the drawing tools.

Color Pencils

37

The use of white pencil can be seen in the lightly "washed" tones of this work by Esther Rodríguez. The surfaces have been polished by repeatedly going over them with the white pencil.

Mixtures with Watercolor Pencils

Watercolor pencils offer a new mixing approach that can be added to the typical techniques of overlaying colors. This is true mixing, a mixture obtained by dissolving the colors in water. When working with watercolor pencils, the mixtures are not made separately on a palette, but directly on the paper, after having put down the colors so that the water dissolves the lines and creates the desired color mixture.

This picture is in an intermediate phase of the watercolor technique. The interesting aspect of watercolor pencil work resides in the combination of lines and washes.

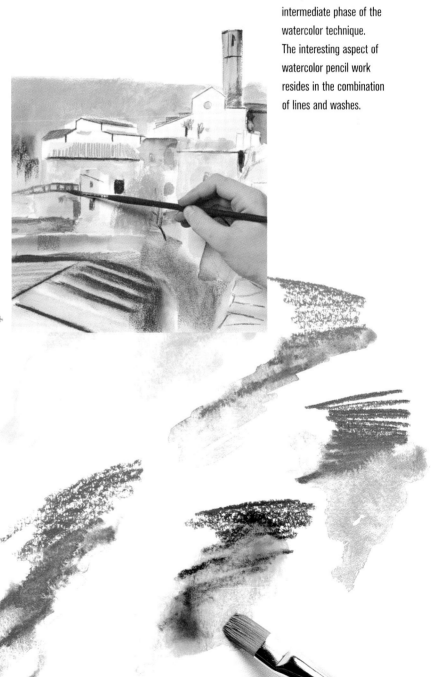

Watercolor pencils allow direct mixing, similar to working with watercolor paint.

INK AND MARKERS

Grouping one of the oldest drawing media (ink) with one of the most modern (markers) into one chapter follows very simple reasoning. Both are fluid media, with indelible lines that must be applied with a drawing instrument (a pen, a brush, a marker barrel, etc.). Furthermore, the fluid in markers is normally considered (sometimes correctly) a kind of ink. In the following pages we will see that the media have many more things in common than just those mentioned here, and that there are also significant differences that give each its own personality.

Rembrandt van Rijn (1606–1669), *Figure Surrounded by Trees,* 1641. Dresden Museum (Germany). Drawn with sepia ink using quill and reed pens.

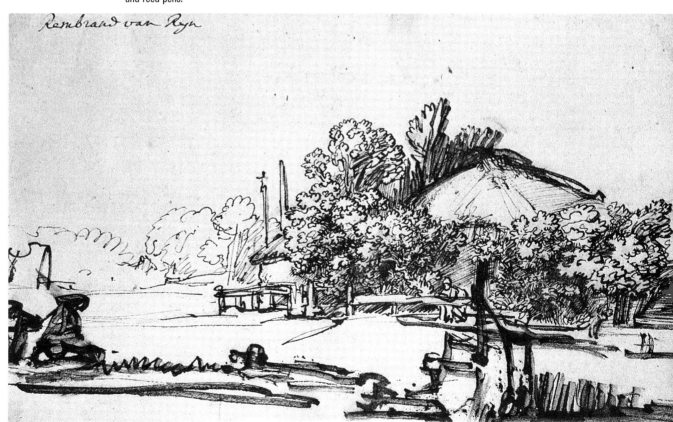

Characteristics of Drawing Ink

Ink has an incomparable strength and graphic quality, used alone or in combination with other techniques. Some types can be mixed with water to achieve more varied artistic effects. India ink is dense and dark, requiring a lot of water in the solution to lighten the tone. It is always black, but among other drawing inks can be found varieties of other colors, such as sepia, traditionally known as bistre. Writing inks have characteristics similar to india ink, but they are usually lighter and less dense. Nowadays, there is such a wide variety of writing inks that it would be impossible to attempt to cover all of them. In the following pages we will talk about the most common inks for drawing, and markers.

India ink has a charm and graphic quality that stands out from every other drawing medium.

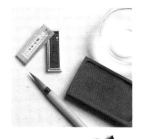

A selection of alcohol-based markers with round tips.

Markers are capable of rendering works of great delicacy, between watercolor and the most advanced graphic techniques. This work is by Claude de Seynes.

Black and Colored Inks

Whether black or colored, ink is a media that can be applied in a multitude of ways. Black ink, or india ink, is the oldest and the most widely used. But the new writing inks, the colored inks, and the anilines are becoming more and more common among those available to today's artist.

The ink drawing, whether with brush, quill, or dip pen, is always graphically striking.

India Ink

India ink is deep black, dense, and glossy. When it is applied to paper, the result is more graphic than artistic. It suggests approaches that are based on the graphic quality of the line and brushstroke more than on the different color values—in other words, blending and atmospheric effects. The graphic quality lends itself to making notes and sketches of urban scenes where various figures in different attitudes interact with the objects and machines of daily life.

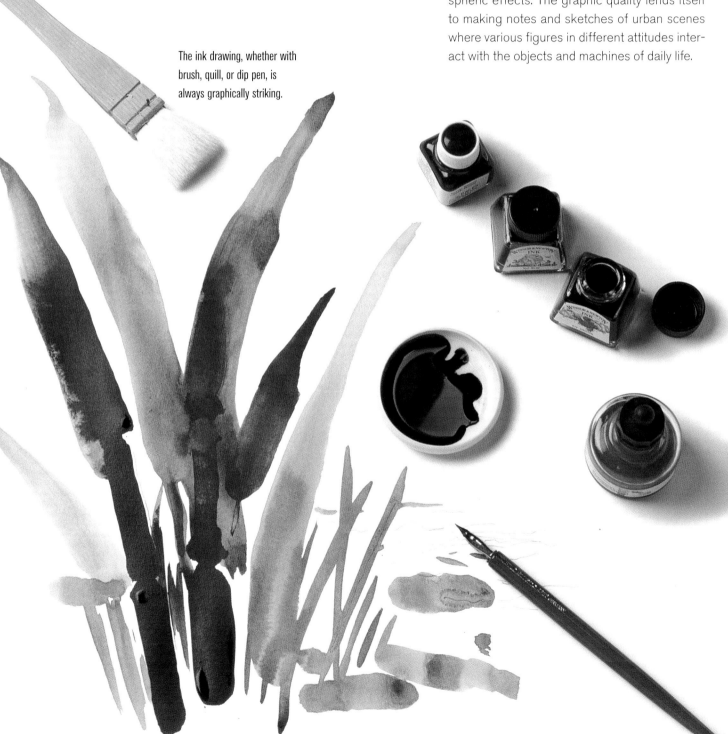

The black of india ink is, for many artists, the most attractive and suggestive of colors.

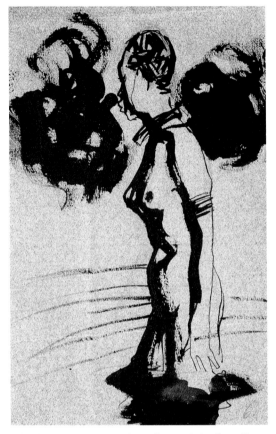

India ink can create very graphic and very artistic effects, like the case of this figure represented with looseness and skill by Vicenç Ballestar.

WRITING INKS

Inks for fountain pens, in blue, black, and occasionally red, offer interesting approaches for wash drawings using a brush. The tones of these inks vary according to their mixture with water, rendering a rich range of values. These inks can be used with dip pens or brushes, and both techniques can be used in the same drawing.

Colored Inks

Some companies manufacture jars of ink in a wide range of colors. Most of these inks are based on coloring agents known as anilines that are strong dyes with great covering power. Made to be used with airbrush, they also give good results when used with pen and brush drawings. They cannot be mixed with other media, since the anilines color every other kind of paint, even when they are completely dry.

A selection of aniline inks with strong colors that give strong graphic effects but are very light sensitive and fade quickly.

A selection of colored inks that can be mixed with each other.

Dip Pens, Nib Pens, and Fountain Pens

Ink, used as a drawing medium, can create different effects depending on the tool with which it is applied. The most common is the nib pen, but it can also be used with a reed pen, brush, quill pen, or fountain pen. The results vary with each one, from the most meticulous detail work to spontaneous effects.

Steel Pens

The classic steel nibs are sold as separate units that can be inserted into plastic or wood handles. Naturally, when drawing with a nib pen it must be constantly recharged by dipping it into an inkwell, paying attention to the amount and the duration of each charge. Nowadays, many artists choose to use drawing pens with a cartridge for ink to avoid such inconveniences.

Some models of nibs can be inserted into handles. Each of them makes a different line, whether for drawing or calligraphy.

A drawing pen with an incorporated ink cartridge (left) can sometimes be substituted for the traditional nib pen (right).

QUILL PENS

Metallic nib pens did not appear until the end of the 18th century. Until then artists used goose feathers as drawing instruments. When looking at some drawings from before that period (such as this Botticelli in the illustration), it can be seen that quill pens had no reason to envy steel nib pens when it came to precision.

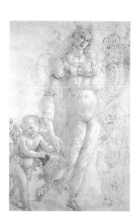

Fountain Pens

In this category are grouped all those ink drawing and writing instruments that have an incorporated inkwell, normally in the form of a refillable cartridge. The basic characteristic of these fountain pens is their constant line width despite the pressure that is applied to them (the nib is rigid) and the way it is applied to the paper.

The fountain pen is a precision instrument. It has a constant line width and is ideal for the neat, clean work characteristic of illustration.

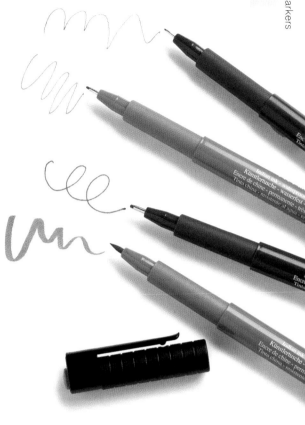

Black, sepia, and sanguine pens made especially for artistic drawing.

Reed Pens for Drawing

These are sold in several models, but the artist can make his or her own with dry bamboo, cutting a beveled point at one end and making a long slit starting at the tip of the bevel.

Here are the different lines that can be made with the various models of dip pens and reed pens. Generally, the line made by the dip pen is cleaner and more precise than that of a reed pen, which is more spontaneous and "crude."

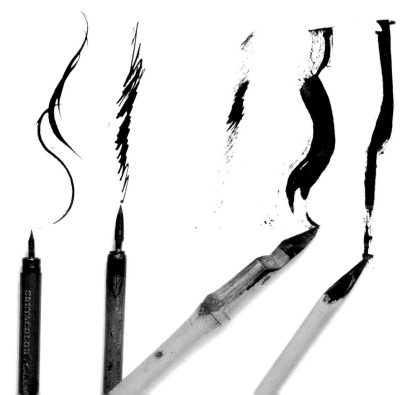

Markers

Working with markers is the most modern drawing technique, and is especially appropriate for illustration and publicity projects. This does not mean that markers cannot be used in more artistic and creative work; all styles and ways of working are valid and possible in today's market.

Composition

Markers consist of a polyester point or tip full of microscopic holes that allow the ink to flow from inside to the tip. A felt wick impregnated with ink and in contact with the tip is found inside the barrel. Capillary action causes the ink to rise to the tip when drawing or writing is taking place.

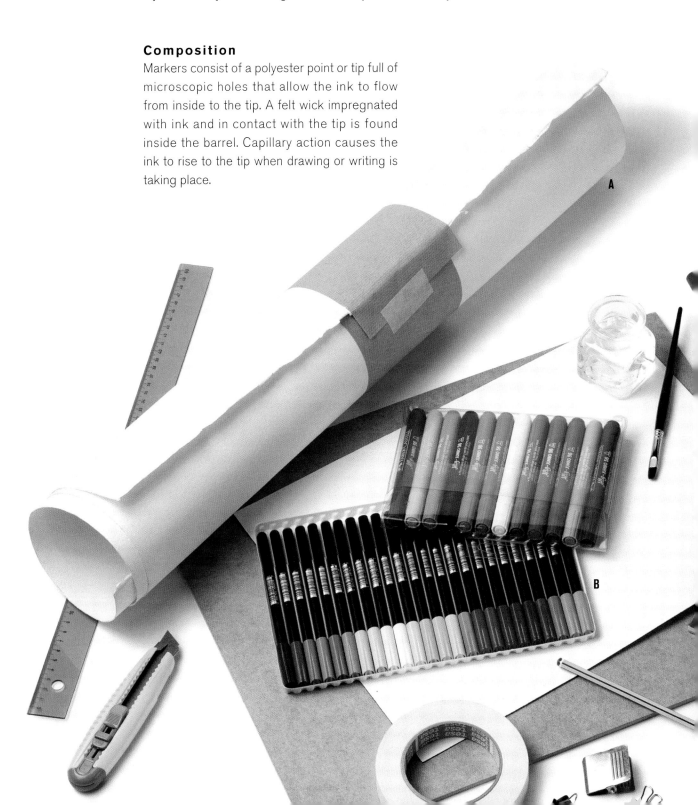

Alcohol- and Water-Based Markers

Markers that have alcohol as a solvent are most widely used by artists. The ink is usually xylene, which evaporates rapidly, causing the ink to dry quickly. Once it has dried, the color of these markers is indelible and can be worked by overlaying other tones without the inks mixing or the color running. The water-based markers are usually meant for school use. The lines take longer to dry, and it is possible for the colors to mix when painting one over the other. Some manufacturers offer water-based markers with an amount of pigment similar to that of gouache, which makes completely opaque colors and works very well in projects that require solid blocks of color.

ORIGINS OF THE MARKER

The first fine-point marker, meant for writing, was created in Japan in 1963. During the 1960s many variations of the new utensil were developed. The invention of the marker was a response to the new requirements of the advertising world that needed a quick method for creating layouts, sample illustrations, and storyboards for advertisements, which had been done in gouache until this time.

The marker was born to satisfy the demands of the graphic artists who created storyboards.

Papers for drawing with markers should be smooth; they are sold in sheets of different size (A). Alcohol-based markers are the most common and are generally available in sets of 12, 24, or more (B). Assortments of markers made especially for design have two points of different size (C). There are also markers with extra-wide points and special ink applicators for precision work (D).

Papers for Ink and Markers

The best papers for these techniques are the smooth ones without texture. This support highlights the cleanness of the line, whether made with dip pen, reed pen, or marker. Many artists use glossy paper to emphasize the clean line even more. However, there is also the option of using textured papers if you wish to achieve very specific results, where the grain of the paper will be part of the effect.

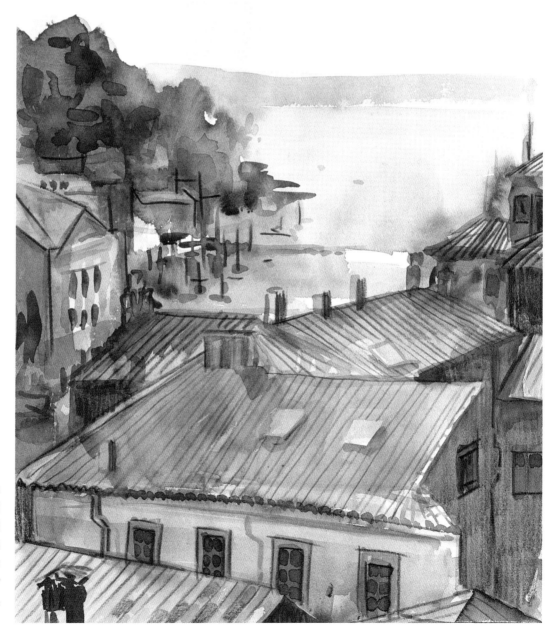

In this work by Gabriel Martín it is clear that the ink flowed smoothly when it was applied to the paper. This fluidity is what most artists want when they choose a paper for working with ink or markers.

The smoother the paper, the greater the graphic purity of an image painted with ink or markers.

Ink Drawing Papers

Paper used for ink drawings should not be very rough, making it difficult to draw lines, nor too soft or absorbent so they will not absorb too much ink and so the nib will glide easily. The best papers for working with this technique are glossy. If a reed pen is used, the paper should have texture, since this drawing tool is dragged across the paper rather than allowed to glide over it.

Marker Drawing Papers

Alcohol-based markers should glide over the support, so the paper must be perfectly smooth and without texture. The ink should not bleed, but rather should penetrate into the paper while staying damp enough to blend with the ink that is applied over it. The ink should dry quickly, but not too quickly. Special marker or layout papers are used by professional advertising artists, but for normal use both alcohol-based and water-based markers work very well on white paper (which always makes a brighter drawing) with a smooth surface.

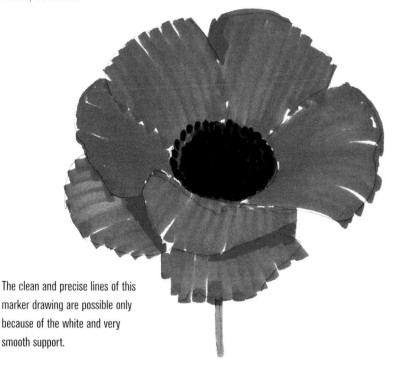

The clean and precise lines of this marker drawing are possible only because of the white and very smooth support.

Papers for ink drawings can be used to make exact tracings on a light table. Their smooth surface and perfect whiteness help this task.

Basic Ink Drawing Techniques

Works in pen and ink have a particularly charming line that is extremely sensitive to the slightest movements of the hand, both in its oscillations and the pressure it applies to the paper. Drawing with ink suggests a linear treatment, pure line work in what is an almost Asian-style calligraphy. But it is worthwhile to also practice cross-hatching, reed pen drawing, and brush techniques.

Controlling the Line

When drawing with any dip pen, nib pen, or reed pen, the line is much finer than it normally is in any other drawing technique. It is also more permanent; drawing with ink leaves no room for guesswork. In other words, ink lines require greater confidence.

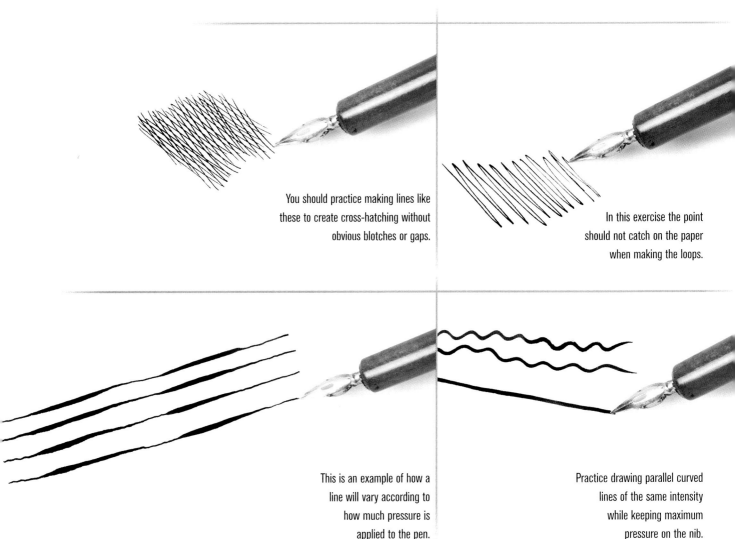

You should practice making lines like these to create cross-hatching without obvious blotches or gaps.

In this exercise the point should not catch on the paper when making the loops.

This is an example of how a line will vary according to how much pressure is applied to the pen.

Practice drawing parallel curved lines of the same intensity while keeping maximum pressure on the nib.

THE LINE AS PROTAGONIST

The great masters of the ink drawing (such as Eugène Delacroix, shown here) exhibit a virtuosity in line control, expressive line work, and meaningful details, all the more admirable because the pen line cannot be corrected and is permanent.

Reed Pen Lines

Lines in reed pen drawings allow greater variation, depending on the side of the point that is applied to the paper. The combination of fine and wide lines can be alternated further with another approach that is typical and exclusive to the reed pen: "faded" lines, that is, lines that are not very dense and are lighter for lack of ink. Whereas nib pens suddenly stop drawing when the ink charge runs out, the reed pen leaves a mark that gradually becomes lighter, which the artist can use to create specific effects.

The reed pen is a bold drawing medium, and requires a resolute frame of mind.

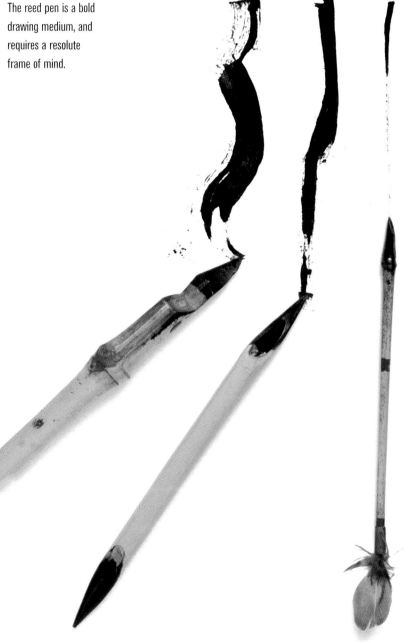

Fountain Pen Lines

In the case of fountain pens, the line is of a constant width, unless the point is made to spread by forcefully pressing the pen against the paper. This causes the nib to discharge ink faster and widens the line. This is the same for most nib pens and any conventional writing instrument. This allows you to make graduated lines while drawing.

Brush Drawings

When used with india ink, the brush is a mellower medium than the nib pen and reed pen. Its use is more agile and fluid, and the variety of the line is incomparably greater than that made by ink pens. One decisive factor in the different nature of the brush drawing is the drawing of curves, and rounded forms in general. Where the pen is abrupt and dry, the brush is delicate and flowing. On the other hand, the brush is not capable of the clean and graphic precision typical of dip pens and nib pens.

Basic Lines

The brush is the drawing tool that is most sensitive to the action of the hand—its movements, twirls, undulations, and changes in pressure. A single brush line can contain many different nuances and suggest the most varied aspects of the form being described. Furthermore, the amount of ink held in the brush, and how diluted it is with water, increases the expressive options of the line. On this page are shown some of the basic lines that must be practiced to learn to control the brush.

ASIAN DRAWINGS

Brush and ink were used for drawing by artists in the Far East many centuries before its use spread to the West. The works of the Chinese and Japanese masters are of incomparable precision, delicacy, and freedom, and possess an absolute technical mastery.

Of all the drawing tools, the brush is the most sensitive to the movements of the hand; the lines possess an incomparable strength and delicacy.

Curved lines made with ink diluted in water and considerable control over the brush.

Line control is essential in brush drawings. This zigzag line is one of the simplest.

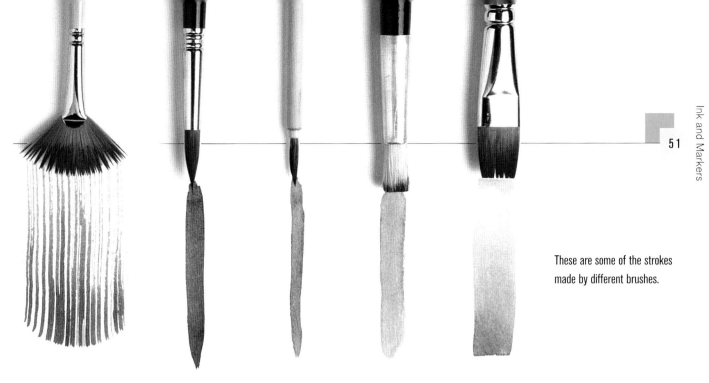

These are some of the strokes
made by different brushes.

Brushes and Water

The results of working with a brush greatly
depend on the amount of water that is used. In
the technique known as "dry brush," the least
possible amount is used and the brush leaves a
textured stroke. If using a lot of water you arrive
at the opposite extreme, a wash or mono-
chrome watercolor. A direct drawing with brush
and india ink, without dilution, is one that results
in the most unified and graphic line.

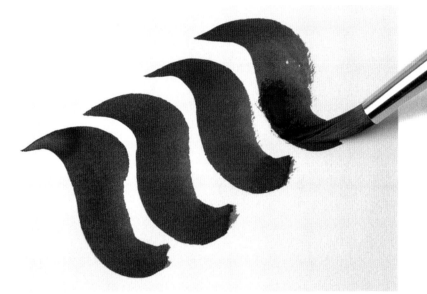

Brushstrokes of ink lightly diluted with water, with the brush
almost completely pressed against the paper.

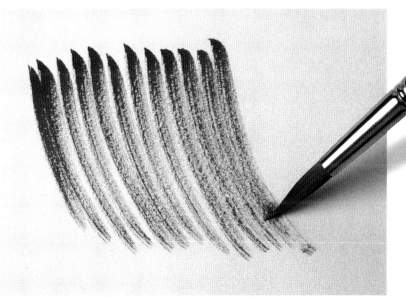

Textured brushstroke typical of the "dry brush" technique,
with very little ink in the brush.

Basic Marker
Drawing Techniques

Drawing with markers will not present many difficulties for anyone who has become familiar with using color pencils. Fine-tipped markers, the most appropriate for drawing, can precisely define outlines and the effects of color and shadow. Markers, like color pencils, can superimpose lines and more or less solid areas of color.

Outlines

The process of drawing with markers is similar to that of color pencils, but some important differences must be pointed out. In the first place, the initial drawing of the outlines must be done in the color of the form being represented. If a general tone is used for this preliminary drawing, gray, for example, this color can distort the final drawing by showing through in light areas, unless a loose, sketchy effect is desired. The initial sketch should be a colored sketch.

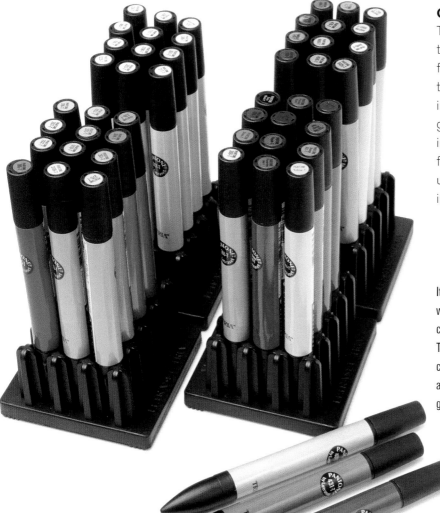

It is a good idea to have the widest possible range of colors so as to avoid mixing. This is a small part of a complete range of special alcohol-based markers for graphic designers.

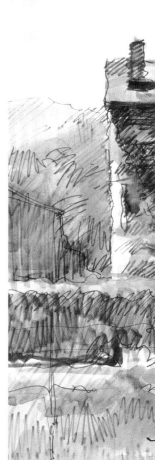

The technique of drawing with markers is similar to that of color pencils: the work goes from light to dark, and excessive mixing should be avoided.

Mixing

Color is directly mixed by laying one color over another. This technique is adequate when working with colors in the same range or else when a darker color is the goal. It is not effective when a homogenous mixture is desired; that is, when the two colors mix to create a pure third color. Direct mixing should not be done at the beginning of the process, because it tends to darken and muddy the tones as the drawing is developed.

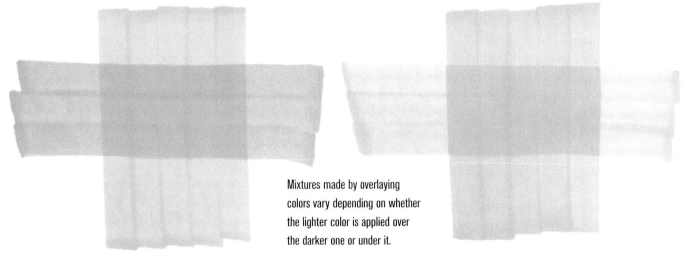

Mixtures made by overlaying colors vary depending on whether the lighter color is applied over the darker one or under it.

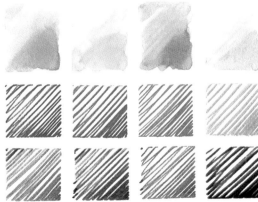

This is the range of colors used to paint the landscape reproduced on this page. The tones are water-based, and the lines can be painted with a damp brush to create a wash.

Miquel Ferrón used water-based markers in this work. The shaded areas were created by blending lines with water applied with a brush.

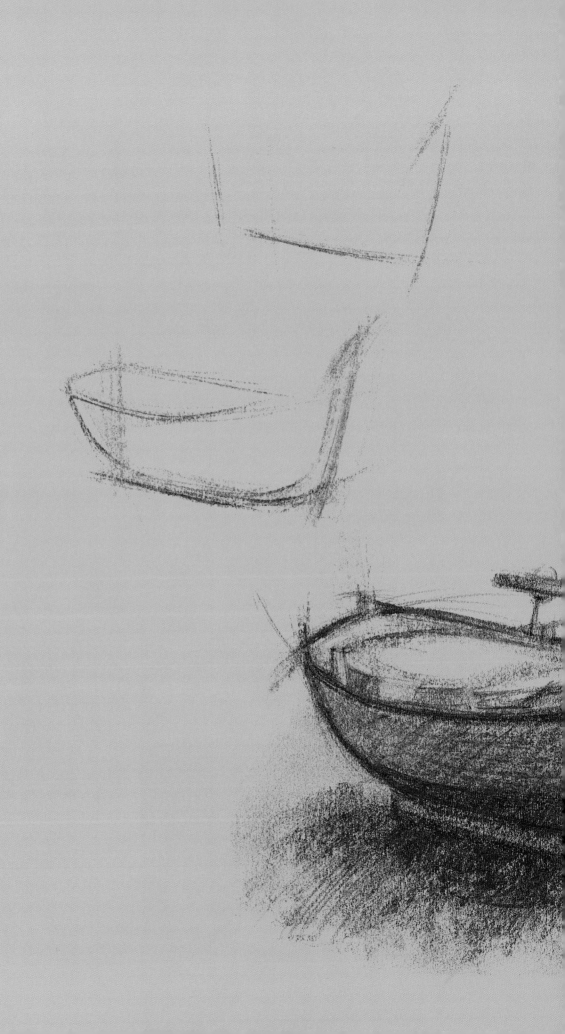

DRAWING

DRAWING

Basic Techniques

*All drawings, whether clumsy or
masterful, are based on a series of basic
techniques that are inherent to this art.
The results can be good or bad, but the techniques are always present in the drawing.
The principles are very simple: blocking-in, proportion, composition, etc. These
techniques and more should be known and mastered by the draftsman, and they
are explained in full detail in the following pages. The basic techniques of drawing
are common to all procedures, whether the artist uses simple materials such as pencils
or the more challenging india ink, although there are important differences that must
be pointed out. This is done in the sections that cover each procedure, so the reader
can find the specific techniques for each medium.*

Drawings and paintings are composed of lines, strokes, and areas of color that create forms. These forms may not be recognizable, as in abstract paintings, but they always have proportion and order, and constitute an overall design that produces a sense of harmony. The proportion and order of the drawn forms are qualities that are achieved only when one is able to discover order and proportion in the forms in reality.

Any good drawing is based on capturing the essential form, the form without features, and in the harmony of simple lines that depict it, as can be seen in these drawings by Josep Roca-Sastre.

CUBISM

Cubist artists explored the possibilities of an art based on elementary forms that suggested, but did not imitate, reality. This approach resulted in a large number of drawings and paintings that were a step away from becoming complete abstraction.

Synthesis

A drawing is always a graphic synthesis, and all syntheses imply selection and summarizing. Only the most significant parts of the reality should be observed and represented with the greatest possible simplicity. This is when we can judge its proportion, adjusting and correcting it when necessary. This means that, above all, schematic, simplified representations must be drawn, working at synthesizing the subject. This is the most difficult thing to do.

Basic Forms

Just as all musical compositions are a combination of a few sounds, a drawing, as complicated as it may be, is the combination of a few forms. They are simple forms, the simplest that can be imagined: the sphere, the cube, the pyramid, and the cylinder. Combining two or more of these forms creates a series of endless possibilities, to the point where all objects in reality can be represented. The artist's gaze should attempt to deduce which of these forms and what combination of them can adequately represent that which is seen.

All forms in nature can be reduced to combinations of basic regular solids: the cube, the pyramid, the cylinder, and the sphere.

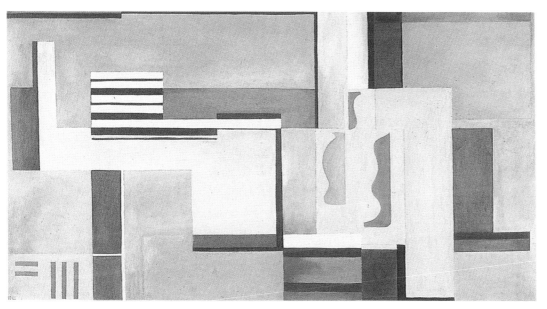

Mario Radie (1895–1968), *Composition.* Private collection. It is perfectly possible to create a harmonious work by using only basic forms and structures. In fact, such structures ensure harmony.

Blocking-In the Drawing

Blocking-in means putting something in a box, and boxes and containers always have very simple forms: cubic, pyramidal, cylindrical, or spherical. No object will exactly adapt to the form of the box it is in, but it is enough to fit into it without too much empty space left over. In drawing, blocking-in means drawing simple boxes the same size as the objects. These simple boxes are, as we have seen, the basic forms and the possible combinations of them.

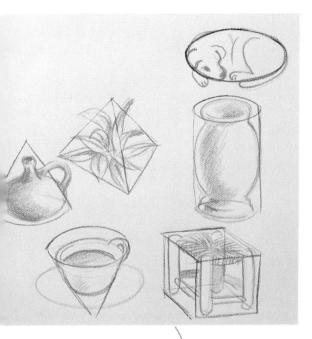

Blocking-in establishes the basic proportions of an object. These sketches are representations of the width, height, and depth of each object in question and the location of its parts. For the artist, blocking-in is the first step in the drawing process.

All forms from nature and constructed by man can be enclosed in a geometric box similar to one of the regular solids or a combination of them.

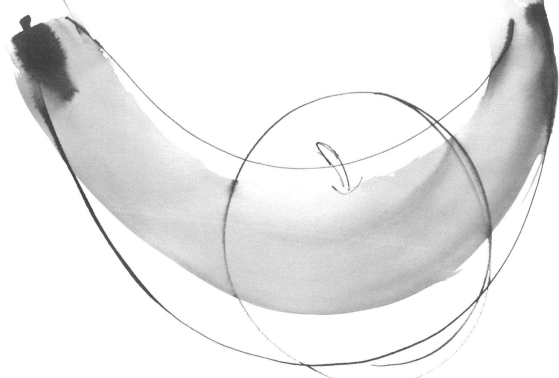

The Blocking-In Technique

Blocking-in an object is very simple, supposing the artist can draw straight and curved lines with some control and confidence. If this is not the case, he or she should first do exercises in drawing lines, repeating the same kind of line many times with pencils, pens, and brushes to learn to control the line with different drawing tools. One of the keys to gaining such control is discovering the correct speed for moving the hand: more fast than slow, but without rushing. Progress is usually quite fast, and after a few sessions the aspiring artist is sure to be able to block-in any subject. The blocking-in technique consists of simply drawing a container of the correct form and proportion for the object, a box with a basic shape.

It is easiest to study the blocking-in of objects in a realistic painting, like this still life by Zurbarán, *Lemons, Oranges, and Roses.* Each group of objects is reduced to its basic forms as seen in the illustration below the painting.

Blocking-in means drawing boxes the size of the objects. These simple boxes are basic forms and combinations of basic forms.

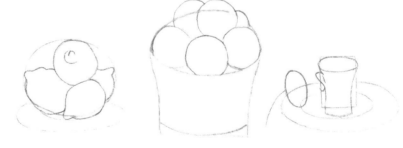

Working with well-drawn shapes is much easier than beginning a drawing without first making a solid framework. These drawings were done based on the sketches seen above.

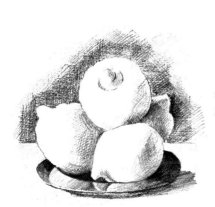

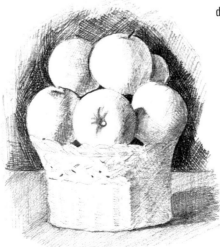

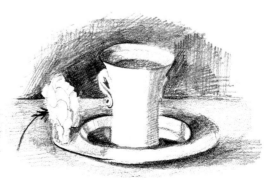

A drawing is a representation of reality to scale. It is not a very precise scale, as you would find on a map, but its correct proportions are there. This means that the size relationships between the drawn forms correspond to the size relationships between the objects that are being drawn. Saying that a drawing is well proportioned is the same as saying that it maintains an accurate relationship to the model or the real subject that acts as a point of departure. It is a convincing representation of reality.

The most effective method of measuring the model is to hold a pencil with the arm extended, marking the desired dimensions on the shaft with the thumb. They are then compared with those of the drawing.

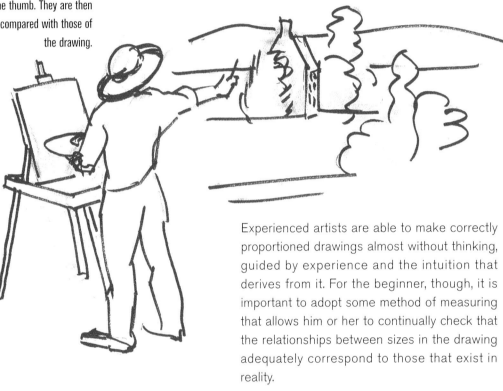

Experienced artists are able to make correctly proportioned drawings almost without thinking, guided by experience and the intuition that derives from it. For the beginner, though, it is important to adopt some method of measuring that allows him or her to continually check that the relationships between sizes in the drawing adequately correspond to those that exist in reality.

The basic measurements are applied to the drawing to create the proportions. Then the subject is further developed according to the chosen technique.

The artist should be able to make correctly proportioned drawings almost without thinking about it, guided by experience and the intuition that derives from it.

Understanding Form

61

Taking Measurements

Some system of measuring the subject must be used to achieve a well-proportioned drawing. The most traditional of these systems consists of using a pencil as a "ruler" for measuring. The pencil is held at the end with the arm fully extended. It should be lined up between the eye and the object that is being measured. The measurement is established between the point of the pencil and some place along the shaft; this place is marked with the thumbnail. Comparing this dimension with any other of the subject will check the relationship between the dimensions (height to width) of the subject.

Of course, this system does not allow great precision, but it is a good way to check the basic dimensions of the object before drawing them.

THE CORRECT DISTANCE

The distance from the artist to his subject should never be too great; if it is, the representation will be too small. On the other hand, if the distance is very short, it will be easy to make a mistake with the measurements and the proportions of the model, since it will be difficult to see the subject as a whole. It is important for the artist to move forward and back until he or she can comfortably capture the subject, easily seeing all of its details.

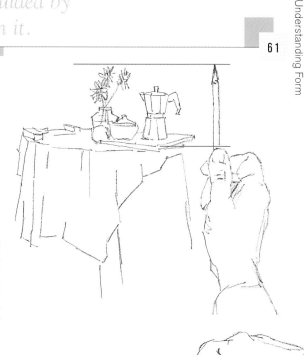

Taking measurements in three phases: checking the height of the subject, the total width, and its partial heights and widths.

The artist should place himself or herself in front of the model so that, with the arm extended, the length of the pencil can span all the dimensions of the subject.

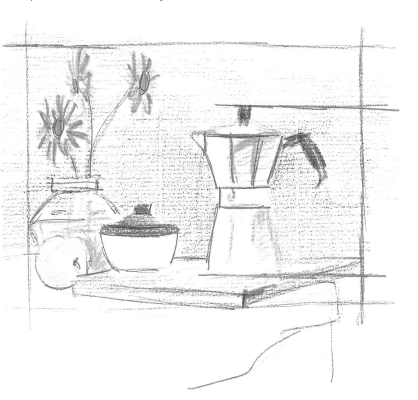

Composing the Drawing

Creating a well-proportioned drawing is a necessary condition for a successful work of art, but that alone is not enough. Besides correct proportions in all its parts, the drawing must be harmoniously located within the format of the paper. This means that large areas of white should not be "left over," nor should there be areas where lines are crowded at the edge of the paper because the drawing "doesn't fit."

Composing a drawing means fitting its dimensions inside those of the piece of paper. And to carry this through, the subject should be treated as a whole, like a block whose dimensions should be in proportion with those of the support.

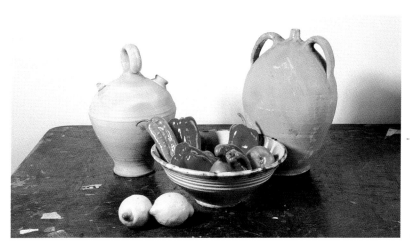

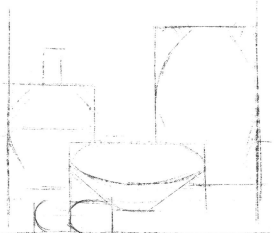

Composition goes hand in hand with the task of fixing the proportions of the drawing. The forms must be located harmoniously in the format, keeping in mind the dimensions as well as the spaces that separate the objects from the margins of the paper.

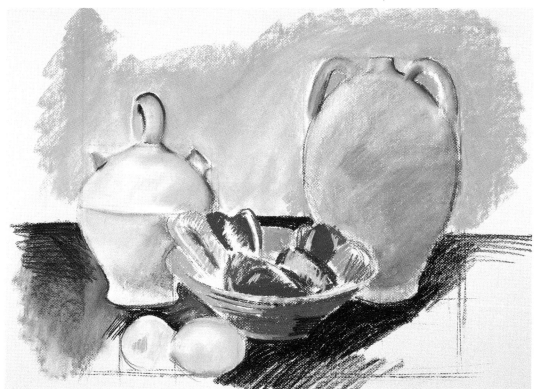

CENTERED COMPOSITION

Some of the great painters, such as Cézanne, composed paintings from the center and extended their work toward the outside; this way the final composition could be decided at the end of the process. Painting from nature requires the artist to adapt, since the landscape is rich in unsuspected details that could be added to the work as it progresses.

Dividing the Paper

The most direct way to compose a subject is to divide the paper, using diagonal lines to locate the center. Two perpendicular lines can be added to divide the paper into four equal parts. This done, the forms of the subject can be distributed in relation to these lines that serve as references to continually check that the drawing is correctly centered on the paper.

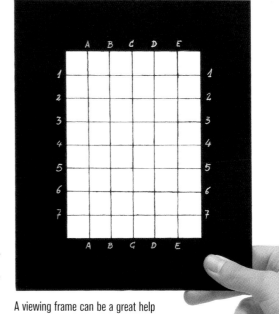

A viewing frame can be a great help for composing a drawing.

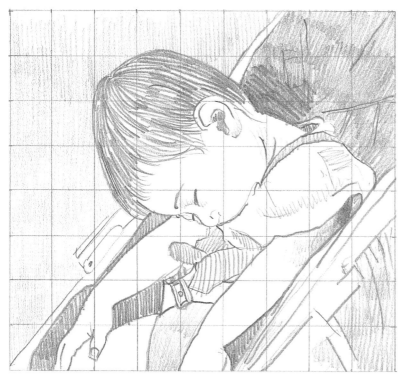

The Viewing Frame

Some artists use a cardboard frame to help compose landscapes. It consists of two right-angle pieces of black board; by moving them, views with different formats and proportions (squares and rectangles) are created. By looking at the landscape through these viewers, the artist can more or less see how the specific fragment of the landscape will work in relation to the format of the paper. Using the cardboard viewer is almost like seeing the painting itself.

After drawing a graph on the paper like that of the viewing frame, it can be used to draw all the details of a subject and adjust it perfectly to the paper.

The Blocking-In Process

This exercise shows the step-by-step process of blocking-in a still life composed of geometric elements. These objects were selected to make the process easier. It will not be necessary to reduce them to basic geometric forms, because they are already there. After taking measurements, all of the forms will be blocked-in while being sure to keep their correct proportions.

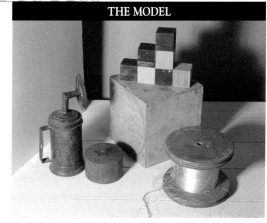

THE MODEL

This unusual still life is composed of geometric pieces. It will clearly show the process of measuring and blocking-in the forms typical of the beginning phases of a complex drawing.

PHASE 1: TAKING MEASUREMENTS

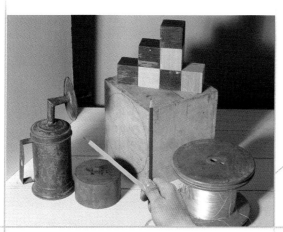

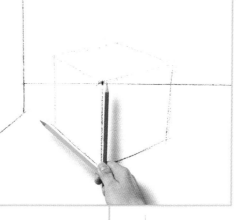

2. The measurements and angles are transferred to the drawing; in this case, the sizes in the drawing coincide with the dimensions taken with the pencils.

1. The dimensions and angles of the model are checked with the arm extended and holding two pencils, specifically the large central cube that holds the small cubes.

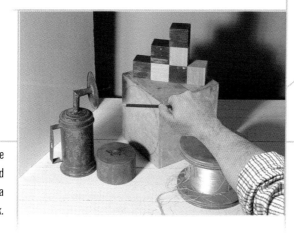

3. The dimensions of the pieces can be checked using a single pencil or a small stick.

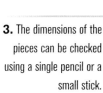

4. The dimensions of the model are marked on the paper using the previous method.

The blocking-in of the objects takes place after taking the measure of their height and width using a pencil.

GEOMETRIC BLOCKING-IN

5. The previous steps should be repeated as many times as necessary to arrive at a well-proportioned grouping. Next, using basic forms, the pieces are blocked-in following the previously taken measurements.

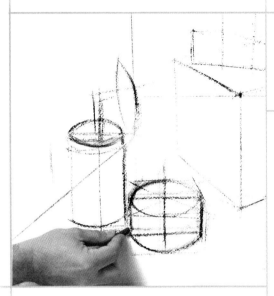

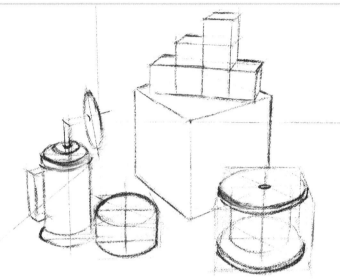

6. Here is the final result of the blocking-in: the result can be elaborated upon, but for now it is enough to understand the keys to blocking-in a drawing.

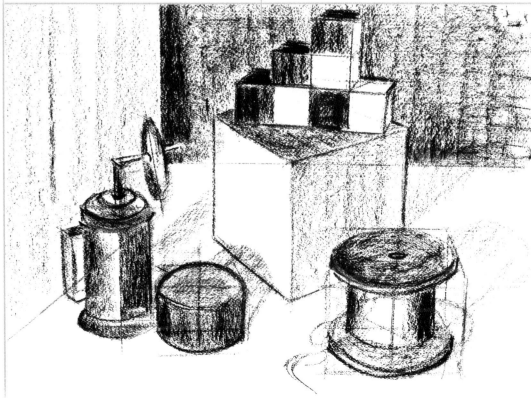

7. The drawing can be completed with more or less detailed shading. The drawn forms will remain exactly the same as they were made when they were blocked-in.

PHASE 3: **MODELING THE FORM**

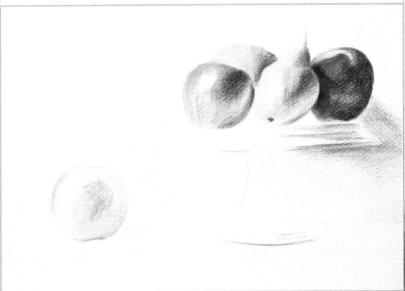

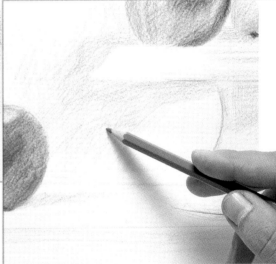

7. Little by little, pencils with stronger colors are used. If the drawing has some preliminary color shading, it is easier to create more defined colors in this phase of the work.

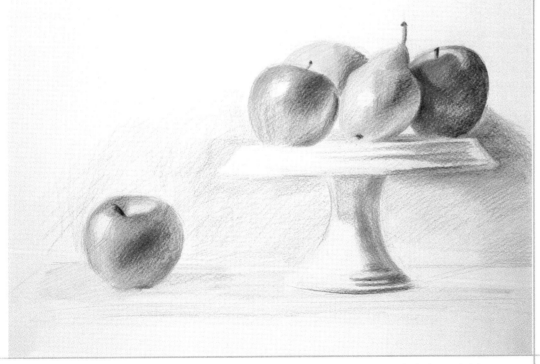

8. Modeling the volumes of the fruit is done exactly the same as with a graphite pencil drawing, using the same graphic technique, which, in this case, is cross-hatching.

9. When the fruit is finished, all that is left to do is lightly shade the background of the composition to unify it and give a superficial indication of atmosphere to the grouping.

Respecting specific areas of the paper that were left white, or covered with light line work, improves the final effect of a work done in color pencils.

69

Understanding Form

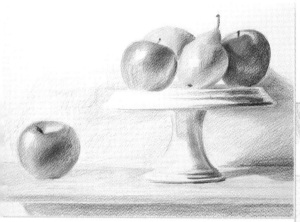

10. The last phase of the drawing essentially consists of unifying the whole composition using light shadows projected on the wall. This should be done in a progressive manner and without emphasizing the pencil lines.

PHASE 4:
FINISHING TOUCHES

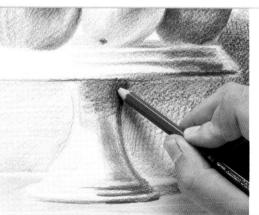

11. The fruit bowl should also be shaded, but with more intensity than the background of the composition, since its volume is important in the play of forms that takes place in the work.

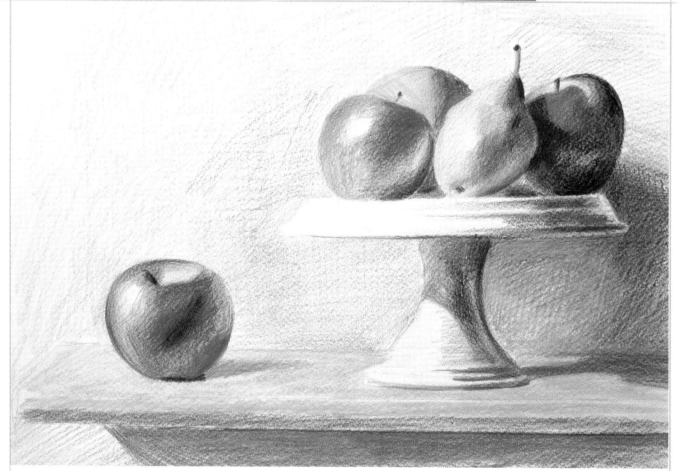

12. Here is the result of all the previous steps: a drawing colored with subtlety and precision that can be done only with a direct and easy medium such as color pencils.

Perspective is the most efficient way of representing the third dimension on a two-dimensional surface. The technique was already being used in ancient Rome, but it did not become a true science until the Renaissance. The entire world is familiar with perspective representations because nearly all the images that surround the individual today (photographs and moving images) are perspective views. The most common of these images is a street or highway seen from the inside of a car.

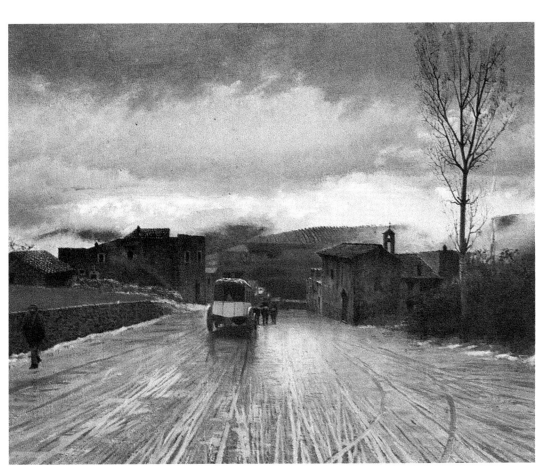

Giuseppe de Nittis (1846–1886), *Crossing the Apennines.* Galeria Nacional de Capodimonte (Naples, Italy). The perspective effects conserve some of the theatricality typical of the era when perspective reigned in cinematic art.

MODERN ART

Despite the abstract tendencies of the 20th century, perspective continued to be used in movements such as Surrealism, where it was sometimes deliberately used incorrectly, ironically, or in exaggerated fashion, by artists such as Salvador Dalí or Giorgio de Chirico (who painted the work reproduced below). Other artists use it as a means of emphasizing deformities, visual ironies, or as a reference to the Renaissance tradition.

The Road to Perspective

Art in the Middle Ages ignored perspective, and figures were placed in flat space with barely any depth. The invention of perspective in the Renaissance is not attributed to any single genius, but rather to a process of investigation with contributions from different artists. The pioneers were painters such as Giotto (1266–1337), Ambrogio Lorenzetti, and Paulo Ucello. But the definitive contribution was made by the Florentine architect Filippo Brunelleschi (1377–1446). Around the year 1420, when he began work on the construction of the cupola of the Cathedral of Florence, Brunelleschi invented an ingenious system of representation based on drawings of the plan and elevation, from which he could develop a perfect perspective view.

Raphael (1483-1520), *The Betrothal of the Virgin.* Galleria degli Uffizi (Florence, Italy). Raphael was a key figure of the Renaissance in Italy, and one of the first to use perspective to give his works a sense of deep space to enhance the noble subject matter.

Stage Sets

During the baroque period, perspective was developed to its full potential in stage sets for the theater and in the large decorations for temples and palaces. Perspective effects allowed the creation of the illusion of deep spaces where there were none, spectacular views of the sky in the domes of churches, and the simulation of imaginary architecture. This caused perspective to become associated with the theatrical, with the false and fictitious in the minds of artists. Finally, by the early 20th century avant-garde painters decided to work without using traditional perspective at all, to the point that abstract painting ignores any representation of depth.

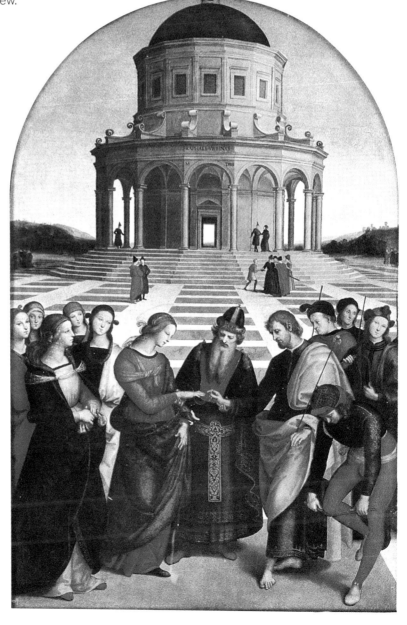

Concepts of Perspective

The horizon line is the most basic concept and also the most important in a perspective drawing. The horizon is the basic reference, whether it is visible (in a landscape, for example) or not (in a still life). When it is not immediately visible, the horizon can be deduced from the direction of the lines of perspective. In other words, all of the perspective lines are directed at a point on the horizon: the vanishing point.

The point of view is always at some point on the horizon and is the same as the vanishing point, and all the perspective lines of the drawing flow to it.

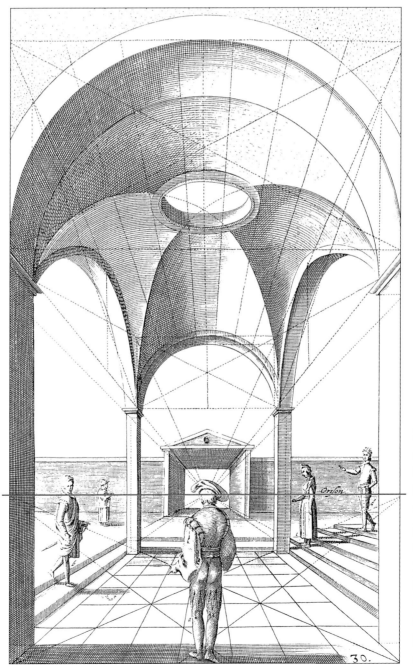

In this illustration from an old treatise on perspective by Jan de Vries are shown the key concepts of this technique. The lines of perspective all go to a single point: the vanishing point. It coincides with the figure's head (the eyes, actually), with his point of view. And this point of view is on the horizon line of the entire scene.

The Height of the Horizon

The horizon is always in front of us, at the same height as our eyes. The example that is easiest to see is the ocean: looking directly at it we see the line that separates the water and the sky, and that naturally is at eye level. It is this way whether we are sitting on the beach or up high on the rocks. In other words, the height or elevation of the horizon depends on our point of view.

The horizon is always at eye level, regardless of the position of the viewer.

Point of View and Vanishing Point

The point of view, always at the height of the horizon, is the starting point for all the lines of perspective. This is logical, because the eye is the place where all visible images converge. When representing the images that we desire to paint or draw, the eye, or point of view, is defined by a point on the horizon called the vanishing point. Following this comparison between point of view and vanishing point, we must add that the images that converge in the eye translate, in our representation, to the convergence of perspective lines at the vanishing point. Simply put, the point of view is always at some point on the horizon and is the same as the vanishing point, and all the lines of perspective (with some exceptions that we will see later) are directed toward it.

Raising the point of view (that of the camera that took this photograph) also elevates the horizon line.

The lines on the photograph indicate the perspective lines of the subject converging at a point on the horizon, the vanishing point. The representation of this subject was made using this convergence.

Artistic Role of Perspective

Perspective is a very useful tool for a true-to-life rendering of reality, and it is indispensable in technical representations in engineering and architecture. But of real importance to the draftsman and painter are the truly artistic possibilities of the perspective view. This means that, without forgetting the necessary geometric guidelines, the artist should aspire to achieve an aesthetic effect of the view with depth, in accordance with the nature of the subject matter.

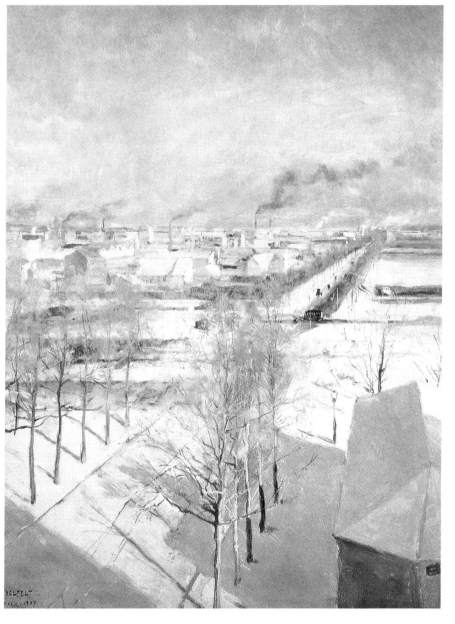

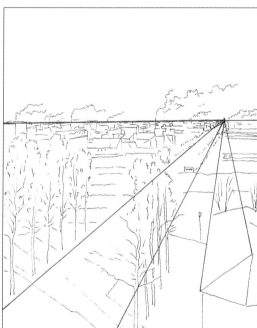

Albert Edelfelt (1854–1908), *Paris in the Snow.* Ateneumin Taidemuso (Helsinki, Finland). In this painting, the elevated point of view creates a high horizon line and a panoramic view of the landscape. The painter was careful to move the vanishing point to one side of the composition to direct the eyes diagonally so they will move across the entire panorama from one side to the other, in a trajectory that evokes the flight of a bird.

The artist should aspire to achieve an aesthetic effect with perspective, in accordance with the nature of the subject matter.

The Center of Attention

The coincidence of the point of view with the vanishing point immediately brings up an interesting consideration: the vanishing point occupies the center of the viewer's attention. The Renaissance artists placed the main figure on the vanishing point of the perspective (normally a religious figure), to ensure his or her preeminence in the picture. Many later artists used this same approach to direct the viewer's attention to the area where the main action is taking place, or conversely, to create an effect of surprise by moving the vanishing point away from the apparent dramatic center of the painting.

CENTERS OF INTEREST

Perspective lines not only are a technical resource, but they also direct the gaze of the viewer toward the points of interest in the work. In fact, the perspective lines always direct the eye, and an artist who uses perspective is obliged to take full advantage of this fact, accentuating it with architectural elements or hiding it with other forms placed over it.

Hugo Birger (1854–1887), *Scandinavian Artists at Breakfast in the Café Leydoyen in Paris Celebrating the Salon of 1886.* Göteborgs Konstmuseum (Goteburg, Sweden). If not for the strict parallel perspective, this scene would be chaotic. But the perspective directs the eye and orders the positions of the figures by aligning the heads along the horizon and centering the gaze in the background of the painting.

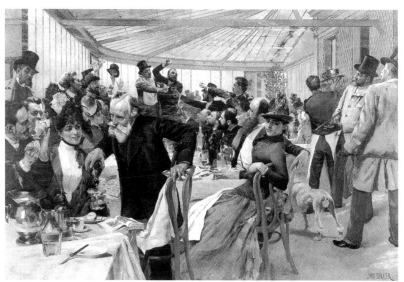

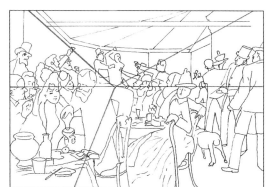

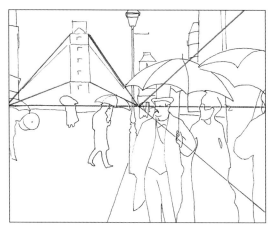

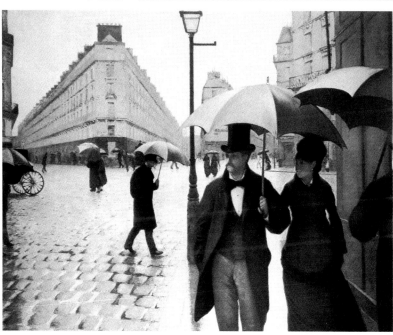

Gustave Caillebotte (1848–1894), *Paris Street; Rainy Day.* The Art Institute of Chicago (Chicago, Illinois). In this celebrated work, the vanishing points of the oblique perspective are away from the obvious center of interest (the two figures in the foreground), which creates the suggestion of space.

Intuitive Perspective

Most challenges in perspective that an artist comes across can be resolved using his or her experience in drawing and seeing. In most subjects it is not necessary to apply the principles of perspective to represent the differences in the space that separates objects. They can be understood intuitively, and the closer objects can be represented in front and those that are farther away behind. A few basic ideas are enough to avoid the most frequent errors.

When representing small objects, parallel or oblique perspectives are not necessary because there is very little depth. They can all be represented within blocked-in parallelograms.

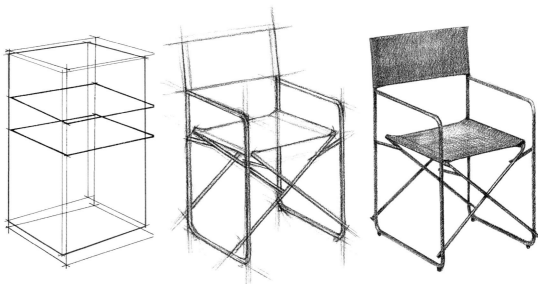

The Sizes of Objects

The effect of lines receding toward one or more points on the horizon can be noticed only on large objects. Applying parallel or oblique perspective to objects in a still life, or to medium-size furniture, only results in absurd and deformed effects. The great majority of small objects can be represented using boxes with parallel lines (truly parallel). This means that boxes based on cubes are regular cubes and not shapes that vanish as they move toward the horizon.

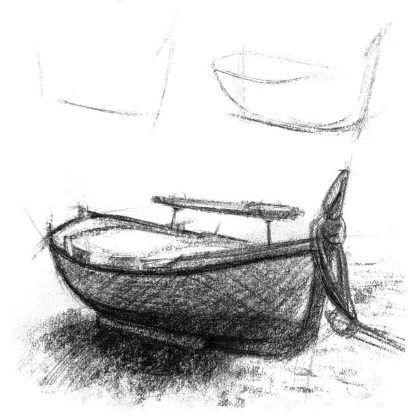

Once it reaches a certain size, the depth of an object is great enough to show the effects of perspective. In such cases it is important to be sure that the blocked-in lines of perspective converge at the same point on the horizon.

CUBIST PERSPECTIVE

Deformations in perspective are not considered wrong when the artist uses them for a specific artistic purpose. This occurred in many movements in the 20th century, such as Cubism and Expressionism, where the perspective is deformed to create works of surprising dimensions and impact, like this cubist "seascape."

The Most Common Errors

The most common error of all is not respecting the parallel lines that are directed toward the background in square shapes or in representations where the perspective lines are not obvious. Another habitual mistake is forcing perspective in views that do not require doing so. Besides these errors, it is important to avoid inverting the perspective so that the lines separate instead of converge. Some of these cases are shown in the adjoining illustrations.

A very obvious mistake is inverting the perspective by making the farthest part wider than the nearest (left). Such distortions are easy to identify and correct (right).

Some big mistakes in perspective appear in the drawing on the left, like the deformed perspective lines in the alcove at the right and the tiled floor. On the right is a correct rendering of the room.

A Church in Perspective

In this exercise we demonstrate oblique perspective (two vanishing points) in a simple subject that will be easy for a beginning artist, at least when it comes to the line drawing; the perspective is what we are interested in here. The exercise is by David Sanmiguel, using pastels.

THE MODEL

Although the horizon that the lines of perspective converge on is not visible, it is simple to locate it by extending the lines.

PHASE 1:
LINES OF PERSPECTIVE

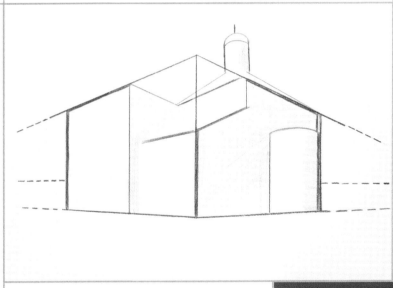

1. The oblique perspective sketch is constructed by beginning with the nearest corner. This line corresponds to the corner of a cube drawn in perspective. The lines of perspective start at the corners and extend to the two vanishing points on the horizon. The drawing is constructed based on lines like these.

Perspective is always applied to the blocked-in figures in the first phases of the drawing. The less important lines are then added, working within this framework.

2. As simple as the drawing may seem, the perspective must be carefully calculated. Of course, it is not necessary to extend the auxiliary lines to the horizon, or to draw the vanishing points.

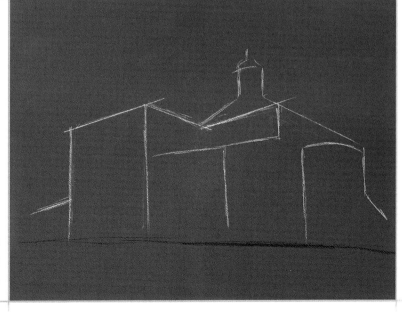

3. A ruler is not necessary for drawing straight lines; just draw carefully, resting the entire length of the lead of the pencil on the paper.

REPRESENTING VOLUME

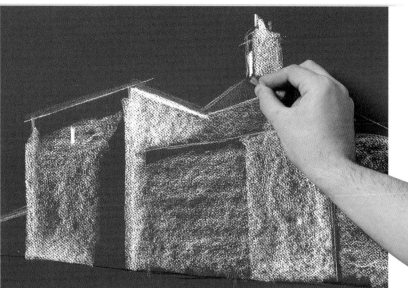

4. The process of elaborating the drawing is not as important here as resolving the perspective. The work is done in only two colors (white and sanguine red) using blending techniques.

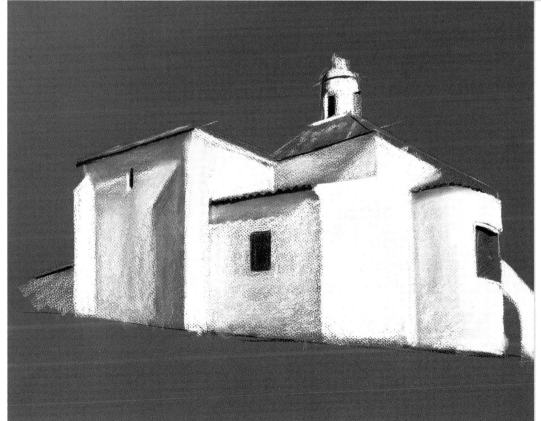

5. The crisp precision of the drawing is a result of correctly constructing the perspective, interpreting the building within the framework of a cube in perspective, and emphasizing different subordinate parts of the church.

SHADING

Shading equally affects all drawing techniques and procedures and is the basis for the construction of forms. The surfaces are rendered so that they seem to have volume and relief. The way this is done depends on which procedure is used, but the objective is always the same: that is, to suggest the physical body of the forms and their location in space.

Jean-François Millet (1814–1875), *The Sowers.* Musée d'Orsay (Paris, France). In this work the shading was done in the darkest range and the lightest values suggest the luminosity of the dusk.

When shading, the artist constructs the form by correctly distributing the different values of light and shadow.

VALUE AND REALISM

The distribution of light and shadow may not follow a strictly naturalistic order. It is possible for a drawing to contain the light and dark values necessary for creating the sense of relief, these values being harmoniously ordered without being a realistic arrangement. An example of this can be seen in the still life by Esther Olivé de Puig reproduced on this page.

Tones or Values

The values in a drawing are the different intensities of the same color that lighten or darken a drawn and shaded object. When working in black and white that color is gray and the intensities are darker or lighter grays. In other techniques the extremes in value are white (the color of the paper) and the darkest possible tone that can be created with the media being used.

Modeling

For the artist to create an adequately valued subject, he or she must have been able to model the forms showing all their volume and relief. It can be said that as the artist models, he or she does in two dimensions what a sculptor does in three: give body and presence to the subject.

José de Ribera (1588–1652), *Woman Holding an Arrow.* Christ Church (Oxford, England). The figure in the drawing has an enormous richness of values created with a simple medium, a sanguine crayon.

Esther Olivé de Puig, *Tray and Reflection.* Private collection. In this drawing the distribution of the values does not follow a realistic pattern, yet it clearly communicates a sense of volume and relief.

Light and Shadow

Speaking of light and shadow is a manner of describing modeling and value. The light and shadows of a drawing are its values; the lightest values correspond to light and the darkest are the shadows. The changes from light to shadow, the transition from one value to another, creates the modeling. The outlines or profiles of a shaded drawing are the limits of the light value and a darker one, with no transition between them.

PAINTING

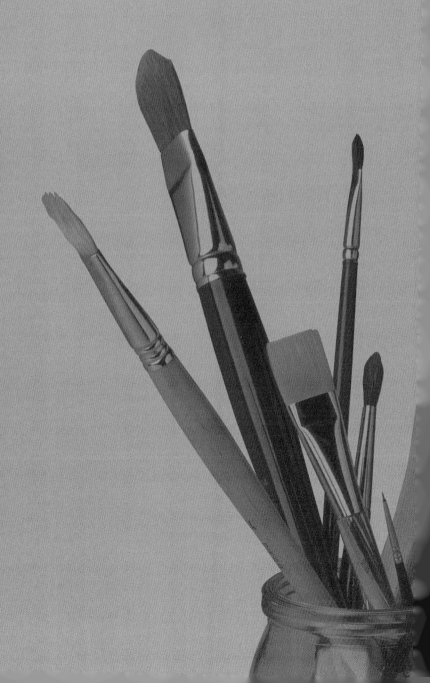

Shading

PAINTING
Materials and Painting Media

From the beginning, painting media have been much more diverse than drawing media, for the simple reason that painting assumes and includes drawing as its own. Nowadays, this great diversity has increased to the extreme, partly because new techniques, unknown until our time, have appeared (such as airbrush, acrylic paints, etc.), and because today's artist has access to a variety of colors, supports, and tools that did not exist before the industrial era. This section offers a complete compilation of painting materials and media constituting an extensive and necessary guide, along with detailed explanations and advice about the employment of all the artistic techniques.

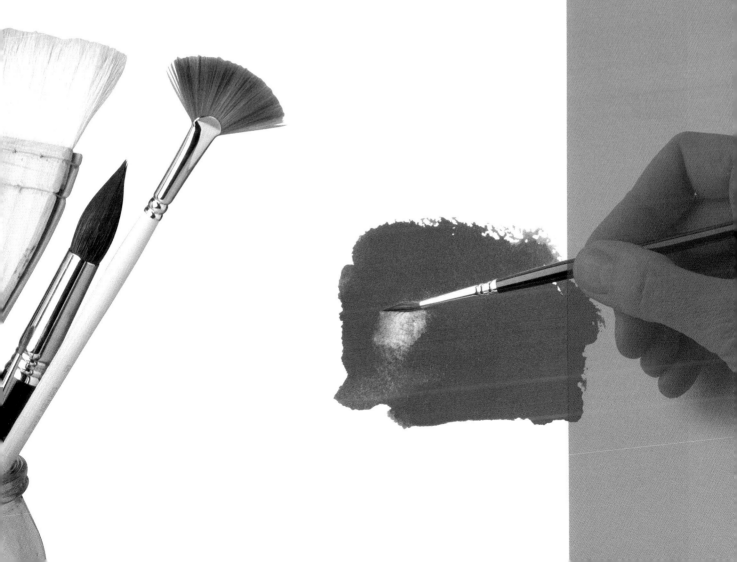

PASTELS

*P*astels are both drawing tools and painting tools, completely and rightly in both cases. They come in sticks of color that are very easy to use; they do not require solvents or drying time, and the tone of the color is exactly the same as the stick. They are handled the same way as charcoal, and to a certain extent, can be erased as easily. This is true for all varieties of pastels. The only differences between them are their hardness.

Édouard Manet (1832–1883), *Study for the Painting of the Folies-Bergère.* Musée des Beaux Arts (Dijon, France). This pastel puts to rest any doubt about the ability of this technique to express chromatic liveliness and quality in a work of art.

PASTEL PORTRAITS

In the works of the portrait artists of the 18th century, pastels were used in imitation of the textures and finish of oil paintings. The lines were completely blended to obtain delicate shading and mixtures of color. The portrait artists often worked with enormous formats, rivaling oil paintings in color and virtuosity.

Characteristics of Pastel Paintings

The name *pastels* comes from the word *paste,* which refers to the binder used to make them. The paste is composed of powdered pigment (the color), a little water, gum arabic or tragacanth gum (which is the agglutinate that holds the sticks together), and a varying amount of chalk (as whiting added to the pigment) to clarify the color. Pastel painting is a direct medium and does not need any mixtures to obtain colors; the wide range that is available provides the artist with all (or almost all) the shades and colors.

Pastels are the artistic medium with the purest color. The pigments are used with only the slightest intervention of any other substance (a small amount of gum holds the sticks together), so the quality of the color is uncontaminated.

Today's pastel painters have access to the widest range of colors possible for creating works of art of the same level as any other technique.

The History of Pastels

Pastel paints had their origin in drawing media like the sanguine or white chalk used by artists in the Renaissance. In the 18th century they were used in the form we know today by French portraitists, who already had a complete range of colors. Some of the great Impressionist painters, such as Mary Cassatt, Édouard Manet, and especially Edgar Degas, laid the foundation for modern pastel painting. Their way of working was characterized by freedom of line and less reliance on blending and mixing colors. During the 20th century this medium was used by the greatest creators, and although they usually preferred to work with small formats, some painters used pastels for their large compositions on canvas.

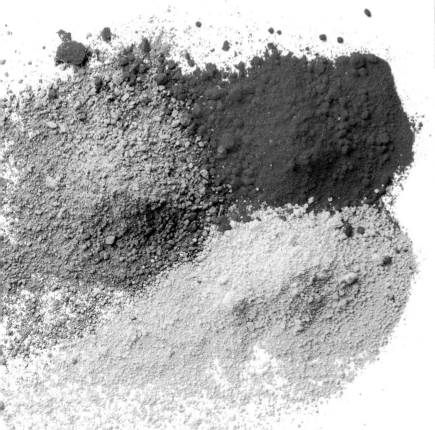

Pastels commonly come in two varieties, soft and hard. The latter are also known (improperly) as chalks. Both are used equally by pastel artists, who usually prefer the soft ones for artistic effects and the hard ones for line work and for drawing in general. They are all sold in sets of different selections, and they can also be bought individually.

Soft Pastels

Soft pastels wear away easily when they are being used, leaving intense strokes of color on the paper. This is because a small amount of agglutinating gum is used in their manufacture, and therefore, they contain a large proportion of pigment. Some manufacturers sell pastels of extra-large size because the color wears down so easily when it is applied to paper, so that artists will not have to deal with many small sticks of the same color. Some characteristics are their cylindrical form, and the availability of extensive and complete ranges, which sometimes have as many as 525 different colors.

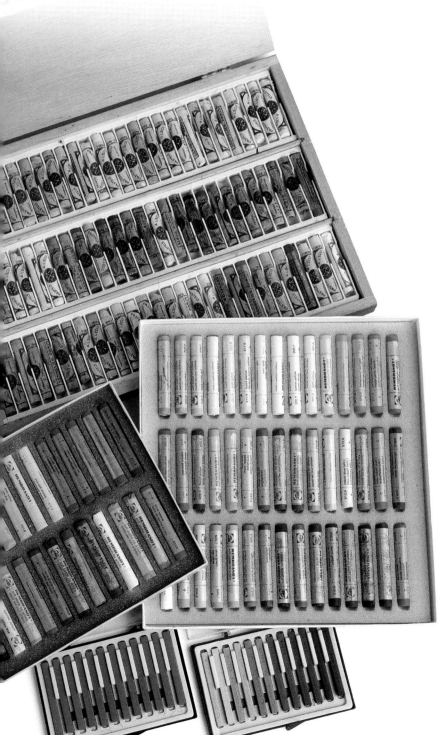

The selections of soft pastels are the largest of all artistic media. Most of the brands also sell them as individual units. The hard pastels are available in thin, square sticks and in smaller sets.

PASTEL PENCILS

Pastel pencils are a little thicker than normal pencils, with leads made of a stick of hard pastel. Their hardness is greater than that of any other pastel so they will not break under slight pressure, and so they can be sharpened like any pencil. Pastel artists often use them for making sketches, for small-format works, and for outlining and detailing larger-size works.

Hard Pastels

Hard pastels are sold in thinner sticks that are usually square. They are harder because they are more compressed and have a larger amount of agglutinate. This hardness allows them to be "sharpened" to create edges that can be used to draw lines. They come in smaller ranges of color, and are meant to be more of a drawing tool, emphasizing the role of the line. They can be used in combination with soft pastels, especially in the early stages of work, since they rarely smudge the paper, do not create dust, and furthermore, are easy to draw with. The resulting line varies according to the pressure applied to the stick: finer, darker, wider, etc.

The major brands of pastel colors manufacture all imaginable shades of each color. However special the color, the artist can find it in the selections offered by the specialized manufacturers.

The hard pastels, soft pastels, and pastel pencils are distinguished by their concentration of powdered pigment and agglutinate. The pencils are at the left of the illustration. In the center are the hard pastels (square), and to the right are the soft pastels (always cylindrical).

Papers for Painting with Pastels

Any surface where a pastel can find a texture, a ridge that will file the stick and allow the particles of pigment to adhere, is good enough for pastels. Consequently, the rougher the support, the more pigment it will retain, and the more intense the strokes of color. The most used support, and the one that probably permits the most varied effects, is paper (as long as it is somewhat rough). Generally, all papers are adequate, except for those with a satin or very smooth finish.

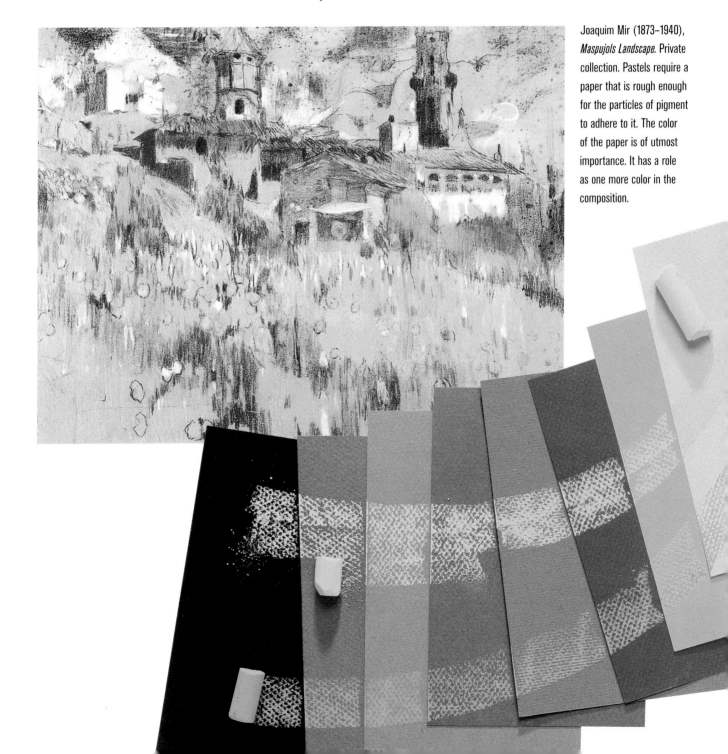

Joaquim Mir (1873–1940), *Maspujols Landscape.* Private collection. Pastels require a paper that is rough enough for the particles of pigment to adhere to it. The color of the paper is of utmost importance. It has a role as one more color in the composition.

Painting on colored paper is much more pleasant than on white paper. The color of the paper helps the work by harmonizing all the colors of the composition.

Types of Paper

Classic charcoal drawing paper (like Ingres) works well for pastel painting, but it has the disadvantage of a mechanical texture that bothers some artists. The most widely used paper for painting with pastels is the Canson style, a moderately heavy paper with a medium texture that is available in a wide range of different colors. In general, it is preferable to choose a paper with a light color when we wish to paint with dark and dense tones, because the darks stand out and are easier to see on light than on dark, and the colors look richer because they contrast. Handmade papers offer many variations of texture, tone, and size, but they have a disadvantage: their prices are usually prohibitive.

Cardboard, Fabrics, Sandpaper

There are other papers and supports that are less used, although equally valid. Cardboard, as long as its surface is not too smooth, is a very comfortable support because of its rigidity, but you have to be sure not to fold it or create permanent wrinkles. Fabric prepared for oil or acrylic painting is also a good surface for painting with pastels because it holds the pigment. Because of its hard texture, it requires working with a large amount of color and in large formats. Some artists enjoy painting on fine-grained sandpaper because of its firm and dense texture. This paper renders great color saturation and sharp outlines.

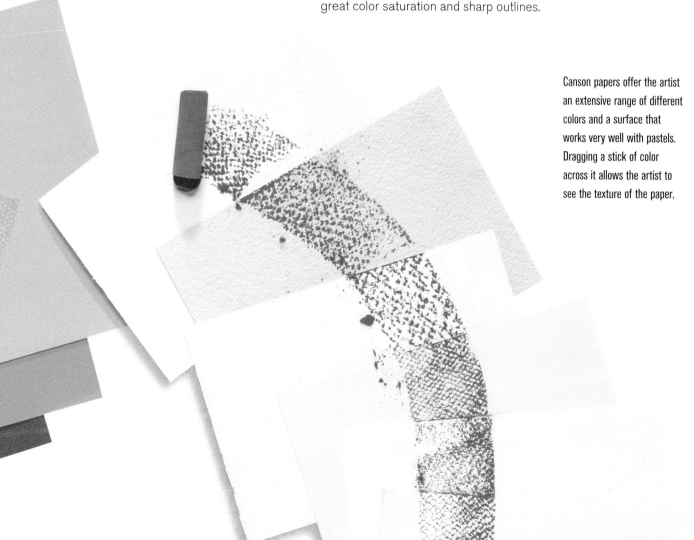

Canson papers offer the artist an extensive range of different colors and a surface that works very well with pastels. Dragging a stick of color across it allows the artist to see the texture of the paper.

The process of pastel painting seems more like making a charcoal drawing than the typical technique of painting with a brush. The color is manipulated with the fingers, there is nothing like a palette, and color mixing hardly takes place. It is all, or nearly all, a matter of manipulating the color with the fingers, blending it and spreading it on the paper with the hand or a rag, constructing the image based on strokes and dabs of direct color, using a stick of the required tone. Only on very rare occasions are two or more colors combined on the paper to be mixed together.

Overlaying color where the top color does not adhere as well to the paper as the lower one because of its density. Nevertheless, what is important is the fusion of both colors.

The mixing is done with the finger until a uniform color is created. Leftover powder is eliminated by blowing on it.

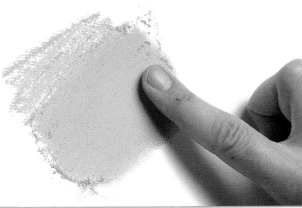

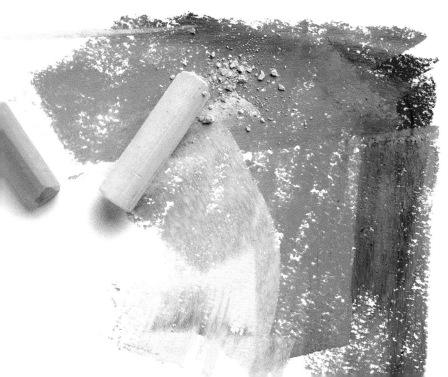

Lightening and Mixing Colors

When painting with pastels we can paint over a color with white to come up with a lighter tone. But just like with other opaque media, the overuse of white produces negative results. In the case of pastels, using too much white will cause colors to turn gray and begin to look like chalk or plaster. On the other hand, one of the reasons wide ranges of pastel colors exist is precisely to avoid the use of white to create lighter tones.

Pastel colors can be superimposed as long as the underlying color is light and does not completely cover the paper.

Pastels are a technique for those who love working directly and are not afraid to get covered with color while working. The color is spread and blended with the fingers, and contact with the support is continuous.

105

Pastels

FIXING THE WORK

Fixative is not prohibited in pastel painting, but it should be used sparingly. It can be applied only during intermediate phases of the work, when we know we will still be painting over the previous applications, never at the end. Also, it should be applied in a very fine spray, with the paper in a vertical position and from a distance of 8 to 10 inches (20 to 25 cm).

Blending

Blending or rubbing the color, or both at the same time, is as easy as passing a finger over the strokes that were previously applied with the sticks. We can paint new lines over the blending and blend it again if necessary, which will cause a new color to appear from the mixture. Blending also allows us to create light gradations of a single color in decreasing intensity, or a fusion of two colors so that one is gently integrated with the other. It is best to blend with the fingers, but it is also possible to use blending sticks and rags to do the same thing. Keep in mind that excessive blending of pastels fills the grain of the paper and that it is very difficult to paint over them with new colors.

Rubbing lightly applied pastel with a blending stick spreads it and evens out the color, further lightening the tone by dispersing the color over the paper.

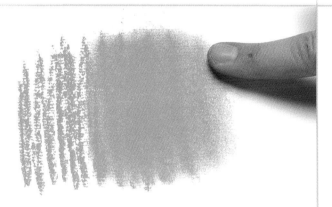

Rubbing a finger over pastel lines creates homogenous and darker areas of color than a blending stick does.

A cotton ball is ideal for the delicate blending in small works that eliminates all traces of lines.

One color can be rubbed into another to create a transition zone. If done with care, these mixtures can be continuous and leave no traces of lines.

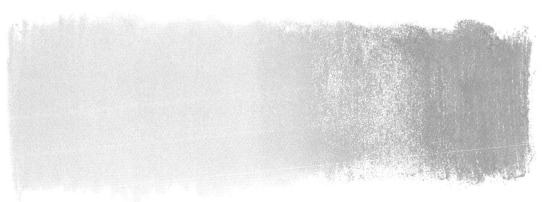

A Landscape: Coloring and Blending

This exercise by Yvan Viñals is an example of the basic techniques of pastel painting. It is conceived in a way that all its technical aspects can be resolved by using simple areas of color and simple blending. The drawing is reduced to a minimum and the colors consist of a few greens, a blue, and some red and yellow.

THE MODEL

The backlighting in this Nordic landscape defines the form of the vegetation in the foreground against a background of light colors and less-defined forms.

PHASE 1: **PAINTING**

1. Applications of dark green made with the side and point of the stick are substituted for an outline drawing. These preliminary colors define the large dark masses in the composition.

2. The space surrounding the trees in the center is partially covered with a medium blue to "cool down" the tone and create a base color for the following tones.

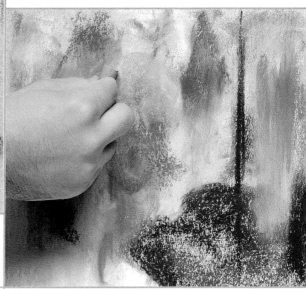

3. The background is now covered with alternating strokes of light green, red, and yellow to suggest an autumn forest.

PHASE 2: **BLENDING**

4. Now is the moment to rub and blend all the previous colors. This will sharpen the silhouettes and unify the color.

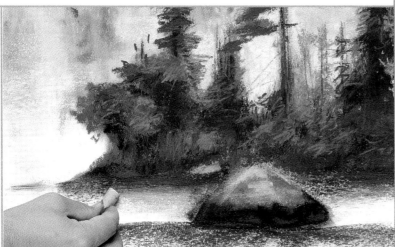

5. A convincing result was achieved by using the previous approaches. All that is left is to emphasize some blue gradations in the lower part of the composition.

6. This is the result of successive applications of simple lines that were later blended in areas that required the suggestion of an atmospheric landscape.

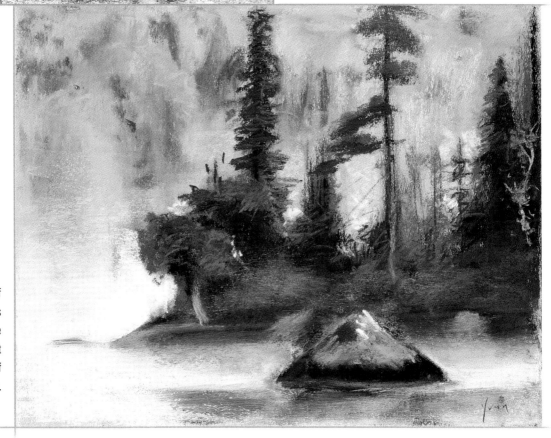

Watercolor and gouache are similar procedures and can be used together without any problems. The only characteristic that sets them apart is transparency: whereas watercolors are transparent, gouache is opaque. To a great extent this difference determines the result of a painting that is done with one medium or the other. It also has an influence in the way they are used. Other than that, both are based on the same principles and share identical elements.

August Renoir (1841–1919), *Harvest.* Musée du Louvre (Paris, France). Watercolor is the most delicate of the artistic techniques. The effect is sometimes complemented by the addition of gouache. This is the case of the white area of this figure's dress.

Gouache is nothing more than an opaque variety of watercolors that has great covering power.

ILLUSTRATIONS AND GRAPHIC ART

Gouache, by its nature, was the best medium for painting posters and illustration in general, until the arrival of computers. From the time of the invention of chromolithography, or lithography in color, in the 19th century, gouache became the medium of choice to create the originals for posters. The qualities of gouache—flat, opaque, and matte—help make the final product clearly visible. Besides, gouache makes it possible to build up the different colors separately, until the entire image is achieved.

Watercolor Through History

Watercolor painting was commonly used in ancient times and in the Middle Ages for mural painting and for the illustration of manuscripts. From the time oil paints were invented, watercolor became a secondary and outdated method, and was reserved for making the sketches that later would be used to create large oil paintings. But this trend changed at the beginning of the 19th century, when watercolor was recognized as an artistic medium in its own right and many artists specialized in this method. Watercolor had an enormous influence on the evolution of many aspects of modern painting. Its role in the establishment of Impressionism was crucial, and pioneers of abstract painting such as Kandinsky used it as a medium for the exploration of the artistic possibilities of a new style.

Limbourgh Brothers (circa 1400), *February.* Musée Condé (Chantilly, France). During the Middle Ages and the Renaissance, watercolor and gouache were used together in the same painting, producing exceptional results.

Gustav Klimt (1862–1918), *Expectation.* Österreiches Museum für Angewandte Kunst (Vienna, Austria). This gouache painting clearly shows that delicate and fine results can be achieved with this medium.

The Predecessors of Gouache

For many years, gouache was intermixed with watercolor, and ultimately it was overshadowed by it. In fact, watercolor was not considered a medium in its own right until the latter part of the 18th century, and until 1760 its name was not differentiated from the generic tempera. The specific rules for watercolor were established when the Royal Water Color Society was founded in London in 1804. In fact, the two essential characteristics of watercolor—transparency and the absence of the color white—are precisely the factors that set them apart from gouache.

Formats and
Characteristics of the Colors

In theory, white is "forbidden" in watercolor, because it makes color look flat. This is a major difference between gouache and watercolors.

Gouache and watercolor share many characteristics. They basically have the same composition, although some significant differences affect their formats considerably. Watercolors are sold in small tubes and in "cakes" (compressed blocks of semi-wetted pigment). Gouache, on the other hand, is sold in larger tubes and even in cans of up to 1 gallon (4 L). The reason for this is that gouache does not have as much covering power as watercolors.

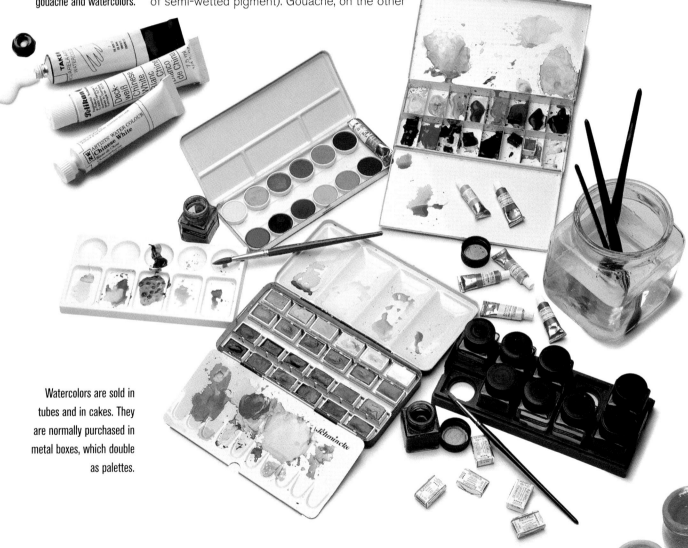

Watercolors are sold in tubes and in cakes. They are normally purchased in metal boxes, which double as palettes.

Composition of Watercolor

Watercolor, regardless of whether it comes in tubes or pans, consists of a finely crushed pigment and gum arabic, an adhesive medium that binds the color to the paper so it does not crack when it dries. Gum arabic is a water-soluble resin that solidifies in tablets. Its special consistency makes this a very transparent medium. Therefore, watercolor paints are made up of different pigments bound in gum arabic with special additives whose purpose is to add creaminess to the paint.

TEMPERA AND GOUACHE

The gouache that is sold for children's schoolwork is often known as tempera. In reality, gouache and tempera are exactly the same thing, but tempera is a lower-quality gouache that contains more filler and less pigment. In other words, it is a low-quality pigment that is more affordable and suitable for school projects.

The Composition of Gouache

In principle, gouache has the same composition as watercolor, and both techniques are very similar, to the extent that, traditionally, gouache is considered a watercolor whose colors are mixed with white—a way of working that has many followers nowadays. The modern manufacturing process of gouache has incorporated different resins in addition to gum arabic, including Ghatti, bone glue, and wheat or potato dextrin, plus the addition of a filler to give the color more body and to make it opaque.

Many manufacturers market boxes of gouache colors in cakes. Although they produce good results, it is difficult to create dense colors with them.

Jars of gouache colors are the format most commonly preferred by artists, although many of them like tubes because they prevent colors from getting dirty or muddied inside the container.

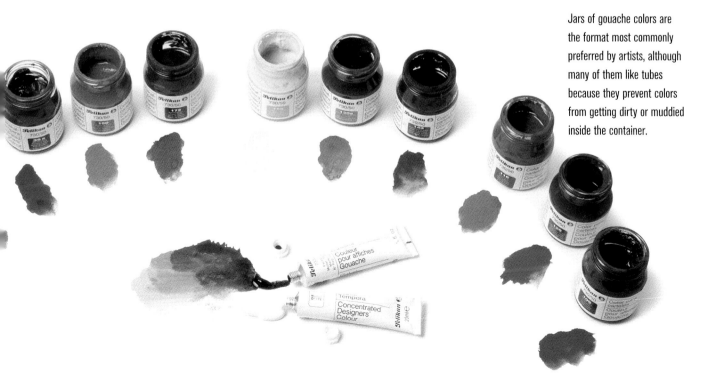

Brushes for Watercolor and Gouache

The most common brushes used for painting with gouache are similar to those used for painting with watercolor. They have short, soft, natural or synthetic hair. Among the natural group, sable hair, ox hair, and squirrel hair are the most common. Bristle brushes, which are much coarser, are not normally used for painting with watercolors, although occasionally they can be useful for gouache.

Natural-Hair Brushes

Among natural brushes, sable offers the highest quality and is the most expensive. Sable hair is extremely fine and resilient, can carry a large charge of color or water, maintains an excellent shape, and always keeps its pointed tip. The high price of sable brushes limits their use to the smaller sizes. For thicker brushes, ox hair is used. This variety is softer than sable and does not keep its shape as well, but it has an excellent capacity for holding paint. Among natural brushes, the *putois* related to the sable also stands out, as well as the hair from the squirrel's tail. Both types are soft and are used for thick brushes.

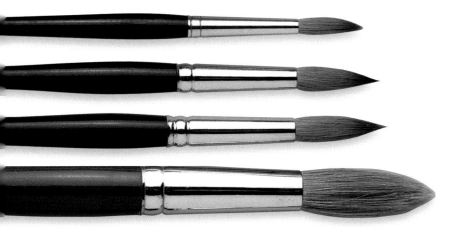

Sable brushes are among the best in natural hair, but if the artist wants to use a more affordable type, ox-hair brushes, the larger ones, are also suitable.

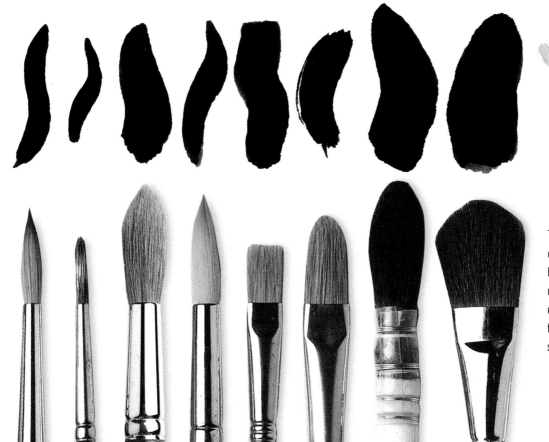

The shape and quality of the tip determines the brushstroke. From left to right: sable brush, badger, ox hair, synthetic, flat, ox-hair, filbert tip, and two large squirrel-hair brushes.

AN ASSORTMENT OF BRUSHES

A complete assortment of brushes should mainly include thick, natural-hair, and round-tip brushes. If they have high-quality hair, the tips will always maintain their shape for drawing details and lines, and have good paint- or water-holding capacity. The type of brushes that offer all these characteristics are those made of ox hair. It is also important to have smaller brushes made of sable hair or a combination of the two, and one or two flat, synthetic brushes (suitable for applying brushstrokes thickly and evenly).

Synthetic Brushes

Since their relatively recent introduction to the market, synthetic brushes have become one of the favorite kinds for painting aficionados. They are made of nylon or polyester filaments, and although they lose their shape faster than natural hair, the flat varieties give good results. This is not the case of round brushes, which lose their points very easily.

Soft-hair brushes are useful for spreading large areas of very liquid color, or in the case of gouache, for covering large areas of the support in big-format paintings.

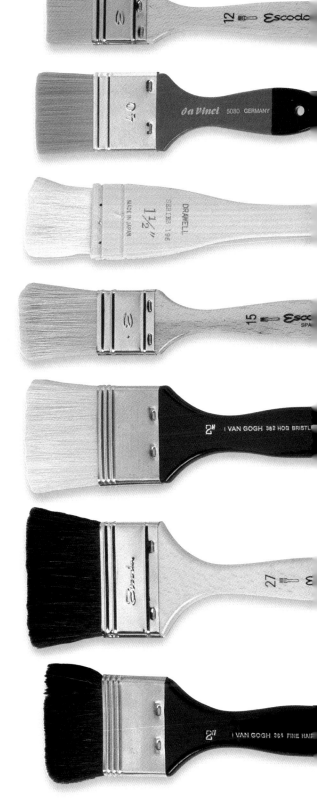

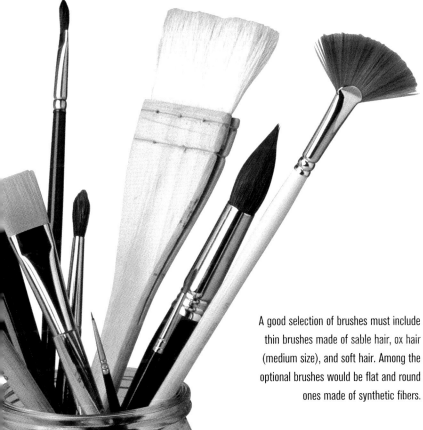

A good selection of brushes must include thin brushes made of sable hair, ox hair (medium size), and soft hair. Among the optional brushes would be flat and round ones made of synthetic fibers.

Papers for Watercolor and Gouache

The appropriate paper for watercolor and gouache should have some specific characteristics. First, it should have sizing (a substance used to fill in the pores of a canvas) to prevent excessive absorbency, but not so much that the paint forms puddles. It should not have a satin finish. The paper should not contain too much sizing because this would reduce the intensity of the color when it dries. It is important to avoid oily bases because they prevent the color from adhering. The paper should be light-fast and resist yellowing with the passage of time.

Watercolor papers are sold in pads and also in single sheets of different sizes. Pads are preferred for small and medium formats.

Watercolor papers are available in different weights, textures, and even colors. This medium requires special papers, unlike gouache, which can be used with almost any paper.

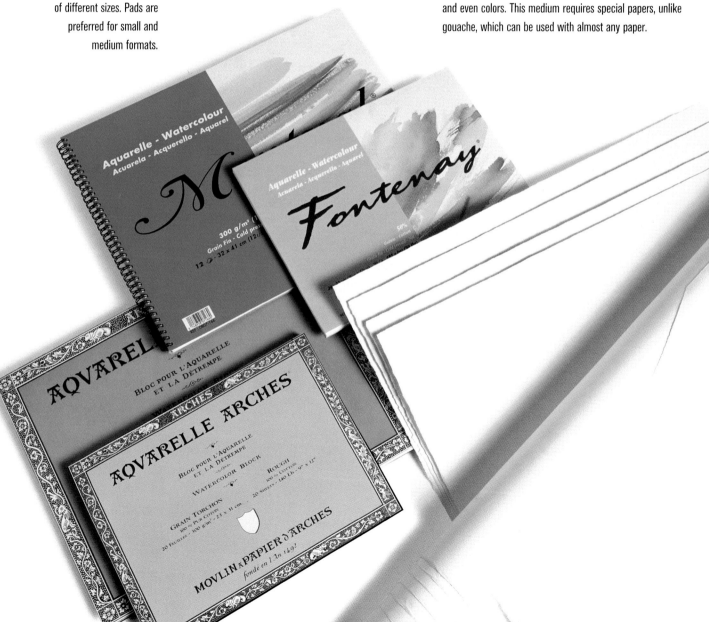

*Gouache can be painted over any type of surface,
unlike watercolors, which require a good-quality
paper to achieve the best results.*

Watercolor and Gouache

115

WEIGHT OF THE PAPER

The thickness of paper depends on its weight; it is based on pounds per ream or grams per square meter. For example, writing paper can weigh 24 lb. (45 grams), whereas posterboard can range between 170 and 185 lb. (340 and 370 grams). A watercolor or gouache paper should range between 120 and 170 lb. (250 and 350 grams). The thickness is independent from the texture of the paper, which can vary in any of the weights.

Watercolor Papers

Professional-quality papers are available basically in three textures or finishes: fine, medium, and heavy or rough. Fine-texture paper is pressed while hot, specifically to make it smoother, but it maintains a light texture without which watercolor paints would not adhere to the surface. This is the reason why perfectly smooth paper, without any texture, is not suitable for watercolor. Medium-texture paper is the most suitable one for most watercolorists. Heavy-texture paper offers a very rough surface, which accumulates and retains water, extending the drying time.

Gouache Papers

When painting with gouache, it is not a good idea to use a paper that has too much texture, such as the ones used by professional watercolorists. The excessive texture slows the brush and the paper absorbs too much paint. Gouache colors never require as much water as watercolors; therefore, it is not necessary for the paper to be as absorbent. The surface should be quite smooth for the brush to flow without difficulty.

Medium-texture high-quality Scholler watercolor paper. Very suitable for any type of work.

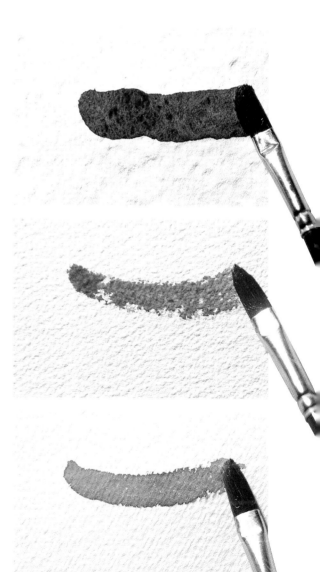

Fine-texture Whatman paper. Ideal for work with delicate finishes.

Heavy-texture Arches paper. Suitable for large formats.

Basic Watercolor Techniques

Using watercolors requires controlling the water that is used to dilute them. Water is not only a solvent for the pigment but also the basic medium for the application and definition of the paint—so much so that the watercolor technique can be studied from the standpoint of the amount of water used in the process. Painting wet on wet and wet on dry are two distinct phases of the watercolor technique.

Wet on Wet

It is said that a work is painted wet on wet when the paper has been previously wetted with a brush and clean water. The paint applied over that wet surface tends to spread out of control, creating irregular areas of color, with ragged borders that mix in with the neighboring colors. This characteristic is very helpful for representing the atmosphere and foggy scenes.

Eugène Delacroix (1798–1863), *View of the English Countryside.* Musée du Louvre (Paris, France). Painting on wet produces airy and atmospheric results that bear the unmistakable hallmark of the transparent quality of watercolors.

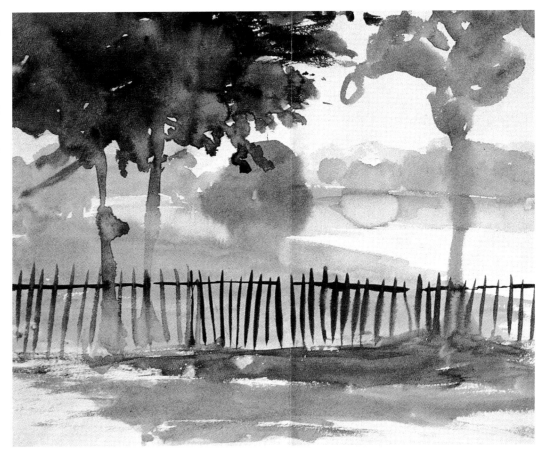

The mastery of watercolor technique requires controlling the wetness of the paint, the drying time, and the expansion of the areas of color on the paper.

WET ON WET

Painting wet on wet requires the courage to apply large areas of color without hesitation. For the beginner, this is an excellent starting point. This approach forces the artist to plan the work as a whole, without paying too much attention to details. Also, this method is more forgiving of mistakes, which are less noticeable among the large areas of color.

Lifting Out

Lifting out is a common procedure among watercolorists. It consists of removing part of the paint from inside an already painted area to expose the white of the paper. Lifting out while the color is still wet is very easy: simply press on the chosen area with a sponge or with a damp brush. The paint will be absorbed and the white will appear.

The gradation of a color or blending it gently with another is easy when the painting is done on wet paper.

Gradations

Gradations are used to make a color lighter by adding water to represent luminous effects (going from dark to light), and also to give the feeling of volume and three-dimensionality—in other words, to model the surface. Unless the artist is representing a clear sky, it is unusual for a graded wash to be perfectly even and sudden, going from very dark to very light. In most cases it is limited to a slight change of tone.

A color can be lifted out with a sponge dampened with tap water, leaving the paper completely clean.

The paint spreads without apparent control when the painting is done on wet paper. This technique should be used in specific areas of the painting, not the entire surface.

Painting Wet on Dry

The most common approach is to combine wet and dry watercolor techniques, whichever best responds to the chosen subject. In some exceptional cases, artists may decide to use one or the other exclusively, and this is attributed to a characteristic of personal style. With the dry technique, paint is applied directly on dry paper without much concern for softening the edges, which in this technique are clearly defined.

Opening Whites on Dry

Opening whites on dry consists of wetting the dry paint until the white of the paper is exposed. The normal way of doing this is by dampening the chosen area with a brush and clean water and applying a piece of absorbent paper to it before it dries. If possible, it is a good idea to use a flat, hard-bristle brush, trying not to damage the surface of the support.

Carl Rottman (1797–1850), *Washer Woman.* Victoria and Albert Museum (London, England). Every area of color in this painting has been applied on dry paper. The result is a very detailed and precise painting.

MASKING FLUID

Liquid gum, or masking fluid, is a solution that dries out quickly and is used to make small reserves for areas that need to be clearly defined. The liquid is applied with a brush in the areas that need to be left unpainted. Once this material dries out it can be easily eliminated by rubbing with the finger or with an eraser after the watercolor is completed. The result is a small white area, which later can be painted with the chosen color.

White Reserves

Reserves are a common technique when the work is carried out on dry, and are one of the main resources of watercolorists. Reserves are the areas of the painting that have been left unpainted on purpose, because this is how the artist wants it or because he or she wants to work on it at the end of the process. Leaving an area unpainted can be achieved by painting around it, drawing its outline. But if these areas are very small, it is more practical to use masking fluid or a solid color.

Dry Brush

For certain details, it is interesting to work with undiluted paint that is much thicker than normal. This way, the brushstrokes leave a characteristic mark, which can be more or less pronounced depending on the texture of the paper. This is a good way for creating some texture with a fluid medium such as watercolor.

The color of the paper can be exposed by rubbing with a damp brush on an area of paint that is dry.

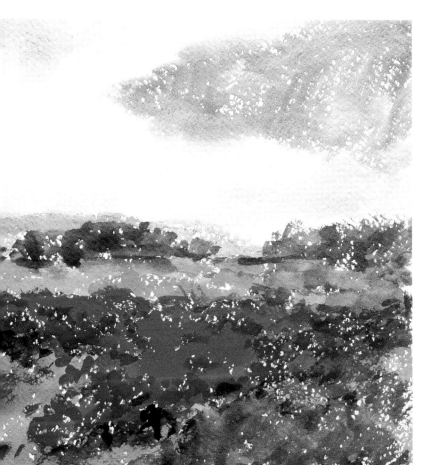

The brushstrokes can be as precise on dry color as on dry paper, with the added advantage of rich combinations of transparencies among tones.

The colors cannot blend when the paint is applied undiluted with water. This method produces an individualistic pointillist character or style.

Constructing with Color: Bottles

Three colored bottles serve as the model for this basic watercolor exercise executed by Vicenç Ballestar. The purity of the color in each of the bottles will help greatly in the formulation of a simple approach for the project. Violet, yellow, and orange are the pure base colors. Parting from those colors are other darker tones that will describe the main shadows representing the volume.

THE MODEL

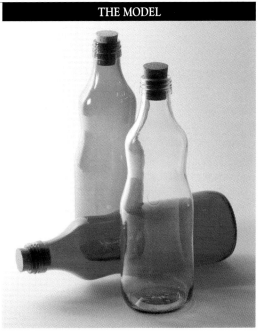

The model consists of three colored glass bottles that can be painted with pure tones, adding other simple combinations. It is an attractive subject that is very appropriate for the teaching purpose of this basic exercise.

PHASE 1: BASE COLORS

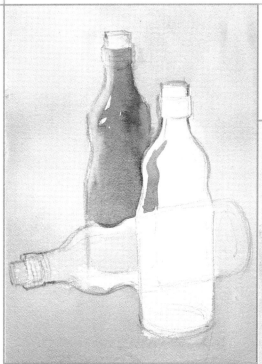

1. A simple drawing done with a hard lead pencil will be the main guide for organizing the areas of color. The first ones are gray (a very diluted black) and mauve (a cobalt violet that has been diluted in a considerable amount of water).

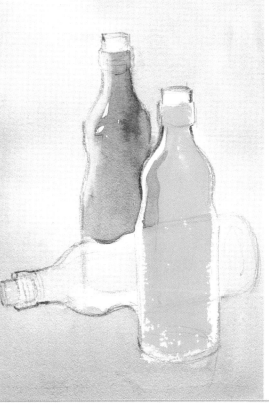

2. Now, the yellow of the bottle in the foreground is added. The color, which should not contain too much water, is applied covering the small mauve area of the bottle that appears behind it, trying not to leave brushstroke marks.

*The general guidelines for the process of watercolor painting is
working from light to dark. The lighter tones are applied first,
followed by the darker ones overlaying the previous ones.*

Watercolor and Gouache

121

PHASE 2:

**TINTED
COLORS**

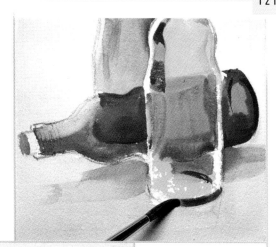

3. The lighter areas of the horizontal bottle should be painted orange, and the darker ones with that same color mixed with English red or burnt sienna. When this color is layered over the yellow that is still wet, the orange acquires a new tone that suggests transparency.

4. The darker tones of the corks and the areas representing the transparencies are darkened with a color created by mixing burnt sienna and black. This must be done when the base colors are completely dry.

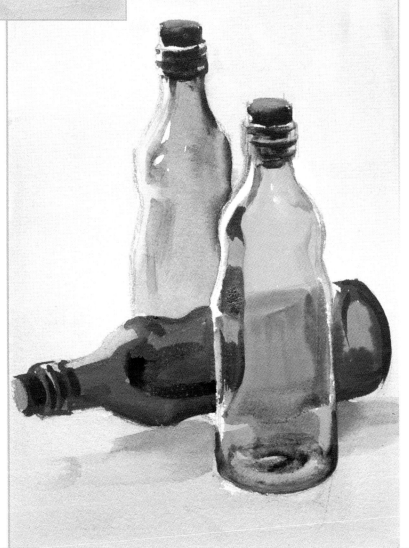

5. A little bit of orange has run to the base of the yellow bottle. To correct this small mistake, the artist has applied a few brushstrokes of the same color used for shading (sienna mixed with black) to represent the color that darkens the glass.

Basic Gouache Techniques

The process for handling gouache is very similar to the approach for watercolors, but since gouache has a different covering power, the technique is a little different. It is possible to create transparencies with gouache, but any work that is based on them goes against the nature of this medium. Gouache is cruder, less subtle and delicate. It does not require the planning that watercolors do because entire areas can be painted over.

Gouache has great covering power, so one area of color can cover another one completely if the latter is dry.

Water applied to a dry color dissolves the color slightly; therefore it is important not to repeat this too much over areas that have already been painted.

Mixing Gouache

When painting with gouache, layering one color over another can be total and perfect, leaving no visible trace of the base color. But it is also possible to mix colors directly on paper. This can be done by repeatedly brushing a color that is quite wet to dissolve the layer of dry gouache and mixing the bottom layer with the top layer.

A spatula is the ideal tool for applying thick layers of gouache.

The velvety and matte quality of gouache can be fully appreciated in medium- and large-size paintings, where the areas of opaque color stand out for their smoothness.

Watercolor and Gouache

123

GUM ARABIC

It is possible to create a transparent wash simply by diluting the paint in a fair amount of water and applying it with a wide paintbrush. But the same effect can also be achieved by adding gum arabic to the mixture. Opaque colors produce a greater contrast effect over a wash like this, causing characteristics of gouache to become more obvious.

Texture

The density of gouache makes it useful for creating textured effects that depend on the surface of the paper. It is possible to produce different textured effects by working with undiluted color on a paper that has some texture. This technique is known as dry-brush painting. The texture of the watercolor paper becomes visible when this technique is used, especially if the paper is heavy. But it is also possible to create different effects on cardboard, handmade paper, wrapping paper, and even lightweight drawing paper.

Because of the consistency of gouache, artists can create a variety of textured effects, like this spattered effect done with a toothbrush.

The colors of gouache are solid and bright. They can be worked in different layers and color combinations. Work by M. Angeles Comella.

Graphic design is the natural artistic medium for gouache. The painting approach should be loose and spontaneous.

Unlike watercolors, using white is the only way to lighten gouache colors.

Opacity and Transparency: The Calm Waters of a River

When painting with gouache, the main approach for an artist is to create areas of opaque and transparent color, unless the work is a graphic design project. Such is the case of this exercise executed by David Sanmiguel. The theme suggests a traditional approach, but we use a method that is not very conventional and works very well.

THE MODEL

A peaceful river in a forest is a subject for a traditional landscape. But it can also be used by someone who wishes to experiment with gouache.

PHASE 1: COMPOSITIONAL AREAS OF COLOR

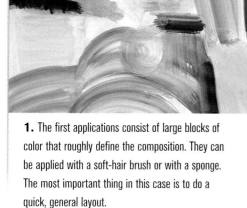

1. The first applications consist of large blocks of color that roughly define the composition. They can be applied with a soft-hair brush or with a sponge. The most important thing in this case is to do a quick, general layout.

2. The areas of color, created with paint diluted with water, have a luminous and transparent consistency. Thanks to this approach, the overall idea of a landscape begins to form on the paper.

3. Now, small touches of color that represent the foliage are applied, breaking up the transparency of the initial tones. The simple contrast between the sizes of the different areas of color introduces an interesting effect.

Gouache can be corrected by painting over colors, but it does not lend itself to heavy impastos because it is a thick medium that cracks when it dries.

PHASE 2: **OPAQUE DETAILS**

4. This is the moment when the natural details that define and characterize the theme are applied. Leaves, tree trunks, and vegetation in general are superimposed over the base layers as opaque areas of color.

5. The texture of the river's surface is created with the same color used for the water, but applied very diluted using a flat, wide brush, maintaining its transparency.

6. Finally, this is the result: a painting that is not completely naturalistic, but that fits the theme, and above all, explores all the possibilities gouache has to offer.

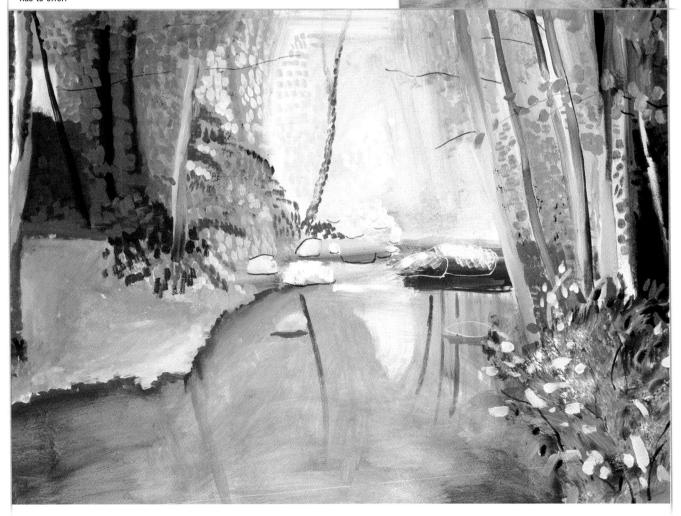

Oil painting is the preferred medium of many artists and the one that traditionally has been highly regarded by professionals and amateurs alike. Its reputation is rooted in the fact that almost all the great masters have been oil painters. Oil paint is a solid and resilient medium that adapts to any format, from miniature paintings to murals.

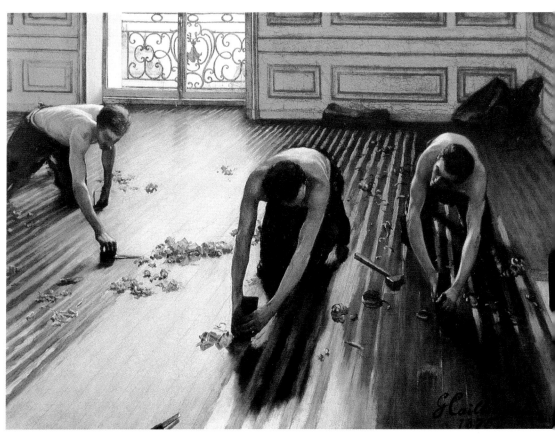

Gustave Caillebotte (1848–1893), *The Parquet Strippers.* Private collection. Oils have proven to be totally adaptable to every style, from abstract painting to realistic painting.

In modern times, oil painting has defined the most important tendencies of the evolution of art, of the styles and trends that we have inherited.

127

Oil Painting

THE INVENTION OF OIL PAINTING

For a long time, the invention of oil painting was attributed to 15th-century oil painter Jan van Eyck. In reality, this painter only perfected a style that already existed in his time. The detailed and careful elaboration of his work is the best testimony of the great technical possibilities offered by oil paints for representing the visual world realistically.

Characteristics of Oil Paints

Oil paints consist of ground pigments suspended in refined linseed oil. Resins and other drying products are added to them to improve their consistency, adhesive power, and drying time. The amount of oil required for each pigment varies, but all the colors have the same dense and creamy consistency. Solvents, such as essence of turpentine (a very refined oil), most commonly known as thinner or mineral spirits (also referred to as white spirit) are used to thin that consistency and make the paint flow better.

William Turner (1775–1851), *The Morning after the Deluge.* Tate Gallery (London, England). Turner introduces a new way of approaching oil painting, where the artistic effects are more important than the exact depiction of the theme.

Jan van Eyck (circa 1441), *The Arnolfini Wedding.* National Gallery (London, England). Traditionally considered the inventor of oil painting, van Eyck carried this procedure to the most minute extreme.

Oil Painting and Its Evolution

The oldest expressions of oil painting were known in ancient Rome, but the practice did not spread to the rest of Europe until after the 15th century. Beginning with the Renaissance and with the introduction of canvas as the universal support, oil painting became one of the most common forms of artistic expression, to the point that almost all of the most important masterpieces painted after the Middle Ages were created with this medium. As a result of its widespread use, oil painting, more than any other technique, has been subjected to the stylistic evolution of every period. Therefore, oil finishes range from the scrupulous enamel-like finish of the Flemish paintings to the quick and heavy brushstrokes of the Impressionist masters of the 19th century, or the Expressionists of the 20th.

Formats of Oil Paint

Oil paints are sold in metal or plastic tubes with a screw-on top, in four or five different sizes. The most common approach is to purchase a medium size for all the colors required, except for white, which is best bought in a larger tube. They are available individually or in sets sold in wooden boxes, which makes them easier to carry. The quality of the paint varies depending on the brand. A medium-quality paint (which usually means a "medium" price) is recommended for a beginner.

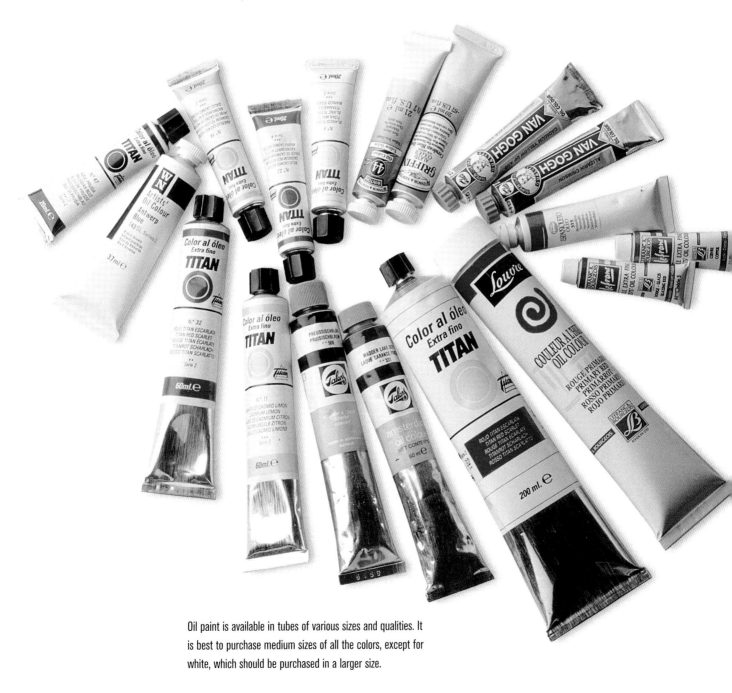

Oil paint is available in tubes of various sizes and qualities. It is best to purchase medium sizes of all the colors, except for white, which should be purchased in a larger size.

An oil painting created with very heavy impastos can take between two weeks and a month to dry completely and thoroughly.

129

Oil Painting

PAINT DRYING IN THE TUBE

Paint tubes do not require any special care. One must only make sure that the tubes are tightly sealed after each use. When the top layer of the paint dries out, the artist can push through the thick layer with a cotton swab until the flow is restored. If the paint has dried out on the threads and the top is stuck, we can heat them with the flame of a match, for example, and the tube will open easily.

Range, Selection, and Assortment of Colors

Almost every brand offers a wide variety of paints, which include all the ranges of colors. Most well-known manufacturers add special colors produced from original, expensive pigments. But the majority of artists require only about twelve colors: white, black, yellow, ochre, raw sienna, carmine, cadmium red, ultramarine blue, emerald green, green, and raw umber, with the option of adding another red or blue.

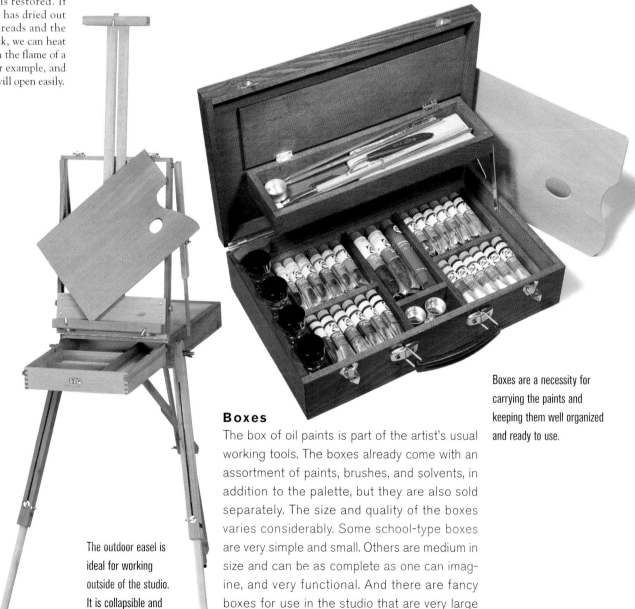

Boxes are a necessity for carrying the paints and keeping them well organized and ready to use.

Boxes

The box of oil paints is part of the artist's usual working tools. The boxes already come with an assortment of paints, brushes, and solvents, in addition to the palette, but they are also sold separately. The size and quality of the boxes varies considerably. Some school-type boxes are very simple and small. Others are medium in size and can be as complete as one can imagine, and very functional. And there are fancy boxes for use in the studio that are very large and made of hardwood. All the boxes are good for carrying the materials, but artists who work exclusively in a studio do not need them.

The outdoor easel is ideal for working outside of the studio. It is collapsible and can be carried as if it were a box of paints.

The brushes most commonly used for oil painting are bristle. However, some artists also use sable and squirrel brushes for certain areas of the painting and for delicate details. Bristle brushes are the most suitable for painting with oils: they can hold a lot of paint, they are durable enough for dragging and for impastos, and the hair improves with time. In fact, with use, the hairs separate and are able to hold more paint. Squirrel and sable brushes are very good for light work that does not require impastos, especially for drawing lines and details.

Varieties and Selection

There are three types of brushes available based on the shape of the hair: round, flat, and filbert (oval and round in shape). The length of the hair is usually in proportion to its diameter (between 3/16 inch [5 mm] for smaller sable brushes, and 2 inches [5 cm] for thicker bristle brushes). A typical assortment of brushes for oil painting would be as follows: one round, thin sable-hair brush; three or more small-bristle brushes of various lengths; two or more medium round bristle brushes; and two or more very large flat bristle brushes, plus an additional wide, flat brush. Sable brushes are not absolutely necessary and synthetic ones can be substituted.

The picture shows the different varieties of brushes that are suitable for oil painting, from flat brushes (always flat because they are used for spreading large amounts of paint), and the thinnest sable brushes, to the flat and round bristle brushes.

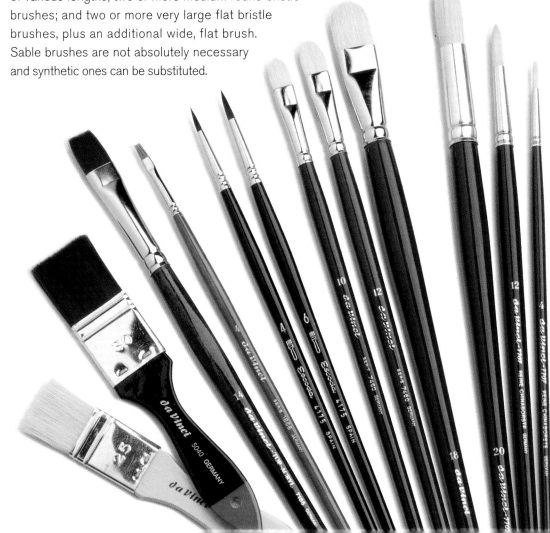

CARING FOR BRUSHES

Brushes can be left submerged in water if the time between sessions is not very long. If they are not going to be used for a long time, they can be stored in a box with camphor. Good brushes are expensive, but if properly used and stored, can last for a long time and even improve with age.

Cleaning and Maintenance

Brushes should be washed after every session. The most practical way of doing this is by removing excess paint from the hair and washing it with mineral spirits to eliminate all the paint. The last step may not be enough to clean the hairs thoroughly, and even if it were, they could be damaged by the corrosive effect of the mineral spirits. Therefore, the brush should then be washed with soap and water.

To wash oil brushes, the hair is lathered and rubbed against the palm of the hand until the soap looks clean, with no traces of paint.

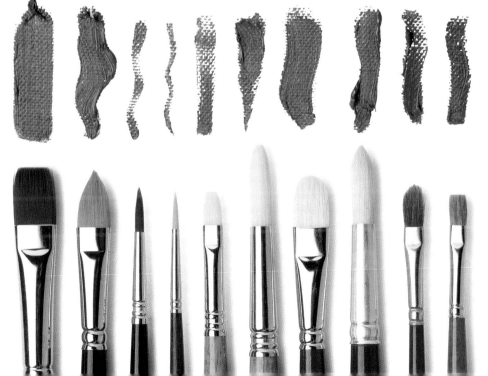

Bristle brushes improve with use: the hair separates and increases the capability for holding paint. Besides, brushes that are a little worn make working more comfortable.

This picture shows the characteristic shapes made by the different tips. Normally, artists work with a variety of brushes, which include flat brushes and round brushes (the latter are usually smaller).

The sizes of the brushes most commonly used for painting are shown here next to one another for comparison (large, medium, and small). We recommend having several brushes of each size.

Canvases

The choice of
fabric should
agree with
the style of
the painting.
For a
painting that
is delicate
and very
detailed, a
dense fabric
should be
used, with a
surface that
is smoother
than one
used for
painting with
rich impasto
and heavy
brushstrokes.

Canvas is the traditional support for oil painting. The material used for making canvas consists of fine linen, hemp, or cotton fibers. The best canvas is made of linen, known for its fine quality and ability to stand humidity (it hardly alters its shape). It is also the most expensive; prices vary according to the thread count. There are also supports that combine linen and cotton fibers, which makes them more affordable. Finally, the fabrics made of hemp are heavier. Burlap is the heaviest of all the hemp fabrics and can withstand heavy impastos.

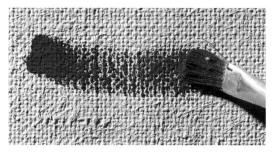

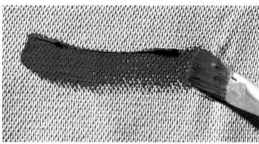

Fabric is the universal support for oil painting. The fabric that comes in rolls is stretched on a frame. But there are also canvas boards that offer an interesting hard-surface alternative for small paintings.

Fabric comes in three different textures (fine, medium, and heavy), which provide different surfaces for the brushstroke.

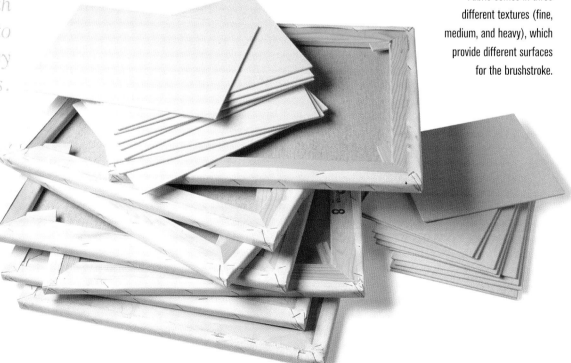

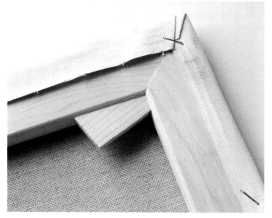

Stretchers usually have mortise and tenon that join the angles firmly. Wedges can be added at these angles once the canvas has been stretched, to keep it firmly taut.

THE TEXTURE OF THE FABRIC

The texture of the fabric depends equally on the fabric itself and on its preparation. A good-quality linen provides a very fine texture and good weight. Some artists prefer fabrics with more texture, and many of them use heavy burlap as a support. Others apply textured backgrounds to their canvases using very heavy paint mixed with fine sand or marble dust.

Priming

The priming of the fabrics that are used for painting consists of a glue (traditionally rabbit-skin glue) and a whiting (Spanish or Paris white). The result is a white primer without texture that diminishes the fabric's absorption capability, seals the pores, and provides a white base for painting. Some manufacturers sell gray, cream-colored, or black fabrics for painters who desire tinted glue bases. It is possible to purchase unprimed fabric and prime it in the studio. This primer can be transparent (only glue) or colored (glue mixed with chalk and a pigment).

Stretchers

Stretchers are required for painting on canvas. A stretcher is a wood frame that holds and tenses the fabric. They are sold in standard sizes, but artists can now purchase the pieces separately to make their own customized formats. Beyond a certain size, the stretcher requires a horizontal wooden crossbar for support, and the larger formats need two crossbars. Conventional frames range from 8¾ inches (22 cm) long (no. 1) to 76¾ inches (195 cm) (no. 120). The smaller formats come in three sizes: rectangular or "figure," long or "landscape," and very long or "seascape." Some art supply stores make custom formats to order.

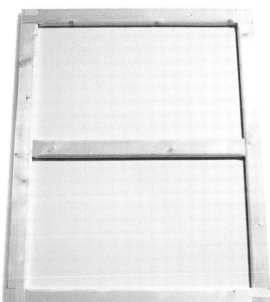

The larger-format frames include one or two crossbars for added support.

Other Supports

Canvas is not the only support available for painting with oils. Cardboard, wood, and even paper are materials that, properly primed, can be used without a problem. These supports tend to be used for small or medium works and should be mounted on a hard frame or structure for transport or showing.

Any surface for painting with oils, other than canvas, has to be primed with some type (natural, vinyl, or acrylic) of white or color glue.

Cardboard

Many artists use cardboard for color sketches and studies. However, its excessive absorbency can be a problem because the paint can dry too quickly. Traditionally, this problem was solved by rubbing the surface with a garlic clove, which reduced the cardboard's absorbency. Nowadays, a layer of primer is applied. It is possible to use any type of cardboard as long as it is not too soft or porous. Canvas boards, especially designed for oil painting, are available at art supply stores. Artists can also make their own by gluing a piece of canvas to heavy cardboard.

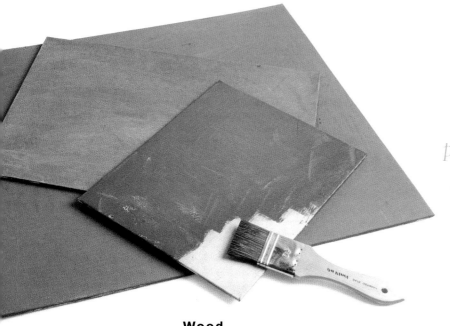

Any support is good for painting with oils, as long as it provides a sturdy surface that is not too absorbent. These surfaces are prepared with a primer to protect them from the effects of the oil.

Wood

Wood is not as absorbent as cardboard, but it also needs to be primed to create a surface suitable for oil painting. The old masters used hardwood, but modern artists can paint on fiberboard, as long as it is firmly supported with a frame or crossbars to avoid buckling.

To prime wood or fiberboard, several thin coats of glue must be painted in layers across the board. The layers are applied, first one vertically, followed by one horizontally, and so on.

From top to bottom: shellacked hardwood support, paper primed with gesso and glue, fiberboard primed with glue, and the same board primed with gesso and glue.

FRAMES

The type of frame used to finish a painting depends on the taste of the artist and the potential buyer. It can be a simple stick of shellacked or painted wood, or a beautifully ornate frame. The style of the artist is the determining factor. Many modern artists do not frame their work; instead they use heavy stretchers to give the painting a hefty presence.

Paper can be mounted on stretchers the same way canvas is, but it has to be dampened beforehand, so it remains totally flat and taut on its stretcher.

Paper

Some artists use paper for their sketches, and even for their large paintings, mounted on traditional frames. Some classical artists, such as van Eyck, sometimes painted on paper (heavily primed with several layers of glue) with thin paint and not using heavy impastos. The problem with this material is that it gets spots and yellow areas from absorbing the oil. Oil paint applied on paper looks flat, but proper priming of the surface with glue can remedy that situation, as well as the other the problems mentioned before.

The mixture for priming supports consists of a combination of glue and fine gypsum, called Spanish white. A powder pigment can be added to this mixture to change the color.

Basic Oil Painting Techniques

The basic rule for oil painting stipulates that the artist should work with thinned paint first, followed by the thick color. The paint that is thinned with mineral spirits dries faster than the paint that has more oil. If the latter is applied first, the paint will crack. This requires that the painting progress in layers, the last one being the impasto. But many artists prefer a slight watercolor-like finish, with areas of color that allow the canvas to show through. In such cases, the artist must work with large amounts of solvent, applying thick paint as a final touch. Otherwise, painting with oils allows corrections to be made and repeated painting and manipulation of the paint to a degree that is not possible with any other procedure.

Oils can be mixed with a lot of solvent and applied to large areas of brightly colored paint with quick and spontaneous brushstrokes.

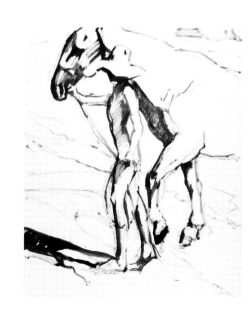

The value of the brushstroke becomes evident when the paint is thick and contains very little mineral spirits.

The slow process of oil painting becomes obvious in the finishing steps. The richer and more sensual the subject, the greater the dedication and time in creating it.

BLEMISHES

The touching up that takes place when the work is finished should be done after the layer of paint is dry. Otherwise "blemishes" or changes in the glossiness of the surface can occur. The areas that have been touched up look matte and stand out because of their dull appearance. Although this can be remedied by using a thick varnish as a finishing step, it is best to wait until the paint is dry.

The normal process of painting with oils begins with a drawing done with a brush and paint that is very diluted with mineral spirits. The first applications should be very thin, later becoming heavier. This building up of paint becomes more obvious in impastos. Work by Miquel Ferrón.

Painting Sessions

Oil paint allows the artist to work either in long or short sessions, and he or she can resume the following day with paint still fresh on the canvas. This is an advantage because it makes the artistic process richer, allowing experimentation until achieving the right color, or the opposite procedure, erasing what was done in the previous session. The technical versatility of oil lends itself to any process: painting *alla prima* (or direct painting), painting before the surface is dry, making corrections directly over the paint within a single session, or slowly building up with color after each layer is dry.

Finishes

Oil painting is the procedure that offers the greater possibility of unique finishes. Because of its physical characteristics, oil paints adapt to fine and delicate finishes, as well as to more rudimentary ones. The finish can be matte or shiny, depending on whether the artist has used a large amount of solvent (matte finish), or a paste rich in oils (glossy finish). The final texture of the painting's surface depends on the accumulation of the layers of color and the way in which they have been applied, with thick or thin brushstrokes, or even with a spatula. This process is very important: it represents the core, the physical muscle of the painting, and it is the element that holds the key to the painting's appeal.

The artist may choose to create a more defined finish, relegating the importance of the brushstroke to second place in favor of precision in the contours of the form.

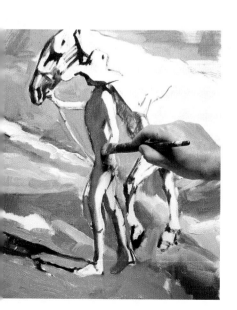

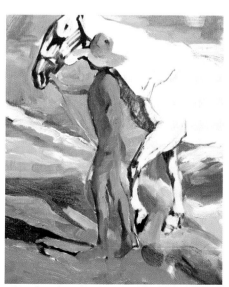

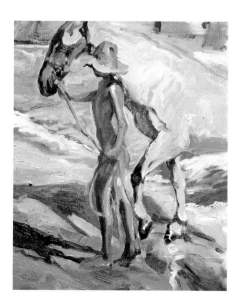

Applying Color with Oil Paints: Skeins of Yarn

This exercise, executed by Esther Olivé de Puig, represents the easiest way to approach an oil painting. Starting with a very detailed line drawing, the colors are applied to the areas defined by the drawing, keeping the manipulation and blending of the colors to a minimum. The subject we have is very appropriate for this approach.

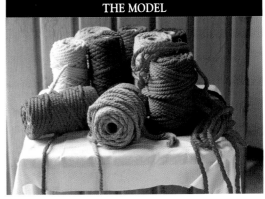

THE MODEL

A grouping of skeins of yarn is as good a subject as any to start painting in oil. The color and simplicity of the drawing are the highlights of the subject.

PHASE 1:
COLOR AND PAINT

2. The red tones can be applied first, painting all the strings that are inside the lines with that color. In some areas, red can be mixed with a little bit of carmine to enliven the tone.

1. The drawing is done with charcoal on canvas, which was previously covered with brown paint. It consists of a basic line drawing, without any shading. It is important to have enough details to facilitate the painting process.

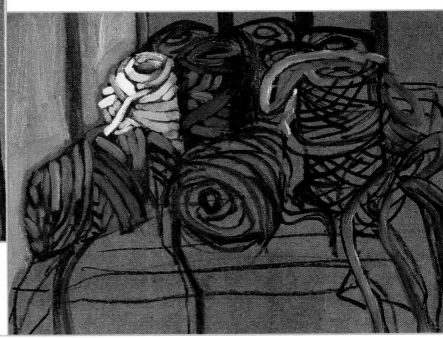

3. It is not necessary to paint the entire yarn ball before moving on to the next area. The background, for example, can be painted any time by going around the skeins.

The bright color contrasts should be complemented with more subtle ones within the same color range, so the painting does not look aggressive and dissonant.

141

Oil Painting

PHASE 2: **LIGHT AND SHADOW**

4. After the background has been painted with ultramarine blue (mixed with a small amount of white), we continue painting the yarn: yellow, orange, and a little bit of green to create the illusion of volume. The color of the blue yarn is darker and more saturated than the background.

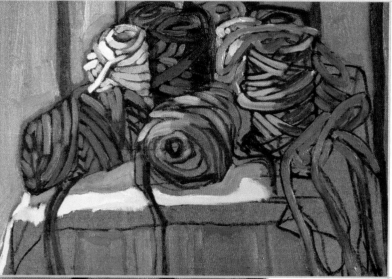

5. To depict the brown skeins, a few areas of the canvas can be left unpainted to create contrasts of dark and light against the painted colors.

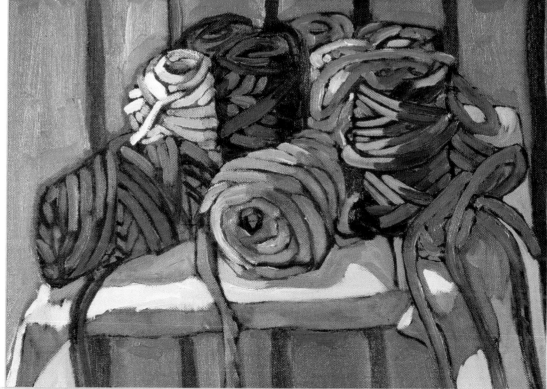

6. Finally, the tablecloth is painted with a combination of cool and warm colors: cool for the shadows and warm for the areas of light. This contrast is more important than the faithful representation of the tablecloth's color.

ACRYLIC PAINTING

Acrylic paint is the most modern of the artistic media. From its invention in the 1940s until today, acrylic has become one of the most commonly used media in the world of art. This is because acrylics are easy to use and produce good chromatic results. Besides, since acrylics dry fast and have good coverage they can be painted over almost immediately. This medium is gaining followers every day, either because they want to explore a new method or because they are interested in taking advantage of a medium that has good covering power and dries very fast.

David Hockney (1937–), *Model with Unfinished Self Portrait.* Private collection. This painting confirms that a new medium such as acrylic can be used with a traditional technique.

GRAPHIC ART STYLE

Acrylic paint, applied in very liquid form, dries as fast as watercolors, but the paint has more covering power and the colors are more solid. This makes acrylic paint the ideal medium for artists who are interested in creating an effect that has a very graphic style, and that is based on clean lines and well-defined contrasts. The spontaneity of the work is immediately reflected in the freshness of the painting.

Characteristics

Acrylic paints are pigments bound in a solution of polymethyl methacrylate. This emulsion dries when the water in it evaporates, and forms an elastic film, which is transparent and very durable. These attributes characterize acrylic paints and set them apart from the other art media. Thick, dry acrylic paint has a shiny surface that is reminiscent of certain plastics, which is why it is not a good idea to apply it in thick layers.

The three main characteristics of acrylic paint—simple use, easy cleaning, and low cost— are the reason why it has become one of the most commonly used media of professional artists and amateurs alike.

Brief History of Acrylic Painting

The first acrylic paints marketed for industrial purposes made their appearance in 1928. Their adoption as an artistic medium came to us at the hands of several American graphic artists who discovered their possibilities in the 1940s. At that time the most popular trend was abstract painting in large formats. Acrylic paints were much more appropriate for this than oils, which were more expensive and difficult to use for large paintings that required bright and clean colors. In the 1960s Pop Art definitely established the use of acrylic paints, and since then it has become the medium of choice of the most important artists in avant-garde circles worldwide.

Arman (1928–), *Color Rainbow.* Peter Stuyvesand Foundation, London. The casual feeling and the poetry of the color dominate this work, which looks like an homage to acrylic painting.

Formats of Acrylic Paint

Acrylic paint is sold in the same formats as oil paint. It comes in two basic configurations: tubes and jars. Acrylic tubes are the same sizes as oil paint tubes. Jars come in different formats and sizes, from very small, equipped with a dispensing system, to large 1-gallon (4 L) cans. They are available in different sizes and prices from a variety of manufacturers.

Color Varieties

Color varieties depend on the brand, but acrylic paint is usually available in as many varieties as any other medium, with the exception of pastels. This selection increases as new pigments are introduced. The colors range from the traditional cadmium, cobalt, and iron oxide to the modern synthetic pigments. Nowadays, every manufacturer is discontinuing (or has discontinued already) the pigments that contained a heavy-metal base (such as cobalt and cadmium, in addition to those with chromium and lead in their compositions) and have replaced them with synthetic pigments that are nontoxic, also known as phthalo. Acrylic colors are sold individually, with the exception of a few manufacturers who sell them in boxes containing an assortment of colors. This may be because this medium is relatively new and there is no tradition of a common use of certain colors and utensils.

Acrylic colors come in different formats and in several sizes, from small tubes to 1-gallon (4 L) cans.

Many manufacturers offer their brands in two formats: conventional tubes, and jars with dispensers.

Many artists prefer to
mix their own colors by
combining powder pig-
ments with an acrylic
medium. The procedure
is very easy; one only
needs to adjust the pro-
portions of both compo-
nents until they become
a smooth paste. Of course,
this paste will not be
as thoroughly mixed as
commercial paint.

A typical color chart for
acrylic paints. Each color
sample is made with a stroke
of real paint, which gives an
idea of the actual tone.

Color Charts

Color charts provided by the manufacturer include, in addition to a sample of the paints available, the specifications of the transparency and permanence of the color when it is exposed to light for a long period of time. Most colors rate favorably under these circumstances. The matter of the transparency is interesting because it is impossible to determine this factor when the product comes directly out of the tube. Most manufacturers also specify the pigment used in each color, by name or with an international key.

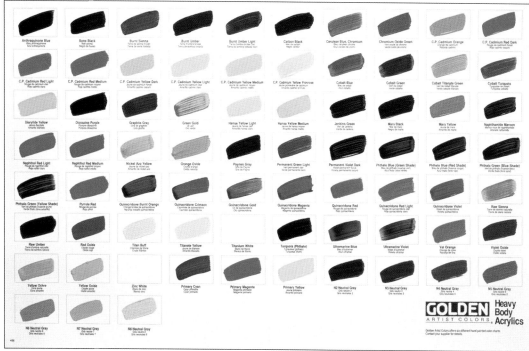

*The containers of acrylic paint
tend to be larger than those
of oils. The reason for this is
that acrylics do not go as far
as oils. Also, since acrylics
dry very quickly, the paint
that remains on the palette
at the end of the session
cannot be used the next day.*

Other Products

Acrylic painting has benefited from the tremendous advances made by the chemical industry in the last decades. Artists will find a wide variety of products that can be used to dilute or thicken the paint—to make it opaque or transparent, to create iridescent and reflective colors, and for many more uses that attest to the clear relationship between acrylic paints and the commercial products available today. With the help of these mediums, one can achieve the desired color effect, especially in large-format paintings.

The variety of products available, such as gels, mediums, pastes, and additives, allow the artist to create a great variety of textures and effects that go together very well.

The industry has created a large variety of products that modify or enhance the characteristics of acrylic paints. They can thin them, or make them brighter, more transparent, textured, and so on.

Acrylic Gel

This is a substance that turns paint into a very creamy paste without altering its composition. It prevents paint from losing its consistency when it dries. When applied to large areas of impasto, acrylic paint acquires a density similar to oil paint. But when it dries, the painted area reduces in size, it "shrinks," and the result is a layer that lacks body. To avoid this problem, colorless gel can be mixed in with the paint so that the applied layer maintains its size when it dries.

The variety of products available to the artist makes it possible to create or to mimic any light or texture effect.

IRIDESCENT PRODUCTS

Some manufacturers sell iridescent acrylic paints that have a pearly finish or that give the appearance of changing colors. To create a similar effect, artists can also use a paste that is mixed with the paint to produce the characteristic appearance of a metallic surface. This effect depends on the amount of paste used and the color that is added to it.

Textured Paste

This is a very dense paste that contains a charge of marble dust, ground pumice stone, or very fine sand that adds texture to the finish. As with gels, these pastes do not change the colors, but they increase their consistency, and in particular they change their appearance. The surface loses its satin-like effect to become more or less textured, depending on the paste used.

Textured pastes contain ground minerals that produce a grainy effect.

Retarding Mediums and Thinners

Acrylic paint dries very quickly, even when it is applied in thick layers or with heavy impastos. For some artists this is an inconvenience, and to remedy it, they use products that delay the drying process. Thinners produce very fine, transparent layers of color without degrading them, a phenomenon that happens when working with water.

Some of the gels and pastes that enhance the creaminess and body of acrylic paints.

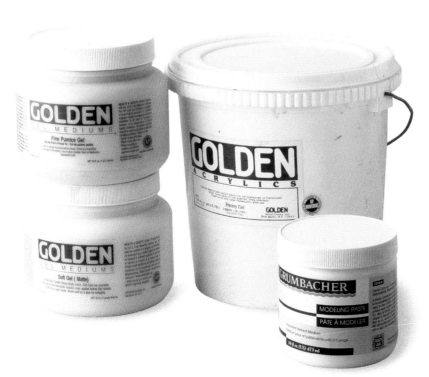

Supports

Acrylic paints can be used with almost any kind of support as long as the surface contains no oils and does not have a high-gloss finish. This is a water-base medium, and the ideal support for it should have characteristics similar to those used with watercolors and gouache.

Normally, artists prefer three types of supports for painting with acrylics: paper (including cardboard), fabric, and wood. In some cases, it is necessary to prepare the surface to give the painting a good base for adherence.

Papers

Any kind of paper can be used to paint with acrylics as long as it is not too thin. Normally, papers are too absorbent, so the paint does not spread easily. In these cases it is a good idea to prepare the surface beforehand. Sometimes, a layer of white acrylic paint is all that is needed to make the process easier. On the other hand, humidity causes the paper to buckle; therefore it is a good idea to secure it to the board by taping along all sides with masking tape, allowing it to go back to its normal state when it dries. Everything that we have said for paper can also be applied to cardboard, although because of its thickness, cardboard usually does not need to be stretched over a wood board.

Paper and cardboard provide a perfectly good surface for acrylic paints, if they have been previously prepared with some type of synthetic glue or with the acrylic paint itself.

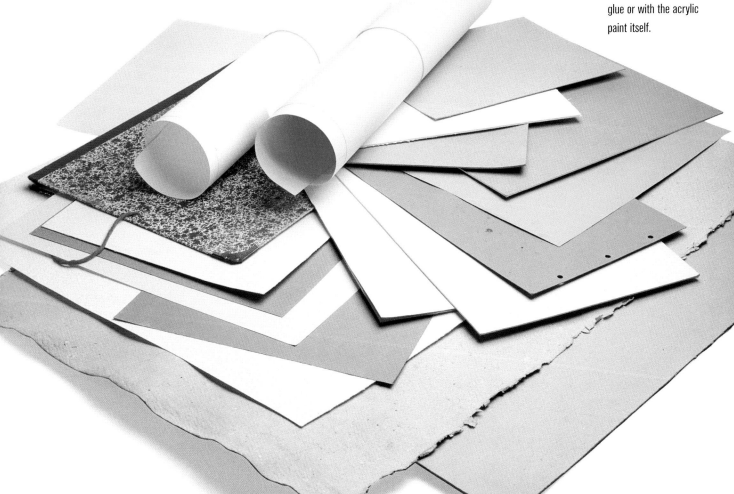

Fabrics painted with acrylics can be stored rolled up without any problems. The paint layer is very flexible, and this method does not damage them or cause any cracking.

PRIMING FOR ACRYLICS

Gesso is a white paste used to prime surfaces that are going to be painted with acrylics. It consists of a mixture of gypsum and an acrylic binder that offers the perfect texture for painting. It dries very quickly and can be applied in several layers until the support is completely sealed.

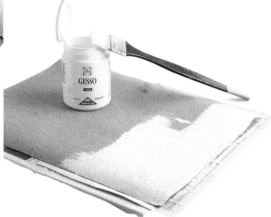

Fabric is the most suitable support for working with acrylics, especially if the painting is large. It is important for the fabric not to have too much texture.

Many artists work with fabrics that are not mounted, and stretch them only when the painting is finished. Others prefer to work on a hard surface, such as wood, which they prepare with a layer of white or colored base.

Fabric

The types of fabric available for painting with acrylics look the same as the canvas used for oil paints. There is a difference, though; the consistency of the fabric or the finish is different. It is important to purchase fabrics that are properly primed. Acrylic paints do not adhere very well to oily surfaces, a characteristic typical of fabrics for oil painting.

Wood

Wood boards are an excellent support for painting with acrylics, but it is extremely important to seal their surfaces with an appropriate product. Conventional sealing products (non-oily ones) are perfectly suitable. If the boards are very large, they must be mounted on a frame, similar to that used for canvas, so the boards do not buckle or warp.

Acrylic Painting Techniques

Acrylic paint can be worked directly, with no other consideration than choosing or preparing the appropriate support for the job. There is no danger of flaking or of problems with drying. The advantages of this medium are obvious and make it ideal for the beginner. But there are also disadvantages, in that the versatility of the procedure can entice the user to excessive mixing and retouching, which ruins the brightness of the colors.

Acrylics are ideal for work that is based on flat, solid colors, and that have great covering power, like this one by Ramón de Jesús Rodríguez.

Heavy impastos should be avoided because the satiny quality of the acrylic finish can give the painting a plastic appearance.

Glazing

Acrylic paints are suitable for manipulating the different levels of saturation or transparency of the color. This can be achieved by working with colors that have good covering power or by glazing, which provides a delicate finish. Certain colors are more transparent than others, and sometimes it is necessary to dilute the paint considerably to achieve the desired transparency. For paintings that incorporate glazing, the best results are obtained by diluting the paint in an acrylic medium instead of in water.

Color transparencies are created by adding a large amount of acrylic medium to the mixture. The paint gets thinner and the color film becomes transparent. Work by Ramón de Jesús Rodríguez.

Acrylic paint does not require any particular working sequence. Painting can begin with paint directly from the tube without any fear of flaking or cracking. The artist decides the method that he or she wants to use.

151

Acrylic Painting

DIFFICULTY IN BLENDING COLORS

Painting with acrylics has the problem that colors cannot be blended easily because of their fast drying time. One solution is to use tones that are very similar to each other and that are applied in even layers to produce an illusion of unity. This effect of color gradation is similar to that created by pointillism.

Direct Painting

The technique *alla prima* (or direct painting) is especially suitable for acrylic paints because they dry very quickly. In fact, acrylic is good for sketching, for quick touch-ups, and for creating impastos, all in the same session, without interrupting the working sequence. It is a very easy and versatile medium, which can be used to do quick studies, color notes, and sketches with a flexibility that is impossible to achieve with oils.

Traditional landscapes can also be interpreted with acrylics. In this case, very diluted paint has been used so it could be blended easily for representing the atmosphere.

A decisive approach and the *alla prima* method are the perfect ways to paint with acrylics. Artists can apply large areas of bright color with total freedom in the chosen working method.

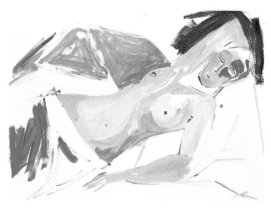

A Basic Process

As a starting point, a sketch is made with the basic outlines of the elements involved. This will serve as a base for the artist, who will not be encumbered by excessive detail. This preliminary sketch can be done with pencil or charcoal. Generally, it is better to use pencil if the support for the painting is cardboard, because charcoal can muddy the color too much. Thanks to the paint's quick drying ability, we can layer brushstroke upon brushstroke without mixing the colors, which creates a very clean surface. On the other hand, if we wish to mix colors, we should work quickly so they do not dry before the task is completed.

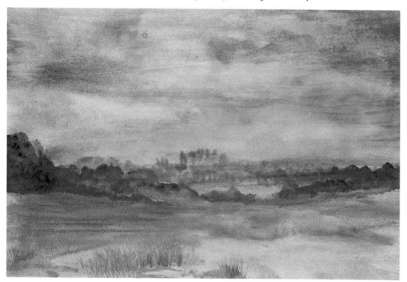

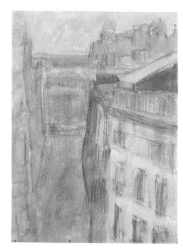
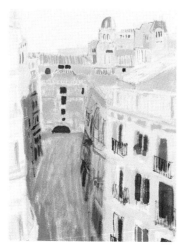
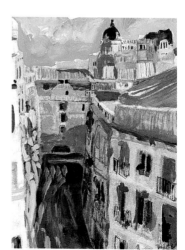

Photos showing the process of a painting with acrylics. First, the large areas of the composition are painted, then the details are added, and finally the color nuances are defined. Work by Muntsa Calbó and final step by Ramón de Jesús Rodríguez.

Effects with Acrylics:
A Seascape

The purpose of this exercise, done by Carlant, is to show the effective use of some artistic effects that can be created with acrylics. These procedures are characteristic of traditional media, such as oils, but are resolved much faster with acrylics. These processes are as relevant to this painting as the finish itself.

The model is the seashore on an overcast day. This subject is very rich in broken tones, in colors that are not well defined, and in a beautiful atmospheric quality that lends itself to many different effects.

1. The color of a background painted with acrylic paints can be shaded until the desired tonality is achieved. A layer of very light gray is applied in all directions, using horizontal brushstrokes to create a texture that suggests the clouds.

PHASE 1:
BACKGROUNDS AND TONALITIES

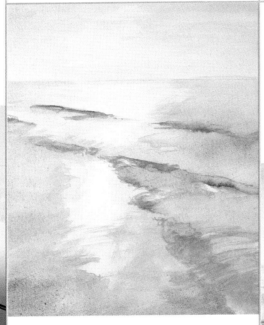

2. Darker and warmer gray tones are used to suggest the waves. The brush is dragged in the opposite direction of the waves, and before the paint dries, it is repeated with a flat, dry brush.

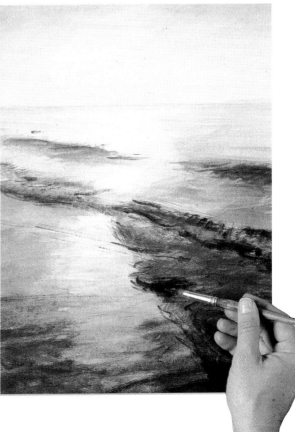

3. More strokes of gray are applied in the area of the foreground. This time the tone is blue mixed with large amounts of black. Here, the paint is thicker and more opaque to create a solid tone that is in contrast with the vanishing tone of the composition.

Acrylic paint lends itself to experimentation more than any other medium. Its stability and quick drying time guarantees the consistency of the final result.

FINISHES

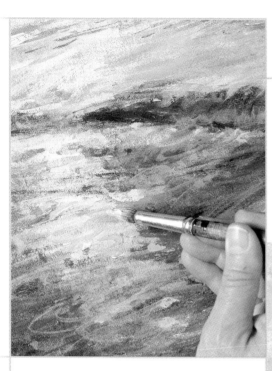

4. Repeated brushstrokes of thick ochre and sienna paint lightened with white are applied in the foreground. These light tones correspond to the area of the sand that is bathed by the sun, clearly in contrast with the cool tones of the waves.

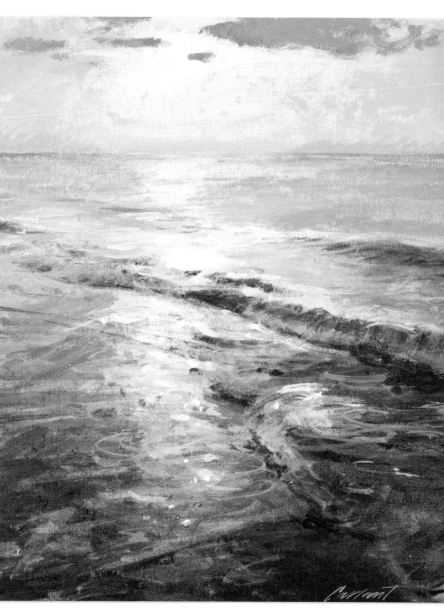

5 . After painting the sky with darker strokes of gray, the rest of the work consists of adding the details that create the texture of the sand in the foreground, with some layers of white for the foam of the waves.

6. The final result is the product of the work done in the background of the composition, which has set the overall gray tone, and of the subsequent definition and detailing done on all areas of the painting.

PAINTING
Basic Techniques

Painting is ruled by certain guidelines that are in large part
independent of the techniques and tools that are typical of each
medium. It is true that the technique affects the result tremendously,
but the execution of a work of art is a mental as well as a manual expression. Ideas must
be sufficiently clear to guide the actions by clearing the way of impediments. The basic
concepts that guide every painting involve color and composition. Color has a logic of
its own that the artist must understand and be able to adapt to his or her intentions.
 Composition is a visual requirement that has to be respected no matter the style
 of the subject represented. These are the two concepts that are studied
 in the following pages.

Color, of all the artistic factors, is the most subjective and the most difficult to conceptualize clearly. But it is also true that there is an internal logic that governs the combinations of colors. When one pays attention to the working technique of an artist, it is interesting to see that each painter has his or her own color preferences or tendencies that are more or less constant despite their subject matter. Those are their own colors, the ones that adapt to their temperament and the ones that help them create the desired harmony. They are the colors that the artist knows how to use to produce a particular expression because he or she has discovered the "laws" that govern their advantages and disadvantages.

Vincent van Gogh (1853–1890), *Garden in Arles.* Private collection. The work of van Gogh encompasses and highlights all the expressive mechanics of color.

NEWTON AND CHEVREUL

The common facts about the color wheel—primary, secondary, and tertiary colors, the concept of complementary colors, and all the basic color principles—are relatively modern. They derive, first, from the research of the English physicist Isaac Newton in the 17th century, and second, from the dye manufacturer Eugène Chevreul in the 19th century.

The Mechanics of Color

What we know about the color preferences of the great masters can be very interesting, many times even helpful, but it is nothing more than a conventional recipe similar to the medieval recipes known in all the studios of the time. For centuries, those recipes were the only color theory available. When modern science was applied to the study of color, many artists thought that there could be a universal "mechanical" way of producing color that was independent from the personal painting style of the artist.

Color is light. Newton proved that sunlight contains all the colors by breaking down a ray of light through his chromatic prism.

The artist works with pigments, not with light. Pigments, however, are an interpretation of the effects of real light.

The Colors of Light and of Pigments

From the time that English physicist Isaac Newton formulated his color theory in 1704, many artists and researchers have tried to apply those optical laws to blending colors—in other words, to art. The only problem with this approach is that Newton's principles refer exclusively to the visual sense, that is, to colors as they pertain to light and not to pigments. Newton's optical observation is based on the fundamental principle that mixing light results in more light, more luminosity, but every artist knows that the greater the number of colors mixed, the darker the resulting tone will be.

"Instead of trying to reproduce exactly what I have before my eyes, I use color more arbitrarily to force self-expression."

Vincent van Gogh

The Nature of Color

Color is light, and light is an electromagnetic emission just like radio waves and other higher- or lower-energy emissions. Light occupies a secondary place in the complete scale of electromagnetic radiation that is present in nature; the majority of it cannot be perceived by our senses. In fact, our senses are capable of perceiving only a fraction of that radiation, whether as a luminous or thermal sensation. The place that light occupies within the scale is known as the colors of the spectrum.

Illustration from the book by J. J. Scheuchzer, *The Formation of the Rainbow*, 1771. (Augsburg, Germany).

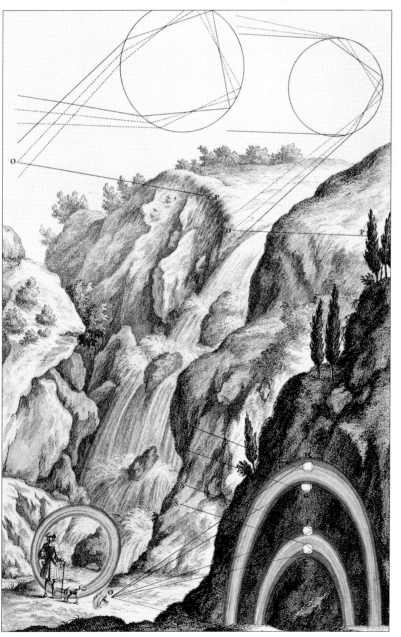

The Names of the Rainbow

To prove his theory, Isaac Newton used a crystal prism to break down a ray of light into a color spectrum. In that small rainbow that anyone can recreate at home, there is no separation between one color and another. The boundaries are diffused and it is practically impossible to decide where the yellow color ends and where the green begins, or when green turns into blue. To make things easier, when we name the colors we dismiss the transition areas and summarize the spectrum in a total of seven colors: red, orange, yellow, green, blue, indigo (bright blue), and violet.

For an artist, the physics of color relating to the properties of light can only serve as an analogy for the physics of the mixture of pigments, because they act very differently.

UNEVEN ABSORPTIONS

Except for the surfaces of some very intense colors (some flowers and fruits, for example), the majority of objects have colors (grays, browns, greens, etc.) that bear little resemblance to the colors of the rainbow. These objects absorb all the colors of the spectrum unevenly without reflecting any one of them completely, but all at the same time in different proportions. (If they reflect red more than the others, the tendency will be brown, if they reflect more green, the tendency will be gray green, and so on.)

The color spectrum of light as would be seen in a rainbow. In reality, the transition of one color to the next is more continuous than is shown in the image, and the distinction between colors is not as noticeable.

The Colors of Objects

The colors of the objects that our eyes see depend on the light cast on them. Under moonlight everything appears blue gray, which can be lighter or darker depending on the intensity of the light. A landscape does not have the same color at sunrise that it does at sunset. Every object has the color of the light that illuminates it. A blue object absorbs all the colors of the spectrum except for the blue part of that spectrum. A yellow surface will reflect the green and red areas of the spectrum (the green and red combined create yellow). A black object absorbs all the areas of the spectrum equally, and a white one reflects them.

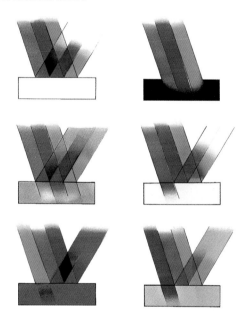

The colors of objects depend on the part of the spectrum that is absorbed and the part that is reflected. From top to bottom and from left to right: the white object reflects the entire spectrum; black absorbs it all; gray absorbs all the colors partially; yellow absorbs only bright blue; the red object absorbs only green; the blue object reflects bright blue and green.

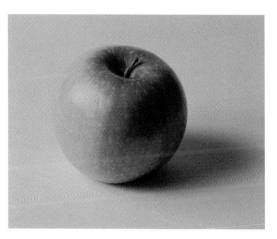

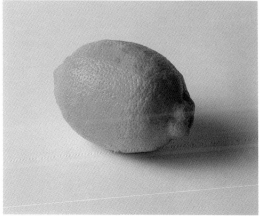

These fruits are proof that light is responsible for the colors of objects (an apple and a lemon) under a certain light where part of the color spectrum is missing (bright blue and green in the apple, and the green in the lemon).

Light and Pigments

The theory of color creates a common misunderstanding, which is that what works for the colors of the light spectrum also works for the color pigments used by the artist. Not only is this not true, but pigment mixtures produce a result that is completely opposite from light. In one case, we are dealing with substances that absorb light (all substances and objects do it in greater or lesser degree). In the other, we are manipulating sources that cast light. Absorption and emission are opposite phenomena, and therefore the consequences of each are also opposite.

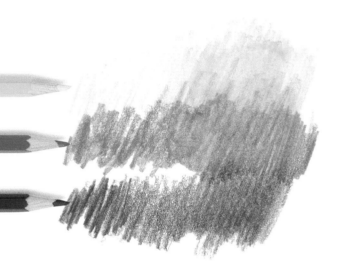

The different types of media have primary colors, which mixed together can produce (in theory) the rest of the colors. The luminosity of primary colors depends on the media chosen (pastel, watercolors, oils, etc.).

Mixing pigments always produces a darker color than the lighter one of the mixture. These illustrations show a few typical combinations of primary colors.

AZUL ULTRAMAR OSCURO
ULTRAMARINE DEEP

CARMIN GARANZA SOLIDO OS
MADDER CARMIN SOLID DE
CARMIN DE GARANCE SOLIDE F

AMARILLO CADMIO LIMON
CADMIUM LEMON

TOO MANY MIXTURES

The best example of the different nature of subtractive mixing versus additive mixing is found on the painter's palette. Inexperienced artists usually make the error of mixing too many colors to obtain a specific one, and what they usually get is a dirty gray. The lesson derived from this is that mixing pigments tends toward black, whereas mixing light tends toward the luminosity of white sunlight.

Light Emissions: Additive Mixtures

If we light a flashlight at night, it will be less bright than if we turn on the car lights: more light, more luminosity. Beginning with this obvious fact we will be able to better understand how adding a green light to a red one will produce a yellow light, and why we get white when a third blue light is added. The greater the number of lights added, the greater the luminosity. This is the reason why mixing light is an additive process.

Pigments, like any other substances, absorb light. This is why white is needed to make mixtures lighter. The mixtures of colored light on the other hand produce lighter colors: more light.

Combinations of light are additive mixtures. The three primary colors of light together make white light.

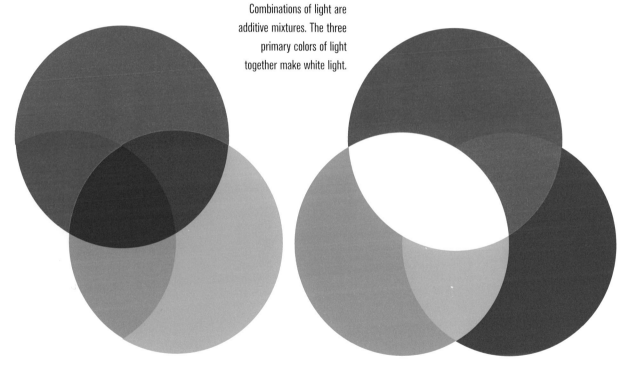

Combinations by subtraction remove light. The primary colors of pigments mixed together produce a very dark gray, almost black.

Absorbing Light: Subtractive Mixtures

We know that the colors of objects depend on the light that is absorbed and reflected by them. Black absorbs almost all the light and white reflects it. What happens when we mix green with red? The resulting mixture makes a dirty brown: a color darker than the two originally involved. This color is darker because it absorbs more light (it reflects less of it) than the ones involved. If we continue mixing that same brown with other colors, we will soon get a blackish tone that has hardly any light. By mixing pigments we accumulate substances that absorb and therefore take away light. This is why mixing pigments is considered a subtractive procedure.

One of the most interesting implications of Newton's experiments is that not only can we combine all colors of light to obtain white light, but we can also mix a few of them to obtain the rest. In fact, with the help of prisms and mirrors, Newton proved that green, red, and indigo lights are sufficient to obtain the rest. These three lights are known as the primary colors of light, which mixed in pairs produce the secondary colors. Any other possible color can be created by mixing the three primary lights in different proportions.

The three primary colors mixed together, lightened with white or darkened with black, can produce, in theory, the rest of the colors.

Mixing primary colors produces secondary colors. Mixing magenta and yellow creates red; cyan and yellow, green; and cyan and magenta, bright blue.

The primary colors named in the theory of color (yellow, cyan, and magenta) are the colors that, together with black, are used in the graphic arts in four-color printing.

163 Color

THEORY AND PRACTICE

Cyan and magenta are two of the colors used in photography, computer programs, and graphic arts, but painters hardly ever use them. Artists work with other blues (ultramarine, cobalt, Prussian, etc.) and hardly ever with the primary color magenta. Instead they use other secondary reds (vermilion, cadmium red, etc.). Carmine is the closest color to magenta in the painter's common palette (equivalent to a dark magenta). However, this does not invalidate the theory. On the contrary, it is thanks to this theory that the painter is aware of the mechanics of color in his or her work.

Combining Primary Lights

By combining green and red light we get yellow light. From the mixture of green and indigo blue we create the light blue of the spectrum, which receives the name of cyan blue. A very bright purplish red, known as magenta, is obtained from combining red and blue lights. Yellow, cyan, and magenta are secondary lights. Interestingly enough, we do not see the magenta color in the rainbow; it does not exist in the color spectrum. This is because the spectrum begins with red and ends with violet, and both occupy opposite ends of the color fan. Magenta is a mixture of bright blue and red, which means that the color fan is "curved" until the ends touch each other and mix.

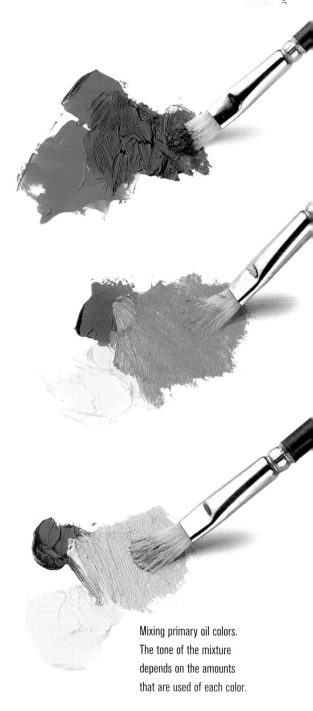

Mixing primary oil colors. The tone of the mixture depends on the amounts that are used of each color.

These are the mixtures of three primary pastel colors. The resulting combinations are not exactly what the theory says, but they are quite close.

The Primary Colors of Pigments

As we know, everything happens differently in the world of painting than in the world of light. Primary lights are equivalent to secondary pigments and secondary lights to primary pigments. Therefore, the artist's primary colors will be yellow, magenta, and bright blue. Mixing these tones in pairs produces the secondary pigment colors: red (mixture of magenta and yellow), bright blue (mixture of cyan and magenta), and green (mixture of yellow and cyan).

The Color Wheel

The best way to systematize the relationships between colors is through diagrams, the most common of which (although not the only one) is the color wheel. This is the result of connecting the two ends of the spectrum in such a way that the violet color at the end extends into the red through a specific magenta, a color that, as we said before, does not appear in the color spectrum of light. However, the differentiation and terms used here belong to the realm of color pigments, that is, to paints, and not to the colors of light.

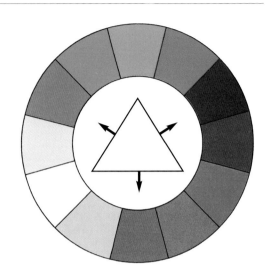

Color Order

To understand how the color wheel is formed, you can imagine an equilateral triangle whose vertexes show the three primary colors (the primary for pigments, not light): yellow, cyan, and magenta. The center of the triangle is also the center of the circle that passes through each one of those colors. Between each pair of colors and along the circle, we place the color that results from mixing that pair: green is between yellow and cyan, bright blue between cyan and magenta, and red between magenta and yellow. The wheel already includes primary and secondary colors and can also include tertiary, if they are inserted between each pair of contiguous colors that result from combining them: orange, yellow green, green blue, ultramarine blue, and violet.

The color wheel is the most common graphic representation for organizing primary, secondary, and tertiary colors. Primary colors are found at the corners of the triangle, and the arrows indicate the positions of secondary colors. Tertiary colors appear between both groups.

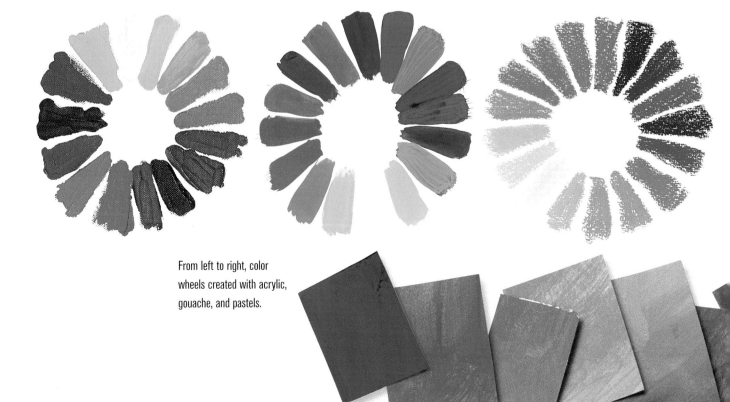

From left to right, color wheels created with acrylic, gouache, and pastels.

The color wheel can include as many colors as you want. To add new colors, you only need to mix two colors that are next to each other.

165 Color

CONTRAST BETWEEN COMPLEMENTARIES

The most powerful color contrast is created by placing two complementary colors next to each other. This is an important resource for the artist who wants to create bright paintings, in which some colors reinforce the effect of others, as is the case of complementary colors. The color wheel is the best tool for finding the complementary of any color.

Complementary Colors

Two colors are complementary when they are at opposite sides of the color wheel. The pairs formed by a primary color and the secondary one obtained by mixing the other two primaries are considered complementary. Therefore, yellow is complementary of bright blue, magenta of green, and cyan of red. These relationships are also valid for the pairs formed by tertiary colors at opposite ends of the diameter of the color wheel.

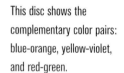

This disc shows the complementary color pairs: blue-orange, yellow-violet, and red-green.

Colors can be arranged in many other ways, like in this pseudo-triangular scheme that multiplies the intermediate colors between primary and secondary.

This progression of colors mimics the order of the solar prism or rainbow.

Color, Tone, and Value

The terms used to describe colors often are not very accurate, and some people use them in a way that contradicts their real meaning. To avoid confusion, it is best to define what we understand for each concept in the context of color theory. Terms such as tone, value, intensity, and luminosity are some of the concepts that must be defined and compared.

Each of the colors included in this version of the color wheel has its own tone (yellow, blue, green, etc.), in addition to a series of different variations of the same color. They are the result of mixing them with white or black to create changes in their luminosity.

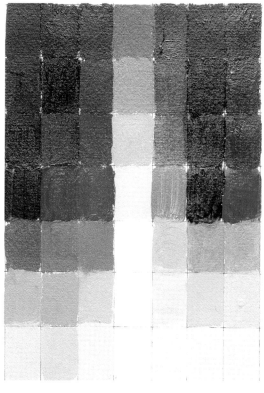

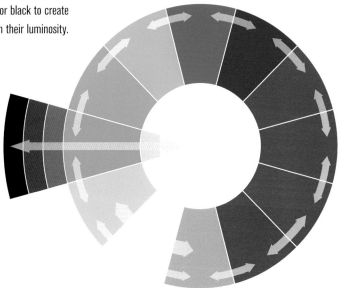

By mixing a color with white or with black we are modifying its luminosity (the greater the luminosity, the lighter the resulting color). This change in luminosity also implies a change in value.

The differences in luminosity and saturation can be compared in these three groups of colors that range from the most subtle pastel tones to the most intense and solid colors.

COLORS AND LUMINOSITY

Each color has a different luminosity. Some colors, such as yellow, reach their highest saturation point at a very luminous value, whereas the saturation of others, such as green, corresponds to a lower degree of luminosity. The concept of luminosity is easier to understand if we imagine a black-and-white photograph of the color wheel. The most luminous colors would be the lightest grays, and the least luminous the darker grays. There is great distance from the darkest to the lightest green, distance that can be reduced with yellow.

Color and Tone

The colors are each of the components of the chromatic wheel, regardless of the number. Tone is one of the qualities of color and can be measured by the distance from that color to the one next to it. Yellow can have a greenish or orange tone before it turns into full green or orange by mixing it with other colors. Red can have more of a purplish tone before it turns into magenta. Blue goes through different turquoise tones before it becomes green. The concept of tone is always relative to the concept of color, and the tone can change without changing the color.

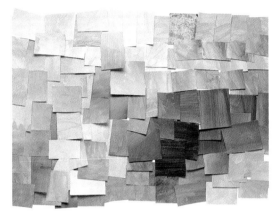

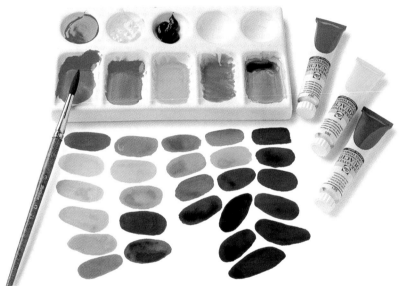

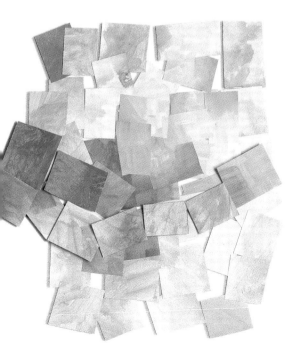

Value, Saturation, and Luminosity

Value is the degree of variation that a color might go through before turning into black or white. In other words, by lightening it with white or darkening it with black, we change its value without changing its tone. A color has its greatest degree of saturation when it is in pure form, without mixing it with black or white. When the value of a tone is changed, whether by lightening it or darkening it, we take away saturation and alter its luminosity. The closer the value to white (the lighter the value), the greater the luminosity, and the closer to black the lesser. This infers that the maximum amount of luminosity corresponds to white and the minimum to black.

Mixing primary colors can result in more or less luminous tones according to how much of the three primary colors are used simultaneously.

Earth Tones

The study of color would not be complete if we overlooked the large group of colors that never show up in the color wheel but are normally present on a painter's palette: the earth tones. They bear this name because these pigments resemble the color of earth and are easy to obtain (they are plentiful in any high-clay soil, rich in iron oxide). These colors could be created by mixing several colors of the color wheel, but no artist is willing to spend precious time mixing colors that can be easily purchased in a tube, especially these colors, which are very inexpensive.

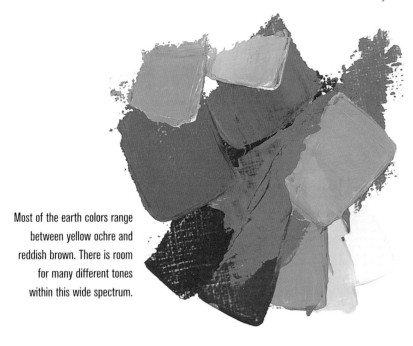

Most of the earth colors range between yellow ochre and reddish brown. There is room for many different tones within this wide spectrum.

Ochres

The tone of this pigment ranges from earthy yellow to oxide orange. It can be opaque or transparent, and the most common of them all is yellow ochre. The color is warm and soft, opaque, and goes very well with many other colors. It turns a little green when used in combination with orange reds and bright pinks. Many artists prefer ochres to the conventional bright yellows because their tones are more natural and subdued.

Reds

The tones of earth reds are deeper and more subdued than the red colors represented in the color wheel. There is a wide range of possibilities from brownish red to purple red. The most characteristic color of this range is iron oxide red, also known as English red (most commonly referred to as light red). This color is opaque, has good covering power, and establishes a sense of stability and firmness in the painting.

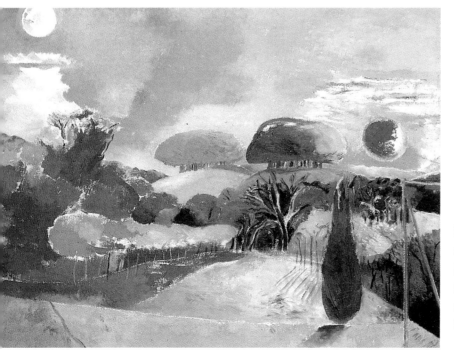

Paul Nash (1889–1946), *Late Summer.* Private collection. Many painters, such as Nash, choose earth tones to create a warm and serene feeling in their paintings.

Earth tones are pigments that are very rich in iron oxide, which gives them their characteristic reddish color. For the most part these colors are very warm and opaque.

169 Color

GREEN EARTH TONES

There are also green colors with a subdued and true earth undertone. Some of these colors are very dark and olive-like, such as burnt umber, which can pass as black when used in pure form and as a delicate gray when combined with white. Other earth colors have a more neutral green undertone, although they are less luminous than the characteristic green of the color wheel.

Siennas and Green Earth Tones

Sienna, whose name comes from the Italian region of the same name, is almost always present on the painter's palette. The most commonly used one is raw sienna (a dark, burnt brown). This color is transparent when its application is not very thick. In fact its color is reminiscent of the shiny surface of the chestnut or of varnished hardwood. It is a beautiful color, the handsomest one without a doubt of all the colors that constitute the range of browns.

From yellow to almost black, the range of earth tones includes a wide variety of colors.

A variety of pastel earth colors. The consistency of this medium goes very well with the earth tones.

A sample of gouache earth tones. Next to each sample is a very diluted brushstroke of the same color.

Four ochre tones. Ochre pigments range from yellow to the deepest gold.

The Painter's Palette

No artist arranges the colors on the palette in the order of the color wheel, and very few work exclusively with the colors dictated by the theory. Every painter has a preference, which is commonly known as his or her palette. It can incorporate a larger or smaller selection, which includes the colors that best suit his or her style of work. Some choose a light or dark palette, others are simple or rich, light or striking, etc. The traditional or classical palette tends to be moderate, whereas the Impressionist and Expressionist palettes favor rich colors.

The Traditional Palette

The traditional palette of the artist is limited. In general, it is based on solid and firm colors: yellow (which can be ochre), red, carmine, blue, green, an earth tone, white, and black. This could be the generic scheme from which many variations could stem, because each school of painting that preceded Impressionism had its color preferences. But in all of them we can observe a limited range of colors that is applied to any subject following the same "system." A limited palette that has been tested by the experienced painter and that can be adapted through various modifications to a great number of themes guarantees a solid color harmony. But not just any selection of colors can give good results. Usually, a palette that is too dark does not work well with landscapes, and one that is too light takes away the solidity of the figures.

The palette of watercolor artists usually does not vary from one person to another, because this medium already suggests and conditions the number of colors.

A PERSONAL PALETTE

Modern artists, like artists from any other period, must choose their personal palettes. But unlike those times, when colors were dictated by strong traditions, today's artists do not have that guidance. They must define their artistic intentions before they make that decision. Expansive artists require varied palettes with a great number of options, especially if they like intense colors. A personality that is austere and very organized will gravitate more toward themes and harmonies that are based on a limited number of colors.

The colors sometimes blend together on the palette of an oil painting artist to form heavy buildups of paint.

The Impressionist Palette

Impressionism brought about a change in the traditional use of color with the introduction of bright and vibrant colors in pure form that translated light with a stronger expressive force than was expected in classical painting. The Impressionist palette (the "clean" palette, as it is usually called) expands to give way to more colors: orange, rosy tones, light blues, violets, mauves, etc. Blacks and dark colors are eliminated. The purpose of this assortment of colors is not meant to establish a defined color system, but to assemble a wide range that will enable the interpretation of the subject with a minimum of mixing.

The classic palette is usually composed of 9 or 10 colors, among which earth tones are always present.

In this drawing by van Gogh, he indicates the position of his colors on the palette, which never included more than 10 or 12 colors.

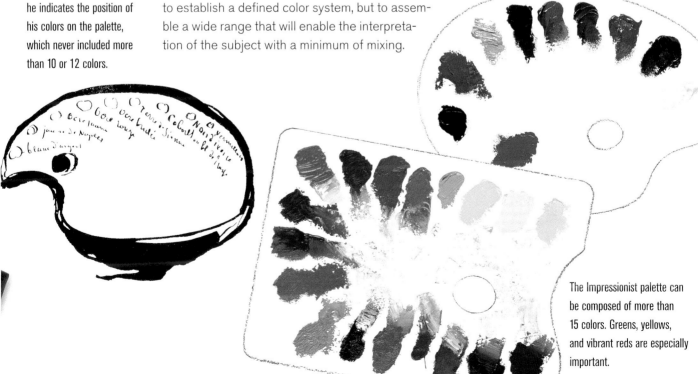

The Impressionist palette can be composed of more than 15 colors. Greens, yellows, and vibrant reds are especially important.

Mixing in Practice

Combining primary and secondary colors is the basic technique that should guide the work. But in practice, artists use many colors that are not exactly those found on the color wheel, only similar to them. Although the same rules that are applied to color that we have studied apply to these hues, it is important to be familiar with them to produce the desired results. Some pigments are more powerful than others, and the amount used in the mixtures should be less than the theory dictates.

Clean Colors

For a color mixture to be clean and luminous, the artist must determine which one of the colors involved is the most dominant. Yellows and violets tend to be less dominant than reds, greens, and blues. Therefore, it is important to increase the proportion of these colors in the mixture if the painter desires to achieve clean and luminous oranges, greens, and yellows. It is also important to add a small amount of white to the color mixtures that are not very luminous to create a clean tone. Such is the case when mauve and purple colors are desired.

Ramón Sansivens (1917–), *Landscape.* Private collection. A composition based on clean colors that blurs the forms and creates a very luminous visual effect.

Yellow cannot be darkened unless it is mixed with green—that is, unless its color is changed.

COOLING WARM COLORS

Warm colors can be "cooled off" by adding white, black, or both—in other words, by creating their gray version. The resulting colors will continue to be warm but less so. Another possibility is to mix them with the coolest tone that is closest to them on the color wheel. The result will be a tone that is cooler and different from the original.

Lightening and Darkening

Whenever a color is lightened with white or darkened with black, we can say we are reducing its saturation, or in other words, we are making it gray. To maintain the saturation of the color as much as possible, it must be mixed with small amounts of a different color that is next to it on the color wheel. Greens are lightened with yellow and darkened with blue. Red mixed with white turns pink, whereas it becomes orange with yellow, etc. Other colors, such as yellow, can only be lightened only with white and should never be darkened with black lest it become muddied and ruin the tone.

In this drawing done with color pencils by Esther Olivé de Puig, the shadows created with black contrast vividly against the pure colors of the flowers, without darkening them.

The dark colors of this work by Esther Olivé de Puig are, in reality, blue. Black is not used in the shading of any color.

Here, the shadows have been created by darkening with black. This approach, as well as limiting the range of colors to only a few, gives a feeling of solidity to the forms and stability to the tones. The work is by David Sanmiguel.

Representing Color

The concept of color and its representation continues to fascinate artists and scientists, but it is proven that its perception depends on immeasurable factors that make it difficult to speak of an objective representation. Real light and its colors are much more intense than the way they are depicted, because this always involves color, which is a compromise between the requirements of the representation and the personality of the artist.

Vincent van Gogh (1853–1890), *Wooden Bowl with Potatoes.* Rijksmuseum Vincent van Gogh (Amsterdam, Holland). The real colors of the objects are translated into relationships of bright colors.

Gustav Klimt (1862–1918), *The Embrace.* Österreiches Museum Für Angewandte Kunst (Vienna, Austria). To achieve maximum luminosity in a painting, some painters have departed completely from realistic representations.

Whether the real color of an object is represented or not depends on the personality of the artist, his or her color preferences, and the desired effects—lyrical, naturalistic, expressionistic, etc.

A SIMPLE PALETTE

Depicting true colors requires combining color contrasts (bright colors) with value contrasts (grays and browns), which is achieved by mixing the colors with black or white. If there are too many different colors, confusion is unavoidable. The solution therefore is to work with a simple palette.

The Problem with Light

In nature, the sky can be a thousand times brighter than a faint shadow, a shaded façade for example, but on a canvas, a painted sky is barely twenty times brighter than a shadow. If we translate this difference of light into color intensity, we will see that, objectively speaking, it is impossible to represent the color of nature; there is no way to duplicate it. What every painter does, whether he or she is aware of it, is to transfer a mental picture of the subject onto the canvas. This translation consists of softening the lights and brightening the shadows based on the artist's personal experience with the color of the objects.

Caravaggio (1571–1610), *Basket with Fruit.* Pinacoteca Ambrosiana (Rome, Italy). In this painting the strict faithfulness to the real color of the objects can be appreciated.

Esther Olivé de Puig, *Bottle and Glasses.* Private collection. The color of this painting is achieved independently of the color of the objects, creating a harmony that is independent from reality.

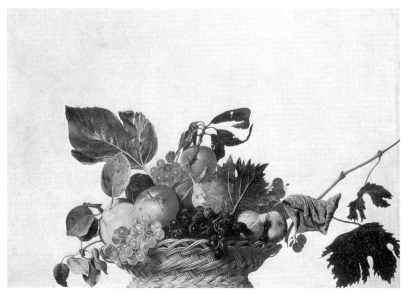

The True Color of Objects

Color is changing constantly. An artist cannot depend on those changes, and has to imagine a color that is consistent throughout the work. Although colors may change greatly depending on the light, the human eye tends to compensate for the differences and to attribute a characteristic color to each part of the object (gray ochre for the soil, certain greens for the grass, a pink tone for the skin, a certain orange for this or that type of fruit, etc.) The true color is that characteristic color. One of the principles of artistic realism is faithfulness to the true color and its lightening or darkening as a result of light and shadow.

Value and Color

Representing light and shadow is the main challenge of chiaroscuro. In terms of color, the problem is resolved by lightening and darkening the real colors of the parts of the object through the use of a limited palette. This way, the artist will emphasize the contrast of light and dark tones (values) by drastically reducing the contrast of colors. But when the complete palette of a colorist artist is used, the approach changes dramatically.

A value approach tends to highlight the volumes, whereas a colorist approach usually reduces the forms of the objects to flat surfaces.

Vincent van Gogh (1853–1890), *Landscape with Snow in Montrouge.* National Museum of Wales (Cardiff, Wales). A pure colorist example where the value of the shadows is as light as the value of the lighted areas, although of a cooler color.

GRAYS AND COLOR

When observing classical and modern paintings, it is easy to see that grays are present in a good portion of the painted surface. The areas painted with neutral or soft colors can be charged with chromatic feeling if the artist knows how to distribute intense colors in the correct places.

Painting with the Value Approach

We can say that an artist has created a painting with the value approach when he or she interprets the themes using the true color of the objects and their light and shadow values with mixtures of black and white. This requires the use of saturated pigments for the true colors and much less saturated ones for the light and shadows. It is a classic approach that gives the painting sobriety and a very solid feeling, but that runs the risk of making it look heavy and lacking vitality, which is otherwise achieved through color contrasts rather than values.

Ivon Hitchens (1893–1979), *Forest*. Private collection. Color and value are independent of the artist's realism. This abstract painting clearly shows the use of color value in its approach.

Colorist Painting

When the artist wishes to preserve the purity of the colors, he or she must represent light by contrasting those colors. This effect cannot be achieved by going from a saturated color to its value through a graying process or by mixing with black. Modeling in a purely colorist painting is a contradiction that saps the vitality of the painting. In a colorist painting, light is color itself, and the contrast between light and shadow can be achieved only through color contrast and not chiaroscuro. For a colorist artist, light cannot be represented directly, but only with color, because the light is the color.

In this completely colorist watercolor, the chromatic approach tends to eliminate the three-dimensional effect. Work by Esther Olivé de Puig.

Colors and Grays

Neutral grays, typical of paintings that emphasize value, can play an important role in the transition between contrasting colors, which are characteristic of a colorist painting approach. Unless the artist wishes to create a clashing effect between colors, grays provide a channel to transition from one saturated hue to another, for example, from orange to green. The procedure is based on the adjustment of the value. A gray of a similar value (same lightness or darkness) is applied next to the saturated color. The similarity between tones provides a natural transition from one saturated color to another, avoiding a clash between them.

olivé de Puig

Emphasizing tonal value has a tendency toward sobriety and seriousness, as in the composition of this work by Esther Olivé de Puig.

COMPOSITION

A composition is the arrangement of a painting's elements done in such a way that the resulting effect inspires unity, coherence, and harmony in those who contemplate it. A well-composed painting can be compared to a well-designed building in that all its parts (windows, columns, cornices, etc.) are naturally integrated into the façade so that it draws attention and provokes the interest of the spectator. The elements that we refer to as drawing, color, and form, and their arrangement, are the objective of the composition.

Tintoretto (1518–1594), *Preliminary Drawing.* National Gallery (London, England). The drawings by the great masters reveal the importance of the artist's compositional criteria in the creation of the work.

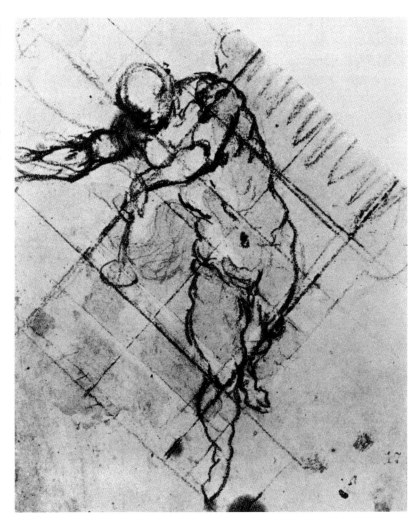

> *"That which we call creation in great artists is nothing more than their particular way of coordinating and depicting nature."*
> Eugène Delacroix

COMPOSITIONAL APPROACHES

Although it may seem strange, the compositional approach can be better studied in a cubist painting than in a realistic one. In the former, the lines of the composition remain visible. A cubist artist isolates the typical aspects of each object, those that can be easily identified, and rearranges them on the canvas according to a strict compositional scheme.

The Origins of Composition

The foundation of artistic composition stems from the intuitive view of the artist, from the sensitivity with which he or she organizes the objects in the reality of the work. But this particular way of working has always been subject to the spirit of each artistic period from which the great compositions of the history of art were born. True artistic composition begins when architecture makes its appearance. This happened after the Neolithic period (about 8,000 years ago). It is then that artists began to impose certain parameters on their artistic work, thinking about different ways of arranging the forms within their limits, according to specific dimensions and proportions. It is at that moment that painters began to use composition.

Charles Lebrun (1619–1690), *Apotheosis of Hercules.* Musée du Louvre (Paris, France). These two drawings are fragments of preliminary studies for large decorative compositions.

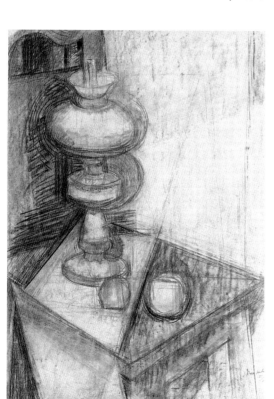

Josep Roca Sastre (1920–1996), *Still Life with Hurricane Lamp.* Private collection. In this work, both the drawing and the composition fulfill the same objective.

Murals and Paintings

The great mural creations (normally painted al fresco) ruled Western art from antiquity well into the Renaissance period. The works were created following the guidelines of architecture and in perfect harmony with it, adapting the subject to the wall surfaces with their relief and openings. With the appearance of the easel and canvas (much smaller and easier to transport), the compositions became less decorative and more realistic. They focused on effects of depth and light, but they maintained the basic principles that govern every artistic arrangement—geometric or linear order and color order. Present-day artists have inherited the second tradition (painting on an easel) and extract their compositional criteria from it.

Compositional Schemes

Every painting begins with a simple compositional scheme upon which all the aspects of the subject, whether complicated or very simple, are arranged. An expert painter has clearly defined tendencies toward specific subjects, which are the ones that conform to his or her way of composing and organizing the forms and the colors on the canvas. The study of paintings from the past reveals a number of different compositional diagrams.

Triangular Composition

The triangle is one of the most perfect compositions because it is balanced and allows for great variety. It is normally used for painting the human figure. It is also appropriate for composing the type of still life that encompasses many elements. The wide base allows the forms to be arranged across the surface, moving toward the top, toward the point of the triangle.

Edgar Degas (1834–1917), *Seated Woman.* Musée d'Orsay (Paris, France). Triangular compositions are normally used for painting portraits because they are stable and have a simple design.

Camile Pissarro (1830–1903), *The Boïeldieu Bridge at Rouen.* Art Gallery of Ontario (Toronto, Canada). Diagonal compositions suggest spatial depth and perspective.

Diagonal Composition

Depth and dynamism can be created with the composition. The simplest and most effective is the diagonal composition. Diagonals that cross the surface of the painting suggest movement in deep space and are used by landscape artists who wish to direct the viewer's eye toward the farthest area of the canvas.

Using a simple compositional scheme based on a simple geometric shape guarantees order and harmony in the painting.

Using a simple compositional scheme based on a simple geometric shape guarantees order and harmony in the painting.

L-Shape or Right-Angle Composition

An L-shape composition can be applied to any artistic genre. It consists of a horizontal arrangement at the base of the painting with a vertical element that closes the composition on one of its sides. The rectangular space that forms above the L can be interpreted as depth, and it will be treated as a secondary area that counteracts and balances the main motif.

Edward Hopper (1882–1967), *Long Leg.* Virginia Seele Scott Foundation (San Marino, California). The L-shape or right-angle composition adapts perfectly to large panoramas where the sky plays the main role.

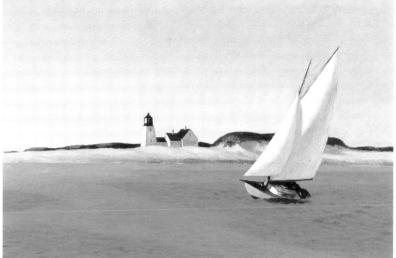

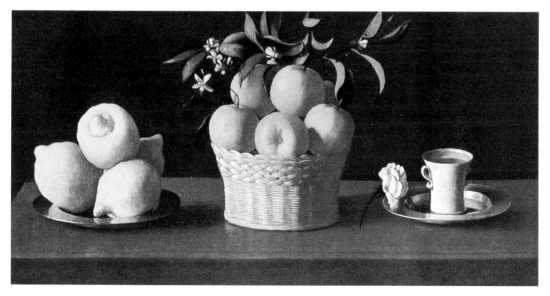

Francisco de Zurbarán (1598–1664), *Lemons, Oranges, and Roses.* Norton Simon Foundation. A classic example of still life arranged in a horizontal composition.

Horizontal Composition

This composition tends to be wide rather than deep. It is very suitable for still-life paintings, as well as for landscapes based on a wide horizon. Logically, this composition adapts better to landscape formats and to motifs that maintain a consistent size or shape, so that they form a line or a series when represented together.

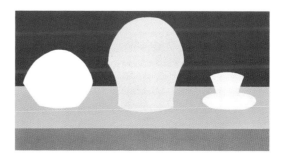

Planar Composition

A painting is always two-dimensional, and all artistic approaches are based on this fact. Planes, by definition, are two-dimensional surfaces, and as such can be painted. If we abandon the idea of associating a plane with a solid body and understand it as a pure chromatic surface or area of color, we will discover that it is possible to create a composition with a two-dimensional surface.

Receding Planes

An arrangement of planes or areas of color always contains a suggestion of space, even when it does not depict any figures or represent any themes. Some colors appear to be "in front" or "behind" others, and some look like the background against which other colors stand out. The artist organizes these contrasting planes or walls like the props on a theater stage. This way a sense of space will be created that will be as intense or as refined as the *distances* created by the colors merging with each other on the canvas.

In this work, the nearest plane strongly contrasts with the rest and establishes the space of the landscape.

Any panorama can be analyzed and recreated using planes that contrast with each other.

A planar composition where the basic contrast is created by the darker colors of the foreground against the lighter ones of the background.

Defining the planes in a composition requires a careful study of the theme to remove all the details that interfere with the view of those planes.

189

Composition

With any given motif, the artist can interpret the subject in different ways according to the distribution of the planes.

COMPOSITION THROUGH MASSES

A composition based on the large masses of the theme is not geometric and does not conform to linear structures, but rather to large blocks. A composition of this type is made from layering of a few light and dark masses color that contain the elements gathered in lighter or darker groupings.

Receding Effect

To create a coherent painting, the planes must be arranged so that they create a receding effect, from the closest plane to the farthest one in the background. The more detailed the receding process in the middle stages, the less the contrast between planes, because each of them suggests a sudden distancing in space.

In this drawing the theme has been interpreted as a single plane with an arrangement of shadows and linear values.

No matter how difficult a subject may appear, it is always possible to remove some of its elements to define the essential planes and masses.

In this watercolor the masses and the planes that suggest the different levels of the terrain are emphasized.

In this watercolor, the above landscape has been represented by identifying the masses and the contrasts of planes.

Rhythmic Composition

Rhythm is a difficult concept to define but an easy one to perceive in those paintings that have it. We say that rhythm is present in the composition of a painting when there is a harmonious relationship between the forms and their sizes. Primitive art possesses a powerful rhythmic effect, probably because the artists in those days were much closer to the elements of nature than we are. Some great masters have an enhanced instinct for organizing the elements of a painting with a sense of rhythm, which produces an effect of vitality and strength.

Guidelines for Rhythm

As a general rule, one can say that a rhythmic representation is based on three compositional guidelines: increasing, reducing, or eliminating certain aspects of the subject. The aspects provided by the model can be size, color, line, form, or light. The application of the criteria mentioned before depends above all on the general impression that the artist gets from the subject. If that impression is sufficiently moving for the artist to decide to work on it, he or she must express it by emphasizing the main aspects of that emotion, reducing the secondary ones, and eliminating those that are cumbersome or act as accessories.

Gustav Klimt (1862–1918), *Portrait of Freiderike Maria Beer.* Private collection. The rhythm in this work is predominantly linear. The lines have a life of their own, independent of the forms that are depicted with them.

Paul Cézanne (1839–1906), *The Lake at Amecy.* Courtauld Institute (London, England). This landscape is based on the repetition of compositional forms with rectangular shapes following an insistent rhythm that is reminiscent of a musical composition.

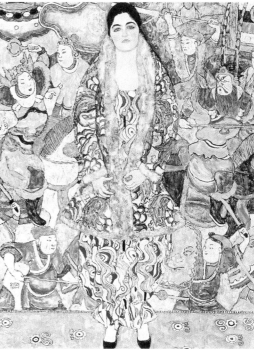

Rhythm is a contribution of the artist, of his or her sensitivity and capability for interpreting the theme.

ANOTHER LOOK

In landscapes, it is not necessary to look for variables that enliven the repetitions, because nature is so diverse that those variations are almost the only thing that can be seen. The problem, however, is to find equivalent shapes: the repetition of the shape of the trunks or the tops of the trees, the similarity between the shapes of the clouds and the foliage, etc.

Paul Cézanne (1839–1906), *Still Life.* (Museum of Modern Art, New York). This painter introduced the concept of rhythm in modern composition.

Musical Parallel

In music, rhythm is a repetition of one or several sounds at equal intervals. We say that a rhythm is bothersome when its repetition is carried to annoying extremes, when it is not enriched with variation. The same is true for the rhythm of a painting. Rhythm comes from repetition, for example, the repetition of the contour of a form in another area of the composition, or of the shape of an object in another part that is close or farther away. These repetitions give a sense of unifying rhythm to the work.

In this drawing the artist emphasizes the individual shape of each element and its progression in height.

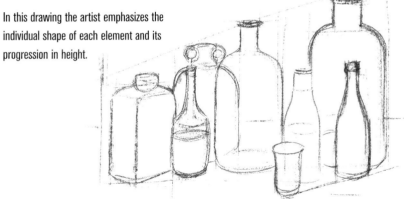

It is possible to represent any subject in many different ways.

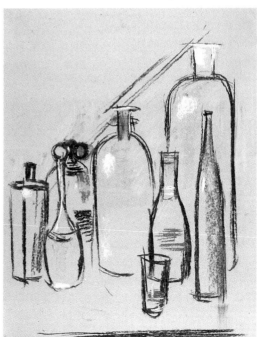

Here, the vertical rhythm suggested by the bottles is emphasized, and their height progression is exaggerated.

PAINTING TECHNIQUES

PAINTING TECHNIQUES

Artistic Themes

A book on art techniques can provide useful guidelines on any practical aspect of drawing or painting. But there is something that cannot be explained to the reader: what to paint or draw. Any scene can be a potential theme for drawing or for painting, but where one artist sees something interesting, another can find monotony. The purpose of the following chapter is not to instruct the reader on how to choose artistic subjects, but simply how to present its characteristics, which can sometimes, like in the case of the human figure, be quite complex.

If we accept the traditional categories, we will be able to classify any artistic subject into one of these areas: figure, still life, or landscape. Because of the wide variety of themes covered in this chapter, as well as the multiple technical demonstrations included, the following pages constitute the best part of this book.

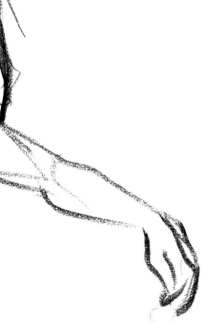

*T*he representation of the human body constitutes the central nucleus of artistic expression. To speak of the human figure is to speak of the entire history of art, because this is the only subject matter that has been represented at all times, in all countries, and in every style. Humans have always painted humans, and in doing so they express their overall view of life.

Auguste Renoir (1841–1919), *The Swing.* Most of the great painters in the history of art created their masterpieces with representations of the human figure. The figure occupies the focal point of artistic expression in every era.

Classicism and Modernism

The representation of figures, as a central theme of artistic expression, reveals the substantial differences between periods and artistic styles. By simply observing a figure from medieval times and another from the Renaissance period, one can immediately see two views that are almost opposed to each other. This is also true for individual styles. Who would not be able to recognize the painting style of Rubens after seeing one of his exuberant female characters? But underneath all the changes experienced by Western art, there is a common essence that stems from ancient Greece, which provides sense and guidance to representations of men and women: the classical form. Today, as heirs of antiquity, we continue to understand the body in a way that is very similar to the Greek and Roman artists.

DISTORTED PROPORTIONS

Twentieth-century avant-garde and Expressionist artists in particular searched for alternatives to the classicism of the human figure. Painters such as Egon Schiele looked to his distorted proportions, which were unpleasant for the taste of the time (around 1910), as a form of personal expression. Today Schiele is a very popular artist and his figures seem classical to us.

Detail of a ceramic decoration from Attica: Heracles surrounded by heroes. The artists from ancient Greece established the guidelines for the representation of the human figure. These guidelines have survived to this day despite the many approaches attempted by the different artistic styles.

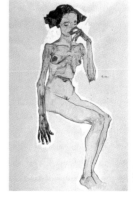

Joan Raset, *Nude Seen from Behind*. Present-day artists continue to base their representations of the human figure on guidelines inherited from the classical tradition. These guidelines do not exclude the avenues for personal expression and fantasy in the treatment of line and color.

The classical legacy stipulates that representations of the human body should be based on the notion of beauty. And that ideal can be realized through objective guidelines of proportion and harmony. Because of those guidelines, the notion of the Greco-Roman model is still valid today.

Proportions of the Human Figure

Every human representation starts with a formal idea or concept for the body—a body that does not correspond to any individual in particular but that exemplifies the general idea of man or woman. The evolution of styles is marked by different ideas and conceptions of the body. It is logical that these ideas can be better understood in nude figures than in clothed ones. For a long time, it was believed that the artist's job was to represent figures according to an ideal of beauty and that that ideal could be formulated through objective rules. From this conviction stemmed the canon of proportions, which determined the height and proportions of beautifully formed bodies.

The most natural canon of proportions is the one that uses seven-and-a-half heads as the height for adult figures, and between four and six heads for children and adolescents. This is one of the most useful guidelines for creating drawings of well-proportioned figures.

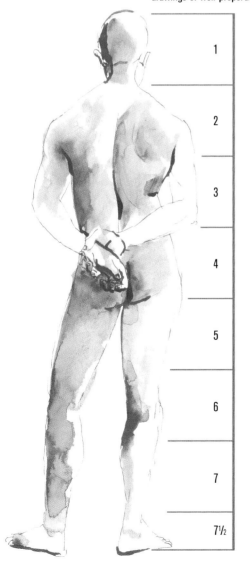

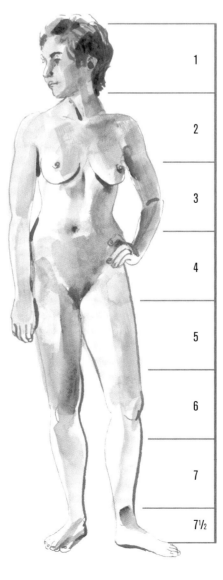

Human proportions vary through the different phases of growth. Organs develop differently and proportions change, progressing from the four heads for a two-year-old child, to six heads for a preadolescent, and up to the permanent seven-and-a-half heads for a young adult.

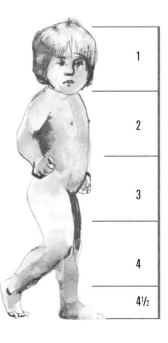

"No figure can be perfect without proportions, no matter how careful one is in its creation."
Albrecht Dürer

ALBRECHT DÜRER

During the Renaissance period the passion for discovering the "secrets" of art and ancient thought projected many artists into creating different systems of proportions that would provide the key to beauty in the arts. Albrecht Dürer devoted a lot of effort to the search for the geometric basis of the proportions of the human body. Many other artists of the time proposed very creative models, which were more or less complex, like the ten-head canon that can be seen in this illustration.

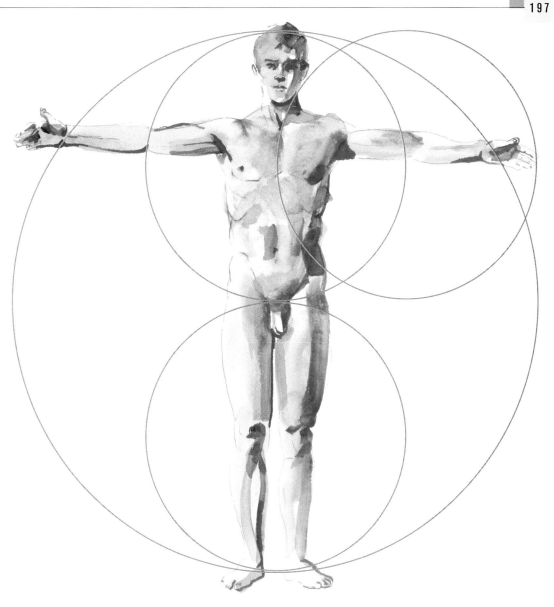

The Relationship Between the Dimensions of the Body

The proportional harmony of a seven-head figure affects the overall dimensions of the body. Ideally, the total height of the figure should be fitted exactly into a circle with its center in the pubic area. The two resulting halves can also be inscribed in as many circles, with their centers at the sternum and at the level of the patella, respectively.

The ideal center of the human figure is at the level of the pubic area, and one half of the overall height equals the length of one arm. With the arm dropped to the side, the elbow should be exactly below the waist.

For many centuries, it was believed that the job of the artist was to represent figures according to an ideal of beauty, which could be materialized by following objective guidelines.

Skeletal Anatomy

The skeleton is an articulated structure that holds up the human body, supporting and protecting its internal organs. Almost all 233 bones that form this skeleton are articulated and can move aided by the muscles. Most of them come in pairs (to the left and to the right of the body's line of symmetry). The exceptions to this rule, for example the cranium and the vertebrae, are formed by two similar halves.

Shapes of the Bones

Depending on their shape, bones are divided into long (the humerus and the tibia), flat or wide (the scapula and the pelvis), and short or irregular (the vertebrae and the bones of the wrist and ankle). Long bones usually form part of the extremities and consist of a central round or triangular area called the body, and two bulky ends that form the surface that fits into the joint. Flat bones conform to a sheet-like shape and have faces, edges, or angles. Short bones are more or less cubical in shape and also have faces and edges.

Leonardo da Vinci (1452–1519), *Drawing of the Bones of the Arm.* Windsor Castle (Windsor, England). Da Vinci offered a faithful representation of the bone's anatomy.

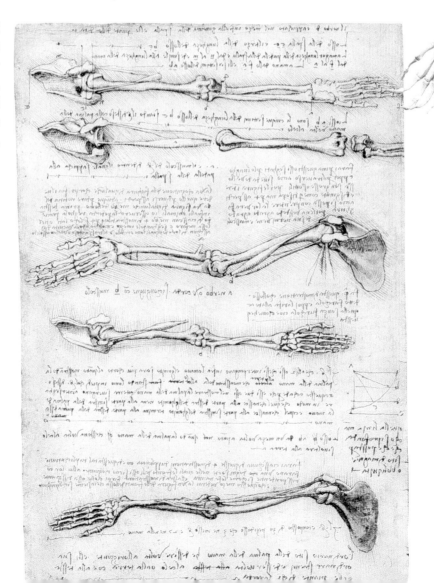

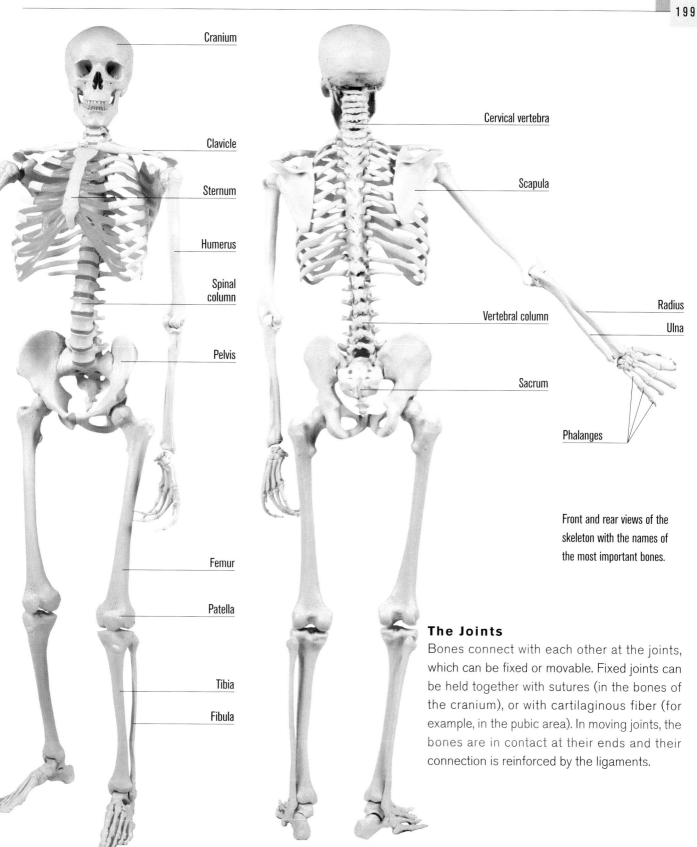

Cranium

Clavicle

Sternum

Humerus

Spinal
column

Pelvis

Femur

Patella

Tibia

Fibula

Cervical vertebra

Scapula

Radius

Ulna

Vertebral column

Sacrum

Phalanges

Front and rear views of the
skeleton with the names of
the most important bones.

The Joints

Bones connect with each other at the joints,
which can be fixed or movable. Fixed joints can
be held together with sutures (in the bones of
the cranium), or with cartilaginous fiber (for
example, in the pubic area). In moving joints, the
bones are in contact at their ends and their
connection is reinforced by the ligaments.

Muscle Anatomy

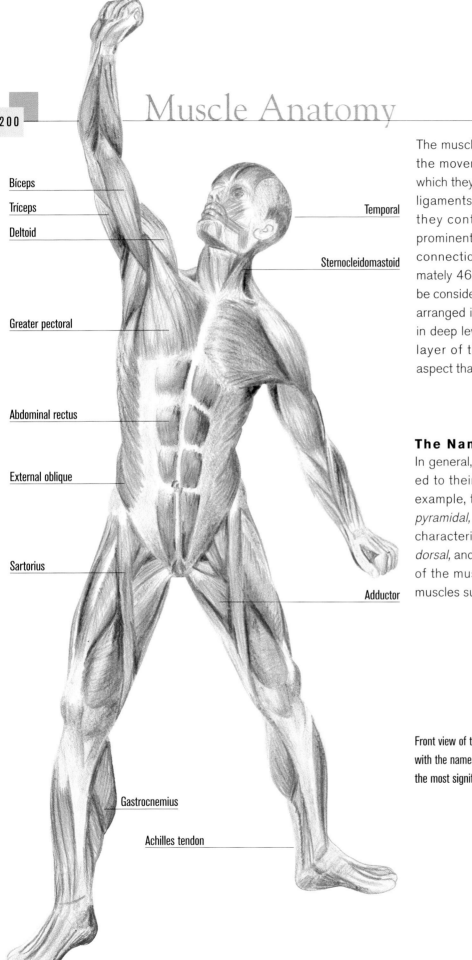

Biceps

Triceps

Deltoid

Greater pectoral

Abdominal rectus

External oblique

Sartorius

Temporal

Sternocleidomastoid

Adductor

Gastrocnemius

Achilles tendon

The muscles are fibrous formations that make the movement of the bones possible and to which they are connected through tendons and ligaments. When the muscles go into action, they contract and shrink, becoming more prominent and moving closer to the points of connection at the joints. There are approximately 460 to 501 muscles (many groups can be considered a single unit). These muscles are arranged in overlapping layers or levels. Those in deep levels are not perceivable on the outer layer of the body, which is the anatomical aspect that most interests the artist.

The Names of the Muscles

In general, the names of the muscles are related to their shape, location, and function. For example, the muscles referred to as *oblique*, *pyramidal*, and *rectus* owe their names to their characteristic shapes. Those called *pectoral*, *dorsal*, and *sacrospinal* derive from the location of the muscles, and function is what defines muscles such as *pronator*, *supinator*, and *flexor*.

Front view of the muscles
with the names of some of
the most significant ones.

The Mechanics of the Muscles

The muscles that can move at will are formed by transversal muscular fibers. These fibers are connected through tendons, tendon bands, or tendon walls. The muscles are covered with a layer that turns into one or more tendons at the tip.

The mechanics of the muscles follow the same laws that govern the arms of a lever: the muscle exerts force to counterbalance resistance (the weight that has to be displaced) and uses the joints as the system's fulcrum or support.

This book identifies only the muscles located on the surface levels, which are the relevant ones for drawing purposes.

Occipital

Trapezius

Latissimus Dorsi

Gluteus maximus

The mechanics of the arm can be compared to those of a lever, of which the elbow is the point of support (which remains static). The forearm exerts the force with muscles such as the biceps, and the arm provides the resistance (the weight that must be lifted).

Fasciae Latae

Long peroneal

Gastrocnemius

Force

Resistance

Support

Rear view of the muscles.

Drawing the Trunk

To draw the trunk with ease you should imagine that it is a square figure topped with a rectangle (the head) in its upper part. In dividing the total drawing into four sections, the top part equals the length of the head, the lower quarter equals the distance between the pubic area and the navel, and the section immediately above this is the distance between the navel and the lower pectoral line. The remaining section includes the neck and the shoulders.

Anatomical References

The basic diagram of the trunk can be used to draw it from the front, from the back, and in profile. In each case the artist will introduce the correct anatomical features. Therefore, in the frontal view the lines that represent the clavicle will be introduced. The view from the back will bear the upper outline of the gluteus, and for the drawing of the figure in profile, it is easy to transfer all those references adapting them to the proper contours for that point of view. Whichever the case, the basic diagram will serve as a starting point. The outline of the torso in profile is more involved than the frontal view, but the indicated references also serve to guide the drawing of the different anatomical volumes.

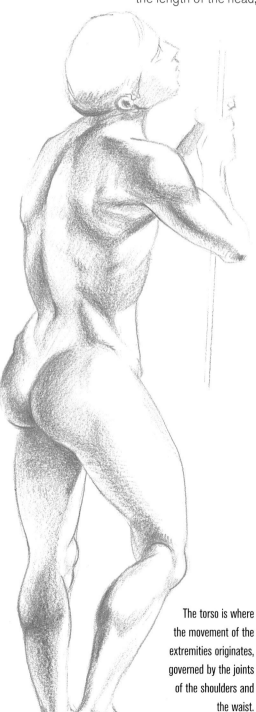

The torso is the symbol of the anatomy where all the forms converge. In the old days, drawing teachers used to refer to the torso as the "aesthetic armor" because it was reminiscent of Roman armor.

The torso is where the movement of the extremities originates, governed by the joints of the shoulders and the waist.

The torso, despite being the least articulated part of the anatomy, is where all the movements of the figure originate.

THE SPINAL COLUMN

The spinal column is a basic reference for drawing the human figure. Its curving line determines the movement of the entire trunk from which all the movements of the extremities originate. It is essential to consider the curves that originate from each pose, avoiding a completely straight line, even in static poses.

Male and Female Torsos

The torso reflects the anatomical differences between a male and a female figure (the shoulders, the chest, the hips, etc.). When drawing a torso, the artist should not only observe those differences but should also remember that the female outline is much softer than the male outline and that the anatomical relief is much less abrupt in the female figure (although it may be more voluminous in general). The transitions should be softer when drawing a female figure and more angular for the male figure.

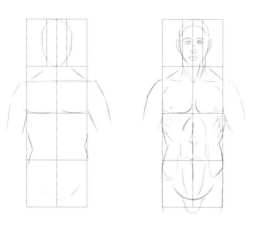

The male torso can be diagrammed using a system of modules that help identify the basic anatomical references.

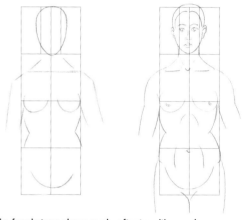

The female torso shows much softer transitions and more rounded shapes.

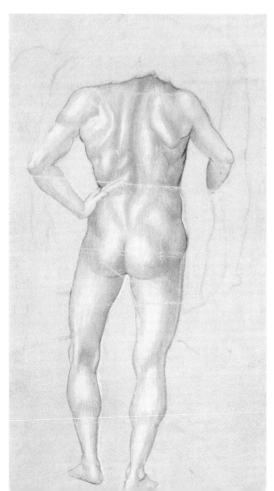

Luca Signorelli (1445–1523), *Nude Figure Seen from Behind.* Royal Library, Windsor Castle (Windsor, England). This anatomical study emphasizes the curvature of the column and its sinuous representation, even though the figure is standing still.

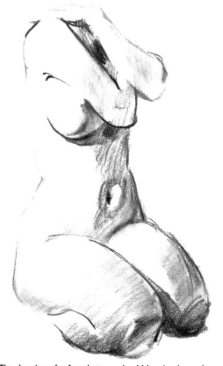

The drawing of a female torso should be simpler and more harmonious than the male torso. Ideally, the external contour lines should be sufficient.

Drawing the Arms

To represent the general shape of the arms, the artist must use a simple diagram that, above all, indicates its correct articulation. The arm is jointed at three points: the shoulder, the elbow, and the wrist. Therefore, there will be three sections in the diagram: the arm, the forearm, and the hand. The proportions of the diagram must approximately relate to the real proportions of each of the parts: the arm will be longer than the forearm, which will be a little longer than the total length of the open hand.

The inside of the arm shows the bundles of muscles more clearly when the extremity flexes in certain movements.

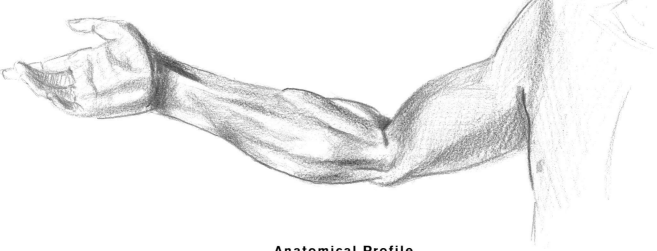

Anatomical Profile

The relief of the arm reveals its bone and muscular structure in several areas. The bones are evident in the elbow and wrist areas, whereas the muscle structure is particularly visible (when the arm is not extended) in the shoulder and arm areas. Logically, when the muscles are tensed, they are much more evident, especially in the arm (deltoids and biceps), but the tendons that run the length of the wrist on the outside are also noticeable.

The outside of the arm and the forearm contain different muscles, much thinner and longer in the forearm, which give the upper extremity its fibrous appearance.

The arms and the shoulders communicate a sense of strength and gesture in the representations of figures, especially in nude figures.

The Human Figure

205

PRONATION AND SUPINATION

Pronation and *supination* are two terms that refer to the rotation of the forearm around its axis. With the arm in a right angle with respect to the forearm, the pronation movement makes the palm of the hand face down (with the thumb turned inward). Supination leaves the arm facing up (with the thumb turned outward). It is important not to confuse these two movements with the turns or rotations of the shoulder while the arm is extended: pronation and supination involve only the forearm.

These are the appropriate diagrams for drawing the arms. The anatomical indications are fundamental for a correct drawing.

Pronation movement of the forearm. This rotation takes place beyond the elbow and turns the palm of the hand downward.

Different Directions

In the preliminary sketch it must be very clear that the arm and the forearm, seen from the front, do not follow the same direction but form a slight right angle at the elbow. It is also important to note that there is a change of direction in the arm's axis when it reaches the wrist. The best approach is to draw the axis of the entire arm first with its change of angles, and then sketch the forms over it, which will be a rectangle for the arm, and two trapezoids of different sizes for the hand and forearm.

Supination movement of the forearm. The twist occurs beyond the elbow and turns the palm of the hand upward.

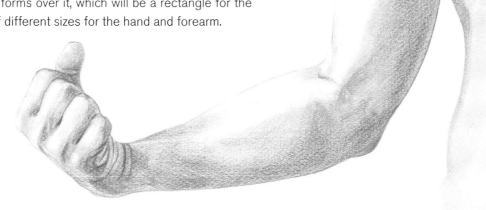

Drawing the Hands

The hand, because of its diverse mobility and articulation, is an artistic subject in itself. It is the part of the body that offers the greatest number of positions because it has five appendages with three joints each. In classical painting, artists had an incredible collection of "hand repertoires" in different poses expressing the figure's various states of mind. In portraits, the hands can provide the viewer with psychological suggestions through gesture.

Proportions

Ideally, the total length of a hand (from the base of the thumb to the end of the middle finger) is equivalent to twice its width. When blocking-in the drawing of a hand in a rectangle of these proportions, the middle line of this rectangle (the one that divides it into two equal squares) should coincide with the knuckles and the last phalange of the thumb, on the back side, and with the protrusion of the base of the fingers on the palm. This indicates that the length of the middle finger is half the total length of the hand. The index and ring fingers are the same length, a little shorter than the middle one, and the little finger reaches approximately the last phalange of the ring finger.

The middle line of the hand crosses the base of the fingers, and its overall proportions are those shown in these two diagrams of the palm and the back.

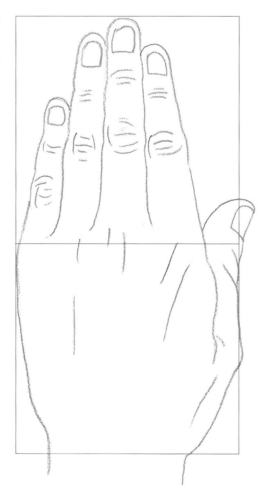
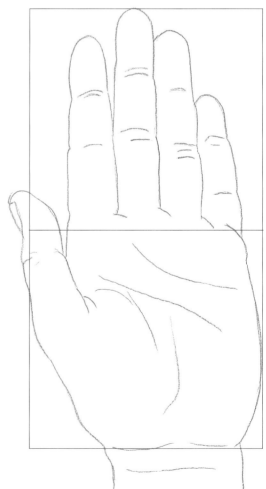

To master hand drawing
it is important to ob-
serve the simplicity of
the diagrams presented
in these pages and, based
on them, interpret the
most common gestures.
Some artists use an artic-
ulated wooden hand
model with the same
proportions as the ones
on these pages, but in
three dimensions. This
articulated hand can
adopt many of the
hand's real gestures, and
drawing it complete
with all its joints can
easily help us under-
stand the basic diagram
that lies underneath this
difficult part of the body.

The Thumb

The thumb deserves a few comments of its own
separate from the other fingers. Its shape and
movement set it clearly apart. The thumb is also
particularly important when establishing the gen-
eral proportions of the hand. When the fingers
are held together, the tip of the thumb almost
perfectly follows the arch formed by the joints of
the first and second phalanges of the other
fingers. When the thumb moves away from the
palm, its tip also forms another perfect arch,
which is not exactly a continuation of the previ-
ous one. The thumb is on a plain that is different
from the rest of the fingers, in such a way that,
when the hand is seen in profile, the thumb
appears to be in a more frontal position than the
rest of the fingers, and when the hand is seen
from the top, it looks more in profile.

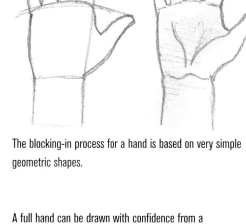

The blocking-in process for a hand is based on very simple
geometric shapes.

A full hand can be drawn with confidence from a
geometric sketch by using the hand of a real model
or a photograph.

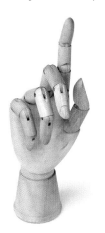

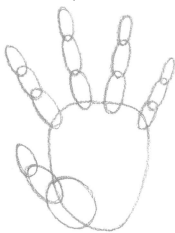

Another way to
block-in a hand is
by drawing ovals
of different sizes.

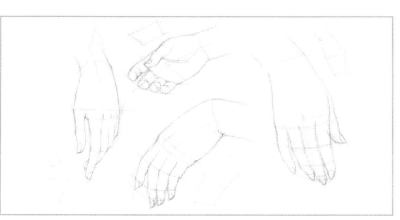

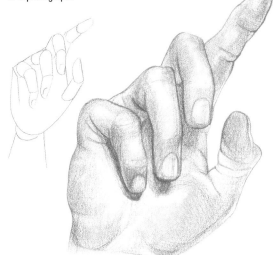

To practice blocking-in and drawing hands, the first step is to lay out very simple forms whose
proportions suggest the placement and movement of the fingers.

Drawing the Legs

Although the legs have the same number of joints as the arms, they have less range of movement. The reason for this is that the joint of the waist allows only flexion and extension, and not lateral movement. Also, the knee does not allow pronation and supination movements similar to those of the forearm. As a consequence, legs in motion are much easier to draw than arms.

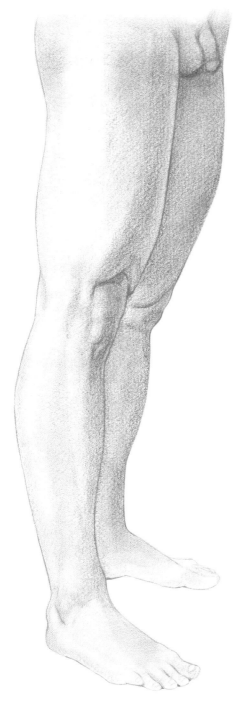

Drawing the legs is less involved than drawing the arms in terms of outlines and internal volumes. Even then, one must keep in mind the relief of the knees and the calves.

Diagrams of the Legs

The sketch of the legs can be summarized with a trapezoidal shape. The inside would be a vertical line and its outside an oblique line ascending from inside to outside. The lower part (the knee joint) is much narrower than the upper one, which descends diagonally inside from the outside, following the trajectory of the groin. The basic muscle references can be easily located on this simple diagram.

The flexing movement of the legs causes muscular tension, which affects the external appearance.

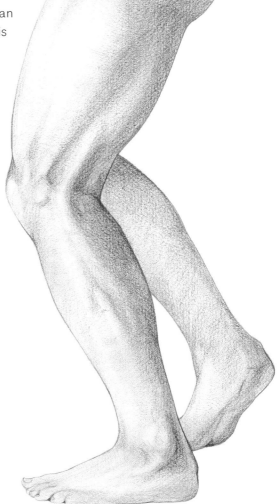

When drawing legs, it is always important to accentuate the powerful volume of the thighs to give the figure the appearance of being held up by strong supports.

The Human Figure

209

THE KNEES

The outline of the knee is an important anatomical aspect in the representation of the legs. The shape of the knee changes according to the movement of the legs. When the leg is completely flexed, the knee looks like a flat surface, and when the leg is completely extended, the relief of the patella is visible in the joint that connects the femur with the tibia.

Drawing the Lower Leg

The most helpful diagram for drawing the lower leg seen from the front is a curve that descends from the outside to the inside of the central axis. This curve provides the outside profile, and the inside profile is represented by a second smaller curve that is inverted, suggesting the outline of the calf. The ends of these curves should create a triangular shape, which will help block-in the foot. To represent the entire leg, one must keep in mind, first, that the leg's axis does not follow the same direction as the one for the lower leg, and second, that the upper leg (from the highest point of the groin to the patella) is almost twice the length of the lower leg.

Side and Rear Views

The diagram of the leg and the calf seen from behind is similar to that viewed from the front, the only difference being the muscular references in each case. Viewed from the side, the diagram should be simpler—for example, a rectangular figure of different widths with characteristic contours added. The illustrations on this page show the best way to proceed in this case.

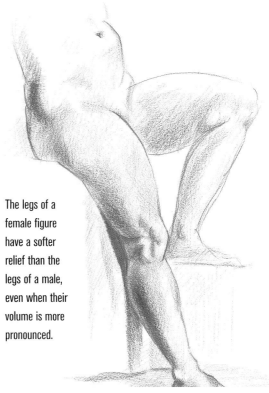

The legs of a female figure have a softer relief than the legs of a male, even when their volume is more pronounced.

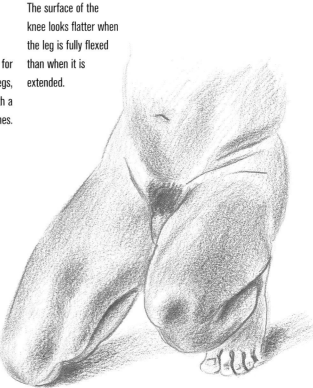

The surface of the knee looks flatter when the leg is fully flexed than when it is extended.

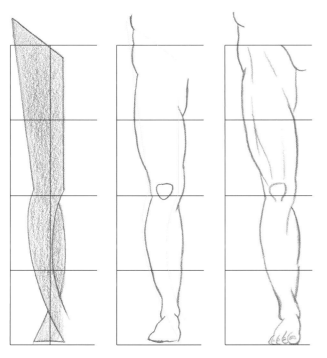

Basic diagrams for easily drawing legs, beginning with a few basic lines.

The Feet

Despite their irregular shape, the feet are much easier to draw than the hands because they have less mobility. Besides, unlike the hands, feet are not usually represented in a close-up view. Knowing how to represent the four basic views (lower profile, outside profile, front, and back) one can approach the drawing of almost any figure with a guarantee of success.

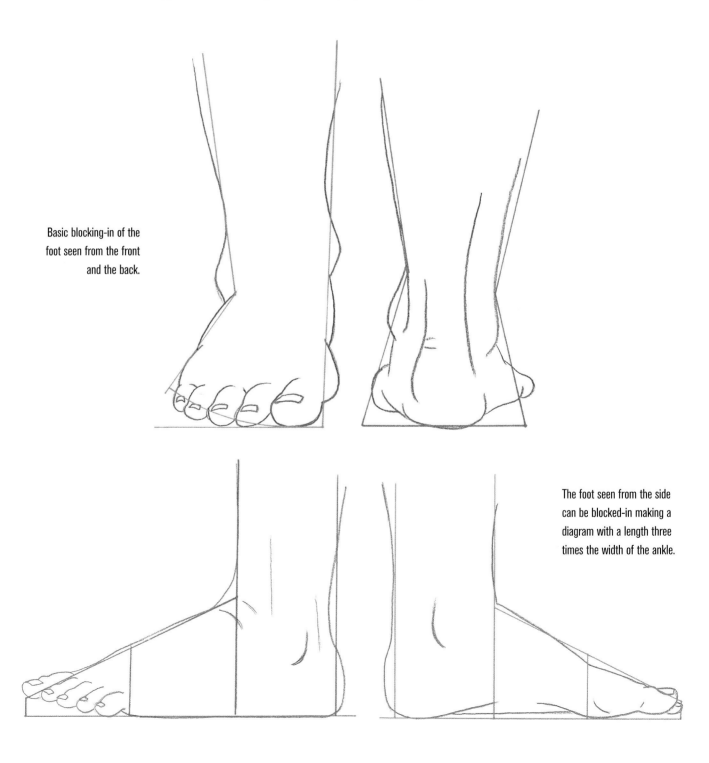

Basic blocking-in of the foot seen from the front and the back.

The foot seen from the side can be blocked-in making a diagram with a length three times the width of the ankle.

Given their limited articulation and
simple forms, feet are usually resolved
more easily than hands.

211

The Human Figure

THE ARCH
OF THE FOOT

The skeletal structure of
the foot presents a curva-
ture on the inside (on the
side of the big toe) that
elevates the bottom of
the foot on that side,
while the opposite side
rests on the floor. Because
of this, the foot touches
the floor only with the
heel, the outside, and the
front part of the foot.
This curvature gives the
movement some elastici-
ty and cushions the foot
from the weight exerted
on it by the body.

Basic Schemes

A side view of the foot (seen from the inside or
the outside) can be diagrammed using a right
triangle with the heel on the right angle. This tri-
angle can be divided into three equal parts,
each one equivalent to the width of the ankle.
The front part determines the area of the toes,
the middle section is the bottom of the foot, and
the rear part is for the heel. These proportional
sections can be seen more clearly from the out-
side of the foot. Seen from the front, the foot
looks like a triangle whose base forms an arch
with the toes along it. Seen from behind, the
proportional diagram of the foot is represented
by two triangles overlapping each other at the
vertices. All of these basic schemes are good
references for making drawings of feet.

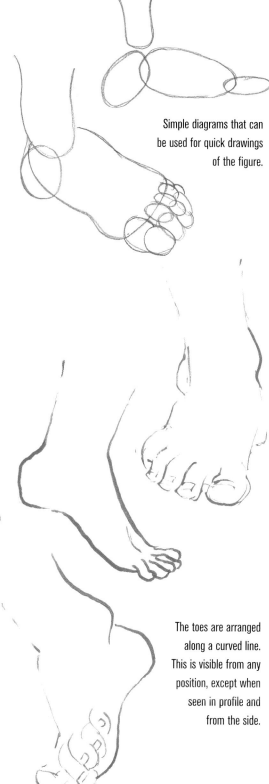

Simple diagrams that can
be used for quick drawings
of the figure.

The arch of the foot is always
visible from the inside. It can
be seen from the outside
when the heel is lifted.

The toes are arranged
along a curved line.
This is visible from any
position, except when
seen in profile and
from the side.

This group of illustrations
shows the variations that the
diagram of the foot must
take when representing
various positions.

The Head

The structure of the head can be studied as just another anatomical form. Certain basic proportions that give the head of a man or a woman its human characteristics are present in all the variations that a human head or face can have.

This is not the only relevant aspect of the drawing. The psychological content of the figure is mainly written on the face, and the artist must pay special attention and sensitivity to its representation.

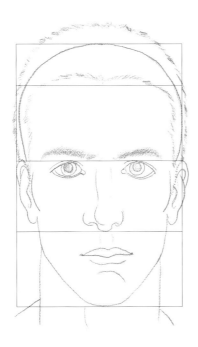

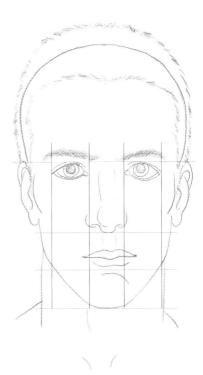

The head seen from the front is symmetrical. Its center is in the area between the eyes where the nose begins. Its proportions, seen from the front, are three-and-a-half times the size of the forehead, and two-and-a-half times the width. The head seen from the side corresponds exactly to the shape of a square, which contains the same number of divisions in height as in width: three and a half.

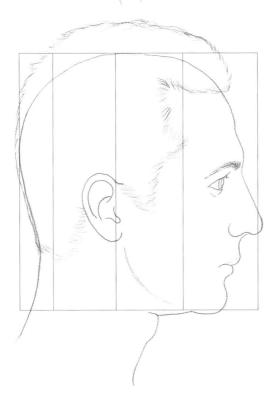

Proportions of the Head

The head seen from the front is symmetrical, and this line of symmetry represents the first reference for the artist. The center of the head, seen from the front (taking into consideration only the parameters of the cranium without the hair), is between the eyes at the beginning of the nose. The basic module of the human head is approximately three-and-a-half times the height of the forehead (from the hairline to the eyebrows), the forehead being, therefore, the basic measurement that will determine the proportion of the rest of the facial features.

The head is an oval upon which the different features are located.
The correct proportions of the oval are usually sufficient to create
a good schematic representation.

THE FEATURES

The facial features deserve careful study and attention in their representation. Although of lesser importance both anatomically and as an overall part of the body, they are essential artistically. Any small variation in their shape and size means a change in the psychological representation of the drawing. This illustration represents a study of several mouths by the baroque painter José Ribera.

Basic References

By dividing the height of the head into three-and-a-half units with horizontal lines, the following references are created: the upper profile of the cranium, the hairline, the placement of the eyebrows, the height and placement of the ears, the lower part of the nose, and the lower profile of the chin.

By applying the same module of the forehead to the width of the head, we can see that the width is divided into two-and-a-half units. These sections provide new references, which are added to the previous ones to help identify the placement of the features in a frontal view of the head.

Blocking-in the head with an oval shape makes it possible to draw all its parts in proportion and in an organized manner.

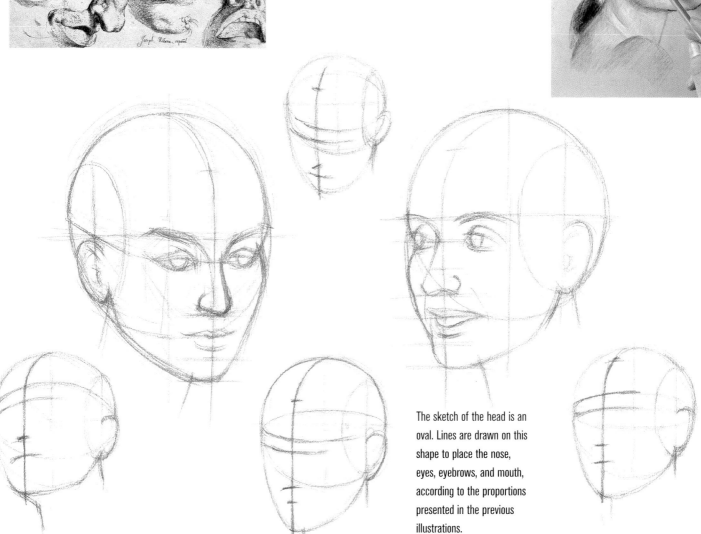

The sketch of the head is an oval. Lines are drawn on this shape to place the nose, eyes, eyebrows, and mouth, according to the proportions presented in the previous illustrations.

Pastel Portrait of a Child

This exercise by Yvan Viñals is an example of the normal process of painting portraits. It was drawn using the preliminary procedures studied in previous pages. The process is quick and simple, and the only materials are charcoal and two sticks of white and blue pastels.

THE MODEL

PHASE 1:

BLOCKING-IN AND PRELIMINARY DRAWING

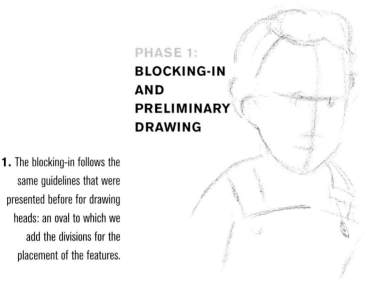

1. The blocking-in follows the same guidelines that were presented before for drawing heads: an oval to which we add the divisions for the placement of the features.

From a group of children's photographs we chose one that presented a simple pose and a pleasant expression, both elements fitting our drawing requirements.

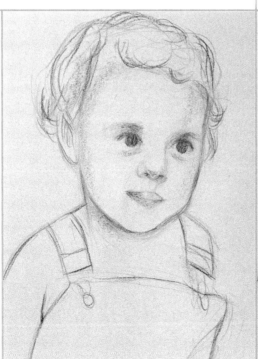

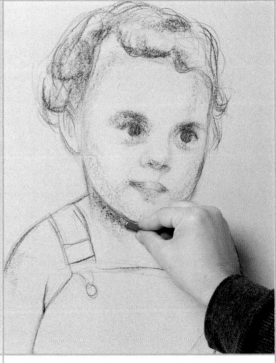

2. If the proportions of the initial sketch are correct, it will be easy to make a careful and convincing representation of the child's features, hair, and outfit.

3. The strictly linear drawing is made with charcoal. At this point some of the lines are shaded with blue pastel.

Working with a dark color and white gives the drawing a three-dimensional quality and a certain painterly feeling that can lead to the creation of a work in full color.

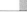

4. Charcoal is used again to redraw the eyes and the eyelashes. The work is now carried out on a drawing where the indication of the eyes is very well defined.

PHASE 2:
WHITE HIGHLIGHTS

6. Several areas of white and blue shading are added to the girl's outfit to create the feeling of texture and three-dimensionality and to enliven the composition. This completes the exercise.

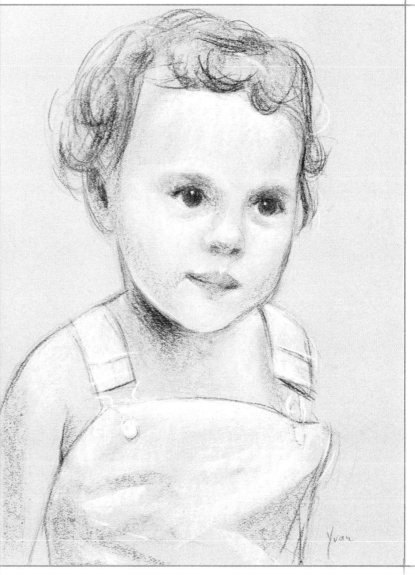

5. Some areas of the body are painted with white to highlight the overall volume. These highlights are applied by dragging the flat side of the stick of pastel on the paper.

The Figure in Motion

The diagrams we have seen so far help create a synthesized vision of the anatomy and represent it in a quick and effective manner. They are all applicable to figure drawing, whether it is a sketch or a detailed and realistic study. However, when representing the movement it is not possible to create a diagram that shows all the possibilities. By movement, we mean the natural attitude of any figure, based on the fact that human figures do not adopt an anatomical position as a norm but as the exception. Therefore, for each movement it is necessary to find the sketches that best address its anatomy.

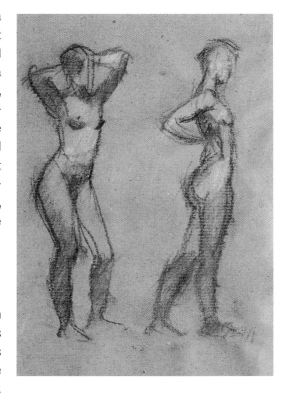

The movement becomes much more convincing when it is represented with simple drawings done in a quick and flexible manner.

Modifying the Diagrams

The basic forms proposed in previous pages are transformed when they are represented in motion: rectangles become trapezoids or rhomboids, open curves are seen closing, and in general, the dimensions of all the elements are reduced. Keeping in mind that such diagrams are formed by lines and simple forms, we will show in these pages how to construct different figures by using simple forms adapted to each case, derived from those seen before.

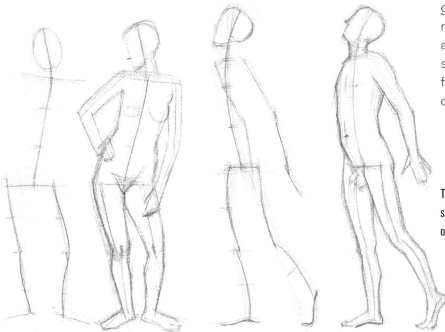

The movement of the figure is synthesized using a very simple skeleton with the correct proportions. This offers a basic version of the different joints of the body.

TRANSVERSAL AXES

Vertical axes follow the length of the body's limbs. To establish the width, the artist can resort to the transversal axes connecting them. There are basically two of them: the shoulders and the hips. Both can tilt up or down. As a general rule, in most of the figures shown standing, the axis of the shoulders tilts in the opposite direction of the hips. If the right shoulder goes up, the right hip will go down, and vice versa.

The Axis as a Starting Point

The first step in drawing figures is to build a diagram of the pose, beginning with the basic axes: the axis of the trunk and the axes of the arms and legs. The axis of the trunk runs from the head to the pubic area, and its possible inflection points are found in the neck, the chest, and the waist. By observing the proportions of the trunk mentioned before, these axes must be properly identified from the beginning. The same is true for the axes of the arms and legs, each one having its inflection points at the joints.

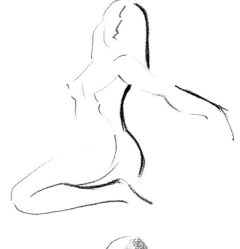

A pen is as good a tool as any to capture the movement of a figure without wasting time in details.

The jointed wooden model is very helpful to approximate the movement of a real model when no good photographs or life models are available.

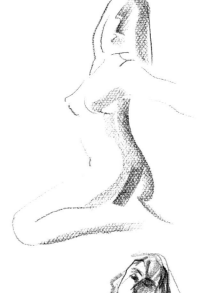

The artist can create his or her own models based on the jointed wooden model to represent a figure in motion.

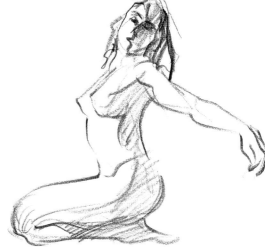

The techniques of using a quick sketch to depict movement begins with very simple lines that express the essence of the movement from the beginning.

The Moving Figure: Walking

The walking motion of a human figure has an internal logic. All the movements of the arms and legs respond to two basic factors: traction and balance. The traction factor is mainly performed by the legs, whereas balance is achieved by the arms compensating for the constant redistribution of weight during the walking process. Therefore, the forward motion of the right leg is compensated for with the backward motion of the right arm, and vice versa.

Sequence of the Walking Motion

Painting and drawing are static representations, but they can suggest dynamics if they respect the logic of the figure's movement. The diagrams here show the basic sequence of a figure walking in relation to the static position. It is interesting to note that the positions of the trunk and the head remain practically undisturbed during all the phases. The legs appear completely extended only when the weight of the figure falls onto one of them. The arms maintain a relaxed position, somewhat flexed, and only the shoulder reflects back-and-forth movement.

These studies depict movement in a very simple way, based on the fundamentals of the walking motion.

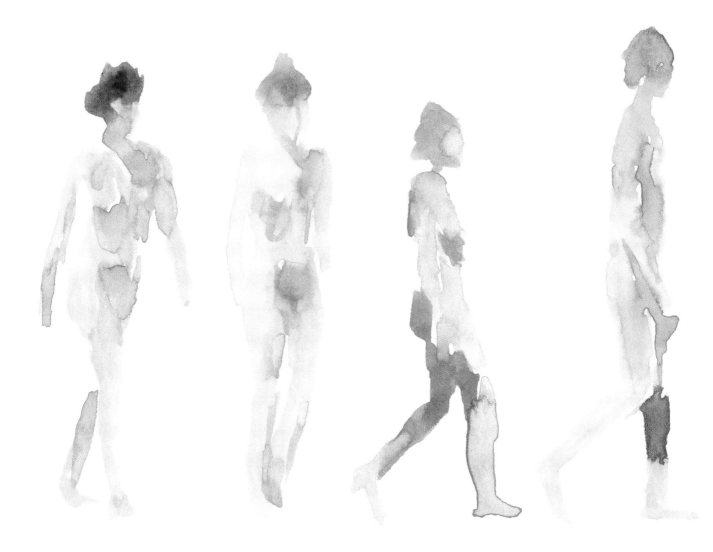

Walking requires a quick drawing with little detail to faithfully convey the feeling of movement.

Basic diagram of the movements of walking. These diagrams make it easy to draw figures in motion.

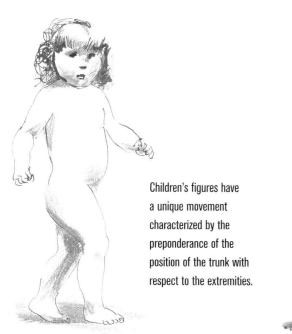

Children's figures have a unique movement characterized by the preponderance of the position of the trunk with respect to the extremities.

Balance

A displacement motion creates a walking rhythm that is stable and continued. The movements are so rhythmic that the person is not aware of them, although balance is always maintained. The best way to understand the balance of a figure in motion is to imagine a vertical line that runs down the drawing along its central axis, from head to floor. This line must coincide at some point with the contacting surface of the sole of one of the feet. This will be true only for figures that progress slowly, not for those that walk with long strides, and much less for those that run.

The sequence of the walking motion. The weight of the figure has contact points on the ground at all times with one or both feet.

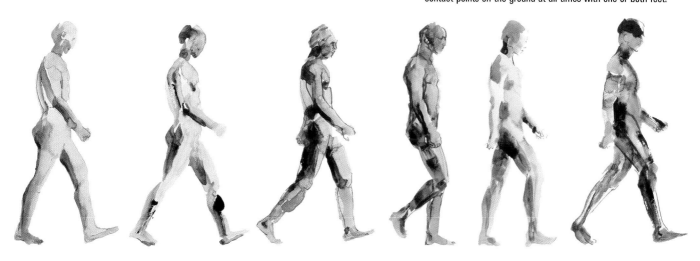

Running

The act of running involves a series of movements that are completely different from those of walking. Walking has only one movement in common with running, which is the rhythmic forward and backward motion of the arms and legs. During the running process the trunk is usually tilted and the figure's center of gravity is shifted forward.

Diagram of progressive movements during running. The last diagram of the sequence gives way to a movement that is similar to the first one in the series.

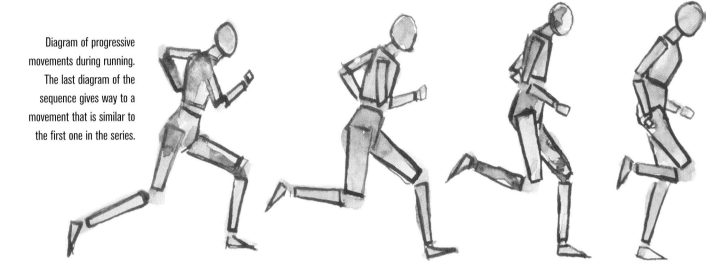

"Falling" Figures

One could say that a running figure is always falling forward and at the same time avoiding that fall with the rapid movement of the legs. This means that a figure's balance represented at a running stage cannot be measured with the method recommended for a walking figure, because during a running sequence the vertical axis often falls outside the area of the foot's point of contact.

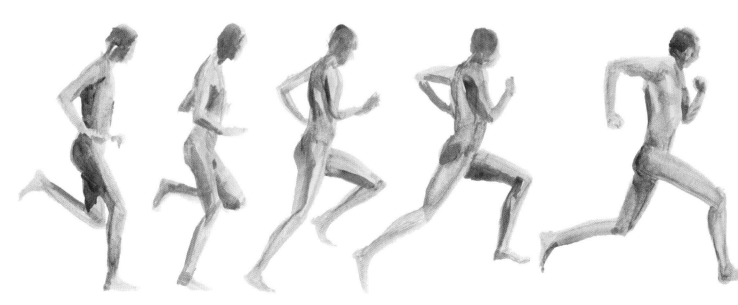

The running motion should be synthesized through simple line drawings, unless the result required is a detailed representation of the frozen movement.

FRONTAL VIEW OF THE RUNNING MOTION

A running figure seen from the front usually shows all its limbs in foreshortening (in perspective). Therefore, its representation is more involved than a view in profile. This is why it is very important to become familiar with the characteristic movements through photographs, selecting images that can be organized by logical sequence.

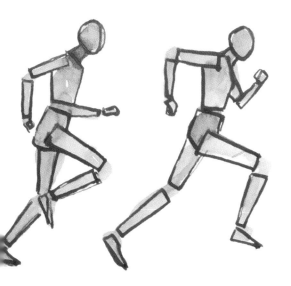

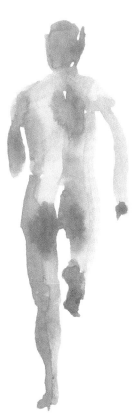

The Sequence of Movements

The drawings on this page demonstrating the sequence of a figure running show the forward tilt of the trunk. This inclination is more pronounced just before the forward foot touches the ground and more erect before the rear foot loses that contact. The arms are more flexed than during a walk, and the back-and-forth motion of the shoulders appears more obvious.

Also, the legs flex much more than during walking, to the point that the calf can lift the foot almost to the level of the buttocks. While the foot makes contact with the ground, the leg remains flexed, and it appears completely extended only just before or immediately after that contact.

A single brushstroke of watercolor paint can describe the basic articulation of the limbs in a running figure.

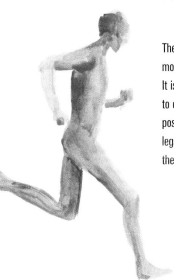

The sequence of movements during running. It is particularly important to observe the relative positions of the arms and legs at each moment of the sequence.

It is much easier to draw a figure running in any of the successive positions by using one of the diagrams as a starting point.

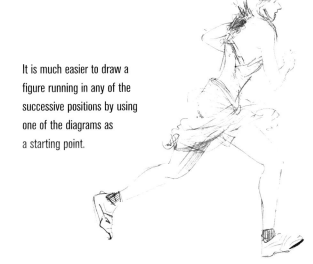

Foreshortening

Any pose presents the artist with several parts of the anatomy in foreshortening—in other words, in perspective.

But some points of view projected over the figure favor general foreshortening of the entire anatomy. This is the case of figures lying down or seen from above: the shortening of the trunk and the extremities is so obvious then that the normal proportions that govern any figure seen from a normal point of view must be adjusted.

Drawing foreshortened figures allows the artist to show his or her mastery of the creation of figures under difficult views.

A viable way of practicing foreshortening that will guarantee a faithful representation is to use a box drawn in perspective within which figures can be drawn in different positions.

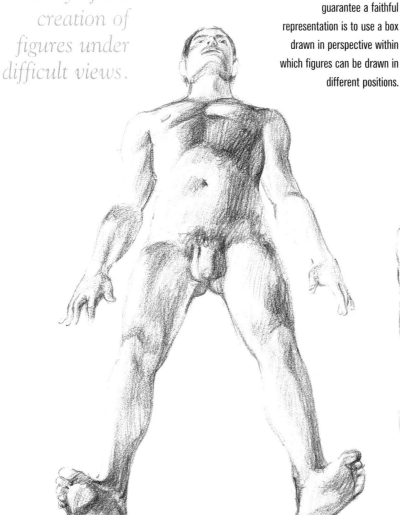

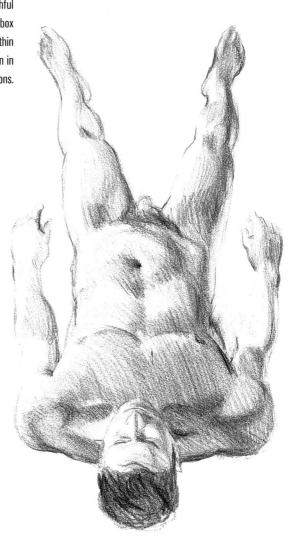

THE MASTERS OF FORESHORTENING

During the Renaissance and baroque periods, many artists showed their great knowledge of anatomy by filling their compositions with foreshortened figures in the most varied (and even forced) positions. Any theme justified the inclusion of multiple contorted figures that gave human anatomy a new figurative dimension. Tintoretto and Rubens were two of the great masters who found a wealth of dramatic effects in foreshortening.

Foreshortened figures lifted from the drawing of the escalator are reproduced on this page. Each one of them is seen from a different perspective, as can be seen in the diagrams.

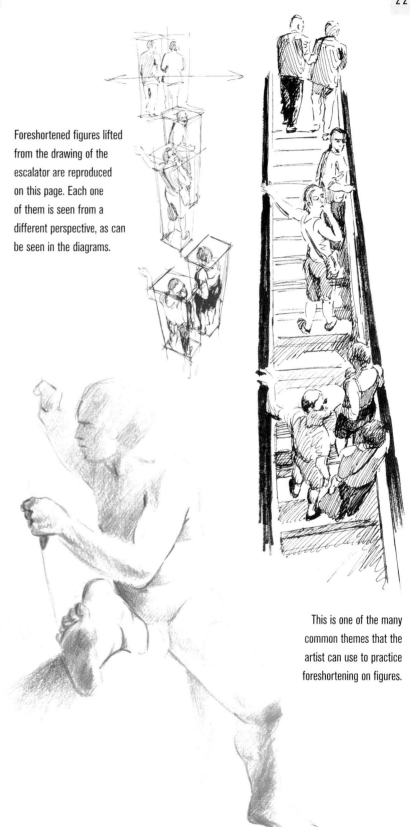

Foreshortening

Foreshortened drawing requires putting the representation of the human body in perspective. This requires a certain amount practice as well as knowledge of the basic anatomical forms. Any figure always presents some part—the face, an arm, a hand, etc.—in foreshortening. But these are foreshortened views of little significance that hardly alter the "normal" view of the anatomy. On the other hand, when a figure is seen from above or from a point of view across the floor, or when an entire arm or leg is drawn from an unusual point of view, then the customary forms of the anatomy must be interpreted differently, in an attempt to understand the logic of their perspective.

This is one of the many common themes that the artist can use to practice foreshortening on figures.

Many times, only one part of the figure is seen in foreshortening. To execute these figures properly, the artist must pay equal attention to the line drawing and to the distribution of light and shadow.

Clothed Figure with White Chalk

The garments of a figure sometimes become as important as anatomy itself. The combinations of folds and wrinkles in the clothing, referred to in artistic language as drapery, become another problem that the artist must know how to resolve. In this exercise, Mercedes Gaspar shows us how to approach the challenge directly and simply.

The amount of chiaroscuro contrast determines the strength of the modeling, making the folds stronger.

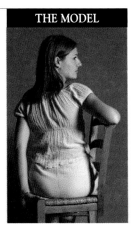

The pose and lighting of the figure are arranged to emphasize the folds and wrinkles created by the clothes. This drapery reveals the anatomy while hiding it in certain places.

PHASE 1:
BLOCKING-IN THE FIGURE

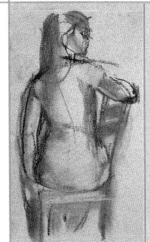

1. This small preliminary sketch was created to establish the overall composition of the drawing, the distribution of the masses, and the correct proportion of all the parts.

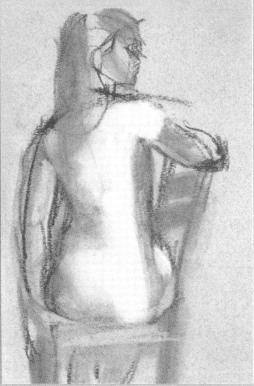

2. A large area of white pastel is added to this preliminary drawing to verify the general effect that the modeling with chiaroscuro will add to the drawing once it is finished.

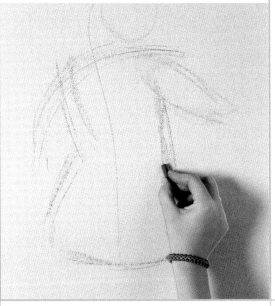

3. The definitive blocking-in of the figure is carried out using straight lines drawn with the flat side of a charcoal stick. The drawing is extremely simple, as a preliminary sketch should be.

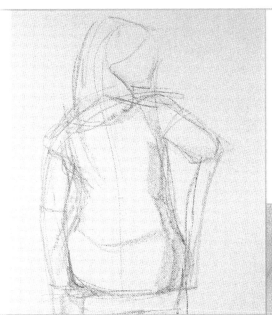

4. The sketch is enhanced with some details: the trajectory of the hair, the joint of the waist and hips, and the joint of the arms.

LIGHT AND SHADOW

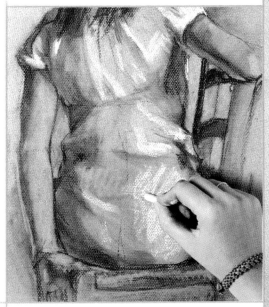

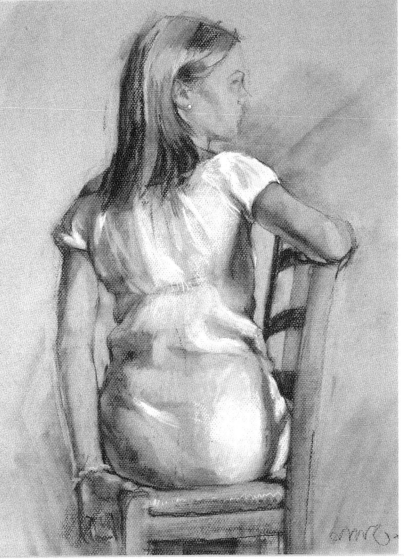

5. New details enrich the initial drawing, especially the application of some shading in the hair and on the sides of the figure. Once this is finished, attention shifts to the drapery, using white chalk to enhance the most illuminated areas of the folds.

6. This is the final result. The folds and wrinkles along the back of the figure have been resolved using the contrast created between the charcoal and the chalk.

Figure with Color Pencils

In this exercise, Yvan Viñals constructs a drawing in which the articulated movement becomes the center of anatomical and artistic interest. It is a global approach based on a vision of the whole rather than on any individual aspect of a figure study. The focus is mainly on the joints of the arms and the legs: the flexing and extending that create different forms in the trunk and the hips. The most important task will be to achieve a correct and harmonious articulation of all the elements that will correspond to the pose chosen for this exercise. Pastel pencils in a warm tonal range—pinks, ochres, and oranges—will be used. Gray tones will be used in the last phases of the

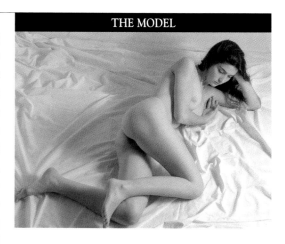

THE MODEL

drawing to create a cool contrast that emphasizes the color of the flesh.

PHASE 1: FORM THROUGH DIAGRAMS

2. When the basic forms of the drawing are proportionately defined, the lines of the diagram are rounded and softened to create a contour that is closer to the real anatomical form.

1. The preliminary sketch is based on stylized anatomical forms created with simple shapes: simple curves and lines that define the proportions and the joints of the limbs.

3. The line sketch is completed after the final contour of the figure is redrawn. This result is achieved by softening the angles and by giving continuity to the basic curves of the preliminary diagram.

The basic diagrams of the anatomy are a dynamic assembly of each part of the body within an articulated group of simple forms.

PHASE 2: **SHADING WITH COLORS**

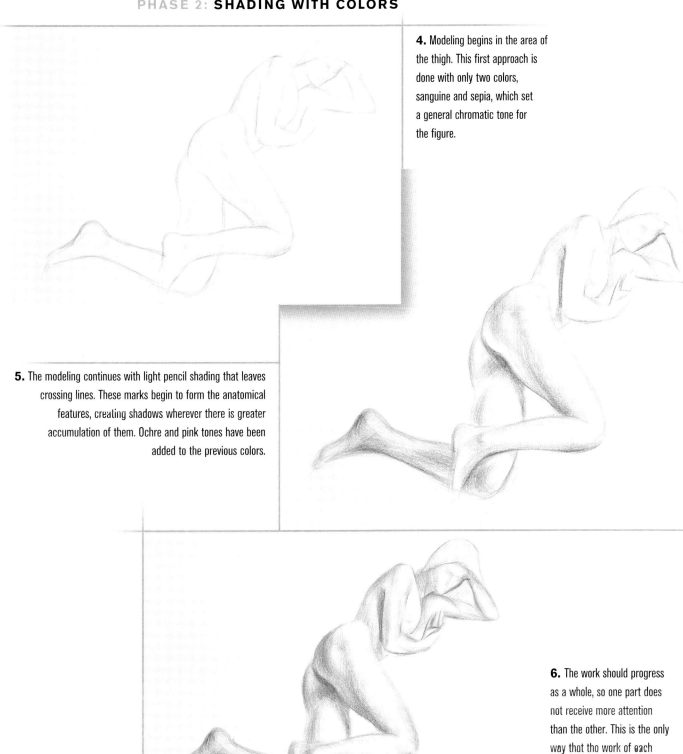

4. Modeling begins in the area of the thigh. This first approach is done with only two colors, sanguine and sepia, which set a general chromatic tone for the figure.

5. The modeling continues with light pencil shading that leaves crossing lines. These marks begin to form the anatomical features, creating shadows wherever there is greater accumulation of them. Ochre and pink tones have been added to the previous colors.

6. The work should progress as a whole, so one part does not receive more attention than the other. This is the only way that the work of each stage can be judged correctly.

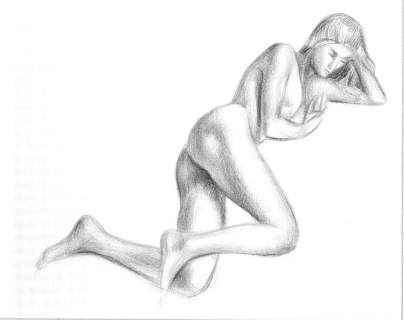

PHASE 3:

DEFINING THE ANATOMY

7. The modeling progresses from the outlines to the inside of the figure, always leaving a light area in the center of the limbs, which corresponds to the most prominent area of the volume where the light reflects more intensely.

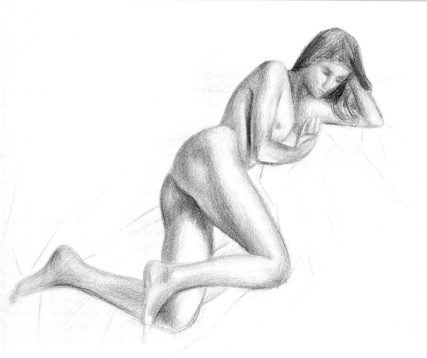

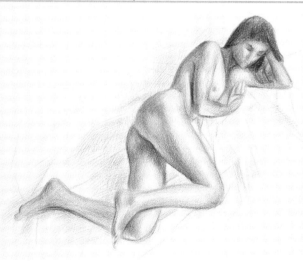

9. The modeling of the body is almost finished. It is interesting to observe how each anatomical form is individualized within the harmonious composition in which no one area stands out more than the others.

8. Although the areas around the shoulders or the knees are not represented expressly, the drawing clearly conveys the fact that there is anatomical relief in them. They determine the shape of the limbs and their movement.

The skin color is more a matter of tone than color: the colors surrounding the figure are as important as those of the figure itself.

10. The right arm of the figure shows how the volumes are based on the rigorous logic of the anatomy: the volume of the deltoid is clearly visible, and there is also a slight insinuation of the biceps. Details like these attest to the artist's knowledge of anatomy.

11. The drawing is finished. It is an interesting synthesis of the anatomy, a drawing controlled by the balance between the anatomical rigor and the chromatic and linear gracefulness of the figure.

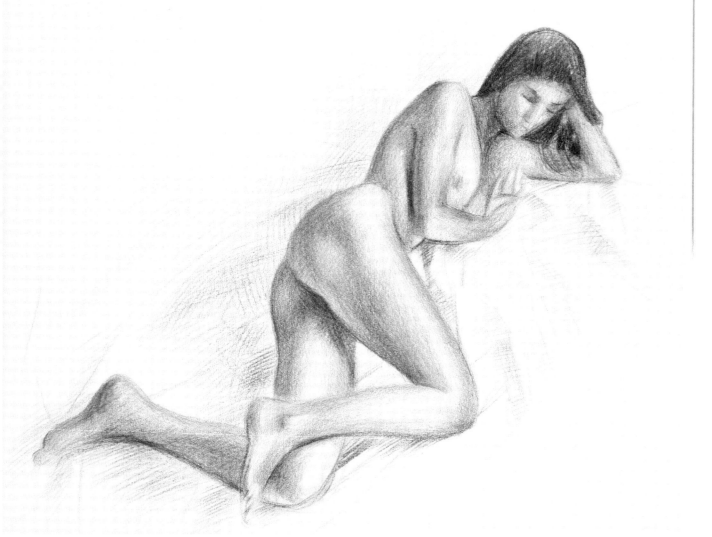

Figure with
Watercolor Pencils

In this exercise, Mercedes Gaspar shows us how a drawing is created with watercolor pencils in which the center of interest is the atmospheric tones of the composition and the resolution of the portrait. Its focus is based on the vision of the whole rather than on the partial elements, and where the portrait plays a central, although not exclusive, role. Blending the colors using a wet brush is the main approach. But it is important to point out that the technique differs greatly from watercolor painting: here the goal is not to paint areas of pure color but to delicately shade the surfaces of the drawing that were painted with color pencils. The most important task will be to compose all the parts properly in a well-balanced unity, which is required in the intimate and familiar theme chosen for this exercise. Watercolor pencils in a warm color range, such as pink and ochre, will be used with the addition of cool light blue tones.

The subject is a full-length portrait of a girl indoors. The charm of the selected theme must be matched by the delicate artistic treatment used.

1. To begin this exercise, a simple diagram of the figure will be laid out using simple blocking-in of the body and the basic forms included in the scene. Naturally, the proper drawing of these elements requires mastery of the basic anatomical factors and of the general proportions of the body.

PHASE 1: **FORM THROUGH STRUCTURES**

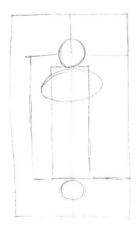

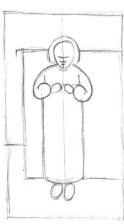

2. The sketch is based on a stylization of the anatomical forms drawn with simple diagrams: simple curves and lines that define the proportions.

3. When the basic forms of the drawing have been proportionately established, the lines of the diagram are rounded and softened to create outlines that are closer to real life.

4. The line drawing is complete once the initial diagram has been enhanced with the details that characterize the figure. This result was achieved after the angles were softened and the elements of the preliminary diagram were rounded using a hard lead pencil.

Pencil lines create the texture and suggest an atmospheric effect. The pencil must be used sensitively, changing the pressure applied on it all the time.

5. Before applying color, all the necessary details are established in pencil to ensure the resemblance of the portrait.

PHASE 2: SHADING WITH COLOR

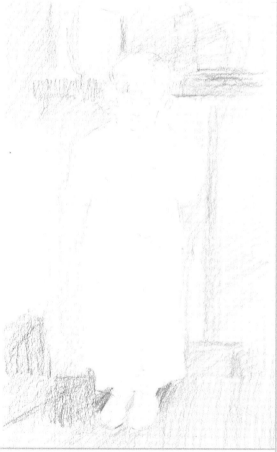

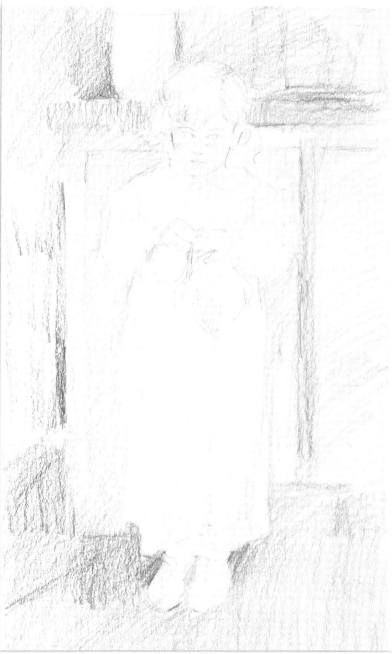

6. The color is applied with light pencil lines that make crossed marks. These strokes shape the space that surrounds the figure, creating shadows where there is greater accumulation of them. Blue is added to the previous ochre and pink tones for the shadows.

7. Now the girl's pink robe is delicately colored. The work should progress uniformly, without spending more effort on one area than another. Only in this way can the work produced in each step be properly evaluated.

There is no need to create heavy lines to watercolor them: the softest lines produce clearly visible colors.

PHASE 3:
WATERCOLORS

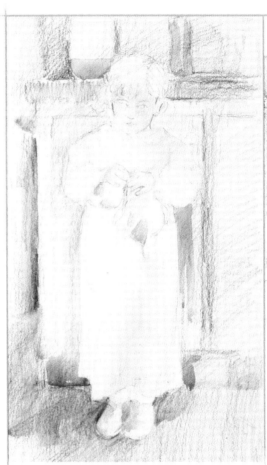

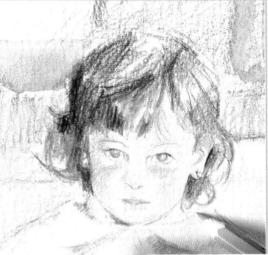

9. The head of the figure deserves very careful treatment. Pencils are used to define the features and to highlight their profiles by combining warm colors for the skin and cool tones (like this green) for the shadows.

8. This is the moment where water is lightly spread over the color lines. This procedure partially dissolves the lines, making unified areas of color and creating a clear three-dimensional effect.

10. The modeling of the body is almost finished. It is interesting to observe how each area of detail on the figure fits into the overall harmony where no one element stands out more than the others. The hair is the darkest area, which frames and highlights the girl's face.

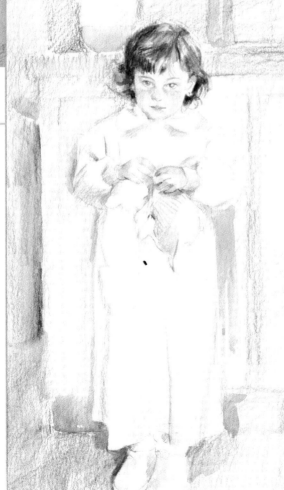

When working with watercolor pencils it is important to avoid accumulating lines so the color does not get muddied by the water.

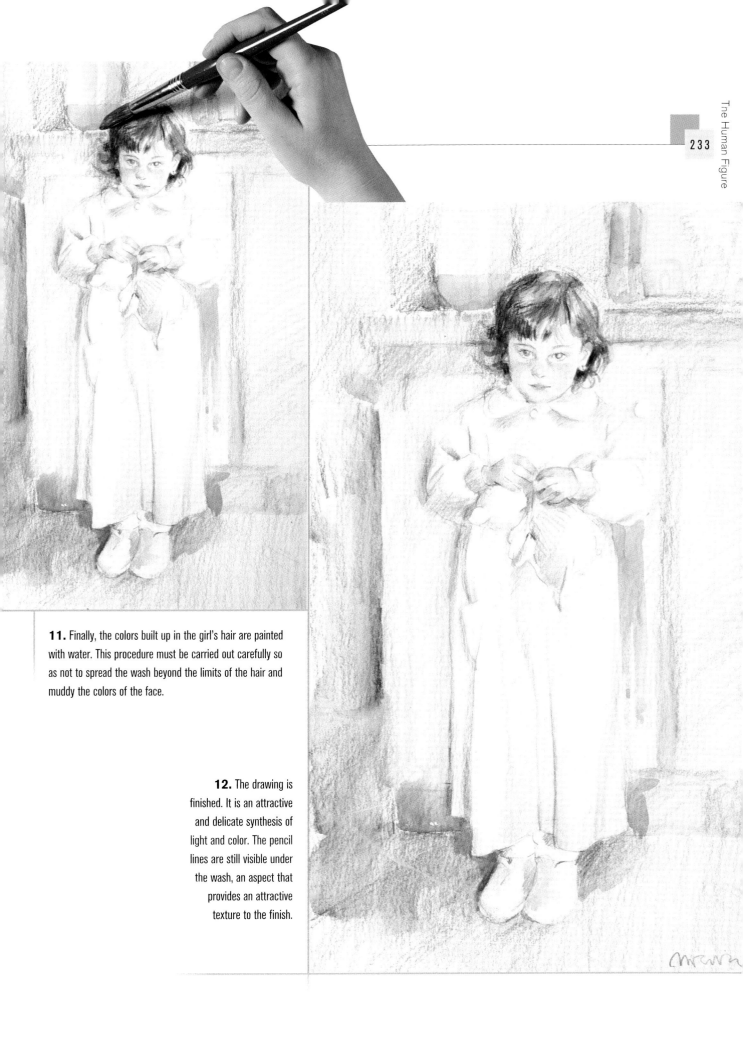

11. Finally, the colors built up in the girl's hair are painted with water. This procedure must be carried out carefully so as not to spread the wash beyond the limits of the hair and muddy the colors of the face.

12. The drawing is finished. It is an attractive and delicate synthesis of light and color. The pencil lines are still visible under the wash, an aspect that provides an attractive texture to the finish.

When we speak of landscapes, we know very well that they do not depict objects but a subject matter that changes with the passage of time and with the point of view. A figure, a bowl of fruit, or a bottle are objects whose images the artist can completely enclose in his or her imagination and that can be combined with other figures and objects to build scenes. A landscape does not have a definite shape; it is constantly changing. Here, more than with any other subject matter, the artist is the one who gives form and visual clarity to the landscape.

Claude Poussin (1594–1665), *Landscape with the Collecting of Focion's Ashes.* Walker Art Gallery (Liverpool, England). Poussin is the master of classicist landscapes from which other artists, among them Cezanne, draw inspiration.

Giovanni Bellini (1430–1516), *The Prayer of the Mount.* National Gallery (London, England). This is one of the first examples of landscapes in Western painting, which was still dominated by religious themes.

Landscape paintings always express a specific vision of nature perceived as a whole, evoking and provoking feelings in both the artist and the spectator.

THE PRESENCE OF THE HORIZON

The presence of the horizon is one of the main aspects of landscape painting, and of any other type of figurative painting. The horizon is not usually visible in still life and in scenes that have figures, but it is implicit in the composition of the painting. In landscapes, the horizon is not an idealist line but a real element, more or less defined but always present, and it determines the spatial depth of the subject.

Landscape Painting in History

Through history landscapes have been interpreted in many ways, all of them related to the prevailing concept of nature of that particular cultural moment. During the Gothic period nature was viewed as an enclosed garden, isolated from the hostile chaos of mountains and forests on the outside. During the Romantic period nature was depicted as a sublime spectacle. Impressionists viewed nature as a moment of light, and so on. Landscapes are based on a general idea of nature, of the natural spectacle, of the whole, as much in the overall pictorial styles as in the individual specific styles. The artist, following his or her particular idea, emphasizes and stresses those particular areas, whether general or specific, and abstracts the rest through color, light and shadow, etc.

Albercht Altdorfer (1480–1538), *Alexander's Battle.* Alte Pinakothek (Munich, Germany). This spectacular landscape initiated a genre characterized by large panoramic views of the earth.

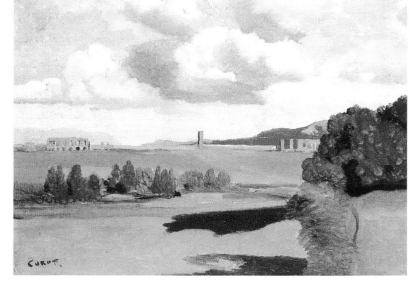

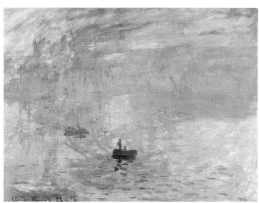

Camille Corot (1796–1875), *The Roman Countryside with Clouds.* National Gallery (London, England). Corot is the immediate predecessor of Impressionism, a school that eliminates mythological and religious references from landscape painting.

The Meaning of Landscapes

The basic principle that governs landscape painting is the creation of a feeling of nature that emphasizes a limited number of aspects that the artist deems important, or that are fundamental in his or her imagination. The art of landscape painting is the expression of nature as a whole through some of its parts.

Nowadays the most predominant expression of landscape is the one inherited from Impressionist artists, who emphasized the light and atmosphere of natural panoramas.

Claude Monet (1840–1926). *Impression: Sunrise.* Musée Marmottan (Paris, France). This painting lent its name to the Impressionist style. The colorism used by Impressionist artists has continued through the 20th century to the latest ramifications of the present.

Landscape with
Charcoal and Chalk

A landscape done with charcoal can rise to the status of a painting in black and white. If we add chalk (sanguine chalk and sienna chalk) to this monochromatic work, it can become a true work of art. Keeping this in mind, we have chosen a subject that lends itself more to tonal values than to a colorist interpretation. Exercise developed by Esther Serra.

PHASE 1: **FIRST VALUES**

THE MODEL

In a wintry forest scene, under the evening light, the leafless trees can be represented with pure line and the color of the landscape can be reduced to shades of gray.

1. The first basic shading of the work is extremely simple: the sky and the ground. The sky is the white of the paper, and the ground is created by rubbing with the flat side of the charcoal stick.

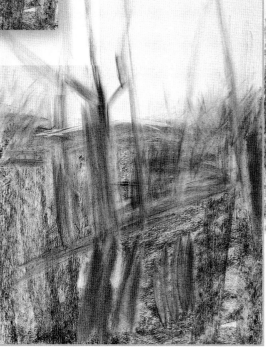

2. The drawing is wiped vertically with a rag to establish the direction of the tree trunks. This procedure has caused some of the charcoal to come off, and in the process the intensity of the tone is lightened.

3. To continue with the basic shading of the landscape, several sanguine lines are added. There is no need for new applications because the excess charcoal on the paper can be spread with a rag and a blending stick.

The blending stick is a tool that is used to spread the fine charcoal powder deposited on the paper to create gradations and light shading.

PHASE 2:
VARIOUS MEDIA

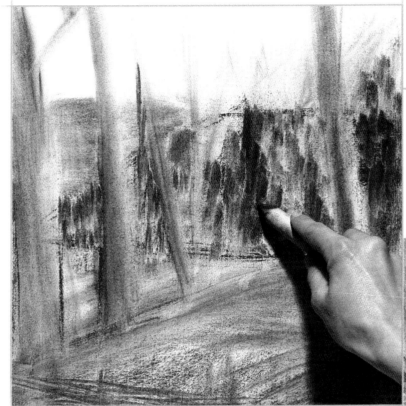

4. The accumulated charcoal is spread with a blending stick to create a first drawing of the tree trunks and branches. This method of drawing allows great spontaneity in the sketching of the forms and establishes a tonal base over which light and shadows are easily created.

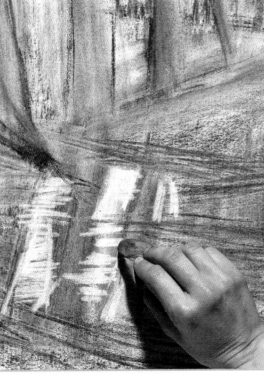

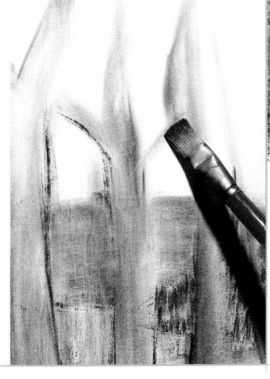

5. A flat brush can be used for shading the trunks and the branches, as well as for establishing the different planes of the composition. These planes are seen as lines drawn in various directions, superimposed at the bottom of the composition.

6. The tonal value of the lower part of the composition is refined without using charcoal lines. The artist begins to define the planes with an eraser, creating the effect of puddles of water on the ground.

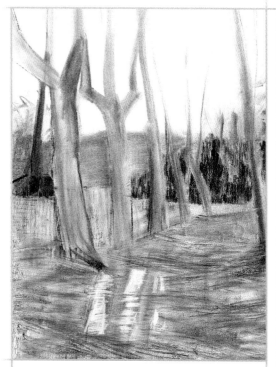

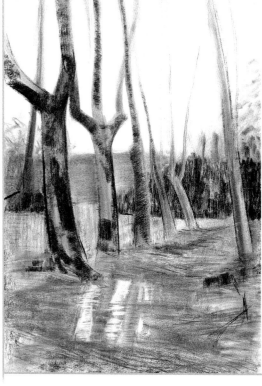

8. The bark is created with heavy applications of charcoal, which is left unblended. This way the volume has a more decisive presence in the overall composition.

7. At this point, the basic elements of the work have already been established. The areas that were somewhat undefined before are now tree trunks that begin to show their volume and shape.

PHASE 3:
FINISHES

9. The system used to create the tonal value of the trunks consists of lightening contours in the areas where the background is dark and darkening them where there are adjacent areas of light. These multiple contrasts enhance the definition of the volumes.

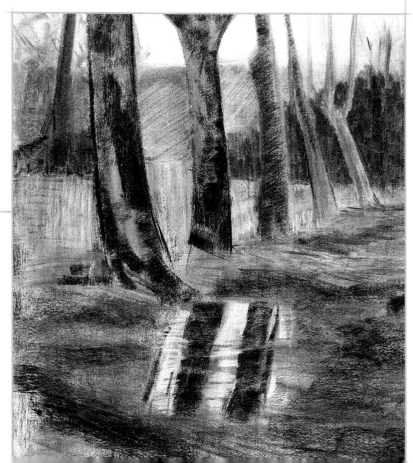

Charcoal and earth tones, such as sanguine, go together very well. The harmony that can be achieved with them is guaranteed from the start.

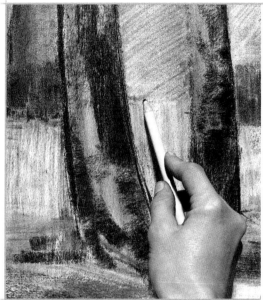

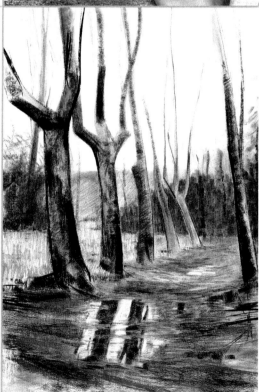

10. Here, a pencil eraser is used to create some small light areas such as these where the façades and walls of the houses are in the background and partially hidden by the trees.

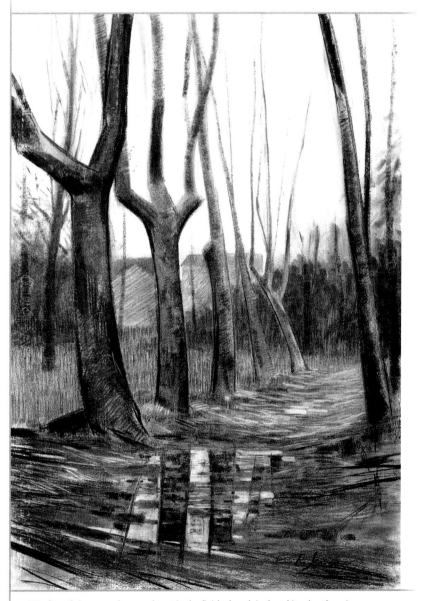

11. The sanguine lines on the ground are chromatically enhanced by the progressive definition of the light and dark values of the drawing. Although the work is almost monochromatic, these reddish tones provide the suggestion of color.

12. One of the areas that stands out in the finished work is the white sky: there is no color breaking its purity. Thanks to the contrast created by the sky against the darker areas, the work maintains a lightness that would have been hard to achieve otherwise.

A Colorist Landscape with Gouache

Two concepts are developed in this landscape: one is composition and the other is color. In terms of composition, this is an enclosed landscape. As far as color, the decisive range is made up of blues, oranges, greens, orange yellow to green, and yellows. Violet is used as an indispensable complementary color. Exercise by Miquel Ferrón.

THE MODEL

PHASE 1:
GREENS AND YELLOWS

1. The pencil drawing that serves as a guide for the color depicts the entire landscape in a circular composition. It begins at the highest branch, which is on the right side. The curve that it makes disappears and later reappears on the left side.

2. The painting begins with the darker shadows and continues with the larger blocks of color, building up the landscape as if it were a puzzle, as dictated by the subject.

The landscape occupies the entire space and does not leave any room for the sky. It is almost like an interior scene but completely outdoors. The backlighted effect, with the great beam of sunlight filtering through the leaves, gives the composition a dramatic feeling.

3. The grass plane combines the two main colors of the composition: green and yellow. This approach favors color harmony because one naturally progresses to the other through gradations and through the combination of color intensities.

The color of this landscape is a compromise between the Impressionist style and the pointillist technique of independent applications of pure color.

PHASE 2:
LIGHT AND SHADOW

4. The color mixture of the shadowy area in the foreground has a purple undertone. This tendency is enhanced in the highlighted area in the middle where purple gives way to an orange sienna. From the chromatic point of view, that orange is the warmest tone of the color harmony.

5. The upper part of the composition is created by alternating cool and warm colors (white, blues, and yellows) and by shading with superimposed brushstrokes that do not mix with each other. This creates a feeling of light.

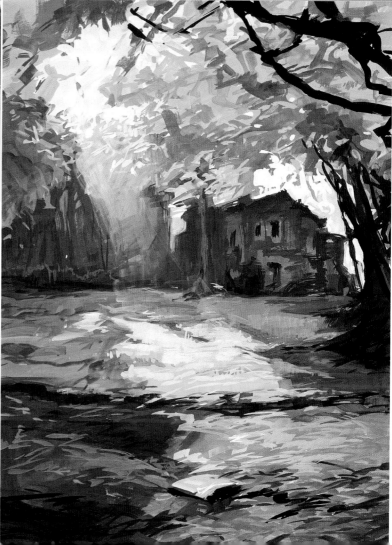

6. The last grays are warm, which are perfect for enclosing the composition. The "powdery" effect of the color has a high atmospheric value, which unifies the luminous effect of the painting.

Color and Texture in an Oil Landscape

In this exercise, the reader will see the wide range of possibilities afforded by painting with oils when the desired effect calls for body and intensity. This landscape will be created by building up paint with very thick brushstrokes, layering them until a dense, sensual, and chromatically diverse texture is achieved. This is a style that relies on appealing colors. Exercise developed by Marta Duran.

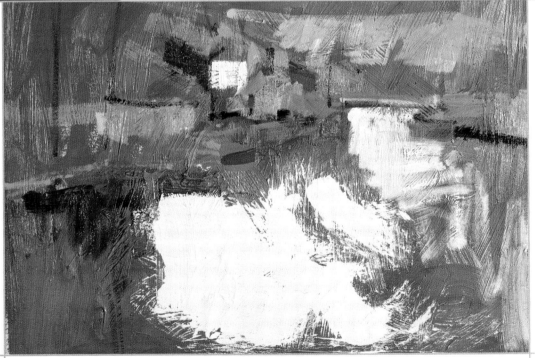

THE MODEL

The theme is not particularly original: a river arranged in such a way that the largest area of the canvas will depict the colors of the calm water.

PHASE 1:
PAINTING DIRECTLY

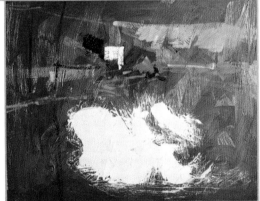

1. This scene will be painted on canvas covered with a very dark layer of gray green color. The unusual tone will force the use of a light range of colors that will stand out against the dark background.

2. The work begins by applying the paint directly, without a preliminary drawing or sketch. The large white area is a good reference for arranging the rest of the elements around it. As new areas are incorporated, other useful compositional references are established.

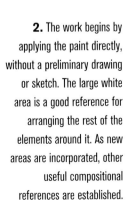

3. At this stage of the painting, almost everything is built up through color and shape. The artist tries out different approaches and elements, which will be kept or eliminated according to the needs dictated by the colors and the overall feeling of the painting.

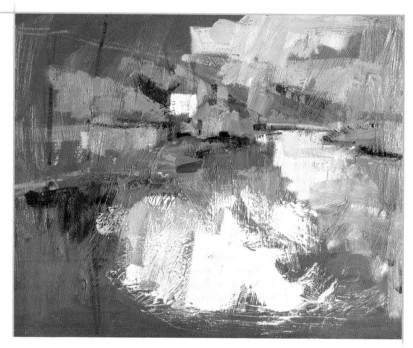

PHASE 2:

REFERENCES AND CONTRASTS

4. The buildup of paint begins to suggest the contrasts between different surfaces and planes in the composition. The areas of color acquire a wrinkled effect as a result of the dense and dry painted background over which they are applied.

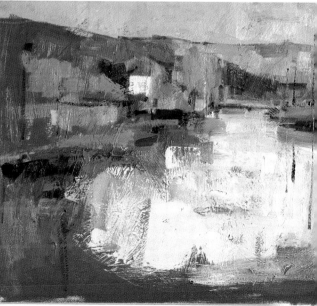

5. The absence of a preliminary drawing forces the artist to define the forms and outlines of each element in the landscape. The middle tones of the mass of trees begin to fill up with areas of light purple that suggest the autumn coloration of the theme.

The color backgrounds help create harmony in an oil painting, but they also affect the tones that are used.

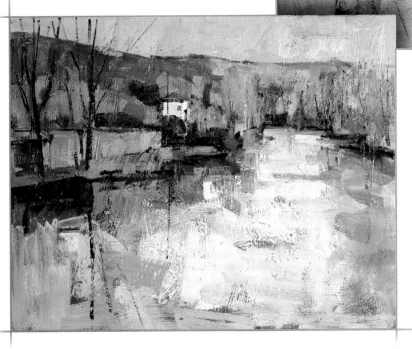

OVERALL HARMONY

6. The sky is completely covered with a pink tone, creating a solid mass of color that perfectly defines the horizon line. The mountainous area in the background still shows the base color of the canvas.

7. The lines that represent the tree trunks and branches provide a more rigorous order to the composition. These linear details are needed to prevent the surfaces of color from flowing without any references.

8. To counteract the lack of chiaroscuro contrasts in the water, tonal changes between the three fundamental planes of the landscape—the surface of the water, the riverbanks, and the sky—are intensified.

The final quality of an oil painting depends as much on the colors used as on the texture of the paint applied during the process.

PHASE 4:
SHADING WITH NEUTRAL TONES

9. The green colors that are seen behind the trees in the middle ground are adjusted with whites and grays, always using the neutral range that dictates the color harmony of the painting.

10. In these final steps of the process, the work focuses on the reflections of the sky on the water. The artist looks for the affinity of light between both elements, repeating the tones of the sky in some areas of the river.

11. The result is a work with very dense color. Great tonal variation as well as a convincing atmospheric effect have been created by working solely with neutral tones.

THE STILL LIFE

M any people are surprised by the fact that a lemon, a fish, and a glass of wine are objects that merit being painted. This prejudice has been the historical obstacle that still-life artists have had to endure. In fact, it is interesting that artists devote themselves to a genre deemed so unfit for the great philosophical artistic themes. Therefore, it is not surprising that still life has been banished to the lowest level of artistic status for many centuries, a simple accessory at the service of important compositions.

Taddeo Gaddi (1300–1366), *Niche with Oil Cruets.* Church of Santa Croce (Milan, Italy). During the Early Renaissance, it was customary to decorate some areas of the churches with pretentious spaces displaying objects.

Frans Snyders (1579–1657), *The Game Merchant.* Nasjonalgalleriet (Oslo, Norway). This baroque still life is characterized by its exuberance and the richness of its objects and colors.

CONTEMPORARY STILL LIFE

For the contemporary artist, still life can also be a vehicle for exploring matters related to visual reality and the reality of the painting itself, for studying the space, color, and form of objects and their relationships, and the emotion of contrasts and harmony. This emotion is conveyed by the magnificence of painting, which does not require extraordinary themes. Caravaggio recognized this fact when he said: "It takes me as long to create a good painting with flowers as a good painting with figures."

Decorative mosaic from a house in Pompeii (Italy). The origin of the still-life genre is found in these Roman decorations based on everyday objects that look like they were dropped on the floor.

Paul Cézanne (1839–1906), *Still Life with Basket.* Musée d'Orsay (Paris, France). Cézanne is without a doubt the most important modern and contemporary still-life artist. His still-life paintings are true explorations of the technique and of the pictorial styles.

History of the Genre

The first still lifes that have been preserved are a few mosaics and mural decorations from ancient Rome. Some of them represent *trompe l'oeil* fragments that create the illusion of a real object. This approach appears repeatedly during the history of the genre. *Trompe l'oeil* is one of the styles that characterize some especially brilliant periods in the history of still life. Besides the decorative purpose, the vases and flowers that appear in many Flemish altarpieces of the Renaissance period have an allegorical and symbolic meaning. These symbols are one of the main features of the genre.

Francisco de Zurbarán (1598–1664), *Still Life.* Museo del Prado (Madrid, Spain). The austerity of Spanish still life serves as an inspiration for many modern and contemporary artists.

The Splendor of the Still Life

The 17th century was without a doubt a magnificent period for still-life painting. In Holland, especially in Flanders, paintings depict tables displaying exquisite foods, desserts, and luxurious china. By the end of the 19th century, Cézanne's apples were the culmination of this art and the starting point for the main avant-garde movements. These still-life paintings provide not only a new approach to the genre but a way to understand color, the placement of the forms within the space, and the design of the composition—in other words, the painting as a whole. This genre revived the accomplishments of the major artistic periods, condensing them in a theme underrated by the majority of the great masters.

Fruit and Objects with Pastels

Arranging a still-life composition is a true art that requires the same kind of attention that is devoted to any other painting style: unity, variety, balance, rhythm, etc. In this exercise, we will use a warm range of pastel colors where red tones are the dominant feature. Project executed by David Sanmiguel.

THE MODEL

This still life is arranged according to the basic principles that rule every artistic composition, as much in terms of the form of the objects as their color (in contrast but within the same chromatic tendency).

**PHASE 1:
AREAS OF
COLOR AND
BLENDING**

1. White pastels and charcoal are used for the blending in this work, spreading into large areas of light and dark. A very simple preliminary sketch with red pastels has been drawn.

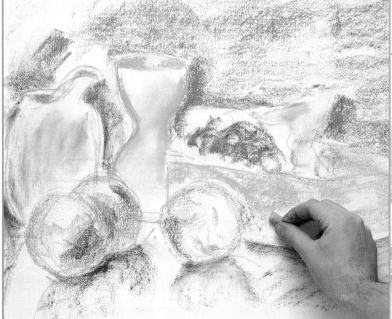

2. The light, general shading of the initial colors make it easier to distribute the additional darker tones that enrich the overall value of the work. Sketches of the basket and pitcher are drawn over the previous gray blended background.

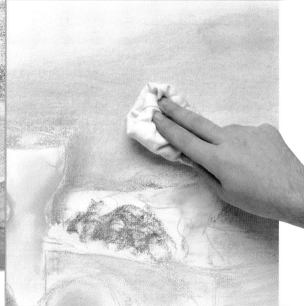

3. To achieve greater tonal unity, the background color is spread with a rag. This will produce a lighter tone, which is indicative of the predominant tendency of the work.

It is a good idea to first practice with uncomplicated compositions, using objects with simple forms whose volume and color contrast with each other.

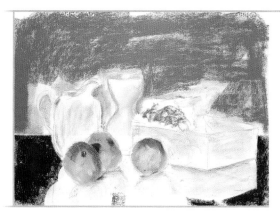

4. The distribution of colors follows the lead of the initial applications. Now the colors are adjusted according to the lighter or darker intensities previously established. During this phase of the process, the artist must work in general terms without emphasizing any isolated details.

PHASE 2:

DETAILS AND FINISHES

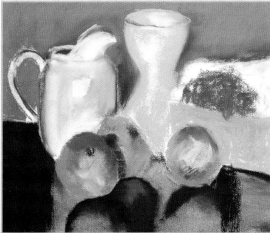

5. The areas where color was defined only by a sketch look much more elaborate at this point. The contrast introduced by the darker tones of the table reinforces the colors of the objects.

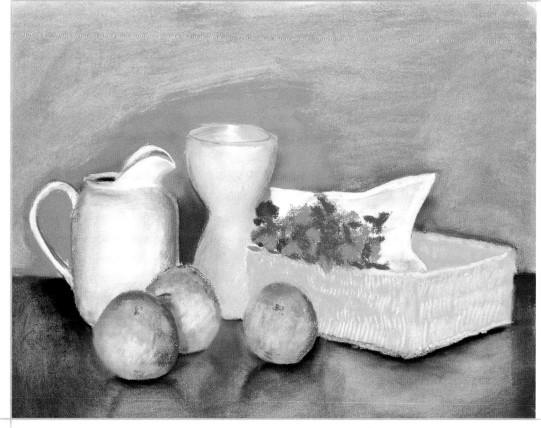

6. The work is completed after the contrasts have been intensified and adjusted. The result clearly shows the process of composition and execution of a still life with pastels planned around simple objects that were arranged with a good sense of harmony.

A Rustic Still Life with Oil Paint

This subject offers a wonderful opportunity for translating the grays of the model into tones and intensities of color, as Esther Olivé de Puig will show us in this exercise. For the colorist it is a matter of seeing something "in full color," eliminating anything that has no chromatic relevance.

THE MODEL

This rustic-looking still life includes a mortar, a cabbage, a few bananas, a knife, a tablecloth with a pattern, and a plaid napkin. It has been carefully arranged, highlighting the most colorful aspects, intensifying the contrasts, and creating a warm, strong harmony.

PHASE 1: COLORED DRAWING

1. This shows a pencil sketch drawn with very light lines that are hardly noticeable. The second and final drawing is created with a brush, and it is not monochromatic since color is used from the beginning to block-in the shapes of the elements.

2. The linear aspects of the composition are resolved. This includes the napkin and its print, which can be created with square lines varying their direction and curving them slightly to convey the softness of the fabric.

3. Here, the procedure for modeling with color can be seen clearly, since neither black nor gray has been used. For example, the dominant color is yellow, but in the darker areas it becomes light green—in other words, a color other than gray.

The dilemma between drawing and color is resolved by applying the paint with brushstrokes of very different colors that construct the form while defining the color of the theme.

PHASE 2:
FORMS AND AREAS OF COLOR

4. Everything appears to float on the ochre background, although the pink colors of the tablecloth's flowers begin to emerge: areas of pure color that do not need to be modeled or shaded. The contrast of color values between the cabbage and the mortar revitalizes the composition.

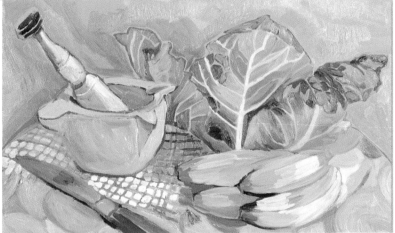

5. The fabric patterns are a great feature because they can be painted with blocks of pure color, and the deformation of the patterns indicates the form. Once this area is resolved, the entire middle section of the painting gains detail and a painterly quality.

6. By studying the finished painting, one can see how light and shadow are defined by color, and how it can create volume and space by itself. The goal of this exercise was to maintain the intensity of the color and all its purity.

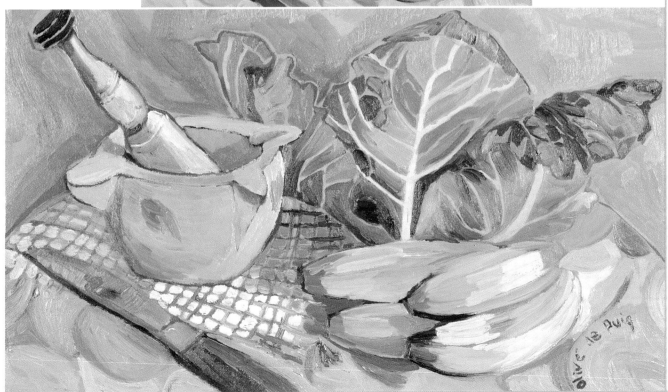

Still Life in Red

This still life has been carefully chosen to depict a grouping unified by color. Still-life subjects allow these kinds of liberties, which are inconceivable in other art genres. Here, red is the dominant color, which will force the differentiation of contrasts within the boundaries of this harmony. Exercise developed by Esther Olivé de Puig.

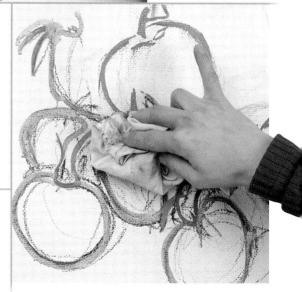

THE MODEL

PHASE 1:

DRAWING AND CONTOURS

The arrangement of these objects forms a solid chromatic block, which, on the one hand, enhances the harmony, but on the other forces the artist to avoid the monotony of excessive color.

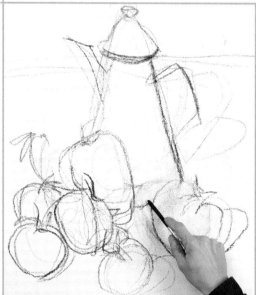

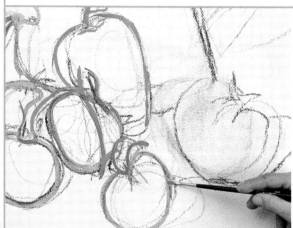

2. The definitive outlines are redrawn with a mixture of green and yellow, establishing the composition of the painting. These lines are thick and maintain a constant presence throughout the work.

1. The drawing done with charcoal is loose and spontaneous. Each object is blocked-in with several tentative lines, which approximate the form and leave open the possibility for alterations.

3. The lines of the drawing that were drawn with oils were highly diluted with mineral spirits; therefore they dry fast. Then, the rest of the lines drawn with charcoal were erased with a rag.

The charcoal lines of a preliminary drawing for an oil painting must be erased before painting begins; otherwise the colors will get dirty when they mix with the charcoal.

PHASE 2:
PROJECTED SHADOWS

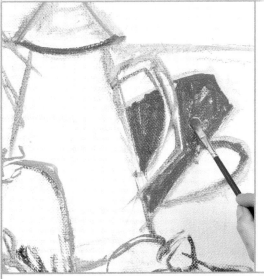

4. The shadows of the different objects were established in the preliminary drawing as well. Now the painting process begins with dark reds, purple, and violet colors.

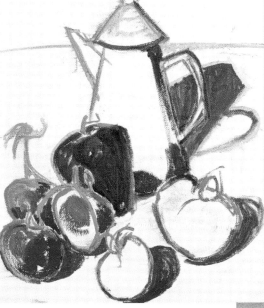

5. Painting the fruits and vegetables is an exercise that requires combining red, carmine, and purple tones. These tones are based on red and, mixed with blue, add depth to the color areas.

6. The green color of the tomato provides a sharp contrasting note to the reds applied until now. It is important to mention that the brushstrokes do not completely cover the areas limited to that color by the sketch; they leave the texture of the canvas exposed.

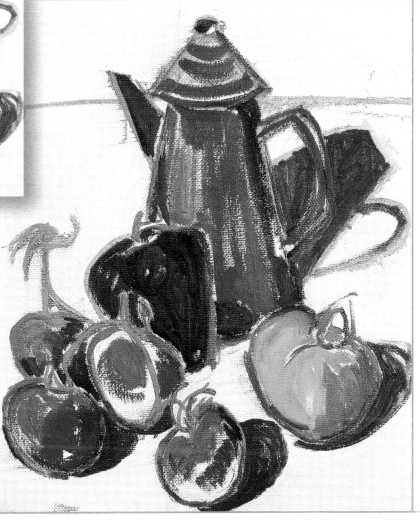

7. The white background is quickly covered, respecting the outlines of the forms in the composition. The color is used diluted with mineral spirits so the brush can glide easily across the canvas.

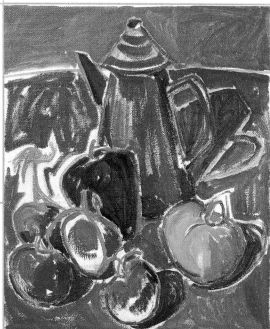

Color backgrounds help harmonize an oil painting, but they also limit the colors that can be used.

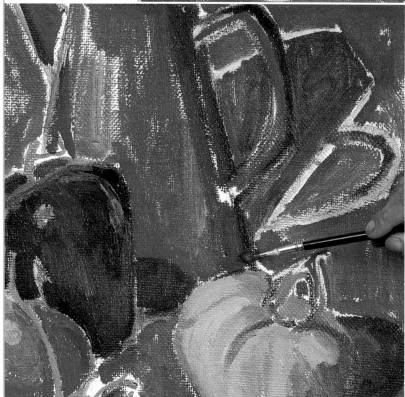

8. The fruits have acquired greater volume thanks to the various applications of color. The dark areas of the coffeepot are highlighted with carmine tones mixed with a small amount of blue.

9. Warm tones are added in the areas where the shadows are more prominent. This will make the objects stand out against the color of the background, and their profiles will have greater definition against the color of the table.

Red creates greater contrast with its complement, green, than with any other color. The juxtaposition of both is an effect that is deliberately chosen to highlight the chromatic power of the composition.

PHASE 4:
COLOR ADJUSTMENT

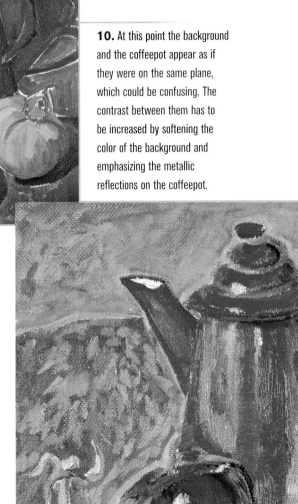

10. At this point the background and the coffeepot appear as if they were on the same plane, which could be confusing. The contrast between them has to be increased by softening the color of the background and emphasizing the metallic reflections on the coffeepot.

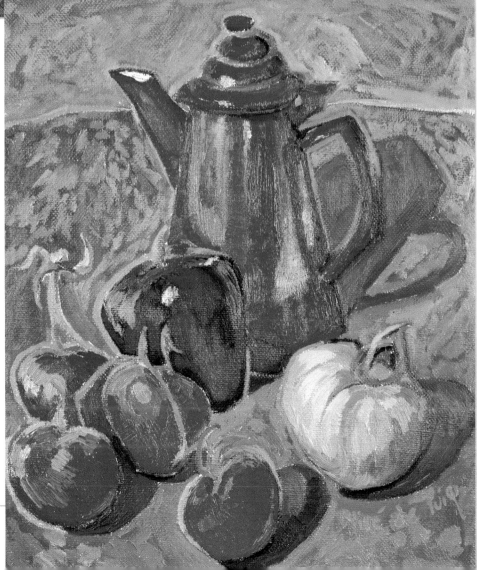

11. This is the final result: a still-life painting created in a bright harmony of vibrant colors. The composition, almost monochromatic, does not prevent the artist from incorporating many different values in this confident, colorful work.

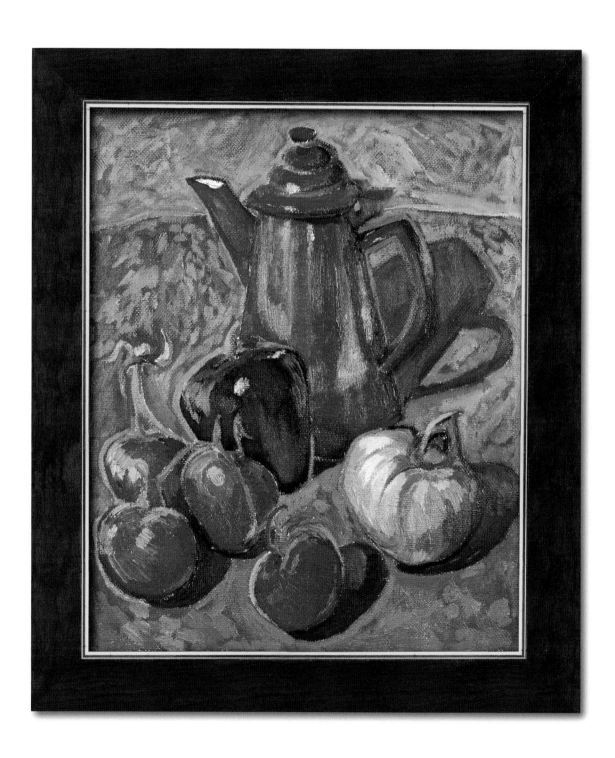

ماتم الأحد

ܦܘܡܥܢܝܢ ܚܣܝ ܠܟܗܐ ܐܟܐ ܐܢܒ ܟܠ ܟܟܘܪܐ ܘܚܬܩܟܐ ܗܘ/ܘܟܐ

ܘܘܠܟܗܡ ܐܝܟܡ ܘܩܬܚܣܐܡ ܗܘܠܐ ܡܬܚܣܐܡ

ܘܚܣܒ ܡܢܢܐ ܢܦܘܝ ܡܢܣܢܐ ܢܢܣܝܢܐ ܚܐ ܘܠܟܗܐ ܗܗ ܘܡܝ ܐܚܐ

ܐܒܢܟܟ ܡܪܡ ܟܟܗܘܝ ܟܬܠܩܕܐ ܠܟܗܐ ܘܡܝ ܠܟܗܐ ܐܗܘܘܪܐ ܘܡܝ ܐܗܘܘܪܐ ܠܟܗܐ

ܡܢܢܐ ܘܡܝ ܠܟܗܐ ܐܡܢܢܐ ܢܓܟܒܪܐ ܘܠܐ ܚܚܒܪܐ ܐܡܚܐ ܚܐܡܚܐ ܠܐܟܗܝܘܝ ܘܚܐܝܒܝܗ

ܗܘܘܐ ܟܠܐ ܡܬܪܡ . ܗܗ ܘܡܢܗܟܟܟܝ ܚܢܬܬܢܐ ܘܡܢܗܠܠܐ ܘܗܘܙܟܝ ܒܢܗ ܡܝ ܬܥܬܐ

ܘ/ܐܝܚܢܡܝ ܡܝ ܘܐܡܢܐ ܘܩܗܘܘܟܐ ܘܡܝ ܡܢܢܡܝ ܕܟܗܘܚܟܐ ܗܘܘܐ ܚܪܢܢܐ .

ܘ/ܠܝܟܚܕ ܣܝܟܟܡ ܚܬܩܡܝ ܦܝܟܗܣܗ ܓܝܠܐܠܗܣܗ . ܡܒܝ ܘܡܟܒܗ ܗ/ܘܐܡܚܐ

ܘܡܒܪ ܟܗܟܟܐ ܬܩܡܝ ܐܡܝܗ ܘܝܕܐܡܝ . ܗܡܒܝ ܟܬܩܡܢܐ ܗܡܒܝ ܡܝ

THE MARONITES

HISTORY AND CONSTANTS

Dear Fr. Prior,
thank you for
all you have done on
my behalf. It has been
an honor to serve you.

Sincerely,

ANTOINE KHOURY HARB

THE MARONITES

HISTORY AND CONSTANTS

" The Maronite Heritage "

Virgin Mary and Child (Hodigitria), as illustrated in the Maronite Chalcedonian Gospel of Rabula (586 A.D.). It is one of the oldest representations of the Virgin Mary.

<u>Frontispiece:</u>

(the upper part): The first historical representation of Christ on the Cross (Rabula). It attests to the Double Nature of Christ (Human and Divine).

(the lower part): Resurrection of Christ and his apparition to the women.

TABLE OF CONTENTS

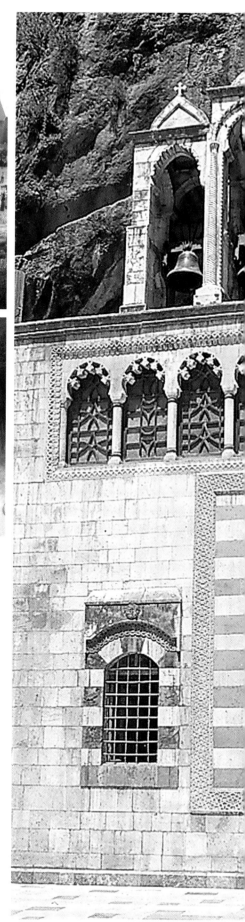

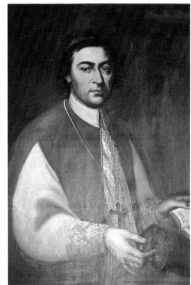

**Maronite Patriarchate
of Antioch and the Entire East**

We highly appreciate the purpose behind the publication of: "The Maronites, History and Constants" by Dr. Antoine Khoury Harb in English after it has been published in Arabic, French, Spanish and Portuguese.

The book introduces the Maronites and calls back to reminisce several aspects of their history, which is impregnated with the spirit of martyrdom, sanctity, and heroism. The history of the Maronites is well known through more than one thousand and three hundred years, and their constants are deeply rooted in their belief in God, their attachment to the values and virtues, namely freedom, justice, human rights, sovereignty and independence. These latter condition and stimulate a real dialogue between all Lebanese citizens irrespective of religious creeds and cultural diversity in a democratic context, thus embodying the authentic Lebanese cultural heritage.

We hope that this book will bring to memory the glorious past of the Maronites, their distinguished constants and the great sacrifices of their ancestors in order to maintain this legacy, so that it remains forever vivid in mind. We reiterate our best wishes to the author for prosperity and success, and bestow upon him our paternal benediction.

Bkerki, November 22 , 2001

Cardinal Nasrallah Boutros Sfeir

Patriarch of Antioch and the Entire East

When Dr. Antoine Khoury-Harb, a distinguished graduate of the Holy Spirit University, asked me to introduce his compelling book on Maronites, he made it clear to me, that it was addressed to the Western reader in general, and particularly, to those who are of Maronite descent or to the Maronites who grew up and were reared outside Lebanon. I did my best to put myself in this perspective and tried to figure out the basic features of this tradition that are to be highlighted.

I was quite aware that my perspective should help the reader situate himself in a vis-à-vis with this cultural and religious legacy. We should make sure that this encounter shall help the reader discover this early tradition, reinterpret it, connect it to his actual tradition and to the true concerns of his current world. What I will highlight in this brief introduction are the basic traits of the Maronite tradition and spirituality, which is the best way to make sense of one's tradition, connect it to reality and build a coherent self identity. The theological underpinning helps us a great deal solve the riddles raised by the dilemmas of the Local Church (Maronite) and the Universal Church represented by the Church of Rome; those of a monastic community that became a Church; the one of an Eastern tradition and the one of a Western tradition.

The Maronites have emerged after the Chalcedonian council in 451, as a community that wholeheartedly supported the Christology professed by the council. This dualistic Christology which emphasized Christ's true divinity and true humanity has profoundly influenced their ministry: a community of confession and martyrdom.

This Christology emphasizes the existential implications of the Incarnation and highlights it's humanistic and practical dimensions. It has given shape to a lifestyle and to an ethos which characterized their society, patterns of behavior, literature and liturgy. The Incarnated God according to this theological view, should not be equated with a romantic or a political aspiration, nor identified to an abstract idea or an attribute which qualifies a transcendent almighty God in total rupture with our humane daily concerns. God in Jesus Christ has set a relationship of love and companionship which invites every man to a life of communion since "the full content of divine nature lives in Christ, in his humanity, and you have been given full life in union with him" (Colossians, 2-9); Paul considers that "Christ message, in all its richness, must live in [our] hearts". (Colossians 3-16).

The major faultlines which characterize the contemporary world and the Middle East are not merely reflective of political, social, economic and technological disparities, but they also mirror major differences in philosophical, anthropological and theological worldviews. Therefore, we consider that a true humanism evolves out of a proper theologica.l

view of God's nature and it's implications on man's self understanding. Our theological tradition has constantly stressed that Jesus's ministry has revealed man to himself; from now on, the life of Jesus gives our personal and communal life a new meaning. The life of discipleship invites man to act Christlike and to rewrite his personal and communal narratives with a different script than the one he has used so far. Jesus the Christ charted in the Beatitudes the path to the Kingdom of God.

If we were to epitomize the basic features of a true Maronite spirituality as suggested by the tradition, I would recapitulate the following aspects:

A - Commitment to man's ultimate dignity and to a humanistic worldview. This view is shaped by their theological understanding which considers man's dignity redeemed by the ministry of Jesus Christ and reenacted on a daily basis through Eucharist and the various ministries of the Church. Maronite Liturgy puts beautifully this basic truth: "Lord, you have united your divinity to our humanity, and our humanity to your divinity, you have taken what is ours and given us what is yours…".

B - A spirituality which emphasizes man's cosmological embeddedness, basic solidarity and fellowship and treasures civilizational differences, political pluralism and democratic values.

C - Faithfulness to the Gospel reflected in being compassionate, a deep sense of the ministry, the spirit of poverty and a continuous struggle for justice and mercy.

D - A tradition of cultural openness which aims at promoting the dialogue of civilizations, the promotion of intercultural understanding and the management of cultural and religious pluralism along democratic lines. Maronites in their political endeavors have earnestly struggled to foster these ideals in Lebanon as a working model in the Middle East, where multiculturalism, civilizational dialogue, and democratic conflict resolution have hard times.

After having briefly reviewed the outlines of an actualized Maronite spirituality; I wish that this well written illustrated history will guide your readings, journeys and wanderings through the historical, cultural and religious sites of Lebanon. This work has required extensive research and was matched by a good pedagogical savvy which will allow you to travel through millennia. This book is no substitute to research in depth, it is meant to be a clever guide throughout the meandrous history of the Maronites and the circuitous paths of their native land, the one of their fathers and forefathers.

Kaslik, 9/10/2001

Abbot Paul NAAMAN

Holy Spirit University

INTRODUCTION

"The Lebanese Communities are not only close human agglomerations of different religions, sects and confessions, "coexisting" harmoniously, as it appears at the first sight. They are rather, like mosaic pieces with varied hues and shapes within one frame. These Communities are intertwined laces forming the Lebanese weave, a weave whose elements are unified in their plurality".

Man alone among all living and inert creatures is composed of three temporal dimensions, besought by his mind, felt by his body and sensations and envisioned by his dreams. Thus, if he looses any one of them, he looses thereby the very truthfulness of his entity.

The human being survives through his Past, not in the sense of an inert sanctified recollection, but in the sense of deeper entrenchment in time and space, which will form the framework of his living and dynamic Present. Man is also the son of the Future, not in the sense of detachment and transcendence, but rather, in the sense of prospection and expectation; he raids it with his wishful dreamy mind and his willingness to strive, survive and continue then and ever. He takes from the Past his birth certificate and the features of his identity; he then carves in the Present the attestation of his existence, as he moulds his overcrossing passport from the Future. All three together (Past, Present, Future) form the History with its actualities, interactions and lessons; this History is not merely narrated events, but the outcome of a dialectic between cause and effect, between what was, what is and what would be. In this regard, History becomes the memory of the Past, the act of the Present and the will of the Future. The people who do not show such understanding of their History ignore the essence of their existence in its three dimensional framework and, thus, become like a man who has lost the qualitative essence of his existence to delve into a purely materialistic context and, as such, transforms from an all knowing, all present and all willing human being to a vegetative creature.

This brief study of the History of the Maronites is not only meant to be a simple narrative about the life of the sons of St. Maron, with reference to the magistral studies, researches and valuable anthologies matching with the Maronite History, but also, a means to highlight three fetched objectives:

- First: Introducing a brief and systematic account of the History of the Maronites, tightly woven within a clear temporal context. This review will constitute an important part of the general History of Lebanon and especially that of the Middle East.

- Second: Deducing the constants of the Maronites' History throughout their existence, their mutual interactions with their physical and human environment, and in particular, showing the effective role of the Maronites Patriarchate ever since its establishment in 685, over the last thirteen centuries.

- Third: Contributing to a better understanding of the History and Heritage of Lebanon, knowing that the History of the Maronites is integral to the History of Lebanon, and their heritage is deeply rooted in the Lebanese culture which derives its characteristics and specificities from its soil.

Thus, writing the History of the Maronites with this new perspective could be a good incentive for others to write the History of other Lebanese Communities.

The Communities we mean, are not only close human agglomerations of different religions, sects and confessions, "coexisting" harmoniously, as it appears at the first sight. They are rather, like mosaic pieces with varied hues and shapes within one frame. These Communities are intertwined laces forming the Lebanese weave, a weave whose elements are unified in their plurality. This plurality has enriched the Lebanese people and distinguished them through the ages. Moreover, it has constantly enabled them to carry a unique message among the peoples. This message is one of dialogue and the embodiment of interaction and brotherhood. This , in fact, is what His Holiness the Pope John Paul II meant by asserting that *"Lebanon is more than a country, it is a Message"*.

The Lebanese land is not a void material surface, rather a "melting pot" where values of spirit and mind merge. Therefore, this book does not entail to create segregation, discrimination, alienation and hostility, feelings of superiority or inferiority and fanatism. On the contrary, it is a quest for "beingness" which is conditioned by the understanding of the absolute self through the understanding of the individual self.

This "beingness" presupposes mindopenness that questions the "self" and seeks an answer from the "other", hence a way to dialogue and a path to closeness. All this is driven by a dynamic dialectic, which is "love". Teilhard de Chardin defines this "love": *"The more man knows, the closer he is to his fellow man"*. By the same logic, we say: if knowledge is love, then ignorance is enmity. Also, Imam Ali says: *"People are enemies of what they ignore"*. Knowledge is the ally of truth, and ignorance the ally of falsehood. Knowledge liberates and ignorance enchains: *"You will know the truth and the truth will make you free"* (John, 8:32)

In this spirit, I hope that this book "The Maronites, History and Constants" contributes to a better knowledge of the Maronites in themselves, and the Lebanese in the Maronites, for the sake of Lebanon, Land and People.

Antoine Khoury Harb

1 - Matthew 28, 19

2 - Josephus, Fl., *"Guerre des Juifs"*, Vol.III, Chap.III, 1
 - Vigouroux, F., *"Dictionnaire de la Bible"*, Paris 1903,V.III, p.87

3 - Joshua 19, 10-40

4 -Josephus, Fl, *"Opera Omnia"*, New York 1821, Vol. II, pp.286, 527

5 - Isaiah 9, 1

6 - Judges 1, 19-36

7 - Judges 3, 5-7

8 - Kings IV, 15, 29 ; 17, 1-18

9 - Josephe, Fl., *"Antiquités Judaiques"*, ed. Leroux, Paris 1968, IX, XI, I

10- Josephe, Fl., *op. cit.*, XII, VIII, 2

11- Book of Maccabees I, 5, 14-23

12- Daou, F. B., *"History of the Maronites"* (in arabic), Vol. VI, *"Lebanon in the Life of Jesus Christ"*, Paulist Press, 1980, p.75

After His incarnation, His crucifixion, His resurrection, and prior to His ascension to heaven, Christ said to His disciples:
"Go, therefore, and make disciples of all nations, baptizing them in the name of the Father, and of the Son, and of the Holy Spirit" [1]. Fulfilling the will of the Master, the disciples carried the promise of salvation to the peoples of the earth.

The Lebanese were the first to receive the promise of salvation which originated in Palestine. This was due to both geographical and cultural variables:

1 - Palestine is delimited in the east and the south by deserts, and in the west by the Mediterranean Sea, which separates it from Asia, Africa and Europe. Whereas, there are no major natural barriers between northern Palestine and south Lebanon.

Christ grew up, preached and performed most of His miracles in Galilee. That is why He was called the "Galilean."

According to the Jewish historian Flavius Josephus (37-100 A.D.), the region then known as Galilee stretched between Akka and the Carmel in the south, Tyre and its region in the north, Tiberias and Jordan in the east, and the coastal plain in the west. Galilee was divided into Upper Galilee and Lower Galilee [2].

For both the Bible [3] and Josephus [4], this area was the "Galilee of Nations", the word "Nations" referring to the "non Jewish" (the pagans). This correlation between "Galilee" and "Nations" was due to the ethnic and cultural predominance of the Canaanite-Phoenician race over the Jewish race since the days of Isaiah, the 8th century B.C.[5].

The Hebrews came from Egypt under the leadership of Moses and Joshua, and occupied the land of Canaan and Galilee. Despite this fact, the natives, i.e. the Canaanites, remained in Galilee[6], and had cultural, social and religious relations with the Israelites[7]. When the Assyrians occupied Galilee in the 8th century B.C., the Israelites were banished to Mesopotamia[8], on the other hand, the Canaanites-Phoenicians remained in their land[9]. Despite the fact that Cyrus the Persian (558-528 B.C), allowed the Jews to return to Palestine, they remained a minority in Galilee as compared to the Canaanites[10].

In the middle of the 2nd century B.C., following the battles between the Jews and the Canaanites, the Jews fled from Galilee[11]. Although the Jews gradually returned in a later period to Galilee, the cultural and ethnic predominance of the Canaanites was more than evident. Therefore, this area continued to be called the "Galilee of Nations"[12], the homeland of Jesus Christ, the "Galilean".

Lebanon the everlasting "White Mountain", the Asian link between the East and West, and the land of dialogue, was among the first countries to receive the message of salvation that originated in Palestine.

Mentioned as "the Holy Mountain of God" (Ezechiel 28:14), Lebanon was honored and sanctified by Christ "The Galilean",who visited it preaching the message of love.

13- Mark 7, 31

14- John 2, 1-11

15- Joshua 9, 25-28
 - Eusebius, *"Onomastica Sacra"*, Goettinger, 1870, p.271
 - Vigouroux, F., *"Dictionnaire de la Bible"*, Paris 1899, V.II, C-F, 106

16- Hourani, Y., *"Cana of Galilee in Lebanon"*, Ministry of Tourism, 1995, p.12
 - Yammine, F. Y., *"Cana of Galilee in Lebanon"* (in arabic), Ehden 1994, p.36

17 - Kawkabani, I., *"Les Monuments de Wadi Cana"*, Bulletin du Musée de Beyrouth, V. XXIV, Beyrouth, 1971, Pl. V.

18 - Matthew 15, 21-28

19 - Mark 7, 31

The evangelists mention that the Lebanese, especially the inhabitants of Tyre and Sidon in South Lebanon, *"hearing what He was doing, they came to Him"* (Mark 3, 8). Christ, for his part addressed the inhabitants of Tyre and Sidon directly, and visited these two cities[13], where He performed a number of miracles. In the case of one such miracle, He turned water into wine. These events in Cana of Galilee *"revealed His glory, so His disciples believed in Him"*[14].

Eusebius of Caesarea, the first ecclesiastical historian (265-339) locates Cana and asserts that it is a village in "Galilee of Nations" on the road to "Great Sidon"[15]. Saint Jerome (347-420), who translated the Bible into Latin (the Vulgate), confirms the assertions of Eusebius. In fact, the location of Cana of Galilee coincides with Cana of Lebanon, 12 kms southeast of Tyre. Its name is Cana of Galilee as mentioned by the evangelists, whereas the two other cities, one of which some presume to be Cana of the Wedding, is known as Kafar Kenna and Kherbet Cana [16].

Cana of Galilee is a Lebanese village situated on the side of a hill on which stands a shrine called the Shrine of Al-Jaleel, built on the ruins of an ancient temple discovered during archeological excavations. The villagers of different confessions worshiped at this shrine and buried their dead in its neighborhood.

Among the remains discovered in Cana of Galilee are stone water jars like the ones described by St. John the Evangelist and used by Jesus Christ to transform the water into wine. The size of the jars is equivalent to the volume of the jars mentioned in the New Testament (two or three measures, i.e. 80 or 120 litres). These stone jars can still be seen either near the ruins of the temple, or in the spacious courtyard where wedding ceremonies used to take place.

Next to the village of Cana of Galilee, one can observe steles dating back to the first centuries of Christianity. One of these steles represents twelve figures surrounding a thirteenth of greater size, the whole probably symbolizes Christ and the twelve apostles[17]. The ancient dwellers of Cana had probably carved this stele to commemorate the first miracle of Christ when He visited their village with His disciples.

The miracle of Cana of Galilee was not the only miracle preformed by Jesus in Lebanon, if one presumes that "Cana" of Lebanon is the Cana of the Wedding. The Evangelist Matthew mentions that Jesus came *"to the region of Tyre and Sidon"* where he healed the daughter of a Canaanite woman" [18].

Christ moved from Tyre to Sidon, as St. Mark reports: *"Then He left the district of Tyre and went by way of Sidon"*[19]. This means that Jesus traveled some 70 kms in Lebanon.

Next to the village of "Cana of Galilee", one can observe steles dating back to the first centuries of Christianity. One of these steles represents twelve figures surrounding a thirteenth of bigger size that probably symbolizes Christ and the twelve apostles. The ancient dwellers of Cana had probably carved this stele to commemorate the first miracle of Christ when He visited their village with His disciples. These steles can be considered among the oldest Christian vestiges, and are an additional proof that Christianity has been deep-rooted in Lebanon since its early beginnings.

Consequently, in vue of its geographical location and its proximity to Palestine, the ancient inhabitants of Lebanon were the most likely to accept Christianity directly through Jesus in the first stage, and not simply from His disciples as it was the case in other countries.

2- The researcher studying the religious heritage of the Phoenicians, i.e. the ancient Lebanese people, is impressed by their beliefs and practices especially when compared with Christian faith and rites. The resemblance may be seen in the following:

- The Phoenician-Canaanite god "El" is a supreme, impartial universal god. He is a peaceful god of love and mercy. He created the land, the eternal Sun and all sons of other gods.
- The belief in a Triad of feminine and masculine elements whose union gives birth to a third element representing "Life" [20].
- The union between man and god, as in the incarnation of the Phoenician god (Adon).
- The death and resurrection of the incarnated god (Adonite rites).
- The rites of self-sacrifice and the sacrifice of sons for the redemption of the masses.
- The worship of "The Lady", "The Virgin", "The Queen of Heavens" (Ashtarut) [21].

Hence, the Lebanese-Phoenician religious thought provided Christianity in Lebanon with a fertile soil for its development especially in the coastal cities that were always receptive to new ideas, beliefs and legislations in the atmosphere of liberty of thought, which prevailed during Greek times between the 4th and the 1st century B.C.

Sidon and Tyre were the most famous cities in the proximity of Galilee to play a major cultural role in Christ's day. The Greek historian Strabo, a contemporary of Christ, attests to the cultural, scientific, and philosophical eminence of the two cities: *"Nowadays as well, any person seeking learning in all fields of knowledge can find in Sidon and Tyre more sources of learning than elsewhere"* [22]. There is no doubt that the fame of Tyre and Sidon in those days made Christ visit them and preach to the people there.

At the same time, Christianity agrees with the moral, social and philosophical precepts of the Phoenician philosopher, Zeno the Stoic, whose philosophy was popular during the Hellenistic period. Stoicism called for brotherhood and equality among people; it also preached virtue and peace based on justice and love [23].

In conclusion, we observe that because of its geographical location, the cultural heritage, the religious ideas, and the mindopeness of its people, Lebanon was predisposed to be the first country to accept Christianity after its birth in Palestine.

20 - Harb, A.K., *"The Roots of Christianity in Lebanon"*, Beirut 1984, p.17

21 - Hourani, Y., *"Lubnan fi qiam tarikhihi"*, Dar Al-Mashrek, Beirut 1972, p. 223

22 - Strabon, *"Géographie"*, liv. XVI, pp. 2, 23-24

23 - Abdel Massih, G., *" Zeno the Stoic"* (in arabic), Beirut 1953, pp. 14-17
 - Ammoun, F., *"Le legs des Phéniciens à la Philosophie"*, Beyrouth 1983, pp.201, 232

- *" Jesus then left that place and withdrew to the region of Tyre and Sidon"* (Matthew 15, 21).

- *" Then , He left the district of Tyre and went by way of Sidon to the Sea of Galilee"* (Mark 7,31).

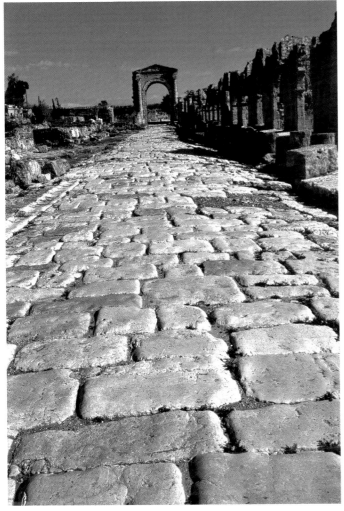

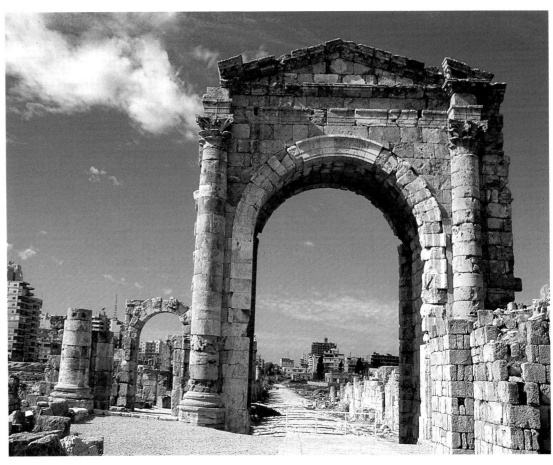

After the ascension of Christ to heaven, His disciples carried the promise of salvation to the peoples of the earth. As they carried out their mission, persecution began. Stephen, stoned by the Jews in Jerusalem, was the first martyr after the Master.

Around 34 A.D., persecution of Christians forced some followers to seek refuge in Lebanon. Moreover, it is mentioned in the Acts that when St. Paul visited Tyre around 58 A.D., he met the disciples and stayed with them for seven days. They pleaded with him not to go to Jerusalem due to the persecution of the Christians[1].

The presence of these first Christians in Tyre can be explained by the fact that many of Tyre's inhabitants had known Jesus personally, listened to His teachings and received the Good News. At that time, Tyre enjoyed autonomy under Roman Rule since the inhabitants paid taxes to the Romans[2], and the followers of the new religion were relatively spared the persecutions that touched Christians in other places.

Christianity spread also in Sidon as it did in Tyre. In the Acts it is mentioned that St. Paul was allowed when on his way to Rome as a prisoner around 60 A.D to meet his friends in the city[3].

Ecclesiastical tradition attributes to St. Peter the mission of spreading Christianity in Sidon. He *"moved from Tyre to Sidon where he stayed several days preaching Christianity. Many believed in him because of the miracles he performed. Moreover, St. Peter had chosen one of his accompanying priests and named him Bishop of Sidon."* [4].

After Tyre and Sidon, Christianity spread throughout the Lebanese coastal cities thanks to the disciples, who had to pass through Lebanon on their way from Jerusalem to Antioch in the north and on their way back.

Beirut also played an important role in the history of Christianity. St. Jude (Lebbaeus), called also Thaddaeus one of the 12 apostles, visited Beirut and preached the new faith there. He built a church, was martyred and buried in the city[5]. Patriarch Severus tells us that the Christians built a large church in Beirut to commemorate his death. Excavations in downtown Beirut may reveal the ruins of this church.

St. Euclimus, disciple and successor of St. Peter, reports that St. Peter also preached the inhabitants of Beirut and founded its Church in the middle of the 1st century A.D.

During Roman times, Beirut was called *"Berytus Nutrix Legum"*, the "Mother of Laws"

1 - Acts 21, 3-6

2 - Hourani, Y., *op.cit.*, p.55

3 - Acts 27, 3

4 - Le Quien, *"Oriens Christianus"*, t.2, Paris 1740, p.801

5 - Chabot, J.B., *"Chronique de Michel le Syrien"*, T.I, Liv. V, ch. X, p.147

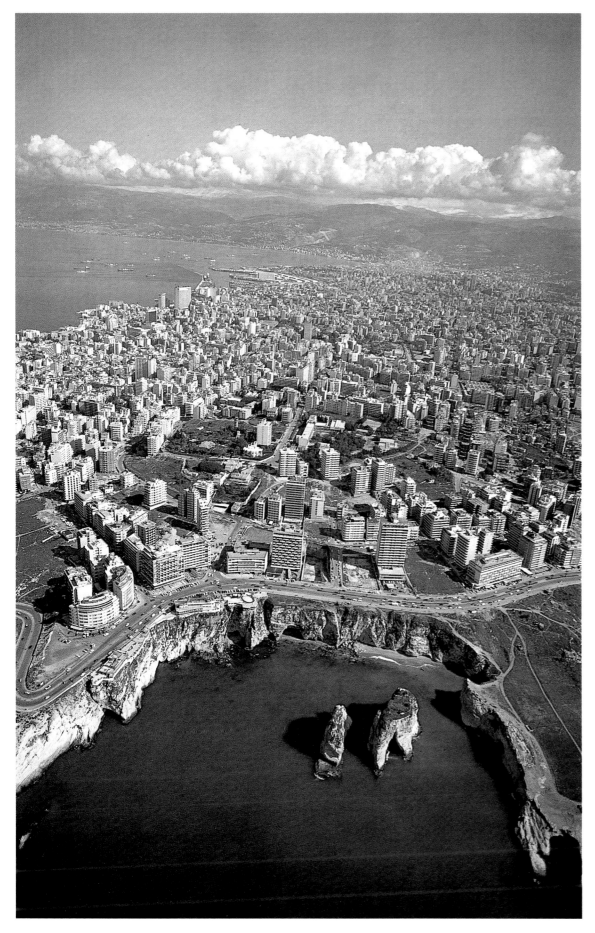

Beirut played an important role in the history of Christianity. St. Jude, one of the 12 apostles, visited it and preached the new faith there. He was martyred and buried in the city.
The Christians built a large church to commemorate his death. Excavations in downtown Beirut may reveal the ruins of this church.

Beirut became one the most important centers for theological studies in the ancient Christian world; it might be the reason for calling it *"Colonia Christi, Amica Beryto"*.

because of its law school. Some researchers such as the German Breitenbach (15th century) and Joanneis Strauchi (17th century) and others believed that Christ might have visited Beirut and its famous school[6].

Furthermore, Beirut became one of the most important centers for theological studies in the ancient Christian world. Among those who were in Beirut or visited it were Pamphilus of Beirut, the martyr theologian, Gregory Thaumaturgus, Bishop of Neo - Caeserea[7], St. Gregory of Nazianza, Bishop of Constantinople, and Severus, Bishop of Antioch.

The Church historian Zachariah of Gaza, who was a friend of Severus (end of the 5th century), mentions five churches in Beirut: the church of St. Jude (Lebbaeus) the Apostle, the church of Anastasia (the Resurrection), the church of the Mother of God, which was in the port area, and the church of St. Stephen, the first martyr.

A student of the Beirut law school and a friend of Severus, Zachariah of Gaza, mentions that he formed a Christian student association (487 A.D.), and that the members used to meet every evening for meditation in the church of the Resurrection in Beirut. Evagrios, Rector of the Law School, was famous for his faith, stoicism, and strict adherence to Christ's teachings. He fasted daily, and so became a model for his students [8].

The role played by Beirut in strengthening the new religion in its early days might be the reason for calling it *"Colonia Christi, Amica Beryto"*[9]. In the middle of the 6th century A.D., Beirut was destroyed by earthquakes and fires; its churches and law school were turned into ruins on which present-day Beirut was built.

St. John Mark, one of Christ's 70 disciples, followed the steps of St. Peter and St. Jude, and founded the first Church in Jbeil. St. Peter appointed him bishop of the city, where he was martyred as mentioned by the historian Dorothea of Tyre, the Syriac and Maronite Martyrologies, and the Roman Calendar [10].

Excavations in Jbeil have revealed the ruins of churches that date back to the early centuries of Christianity, a fact which proves that Christianity reached Jbeil in the early decades of the new faith. St. John's Church was probably built over the ruins of St. John Mark's Church. A painting of St. John Mark stood above the altar until it was replaced by a painting illustrating John the Baptist.

6 - Al -Mashreq Magazine, no.4, Feb. 1898, p. 191
- Strauchi, J., *"Dissertatio de Beryto"*, Brunzvigae, 1662

7 - Dionysius of Alexandria and Archelaus, *"The Works of Gregory Thaumaturgus"*, tr. S.D. F. Salmond,Edinburg, 1871 pp.49-50.

8 - Kugener, M.A., *"Patrologia Orientalis"*, Vol, II, *"Vie de Sévère"*, Paris 1907, pp.1-115

9 - Samrani, P. Ph., *"Christianity in Lebanon"* (in arabic), Al-Masira Magazine, Y.24, no. 3, 1983, p.438

10- Al-Mashreq Magazine, no.22, 1924, p.330

2

3

الشهيدة أكويلينا الجبيليه

Christianity spread throughout the Lebanese coastal cities because the Apostles and disciples had to pass through the Lebanese littoral on their way from Jerusalem to Antioch and on their way back (1).

St. John Mark, one of the Christ's 70 disciples, founded the first Church in Jbeil (Byblos). He was appointed by St. Peter bishop of the City, where he was martyred.

St. John's Church (XII° century) was probably built over the ruins of St. John Mark's Church (2) .

St. Aquilina of Byblos suffered martyrdom (293) in defense of her Christian faith and was buried in the city (3).

ARKA
TRIPOLI
ENFE
BATROUN
JBEIL
SARBA
BEIRUT
SIDON
TYRE

1

In Akura (1), in the upper region of Jbeil, a sepulchral cave had been transformed into a church, dedicated to St. Peter and St. Paul (2). The cave overlooks the old road (3) which was half-way carved in the rock. This road joined Yammuneh to the region of Akura-Tannurin where Nahr al-Jaouz springs. (4)

confirms that he saw these crosses in Hasrun, Bsharri, Ehden, and Aitou [3]. These four crosses are probably what remain of the seven crosses which St. Simon had asked to be carved.

The cross holds a special place for St. Simon and his followers, because he had chosen to live on a column to be freed from earth and to prove his yearning for heaven, imitating Jesus Christ, who was crucified for man's redemption. The union with the Crucified was the model and the stimulating power of the life of St. Simon Stylites and his followers [4]. This relation between the stylite hermits and the cross justified the construction, west of Aleppo, of St. Simon's Church in the second half of the 5th century, in the form of a cross. In the middle of this church lies the column on top of which St. Simon lived under the sky for thirty-seven years.

Several churches and shrines were built in honor of St. Simon in Lebanon, and particularly in northern Lebanon. Most of these churches are built on or near the ruins of old temples, as it is the case of the churches built in honour of St. George "Al Khodr". It is worth mentioning that those two Saints have become a symbol of the triumph of Christianity over paganism in the Lebanese mountains. The people of Jibbe pray to St. Simon when their water resources dwindle [5]. Moreover, people bring soil from the monastery bearing his name to spread it where harmful insects proliferate.

The stylites hermits had used the columns of the façade (propylaeum) or the peristyle of ancient temples. Some of these pillars were more than 16m. high and 2m. in diameter and most of them were monoliths (i.e. hewn out of one rock) as in the temple of Baal Markod in Beit Merry, or the temples of Baalbeck.

On a hill overlooking Jbeil, near Deir al-Banat (Convent of the Girls), a small church was built over the pillar of a huge old temple which is still buried until today.
This church, whose cupola almost touches the capital of the pillar, is known as the Church of St. Simon. In the region of Baoushrieh, near Beirut, the faithful still honour a pillar of St. Simon. It is believed that one of the saint's followers had used it.

Following the evangelization of the Lebanese mountain by St. Maron's disciples, monasteries, churches, and hermitages were founded in northern Lebanon, especially in the Kannoubin Valley, also known as the Kadisha Valley. The word Kannoubin or *Koinobion* is a Greek word meaning "meeting place", in reference to "the group of monks living in the monastery". Kadisha is a Syriac word meaning sanctity, denoting the sanctity of the hermits who secluded themselves in the remote grottos of the valley.

3 - Debs, B.Y., *"Tareekh Suria"*, Vol.IV, p.351

4 - Daou, F.B., *op.cit.*, Vol.I, pp.123-124

5 - Kings III, 26, 45

Not far from Aleppo (in Syria), a huge church was edified in the 5th century A.D., all around the column on top of which St. Simon Stylites lived for thirty seven years. (1)

On a hill over looking Jbeil (Byblos) a small church (2) was built over a big pillar (3) of an old huge temple, used by a Stylites Hermit.

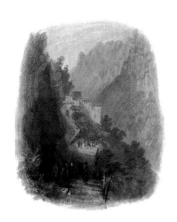

According to the historian Patriarch Douaihy, the Emperor Theodosius (378-395) built the monastery of the Kannoubin Valley around 375 i.e. before Christianity began to spread in this region with the arrival of Abraham of Cyrrhus or the disciples of St. Simon Stylites. But the Jesuit Father Henri Lammens said that the monastery had probably been built by the monk Theodosius, known as the Kannoubian. The monk Theodosius was born in 423 and lived in the period during which Christianity spread in the Jebbeh region. Theodosius is one of the fathers of asceticism who had built a monastery in Palestine. Monks flocked to this monastery from Greece, Armenia, Cicily, Syria and Lebanon. It is worth noting that the Maronites honor Theodosius and consider him among the most famous hermits.

St. Rabula Assamyati was another of those holy monks who helped spread Christianity in the Lebanese Mountain in the middle of the 5th century. *"With the help of the Caesar Zenon and John, the governor of Beirut, St. Rabula had built a big monastery in the heart of the mountains. He was living with his disciples among the inhabitants who were plunged in the darkness of paganism. He showed them the secrets of the new faith and made them convert to Christianity"* [6].

With Abraham the Hermit and Simon Stylites, spiritual ascendancy over the Lebanese Mountain passed gradually from the Baal Adon to St. Maron, both names meaning the Lord.

6 - Lammens, P.H., *"op.cit."*, Vol.I, pp.11,117

At the beginning of the 5th century, spiritual ascendency over the Lebanese Mountain passed gradually from the Baal Adon to St. Maron, both names meaning the Lord.

In 451 A. D., the Fourth Ecumenical Council was convened at Chalcedon and confirmed the teaching of the Synod of Antioch affirming the two natures in Christ: Christ is perfect God and perfect Man. He is one person in two perfect natures, divine and human. He is particularly human since nobody has denied Christ His divine nature, but rather His perfect human nature.

The Chalcedonian dogma confirms Christ's humanity, i.e. His incarnation in time. "Incarnation means that God has practically entered into history, in time and space in the shape ordinary of Man, in order to carry out the operation of Redemption and Salvation.
"The incarnated God is a model to be followed. Divine participation in Human nature therefore enables Man to participate effectively in the divine nature, such as the operation of Salvation. "From this incarnation sense, Christianity is the meeting with every man, in the perfect humanity of Jesus Christ. It is a dynamism of becoming through which the Christian, by identity, may or may not enter its realm. The more he elevates with his humanity, the more he fulfills his Christianity; the elevation of humanity is a meeting with Man because every man is potentially redeemed by Jesus Christ" [1].

The Council of Chalcedonia led to a split into the Church. On the one hand, the Chalcedonians who distinguish a dual nature in Jesus Christ, viz. the Western Church, the Byzantines, the Melkites (name now applied to the Greek Catholics) and the Maronites. On the other hand, there were the Non-Chalcedonians, so-called Monophysites who recognize in Christ one single and unique nature, viz. the Copts, the Abyssinians, the Syrian-Orthodox and the Armenian-Orthodox.

This schism was not only ideological but also political. Behind it was the struggle for power between Constantinople, the new capital of the Roman Empire, and Alexandria, which was considered as the second see of Christianity after Rome.

In 452, at the request of Pope Leo and Bishop Theodoret, the Emperor Marcianus ordered a great monastery to be built near the Orontes River north of Hama in order to strenghthen and spread the Chalcedonian dogma. This region was administratively considered, during Greek, Roman and then Byzantine times, a part of the Apamea Diocese [2]. The monastery, the largest among some thirty Chalcedonian centers, was named after St. Maron, "probably because the monks got St. Maron's relics or the whole body" [3], or because they were St. Maron's followers long before the monastery was built. St. Maron's monastery, the "cradle of the Maronite Church", was the most important of the Chalcedonian monasteries.

1 - Naaman, Ab. P., *"The Maronitism: a Middle Eastern vocation of Liberation"*, Al-Fusul Magazine, Imp. Catholique, 1980, no.3, p.40

2 - Abou El-Fida, *"Al-tawareekh Al-kadeema min al Moukhtasar fi Akhbar al-Bashar"*, Flisher Publ., Liepzig 183, p.114

3 - Lammens, P.H., *op. cit.*, Vol.II, p.90

The Council of Chalcedonia (451) led to a schism in Church. This schism was not only ideological but also political. It was behind the struggle for power between Constantinople, the new capital of the Roman Empire, and Alexandria which was considered as the second see of Christianity after Rome.

Legend:
- areas strongly Christian by 325
- areas largely Christian by 600
- ○ sites of churches founded by 600
- patriarchate
- archbishopric
- bishopric
- ecumenical council
- council
- seven churches of Asia
- Paul's first journey
- Paul's second journey
- Paul's third journey
- Paul's journey to Rome

Journey of Thomas to India

The monastery of St. Maron had quickly prospered and a large agricultural village developed in its area. This was in addition to the social, cultural and religious institutions, which flourished at the time. All this had made the monastery into a large monastic city and a powerful spiritual, cultural and religious center. *"For five centuries Maronites used to gather in the Monastery which was the center of their activities, and the heart of their struggle for their faith"* [4].

The followers of "Beit Maroun" (the Maronites) were strong defenders of the Chalcedonian dogma in Syria, Lebanon, Iraq and Palestine, "even when the Byzantine emperors and Patriarchs, and the Patriarchs of Antioch were against it." This had led to a dogmatic and moral commitment between the other Chalcedonians and the followers of Beit Maroun, who were later known as "Maronites". Maronites designated the monks of the Monastery of St. Maron and all their followers.

The struggle to establish the Chalcedonian dogma led to conflits between the Maronites and the Monophysites, who solicited the aid of the Byzantine Court, "the most inconstant in the religious history of the oriental Church". Supported by the Byzantine Emperor Anastasius, Bishop Severus became Patriarch of Antioch in 512. He persecuted the Chalcedonians, in particular the monks of

St. Maron's Monastery. In 517, the Monophysites ambushed some of the monks and their followers in the pass of Kalaat Semaan while they were on their way to St. Simon's Monastery near Aleppo. Some 350 monks were killed; their martyrdom is celebrated annually on July 31st by the Maronite and Latin Churches worldwide.

The massacre led the friends of the victims to send letters to the Church authorities complaining of the atrocities committed by the Monophysites. In a letter addressed to Pope Hormizdas dated February 517, the Maronites confirmed their belief in the Chalcedonian dogma, their loyalty to the Pope and his authority over the entire Church.

The following is an extract of the letter *"Presented by the humble servants the superiors of the monasteries in the districts of the Second Syria, to His Holiness and Sublime Sanctity, Hormizdas, the Universal Patriarch, who sits in the See of Peter, the Prince of the Apostles... Because the grace of Christ, our Lord, inspired us to have recourse to your Beatitude, like one who takes refuge from the heavy rains and storms in a safe port, we believe that the storms of persecution will not hurt us. For even though we suffer the direst hardship, we bear it with joy, believing, as we do, that the sufferings of this world are as nothing compared with the eternal glory that will be revealed to us. Because Christ, our Lord, the Supreme Pastor, has established*

1 - Daou, F.B., *op.cit.*, vol.I, pp. 145-158

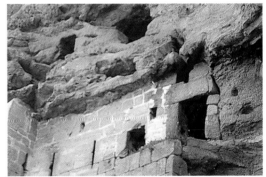

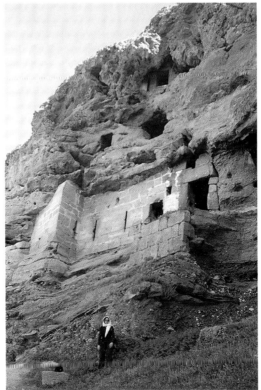

In the north of the Bekaa, near the region of Hermel, the followers of Saint Maron took refuge in three storeys-monastery named after Mar Maroun ("Magharet al-Raheb") carved in the rocks overlooking the Assi (Orontes) River.

you Doctor and Physician to every soul, we deem it our duty to reveal to you what persecution we have suffered... on the part of Severus (Patriarch of Antioch) and Peter (Bishop of Apamea)... for the purpose of compelling us to reject the Chalcedonian Council... While we were on our way towards St. Simon's Monastery for the well-being of the Church, we were attacked by wicked persons who killed 350 of us and injured as many.
Even those of us who hurried to the churches to take refuge there were killed before the altars...
We beseech you, Holy Father, to arise with strength and zeal and to have mercy on the lacerated body because you are the head of all..."
Signed: Alexander, Priest, Superior of the St. Maron Monastery. The letter was also signed by 210 Superiors of monasteries, priests and deacons [5].

On February 10th, 518, Pope Hormizdes answered in a long letter offering his condolences for those he describes as *"soldiers of Christ and members of His living body"*, and encouraging them to be stead fast in their true faith, and in their loyalty to the Papacy. He also condemned the heretics, and proclaimed that he would make every effort to defend and support the Maronites, priests and monks.

The monks of St. Maron Monastery rallied support for their cause. A Council was held in Constantinople in 536 during the reign of Emperor Justinian I (527-565). The Council excommunicated Patriarch Severus and other Monophysites. Moreover, the Emperor exiled Patriarch Severus from Constantinople and Antioch.

Because of the shrewdness and courage manifested by the Maronites in dealing with the Monophysites, Justinian II ordered the reconstruction and fortification of St. Maron Monastery to protect it against the attacks of the nomads. Empress Theodora, however, sympathized with the Monophysites and their bishop Jacob, who gave his name to the Jacobites. This sympathy was carried on by Justinian's successors, who allowed the Jacobites to organize themselves in a Syriac Jacobite Church that did not acknowledge the official Church of the Byzantine Empire. In 610, Heraclius became Emperor. He supported the Chalcedonians and endowed the monks of St. Maron with land and property.

5 - Daou, F.B., *op.cit.*, pp. 165-170 from:
 - Mansi, *"Amplissima Conciliorum"*, T. VIII, Col. 426429

The Emperor Justinian condemned the Monophysites during the Council of Constantinople held in 536, whilst the Empress Theodora sympathizing with the Monophysites and their bishop Jacob , gave them support and protection at the expense of the Maronites.

During the first half of the 7th century, the Byzantine Empire faced two dangers. The Persian or Sassanid forces conquered Syria, Lebanon and Palestine, including Jerusalem. The Church of the Resurection or Anastasis was burnt and tens of thousands of Christians were killed, all Chalcedonians. The Persians did not persecute the Jacobite Monophysites because of the latter's opposition to the Byzantine state.

Hardly had the Byzantines managed to drive the Persians back, when Arab Muslims attacked the Empire in 635 and took over Syria, Lebanon, Palestine and Egypt. They also attacked the Persians and conquered Mesopotamia. The Monophysites (oriental Semites) contributed to the downfall of the Byzantine Empire and welcomed the Muslim conquerors. They considered Islam as closer to their creed than the Chalcedonian creed, defended primarily by the Maronites. It is worth noting that most of the Christian Arab tribes in the Levant region, especially the strongest and biggest tribe, the Ghassanids, believed in the one nature of Christ .

The Council of Chalcedonia (451) had established the Christian Creed, and led to the separation of some of the Oriental Churches who had adopted the Monophysite formula (Copts, Armenians and Jacobites) from the Catholic Church. Around 638, a new theological creed, based on the belief in one will in Christ with His

dual nature, appeared in the East and compounded the dissensions among Christians. Some said that Christ had only one divine will, and were called Monothelites, while others said that Christ had two wills, one divine and one human, and were called Diothelites. "Christians in Syria (including the Maronites) believed that Christ had one will according to the official belief" [1] that had prevailed during the reign of Emperor Justinian (528-566) and Emperor Heraclius (610-641). This was also the position of Pope Honorius I (625-638) and the Patriarchs of Alexandria, Jerusalem, Constantinople and Antioch. But, the Byzantine Emperor Constantine IV (668-685) favored the creed of the two wills; the successors of Pope Honorius rejected his teachings and condemned the Monothelites. In 680, a sixth Ecumenical Council was convened in Constantinople and decreed that Christ had two wills.

At the same time, the conquest of Bilad Al-Sham by the Arabs (636) made communication between Byzantium and the West impossible. The Syrian clergy did not attend the Council of Constantinople and were not acquainted with its decisions. Therefore, Maronites kept the belief that Christ has one will with his dual nature (divine and human) expressed by Pope Honorius.

1 - Dib, Mgr. P., *"Histoire de l'Eglise Maronite"*, Beirut 1962, vol. I, p. 30

In 635, Arab Muslims invaded the Byzantine Empire and took over Syria, Lebanon, Palestine and Egypt. They also attacked the Persians and conquered Mesopotamia.
Consequently, all the roads were cut off between the Byzantine Empire and the West, on one hand, and the Levant countries ("Bilad al-Sham"), on the other hand.

Conquests of Muhammad (The Prophet) 622-32
Conquests of the Rashidin Caliphs 632-61
Conquests of the Umayyads 661-750
Conquests of the early Abbasids 750-945
Routes of conquest
Byzantine empire at the end of the 10th century

0 800 km.
0 500 miles

In 727, a schism occurred in the Church of Antioch between the Maronites and the Chalcedonian Greeks because of the Monothelite belief. Michael the Syrian, quoting from Al-Talmahri, affirms that the schism between the Chalcedonians was due to the "heresy (i.e. the dogma of two wills) which prevailed in the Byzantine empire since the reign of Constantine", and "which was not admitted in Syria. This heresy came with the prisoners brought by Arabs to Syria". [2]

But, when the Maronites had direct contact with the Latin Church during the Crusade period, they realized that the Monothelite belief disagreed with that of the Roman Church. The Maronites did not hesitate to adopt the decisions of the Roman Church; their first attitude had been sincerely innocent because they thought it was the true belief of the Church of Rome; they had considered themselves always united with the papacy because their faith was the faith of St. Peter.

The religious conflicts between Chalcedonians and non-Chalcedonians, Monothelites and Diothelites, involving the Maronites since the second half of the 5th century, *"had hidden political interests and rivalries as well as expressing the strong aversion of the Semitic Egypt and Syria to the Greek world and its capital, Constantinople."* [3]

These political and religious conflicts nourished the Maronites' sense of independence.

All Maronites living in the mountains belonged to the Syriac-Aramaic culture; they embraced Christianity, be it in Syria or in Lebanon, at the hands of the followers of St. Maron, contrary to the Christians of the big cities who belonged to the Greek, Roman and Byzantine culture, and who were preached to by the Apostles and the disciples.

The inconstancy in the positions of the Byzantine rulers, at the end of the 7th century, led to political strife and encouraged the faithful of the Church of Antioch , mainly the Maronites, to seek independence from the Byzantine Empire. Moreover, they opposed the intervention of the Byzantine Court in the affairs of the Church [4], because this intervention and tyranny resulted in political corruption. Parallel to their aspiration to independence from Byzantium, Maronites complied with the heritage, dogma, administration and organization of the Church of Antioch, and kept their loyalty to the Roman Catholic Papacy. Rome encouraged this trend of independence from Byzantium because the Byzantine Empire and Church had attempted to affirm the see of Constantinople as the first see in the Christian Church, after Constantinople became the capital of the eastern part of the Roman Empire at the end of the 4th century.

This trend gradually pushed the Maronites to rebel against the policies of the Byzantine regime, which had compromised their freedom and independence.

2 - Daou, F.B., *op. cit.*, vol. I, pp. 342-381

3 - Diehl et Marcais, *"Le Monde Oriental de 395 à 1081"*, Paris 1944, p. 22

4 - Saade, F.S., *"al-Fikr al-Marouni fi al-Tarikh"*, Beirut 1985, p. 67

The Maronites as a mountain people, belong to the Syriac-Aramaic culture. They embraced Christianity, be it in Syria or in Lebanon, at the hands of the followers of St. Maron, contrary to the Christians of the big cities who belonged to the Greek, Roman and Byzantine culture, and who were preached by the Apostles and the disciples.

The Mardaites

1 - Al-Balaziri, *"Futuh al-Buldan"*, Salah eddin al-Munjid Publ., Cairo 1957, Part.I, p. 189

2 - Daou, F.B., *op.cit.*, vol. III, 1976, pp. 203-216

3 - Lammens, F.H., *op.cit.*, vol. II, p. 47

4 - Daou, F.B., *op.cit.*, vol. I, p. 304

5 - Lammens, F.H., *"Etude sur le règne du Calife Omayade Moawia 1er"*, MFO, I, 1906, p. 17

6 - Daou, F.B., *op.cit.*, vol. IV, pp. 209-220

7 - Daou, F.B., *op.cit.*, vol. I, p. 293

Between 660-690, a militant movement appeared in the mountainous region extending from Amanus and northern Syria to the mountains of Galilee, with Lebanon as its stronghold. The Byzantines organized this movement to fight the Umayyads. It was formed of groups of warriors known as the "Jarajima" (named after the city of "Jarjouma" near Antioch [1].

The Jarajima, also known as "Marada" ("Mardaites", strong men) were "a ruthless Persian generation, called after by kings to defend their property because they were well trained for wars" [2].

According to the German scholar Noeldeke, Arabs called the "Marada" by the name "Jarajima" although both formed one nation [3].
The Byzantine historian Theophanus called them *"the brass arm of the kingdom"*. They had been Zoroastrians but then converted to Christianity and became Chalcedonian Melkite since they had inhabited the mountains under the Greek Byzantine rule. *"No doubt that the Maronite monks preached Christianity to the Jarajima (Mardaites)"* [4], because the region of Cyrrhus, which was the cradle of monastic life and evangelization was near Djourjouma, capital of the Mardaites.

During Byzantine rule, the Jarajima were under the authority of the governor of Antioch. After Abu Obeida conquered Antioch in 638, the Jarajima sought reconciliation with the Arabs, and committed themselves to assist the Muslims in Mount Amanus during wartime, provided that they did not have to pay taxes. The Jarajima were sometimes loyal to the governors and sometimes took side with the Byzantines [5]. In 677, the Byzantines waged war against the Umayyads to regain the territory they had lost, taking advantage of the internal conflicts among the Arabs particularly between Moawiya and Imam Ali . The Byzantine army gathered "a big group of the Jarajima among whom were Maronites from Syria and Lebanon" [6].

The Byzantines were able to dominate the mountainous region stretching from the "Black Mountain" overlooking "Assouaydia" to Jerusalem. The Marada-Jarajima made of the Lebanese mountains their stronghold; they raided the Umayyads causing them extensive damage. Consequently, Moawiya, the Umayyad Caliph, was forced to sign a peace treaty with them and with the Byzantine emperor Constantine IV, by virtue of which he agreed to pay a ransom of 3000 golden dinars and fifty Arabian horses annually, and to set free 8000 Byzantine prisoners [7].

Antioch
Aleppo
Amanus
Hama
Homs
Byblos
Baskinta
Beirut
Damascus
Sidon
Tyre
Al-Jalil

The Mardaites formed with the
Maronites a strong army.
The merging of the natives with
the non-natives (the Mardaites) was
accelerated because they shared the
same language (Syriac), the same
Chalcedonian faith which distinguished
the Maronites, and the same objectives
of defending their land against the
expansion of the Umayyads.

This treaty endowed the Mardaites with more authority and power. When Justinian II became emperor of Byzantium (685-695), he wanted to regain the Levant region from the Arabs. He mobilized large groups of the inhabitants of the northern borders and sent with them a division of the Byzantine army. This army was able, with the support of the Jarajima, to conquer Syria, Lebanon, northern Palestine and the Golan region.

In this sense, the historian Balaziri mentions that *"the Byzantine army walked into the Loukam Mountain then to Lebanon. They were joined by the Mardaites, and the Muslims' slaves. The Caliph Abdul Malik was obliged to sign a treaty in which he agreed to pay the Byzantines 1000 golden dinars per week, half the revenues of Cyprus, Armenia, and Iberia; and to offer a horse and a slave to the Emperor every day"* [8]. This treaty enabled Abdul Malik to go to Iraq and Hijaz and assume the Caliphate. On the other hand, the treaty committed the Byzantines to withdraw their forces from all the regions they had conquered. Justinian II withdrew his army composed of 12000 soldiers; but some of the Mardaites and the autochtonous remained in their strongholds [9].

Mount Lebanon had become the stronghold of the Mardaites, and Baskinta their capital. Patriarch Douaihy notes in his history that *"a king named Youhanna conquered the entire Holy Land. Accompanied by a large group, he headed to Jerusalem passing by Carmel. On their way, thieves embushed them and killed 3000 men. The king and his remaining men retaliated by killing 9000 persons of their enemy, plundered for booty, and took the children, the women and the cattle. Back in Lebanon, the King settled in Baskinta"* [10].

The Mardaites formed with the Maronites a strong army. The merging of the natives (the Maronites) with the non-natives (the Mardaites) was accelerated because they shared the same language (Syriac), the same Chalcedonian faith which distinguished the Maronites, and the same objectives of defending their land against the expansion of the Umayyads.

The historian Ibn al-Qilai talks about *"the Maronites and their prince who lived in Baskinta"*. In his description, he makes no distinction between the Mardaites and the Maronites: *"The Maronites lived in Mount Lebanon where they spread their authority on the mountains and neighbouring coasts. They were loyal to the Roman Church and to their Patriarch"* [11]. Ibn al-Qilai adds that the Prince of the Maronites who lived in Baskinta was "proud of himself and his men. He attacked the Bekaa Valley, plundered the villages and killed many villagers. When the news reached Abdul Malek ben Marwan, he sent the Prince gifts

8 - Ismail, A., *"Histoire du Liban"*, 1955, T.I, p.171, note 358

9 - Makki, M-A., *"Lubnan, min al-Fateh al-Arabi ila al-Fateh al-Uthmani"*, Dar al-Nahar Publ., Beirut 1977, p.44

10 - Douaihi, Pat. E., *op.cit.*, pp. 69-70

11 - Ibn Al- Qilai, *"Hurub al-Muqaddamin"*, publ. by Father Bulos Karali, in al-Majallat al-Batriarqiat, Y.5, vol. 8, October, p. 522
- Hobeika, Arch. B., *"History of Baskinta"* (in arabic), Beirut 1946, pp. 8-9

The Arab conquest had negative repercussions on the economy of the Lebanese coastal cities. The maritime commercial activity of the ancient Lebanese-Phoenician cities was crippled; consequently, the Lebanese sought refuge in the mountains, where they lived from what the land offered. They became "mountain fighters," strongly attached to their land and ready to die defending it because it was the stronghold of their freedom and faith.

on the pretence of allying with him. But later, he betrayed the Prince and killed him along with his men, burnt the villages and chased the Maronites from the Bekaa. Al-Douaihy relates that the Prince of the Maronites was *"the Prince of the Mardaites, whose name was Youhanna and whose title was Prince of Mount Lebanon"* [12].

The Arab conquest had negative repercussions on the economy of the Lebanese coastal cities. The maritime commercial activity of the ancient Lebanese-Phoenician cities was crippled; consequently, the Lebanese sought refuge in the mountains, where they lived from what the land offered. They became "mountain fighters," strongly attached to their land and ready to die defending it because it was the stronghold of their freedom and faith.

Ibn al-Qilai describes some battles in which the Maronites fought bravely to defend the freedom of their land. Among these battles were those of Al-Mrouj and Nahr al-Kalb (around 690); *"After Prince Youhanna was killed in Qab-Elias, the Maronite army accompanied by its leaders headed to the mountain where they fought against the Muslim army in Al-Mrouj. The Muqaddam Semaan won the battle but the war continued for thirty years. Another battle took place at Nahr-el-kalb. Meanwhile Muqaddam Semaan was in Bikfaya. When he heard about the battle, he led an army of 1500 soldiers and headed to Nahr al- Kalb where he victoriously fought the enemy".*

In the 8th and 9th centuries, the Maronites homeland, which stretched between the Beirut River in the south and Akkar in the north, formed a compact unity, headed by the Patriarch as national and ecclesiastical chief and administered by two princes; the prince of Baskinta governed Kisrawan and the southern half of the Maronite state, and the prince of Byblos administered the northern half.

Ibn al-Qilai reports that *"Prince Semaan of Baskinta visited Prince Yussif of Byblos in the presence of Patriarch Gregorios. The meeting had the solemn form of a general Maronite Council, assembling all forty Maronite bishops, headed by the Maronite Patriarch, from the boundaries of Akkar to those of the Shouf. They confirmed Semaan as prince of Kisrawan and granted him great support in the event of war with the Muslims".* Semaan was succeeded by his uncle Kisra, who won successive victories over the Muslim armies. As a result, the Maronites recognized him as a national hero. To perpetuate his memory, a great portion of the Lebanese Mountain, Kisrawan was named after him [13].

Around 708 A.D., the Umayyad Caliph Al-Walid ben Abdul Malak fought a war against the Jarajima in northern Syria. His brother conquered Jarjouma, forcing the inhabitants to flee to Anatolia and Lebanon, where they joined their Christian coreligionists. Once again, the Lebanese mountain proved to be the stronghold of the minorities and the persecuted.

12 - Makki, M-A., *op.cit.,* p.44

13 - Douaihi, Pat. E., *op.cit.,* pp.98-100

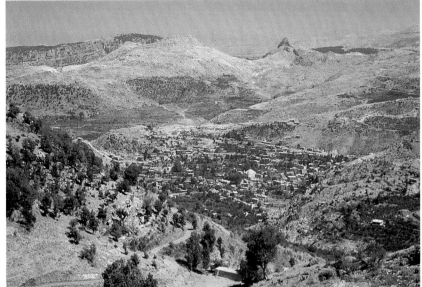

"The Maronites lived in Mount Lebanon where they spread their authority on the mountains and neighbouring coasts. They were loyal to the Roman Church and to their Patriarch" (Ibn al-Qilai).

Youhanna Maroun, First Maronite Patriarch of Antioch (685)

Following the Persian Sassanid invasion of Syria, to the falling of Antioch and the killing of Patriarch Anastasius II in 609, the Patriarchal See of Antioch remained vacant for more than 36 years. The see remained vacant on account of the Persian invasions on the one hand, and the Arab occupation of the Levant region (Bilad Al-Sham) on the other.

The Patriarchs appointed by Constantinople were nominal and uncanonical because, according to Church law, bishops used to convene in the patriarchal diocese and elect the Patriarch without any intervention. The king only had the right of confirming the election which took place in a legitimate and free way. After the Arab conquest, the patriarchs appointed by Constantinople never stayed in Antioch because roads were cut between the Byzantine capital and Syria. Besides, they did not have any real authority and were not recognized by the Roman Church.

Five patriarchs appointed by Constantinople succeeded to the Patriarchal See of Antioch from 645 to 702. Macedonius held it from 645 to 649, but was excommunicated by the Pope because he had usurped the title of Patriarch. Then Macarius had held the see from 650 to 680. The sixth Ecumenical Council deposed him and exiled him to Rome because he refused to renounce the heresy of Monothelite. Theophanus succeeded him in 681 and then

Georgius held the see from 686 to 702.

When Abdel Malek bin Marwan became Caliph in 685, the Marada Maronites renewed their attacks from the Lebanese mountain against the Umayyads with an army of more than 30,000 men. The Umayyad Caliph and Justinian II then signed a treaty in which the Byzantine Emperor pledged to remove the Mardaites from Lebanon. This treachery dealt the Maronites and Christianity in the East a severe blow and deepened the Maronite resentment against the Byzantine Empire. It also augmented the Maronites' sense of independence and their desire to liberate the Antiochean Church from Byzantine influence.

In 685 the Patriarch of Antioch Theophanus died. The Chalcedonian party of the Antiochean Church elected Youhanna (John) Maroun, one of the monks of St. Maron's Monastery, as Patriarch of Antioch. The Chalcedonians did not consult the Byzantine court because of its former abuses of authority in nominating patriarchs who, because of the Persian and Arab invasions, could never reside in Antioch. Thus, Youhanna Maroun, Bishop of Batroun and Mount Lebanon in 676, became the first Maronite Patriarch and the sixty-third Patriarch of Antioch since St. Peter. With him, the Chalcedonian Church in the Levant began a new era.

In 685, the Chalcedonian clan of the Church of Antioch elected
Youhanna (John) Maroun, one of the monks of St. Maron's Monastery
and bishop of Batrun and Mount Lebanon since 676, as the first
Maronite Patriarch of Antioch and the sixty third Patriarch of Antioch
since St. Peter.
He resided in Kfarhai, where he died in 707.

St. John Maron was born in the village of Sarum (or Sarmaniah), in Al-Souaidiah Mountain, 50 kms from Antioch and 40kms from St. Maron's Monastery. When John was but a small boy, he was sent to Antioch to pursue his studies in Syriac and Greek. Later he was sent to the St. Maron monastery, and then he went to Constantinople to study Greek and patristics. When he learnt of the death of his parents, he returned to Antioch. He retired to St. Maron's Monastery, where he was ordained priest. He started his mission spreading the teachings of the Chalcedonian Council and the Roman Church.

In his *History*, Patriarch Douaihy relates how, in 676, John Maron was consecrated bishop of Batroun and Mount Lebanon. *"The Pope's delegate came to Antioch to preach the dogma of the two natures and two wills in Jesus Christ. In that time Macarius, the Antiochean Patriarch living in Constantinople, professed the official dogma of the Byzantine Empire, that is to say the one will in Jesus Christ. John Maron attracted by his deeds and faith the attention of the French prince Eugene who presented him to the Pope's delegate. The Cardinal consecrated John Maron bishop of Batrun and Mount Lebanon with the mission of preserving the Roman Catholic faith in Lebanon"* [1].

In the same year that John Maron became bishop of Batrun and Mount Lebanon, the Jarajima-Mardaites extended their conquests to Mount Lebanon, their main stronghold. It was no coincidence that in the same year that John Maron was made bishop the Mardaites conducted their compaign. The main purpose of the Roman Church was to ensure that the Lebanese Maronites preserved their Catholic faith and maintained their loyalty to Rome, and to protect the Mardaites against the Byzantine Empire influence. Patriarch Douaihy mentions that when John Maron was consecrated bishop, *"he joined his flock in Lebanon, working with the zeal of Apostles for the conversion of non-Catholics. Under the guidance of St. Maron, the Maronite community increased greatly in number, and took possession of Mount Lebanon and the mountain range from Cilicia and Armenia to Jerusalem"* [2].

Bishop John Maron's main purpose was to unite the Maronites spiritually and to secure the freedom and independence of the Church with respect to the Byzantine Empire, fact which qualified him to become bishop of Antioch to put the Antiochean Church on the right track.

The Byzantine Emperor considered this election a violation of his authority. He sent an army to capture the new Patriarch residing in St. Maron's monastery and to put an end to the separatist movement. The army pillaged St. Maron's monastery and killed 500 monks. Youhanna Maroun managed to escape to the castle of Smar Jbeil in Lebanon. In his diocese in Batrun, the Patriarch prepared to fight the Emperor's army.

1 - Daou, F. B., *op.cit.,* vol. I, p.363

2 - Douaihi, Pat. E., *op.cit.,* p.63

Smar Jbeil, an ancient shrine of the Lebanese Mountain, became the refuge of Patriarch Youhanna Maroun, tracked by the armies of the Byzantine Emperor.

According to the Maronite chronicles, the Patriarch's nephew, Ibrahim, sent his uncle 12,000 men from Syria. They joined the Lebanese Maronites and what was left of the Marada army under the leadership of Prince Massoud. The joint forces defeated the Byzantine army in 694. Maurikios and Markianos, the leaders of the Byzantine army, were killed and buried in Amyoun and Shoueti-Akkar respectively [3].

Youhanna Maroun transferred his patriarchal seat to Kfarhai, where he built a monastery to house St. Maron's skull. Later, Maronite Patriarchs stayed either in Kfarhai or in St. Maron's Monastery in Syria.

The Maronites' determination to be independent of Byzantine authority led the Umayyads to change their attitude. In his *History of Damascus*, Ibn Açaker mentions that several caliphs lived and died in Maronite monasteries. Abdul Malek bin Marwan (685-705) used to spend spring in St. Maron's Monastery near Damascus; Omar bin Abdulaziz (717-720) used to stay in St. Simon's monastery near Aleppo and was buried there. In addition, the weddings of some Umayyad princes were held in St. Maron' Monastery [4].

Relations between the Maronites and the Byzantines improved during the reign of the emperor Tiberius. As a result, the Maronites, led by Simon the Mountain Prince, joined the Byzantines and defeated the Arabs in 669. *"As a token of gratitude, the Byzantine Emperor sent Patriarch John Maron a royal flower along with a letter thanking his holiness and his brave followers"* [5].

In 702, following the death of the Patriarch of Antioch in Constantinople, the Emperor was not keen to appoint another patriarch. Youhanna Maroun thus became undisputed Chalcedonian Patriarch of Antioch. He died in 707 and was buried in Kfarhaï. In 742 the Antiochean Church was divided into two distinct Churches: The Antiochean Chalcedonian Syriac Maronite Church and the Antiochean Chalcedonian Imperial Byzantine Church.

Patriarch St. John Maron died, according to the Maronite traditions and historians, on the 9th of February of the year 707 in St. Maron's Monastery, in Kfar-Hai, Batrun-Lebanon, and was buried there. His feast used to be celebrated in the Maronite calendar with that of St. Maron, i.e. on February 9th, until in 1787 Patriarch Yussef Estephan from Ghosta moved the feast of St. John Maron to March 2nd [6].

3 - Debs, Bish Y., *"History of Syria"*, (in arabic), vol. V, pp.121-122

4 - Ibn Açakir, *"History of Damascus"*, (in arabic), Al-Raouda Press, Damascus 1329h., pp. 210-251

5 - Douaihi, Pat. E., *op.cit.*, p.91

6 - Fahed, Ab.B., *op.cit.*, from 685 to 12ᵗʰ century, p.126

In 938, Yanuh, *"one of the most beautiful towns of Jibbet al-Munaytra"*, became the Maronite Patriarchal Seat in Lebanon, after the destruction of St. Maron's Monastery on the Orontes River *"by the Sultan and the agression of the Arabs"* (Douaihi).

In Yanuh, on the ruins of an ancient temple dedicated to Baal Adon, a monastery was built and dedicated to Saint George named "Al- Azrak" = the "Blue" (rather: the "Green" = the "Khodr" = "Adon").

Between the fall of the Umayyads and the rise of the Abbasids in 750, and the first Crusade in 1098, the East suffered from chaos and instability. The regional states fought over this land and control passed from one hand to another several times.

The Maronites fled to the mountains and managed to maintain relative autonomy. *"The owners of large estates in Lebanon, urged by a desire to become the military leaders of their farmers, formed with the encouragement of the clergy a small Maronite nation with a feudal hierarchy. This nation had a strong patriotic feeling often manifested itself in times of distress and when the inhabitants rallied in support of their Patriarch"* [1].

When the Maronites had elected John Maron Patriarch, the Lebanese mountainous region knew relative stability under one spiritual leadership. Moreover, the relations between the Maronites and the Umayyad Caliph Moawiyah and his successors were governed by treaties and understanding.

The Maronites tilled the land and turned the rugged terrain into a fertile one to compensate the closing of the coastal maritime cities. This prosperity was also spiritual, for many hermits and anchorites lived in Mount Lebanon, as attested by many historians such as Ibn Qutaiba, al-Maqdissi, and others.

Chaos prevailed during the reign of the last Umayyad caliph, Marwan II (744-750). The situation worsened when the Shiites rejected the Umayyad power, for they considered it a usurpation of the caliphate, which should legally have gone to Imam Ali and his successors. Added to that, the resentment of non-Arab Muslims in general and Persian Muslims in particular due to their bad treatment under the Umayyads, made the situation worse.

With the outbreak of the revolution in Khorassan (Iran) and Irak in 749, the Abbasids overthrew the Umayyads and Abul-Abbas seized the caliphate, the seat of which was moved from Damascus to Baghdad. In 750, *"the soldiers of Abdallah Bin Ali spread terror by killing many Jews and Christians"* [2]. The Lebanese were on their guard against the new rule of terror, and did not react at the beginning.

The outrages committed by the Abbasids and their rulers provoked the resentment of the Maronites of Mount Lebanon. In 759, the inhabitants of the region of Jebbet al-Munaytra complained to the Abbasid ruler of Baalbeck about the high taxes, but received no response.

1 - Ristelhueber, *"Les traditions Françaises au Liban"*, Paris, Lib.Felix Alcan, 1918, p.15

2 - Makki A., *op.cit.*, p.60

When the Maronites had elected John Maron Patriarch, the Lebanese mountainous region knew relative stability under one spiritual leadership. The Maronites tilled the land and turned the rugged terrain into a prosperous one to compensate for the closing of the coastal maritime cities.

This prosperity was also spiritual, for many hermits and anchorites lived in Mount Lebanon, as attested by many historians such as Ibn-Qutaiba, Al-Maqdissi, and others.

Led by their chief Bandar, a youthful and burly mountaineer, whom "they crowned king", and who raised the banner of the cross, the Maronites assaulted some villages of the Bekaa [3]; while advancing towards Baalbeck, they suffered heavy losses in an ambush. They were then followed to al-Munaytra, where their fort was seized and many inhabitants were killed and others captured. These cruelties against the Christians of the Lebanese mountain provoked the protestations of the Baalbaki legislator, Iman Abdul Rahman al-Ouzai (707-774-), who wrote a letter to the ruler of Baalbeck expressing his indignation at the killing of innocent Christian villagers [4].

After the revolt of al-Munaytra, the Abbasid Caliph Abu Jaafar al-Mansur (754-775) implanted Arab tribes in the Lebanese mountain for the purpose of restraining Maronite expansion from the north and Byzantine raids from the sea. The most important of these tribes was that of al-Tannukh (763) [5]. The newcomers fulfilled the mission assigned to them by al-Mansur, protecting the coastal region and the mountain overlooking Beirut from Maronite invasions. Many military confrontations occurred between the Maronites and the Tannukhi; the most important of these were those of Nahr-al-Mot, near Beirut resulting in the withdrawal of the Maronites to the north of Beirut. Thus, the first Islamic Arab Emirate of Tannukh was established in Lebanon. It lasted

for eight centuries, until the beginning of the Ottoman rule.

In the 9th century, the Muslim Abbassid Caliphate began to crumble because the caliphs adopted the principle of renting out the districts of the empire to rulers who were mostly Turks and Persians. Moreover, army leaders and the Caliph guards were Turkish Mamluks who became the real rulers of the empire from the beginning of the reign of al-Mo'tasem (833-842). Consequently in 872, Ahmad Ibn Tolon, the Turkish ruler of Egypt, declared it independent from the Abbassid Empire and conquered Palestine, Syria, and Lebanon. In 935, the Akhshidi kingdom replaced the Tolonians; and in 969 the Fatimid Empire rose in Egypt and conquered Palestine, Syria, and Lebanon. Thus, the Shiite Fatimid Caliphate in Egypt replaced the decadent Sunnite Abbassid Empire centered on Baghdad since 945.

During the reign of the Fatimid Caliph Al-Hakim bi-Amrellah (996-1021), Christians were persecuted and subjected to humiliating disabilities. Thousands of churches were demolished, among which was the church of the Holy Sepulchre in Jerusalem, a fact which led Christian European nations to mobilize the Crusades to liberate the Holy Land.

3 - Ibn Açakir, "Tarikh Dimashq",part 5, p.341

4 - Al-Balaziri, "Futuh Al -Buldan", Leiden 1863-1866, p.162

5 - Al-Shidyaq, "Akhbar Al-Aayan fi tarikh Lubnan", Al-Ourfan Lib., Beirut 1954, vol. 2, p.279

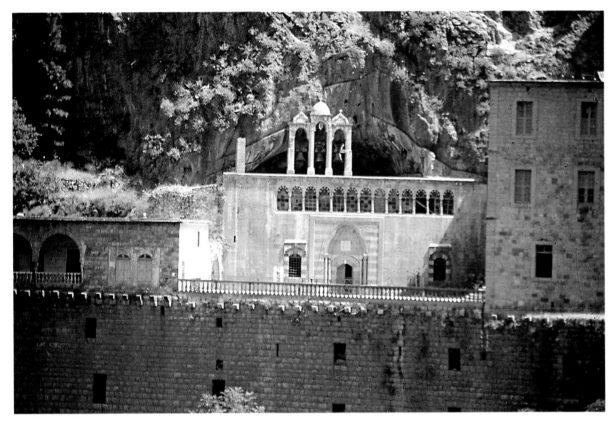

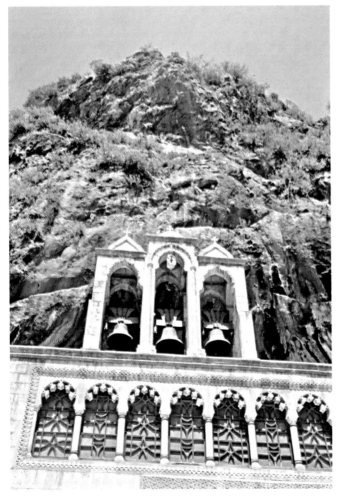

The foundation of the Maronite School of Rome was followed by the establishment of the first printing press in the Levant in 1610, in the Monastery of Qozhaya, Lebanon. This press published Arabic books in the Syriac script (Karshuni).

BIBLIOTHECAE
M E D I C E A E
LAVRENTIANAE ET PALATINAE
CODICVM MMS. ORIENTALIVM
C A T A L O G V S
SVB AVSPICIIS
REGIAE CELSITVDINIS SERENISSIMI
F R A N C I S C I I I I
LOTHARINGIAE ET BARRI DVCIS
REGIS HIERVSALEM
M A G N I D V C I S E T R V R I A E
STEPHANVS EVODIVS ASSEMANVS ARCHIEP. APAMEAE
RECENSVIT DIGESSIT MARIA ILLVSTRAVIT
ANTONIO FRANCISCO GORIO CVRANTE.

FLORENTIAE ANNO · CIƆ IƆ CC XLII.
EX TYPOGRAPHIO ALBIZZINIANO · PRAESIDIBVS ADNVENTIBVS.

into a school where, with the approval of Pope Leo XIII and Patriarch Youhanna el-Hajj, he accommodated fifteen students from Lebanon. Lebanese Maronite students studied in this new school, which was administered by the Jesuit Fathers from 1931 to 1939, date of the outbreak of World War II. Subsequently, the School closed its doors; it later became the seat of the Maronite Patriarchal secretary in Rome.[6]

The Maronite School of Rome fulfilled its mission for 254 years (1584-1939). It had a pioneer role in the different religious, scientific, political and cultural fields, enriching both East and West with the achievements of its scholars, who introduced Western culture to the East, and were an incentive for Europeans to study the Orient. Although the Maronites had aquired Western culture, they remained faithful to their Eastern heritage and confirmed the cultural role of Lebanon as a link between East and West.

Two hundred and eighty students graduated from the Maronite School between its foundation and its abolition by Napoleon in 1788. The documents mention around forty bishops among the School alumni, seven of whom became patriarchs; the first was Patriarch George Amira (1568-1644), and the most brilliant was the historian scholar Patriarch Estephan Douaihi (1630-1704).

Among the most brilliant scholars, alumni of the Maronite School, we distinguish:

• Gibrael al-Sahyuny (1577-1648) known in the West as Gabriel Sionita. He acquired so great a reputation that Louis XIII, king of France, appointed him at the head of the Oriental languages department at the Royal College of France, and gave him the title of Royal Interpreter. He published the Parisian Polyglot Bible in seven languages, and contributed to introducing the Oriental characters to Europe. He was also the author of many other works.
• Youhanna al-Hasruny (Hesronita in Latin) collaborated with al-Sahyuny in the Polyglot Bible, and in the Arabic grammar published in Latin.
• Ibrahim al-Haqlany (1605-1664) (Abrahamus Ecchellensis in Latin) taught Arabic and Syriac at the University of Sapienza in Rome. He published many books and treatises, a fact which made him illustrious in the East and the West.
• Sarkis al-Jamry taught Oriental languages at the Royal College of Paris between 1648 and 1658. He was appointed interpreter to Louis XIV.
• Yussef Asemaani (1687-1768) was the most distinguished scholar of the Maronite School of Rome. He was appointed custodian at the Vatican Library. The Pope sent him to collect Oriental manuscripts from Egypt, Syria and Lebanon. The Pope also appointed him at the head of the Regional Maronite Synod held in 1736 in the monastery of Our Lady of Louaizeh, in response to the request of the Maronite Patriarch and bishops. In this Synod, the reorganization of the Maronite Church and the establishment of schools in all villages and cities were considered among the necessary Church reforms: *"we command that fathers send their boys to school to acquire knowledge even against their will"*. Asemaani published many works in different fields including history, philosophy, theology, law, and art.
• Yussef Louis Asemaani (1710-1782) was appointed professor of Oriental languages at the Sapienza College. In 1749, he was appointed both a member and a professor in the Pontifical Academy.
• Michael al-Ghaziri (1710-1791) settled in Spain where he worked on the organization of Arabic manuscripts in the Royal Library of the Escurial. He also published many books on Arabic grammar.
• Tadros al-Adm (1721-1799) was the first professor of Oriental languages in Prague.
• Yussef Estephan (1729-1793), who later became Patriarch, established the school of Ayn Warqa in 1789, which was the first Oriental Christian school to graduate priests who were later to become teachers of their own communities.

The cultural peculiarity of the Maronite School had its impact in Europe, where the saying "Knowledgeable like a Maronite" was very much in use.

8 - Gemayel, F.N., -" ... *Students of the Maronite School"* (in arabic), Al-Manarat Magazine, Y. 25, p. 91...

The Maronite Patriarchs built churches and monasteries, the belfries of which called the faithful to prayer.
They also established schools to spread the light of learning throughout Lebanon and the neighbouring regions.

1 - Al-Shahabi, H., *"Al-Ghorar al-hissan fi tawarikh al-zaman"*, Cairo, p. 561

2 - Al-Shidyaq, T., *op. cit.*, p. 252
- Maalouf, 1., *"History of Prince Fakhreddin Maan II"* (in arabic), Beirut 1966, pp. 45-50

3- Salibi, K., *"Fakhreddin II..."*, USEK symposium: *"The Lebanese Nationalism"*, Kaslik, Lebanon 1970, p. 109

In 1120, Prince Maan al-Ayyubi received orders from Tughtagin, Saljuk governor of Damascus, to lead his tribe into the Shouf, on the southwestern slopes of Mount Lebanon, and harass the Crusaders on the maritime plain. The Maan family converted to the Druze religion and made Baaklin their headquarters.

After the Ottomans had defeated the Mamluks in the battle of Marj Dabiq (1516), the Ottoman Sultan Salim I appointed Fakhreddin I, his ally, Prince of the Shouf Emirate and gave him the title of "Sultan of the Land". Qurqumaz Maan succeeded his father as Emir and married Sitt (Lady) Nassab, sister of Prince Sayfeddin al-Buhturi. After Prince Qurqumaz died in 1584, Prince al-Buhturi took over the custody of his minor nephews, Fakhreddin and Yunis. In 1590 Sayfeddin entrusted to Fakhreddin II with the Shouf Emirate. Fakhreddin had many goals, among which were the unifying of Lebanon and the extension of his emirate. In 1591, he persuaded the governors of Damascus to entrust him with the districts of the West, the Jurd and the Metn. He also benefited from the elimination of the Furaikh family and incorporated the Beqaa into his expanding emirate.

In 1594, the governor of Damascus granted him rule over the district of Sidon. Thus, he was ruler of all Lebanon excepting only the North. Now his only adversaries were the Syfas, princes of the northern region of Akkar, who had defeated the Assafs, allies of Fakhreddin, in 1590. Fakhreddin's emirate now stretched from Akka in the South to Beirut and Kisrawan in the North. In 1605, Fakhreddin defeated his rival Yussef Syfa in the battle of Jounieh; as a result, Fakhreddin took over Beirut and Kisrawan. After he conquered Kisrawan, his relations with the Maronites strengthened. This relationship, especially with the Khazen family, goes back, according to some historians, to the story about how Prince Fakhreddin and his brother Yunis took refuge after their father's death in Balluneh, Kisrawan, in the house of Ibrahim Sarkis al-Kazen and his brother Rabah. There were other factors that fostered this relationship:

First, the Maronites were favored in Kisrawan during the reign of al-Assaf. After Prince Mohamad Assaf was killed, Yussef Syfa took over the region and persecuted and killed the allies of the Assafs, mainly the Maronite Hobeish family, who fled to the west, and were replaced by the Shiite Hamadi family. The Hobeishes called Fakhreddin and persuaded him to chase away Yussef Syfa from their region. When Fakhreddin conquered Kisrawan, the Maronites rallied around him and offered him support. In 1615, Prince Yunis appointed Sheikh Aba Nader al-Khazen to the district of Kisrawan, a fact which resulted in "the rise of the new Maronite leadership of the Khazens instead of the Syfas. The new family had strong bonds with the Maan Emirate ."

Prince Fakhreddin Maan II (1572-1635)

" *Small of stature, but great in courage and achievements; subtle as a fox, and not a little inclining to the tyrant*" (G. Sandys 1621).

In 1624, the Ottoman Sultan Murad IV acknowledged Fakhreddin as the *"Lord of Arabistan"* from Northern Syria to Southern Palestine, and from the Syrian desert to the Mediterranean Sea. He, however, preferred the title of *"Emir of Mount Lebanon, Sidon and Galilee"*.

Throughout this entire area, he organised a tremendous security system composed of forty-seven castles, fortresses and towers.

Second, Fakhreddin's goal was to free Lebanon from Turkish control and for this he sought the aid of a strong foreign power, enemy to the Sultan. Thus, instead of resorting to France, which was a friend of the Sublime Porte (Ottoman Sultanate), he solicited the aid of Florence, which was then governed by the Grand Duke of Tuscany, Ferdinand I de Medicis.

Before becoming Duke of Tuscany, Ferdinand had been a Cardinal, one who had a special interest in the Maronites of Lebanon due to his relations with the Maronites of the School of Rome. Fakhreddin established firm relations with the Maronite Patriarch, Yuhanna Makhluf, who had been consecrated in 1608, and resided in Mejdel-Meoush in the Shouf, under the protection of Fakhreddin. The Patriarch appointed Bishop Gerges Omayra ben Maron as representative of the Emir to the Papal See. Omayra negotiated with Pope Urban VIII and the Duke of Tuscany to wage a military compaign to free the Holy Land from Turkey.[4] In the same year (1608), Fakhreddin signed a secret treaty with the representative of Ferdinand I by virtue of which the two parties agreed to form an alliance against the Ottomans. This treaty included an article stating that Ferdinand should obtain from the Pope a bull commanding the Maronites to be on the side of Fakhreddin in his future wars.[5]

When the Sultan learnt about the treaty, he commanded Hafiz Pasha of Damascus to attack Fakhreddin from land and sea. The prince was notified of the situation, so he left for Italy in 1613, where he was received by the Duke of Tuscany. His son Ali was entrusted with the Emirate.

Third: Due to the administrative autonomy of his emirate, Fakhreddin was able to benefit from the flourishing maritime activity between the Orient and Europe via the ports of Beirut and Sidon. He helped the silk industry flourish by encouraging the Maronites of the North to move to the Shouf and to Kisrawan. By encouraging production and protecting trade, he managed to modernize Lebanon and set it on the track of European progress.

The historian Patriarch al-Douaihy mentions that the Maronites enjoyed freedom during the reign of Fakhreddin. *"They held their heads high, built churches, rode saddled horses and wore white headdresses. Moreover, missionaries came from Europe and resided in Mount Lebanon. Most of the army of the prince, his ministers and his collaborators were also Maronites".*[6]

The growing power of Fakhreddin, especially after his return from Italy (1618), the flourishing economy of the country, his negotiations with Europeans and his leaning toward Christians once more attracted the suspicions and apprehensions of the Turkish authorities. In 1633, orders were issued to Ottoman pashas to attack the Lebanese prince. After bloody battles, Fakhreddin was taken as a captive with members of his family to Constantinople, where he was executed in 1635.

During his rule, which lasted around half a century, Fakhreddin was able to unify the land, strengthen the national spirit, encourage understanding between Druzes and Christians, and free Lebanon from Turkey.

4 - Qara'li, B., *"Fakhreddin II"*, (in arabic), Harissa 1937, vol. II, p. 37
 - Fahed, Ab.B., *op. cit.*, p. 15 XVII.c.

5 - Chebli, M., *"Fakhreddin II Maan"*, Imp.Catholique, Beyrouth 1946, p. 39

6 - Douaihi, Pat.E., *op. cit.*, p. 505

Fakhreddin sought to achieve many national goals, such as the unifying of the Lebanese communities, the promoting of national prosperity, the building of a great national army and the freeing of his country from Turkish hegemony

According to the Italian traveller Dominico Magri (1624), *"the permanent army of Fakhreddin was composed of twenty thousand Maronites and twelve thousand Druze"*. The Maronite Abu Nader al-Khazen was the Chief of the Infantry of the Prince.

During the reign of Fakhreddin II, the Lebanese regions became united under one local ruler. The prince gave a new impulse for the interests binding the different Lebanese communities. The Maronite loyalty to Fakhreddin was based on common interest and objectives, achieving the independence of Lebanon and freeing it from Turkish domination, establishing relations with Europe, attaining economic growth by promoting agriculture and related industries, encouraging trade and establishing security.

The Maronites' loyalty to the Maan princes continued under the successors of Fakhreddin. It is worth noting that all Maan princes were persecuted and many were killed by the Ottomans because of their aspiration to independence. After Fakhreddin's death, Prince Melhem, son of Prince Yunis and nephew of Fakhreddin, sought to accede to power, but the Ottomans opposed his plans. He asked the Maronite Patriarch Gerges Omayra to act as intermediary between himself and the Pope, so that the Pope might use his influence with the Sultan so as to appoint him ruler. The Patriarch's request was in fact accepted and Prince Melhem ruled for 34 years.

During the reign of Prince Ahmad, the last Maani prince, the Maronite Patriarch Estephan Douaihi moved his seat from the Our Lady of Qannubin monastery to Mejdel-Meoush in the Shouf in 1675 because of the harassment of the

Hamadis. He remained there under the protection of the Maan prince for three years. The Maronite Patriarchs had had their seat in Our Lady of Qannubin Monastery in the Kadisha Valley since 1440, when Patriarch Yuhanna al-Jaji left his seat in Ilige-Mayfuq (Jbeil) because of the persecution of the Mamluks. [1] In those days, a large number of European travelers, orientalists and papal envoys visited Lebanon. In addition, Catholic missionaries, such as the Capucins, the Franciscans, the Jesuits and the Carmelites, visited Lebanon.

These visitors gave their impressions of the Maronites of the Lebanese Mountain in reports which are conceived as the most important and valuable documents on the history of the Maronites in that period.[2] In 1658, the French traveler, Laurent d'Arvieux, envoy of King Louis XIV to the Ottoman Sultan, and Consul of France to Tripoli, visited the patriarchal seat in Qannubin. Upon his arrival, the Consul found out that the Patriarch Gerges Sebaali (1657-1670) was not there to welcome him. *"The fact that the region was in a state of war made the Patriarch seclude himself in a secret well-protected grotto not far from the monastery. The pasha often used to send Ottoman soldiers to abduct the Patriarch, because he was sure that the Maronites were ready to sell everything they owned to liberate him"*.[3] However, the envoy's visit made the Patriarch leave his shelter and meet his visitor.

1 - Boulos, J., *"Les Peuples et les Civilisations du Proche Orient"*, T.V, Dar Aouad, Beyrouth 1983, p. 89

2 - Abou Nohra, J., *"The Maronite Patriarchs..."*, Al-Manarat Magazine, 1985, nᵒˢ 1-2, pp. 105-129

3 - D'Arvieux, L., *"Mémoires"*, Dar Lahed Khater, Beyrouth 1982, (Collection Voyageurs d'Orient - 1), p. 183

In the Valley of Qadisha, the "Valley of Saints" in Syriac, hermits carved out in the rock their cells like eyries, where they lead an ascetic life of prayer and contemplation.

"Communities of ascetics animated these ravines; their walls of rocks are hollowed with retreats and cells… their monasteries half dug in rocks and half built, cling to the most inaccessible walls".

(Dunand)

D'Arvieux describes the lifestyle of the Maronite Patriarch, bishops and priests; he says: *"All Maronite prelates live austerely and are poorly dressed, and have no income except what the land yields to their manual work. They do not display the pomp of our European prelates. Their garments are poor but clean. Virtues adorn them, not rich clothes embroidered with gold and silver. Their crosiers are of wood, but they are bishops of gold…".*[4]

In 1701, Jean Baptiste Estelle, Consul of France to Sidon, visited Patriarch Douaihi in Qannubin. Four bishops welcomed him, while the Patriarch stood, wearing his pallium, and waiting for his arrival in front of the monastery. *"When the Consul's convoy got closer, the bells began to ring, and the priests to sing. The Consul had only just crossed the threshold when the Patriarch took his hand and headed to the church while singing hymns. The thanksgiven prayer was followed by prayers for the King of France, whose portrait adorned the altar on the right".*[5]

According to d'Arvieux, the bells of the Our Lady of Qannubin monastery were the only bells in the entire Ottoman Empire. *"The large and beautiful church is carved out of the rock. Its entrance is a high wall in which a door and two widows with a big bell in each call people to prayer. I think that these bells are the only ones in the whole Ottoman Empire".*[6]

Father Sylvestre de Saint-Aignan, head of the Capucin Order in Beirut (1638), describes the qualities of the Maronite Patriarch Gerges Omayra, who was then 76 years old; he says: *"This prelate impresses you by his virtues while fulfilling his religious duties, and singing hymns without sitting on his patriarchal chair. He spends his time standing up, and just leans on a cane like ordinary monks do… His religious duties do not prevent him from performing manual work… He is a model to be followed by his subordinates, inciting them to stay away from vices and to work in order to pay the taxes imposed by the Turks…".*[7]

In a report on the Maronites, the Capucin Father Eugène Roger, who was a very close friend of Prince Fakhreddin II, deals with the secular authority of the Maronite Patriarchs. *"The Prince, who had a great esteem for the Maronites and the Maronite Church, did not want to rule on the Maronite cases. He left to their Patriarch the task of making them respect the laws, and settling their conflicts".*[8]
The Patriarch *" used to bring the contentious parties to stand before him, and settle their conflicts. They used to accept his judgment as God's words. Thus, the Turks were unable to interfere in the conflicts arising among the Maronites".*[9]

In 1569, the Papal envoy Father Jean Francisco Morkanti was designated by Pope

4 - D'Arvieux, L., *op. cit.*, p. 185

5 - Ristelhueber, R.,
 "Les Traditions Françaises au Liban", Paris, Lib. F. Alcan, 1918, p. 200

6 - D'Arvieux, L., *op. cit.*, p. 186
 - De Pinon, C., *"Voyage en Orient"*, Paris 1920, p. 294

7 - Gemayel, F.N., *op. cit.*, Vol. II, p. 835

8 - Roger, E., *"La Terre Sainte"*, Paris, A. Berthier, 1667 (2nd ed.), p. 323

The Valley of Qadisha, was also called the Qannubin Valley, referring to the Monastery of Qannubin (meeting place of monks in Greek), which became the Maronite Patriarchal Seat in 1440.

"This cradle of the Maronite community remained a sanctified place through centuries of strong faith". (Dunand)

10- Moubarac, Ab.Y., *op. cit.*, T.I., vol.1, p. 850

11- Abou Nohra, J., *op. cit.*, p.125
- Al-Amshiti, F.Y., *"The Voyage of Father Jerôme Dandini to Lebanon"* (in arabic), Beit Shabab 1933, pp.11-12

12- Sheikhu, F.L., *"The Maronite Church and the Jesuit Order"* (in arabic), Beirut 1923, pp. 6-69

13- Sharaf, J., *"The Council of Hrash"* (in arabic), Al-Manara Magazine 1938, n°1, pp. 65-82
- Gemayel, F.N., *op. cit.*, pp. 850-853

14- Charles-Roux, Fr. *"Les Echelles de Syrie et de Palestine"*, Paris, Paul Geuthner, 1928, p. 6

Pius V to investigate the conditions of the Maronites. He reported saying: *"I visited the Lebanese northern regions and inquired about the Maronites' living conditions. I found out that this people led a simple and bucolic life, nurtured by a great willingness to obey the Roman Church... They were, young and old, virtuous Catholics, ready to sacrifice themselves for the Glory of God and the Roman Church."*

The Maronites' loyalty to the Pope is described by Father Thomas Vitali, who visited Lebanon in 1643. Vitali says: *"They are Catholics most loyal to the Apostolic See, and they are the only community in the East to maintain their faith, and preserve the virtues that characterized their ancestors".*[10] This special relation between the Maronites and Rome jeopardized the relations between the Maronites and the Ottomans, who labeled the Maronites as "Franjs" or "the Pope's followers". Moreover, the confirmation which the Maronite Patriarchs requested from the Pope added to the Ottomans' apprehensions and doubts. The papal envoys were considered the "spies of Rome" by the Ottomans. Because of this, Jerome Dandini, who visited Lebanon in 1596 as envoy of Pope Clement VIII, had to change his name and conceal his identity to avoid harassment.[11]

Despite their loyalty to Rome, the Maronite clergy maintained their oriental Antiochean rite and were not influenced by the growing latinization of rites as advocated by the Catholic missionaries in Lebanon. In 1560, the Papal envoy Eliano, a Jesuit of Jewish origin, visited Lebanon, and demanded the burning of the books and the manuscripts of the Maronite rite, under the pretense that they might contain erroneous information, contradictory to Catholic dogma. Thus, an irreplaceable oriental Maronite heritage was lost forever.[12]

Such incidents made the Maronite Church authorities reluctant to invite some of those who represented the "latinizing" current. For instance, when Patriarch Yussef al-Akuri held the Council of "Hrash" in 1644, he did not invite Rome's representatives, so as to avoid giving these representatives the opportunity to impose their Latin conceptions on the Maronite Church. Furthermore, the prelates of the Maronite Church protested to the Pope against some of the Latin missionaries in Lebanon, such as the Capuchins.[13]

In the 18th century, Charles-Roux, the French Ambassador, noticed that the competition between the European clergy and the Lebanese once put sometimes the Consuls of France in a critical situation. France, the protector of the Maronites, had to compromise between the two parties on one hand and its own interests through the missionaries on the other.[14]

"All Maronite prelates live austerely and are poorly dressed, and have no income except what the land yields to their manual work. They do not display the pomp of our European prelates. Their garments are poor but clean. Virtues adorn them, not rich clothes embroidered with gold and silver. Their crosiers are of wood, but they are bishops of gold…" (L. d'Arvieux)

The Maronites and the Shehab Dynasty (1697-1842).

When Prince Ahmad, the last prince of the Maan family, died in 1697 without male heir, the notables of Lebanon gathered in Samqanieh and elected the Sunnite Emir Bashir Shehab I Prince of the Shouf as regent of Emir Haidar Shehab, son of Ahmad Maan's daughter and still a minor. This marked the end of the Maan emirate and the beginning of the Shehab emirate that ruled Lebanon for 145 years.[1]

The Shehabs descend from the Arab tribe of Qoraish, who came to Lebanon during the days of Salah Eddin el-Ayubi towards the end of the 12th century to fight against the Crusaders. They settled in Wadi el-Taym, and took Hasbaya as their capital. The Shehabs belonged to the Qaysi party; they cooperated with the Maans and developed close ties through marriage. When Prince Ahmad Maan died, the Shehabs, relatives of the Maan, took over. When the regent Prince Bashir I passed away in 1706, Prince Haidar reigned, and moved the seat of the emirate from Hasbaya to Deir el-Qamar. The Ottoman Wali of Sidon deposed the Shehabi Prince and replaced him by the leader of the Yamani party, Prince Yussef Alam - Eddin. Haidar fled with his two sons and some of his followers to Ghazir in Kisrawan where his allies, the Khazen and Hobeish families from the Qaysi party, were in control. When the army of Prince Yussef Alam-Eddin conquered and burnt Ghazir, Haidar left his sons in Kisrawan and took refuge in Hermel. The sheikhs of the

Khazen family offered hiding-places to the prince's family.

When the inhabitants became discontented with the rule of Yussef Alam Eddin, the Qaysi dignitaries asked the Khazen family to write to prince Haidar, asking him to return to the country, and promised to support him in fighting the Yamani party.[2] The Shehab prince settled at Abi Lamaa in Ras al-Metn, and gathered around him the Qaysi family, his allies, to fight the Yamanis and the army of the Wali of Damascus and Sidon. In 1711, Prince Haidar defeated the Druze Yamanis in the battle of Ain-Dara. The Yamanis who escaped death fled to Hauran in Syria, where they resided in Jabal el-Druze (the mountain of the Druzes).

After Prince Haidar had affirmed his authority over Mount Lebanon, he established good relations with the Shiite leaders and Sheikhs of Jabal-Amel, Baalbeck and Wadi el-Taym. Thus, the Shehabi Prince was able to extend his rule over an area equal to that ruled by Fakhreddin II.

In 1729, Prince Haidar abdicated in favor of his son Melhem, who extended his rule to Bilad Beshara, the Bekaa and Baalbeck after he had defeated the governor of Damascus in the battle of Bar-Elias in 1748. The following year, Prince Melhem added Beirut to his emirate, and made it his second capital after Deir el-Qamar.

1- Al-Shidyaq, T., *"Akhbar al-A'yan"*, Beirut 1970, pub. Lebanese Universty, part 2, p. 311

1790 — 1695

On 10 November 1695, by permission of Patriarch Estephan Douaihi, the first Order was founded in the Maronite Church by four young monks from Aleppo, Gibrail Hawa, Abadallah Qaraali, Yussef al-Betn, and Gibrael (Germanos) Farhat.

After the confirmation of this Order in 1700, the founders resided in the monastery of Mart Morah in Ehden, and then they moved their seat to the monastery of Mar Lishaa in Besharri. In this monastery, the rules and regulations of the first Maronite Order were drafted, and its general Assembly was convened there in 1698.
On 19 July, 1770, the Maronite Order split into two groups: the Baladite Order, now known as the Lebanese Order, and the Halabite Order, now known as the Mariamite Order.

In 1874, a conflict arose among the monks of the Baladite Order.
With the approval of the Apostolic Delegate,
the Maronite Patriarch and the Consul of France,
the Mutasarrif Rustom Pasha intervened and met with
the losing party in the Monastery of Qozhaya.
At the meeting, he used an insulting and threatening tone.
At this point, *"the monks rose and hit him with their leather belts"*.

Karam's partisans, among whom was the Maronite bishop Boutros Bustany, made efforts to obtain his return to Lebanon. This fact gave rise to a conflict which arose between the Mutasarrif and the bishop in 1874. On the other hand, another conflict took place among the monks of the Lebanese Order (Baladite) following a synod, which divided them into two parties. As a result, the losing party (partisan of Yussef Karam) refused to submit to the winning party. Consequently, Rustom Pasha intervened with the approval of the Papal envoy, the Maronite Patriarch and the Consul of France. He went to Ehden and met the monks of Kozhaya Monastery (the losing party). During the meeting, he used an insulting and threatening tone. At this point *"the monks rose and hit him with their leather belts"*. The Mutasarrif gave orders to arrest eighteen monks, and drove them shackled to Deir el-Qamar prison.

This incident provoked the indignation of Bishop Bustany and many other protectors of the dignity of the Community and its clergy. On the other hand, Pasha's attempt to impose new taxes were opposed by Bishops Bustany and Debs along with their partisans. The two bishops petitioned the Porte, omplaining about Rustom Pasha's practices. The dignitaries of the country also expressed their discontent to the consuls of the foreign countries. Rustom Pasha was furious. In a petition to the Sultan, he accused Bishop Bustany of reviving the strife between Maronites and Druzes. He also asked the French Consul, who was at odds with bishop Bustany, to support his claim before the Maronite Patriarch Boulos Massaad for Bustany to be sent into exile on the pretense that the latter opposed the policy of France in Lebanon. When the Sultan signed the for exile order on May 31, 1878, the Patriarch tried to remedy the situation, but the Pasha was guide to execute it. He sent two hundred soldiers to drive Bishop Bustany out of his seat in Deir el-Qamar to his exile in Jerusalem. Bishop Bustany yielded and addressed his community, asking them to remain calm.

As soon as of the exile news spread, the *"inhabitants of Deir el-Qamar, Jezzin, el-Jurd, el-Gharb, el-Shahar and others closed the churches and brought down the bells"*. They also decided to *"refrain from praying as long as their bishop was in exile"*. The sultan, the consuls of the Great Powers, the Holy Congregation of Rome, and the President of the French Republic received petitions from the Maronite Patriarch, bishops, dignitaries and commoners. Some Druze Sheikhs sent petitions express indignater as well.

When the news of Bishop Bustany's exile reached France, it commanded its ambassador in Istanbul to intervene and obtain the release of the bishop. The Sultan issued another order allowing the bishop to return to Lebanon. At the "command of the Maronite Patriarch", a French warship carried the bishop from his exile to the port of Jounieh, where he was received by large Christian crowds on November 9, 1878.

On the whole, the period of the Mutasarrifate was one of general development and prosperity. It was noted in particular for the cultural awakening which took place in Lebanon at the time and which was reflected in every aspect of life. This awakening began with the foundation of the Maronite School of Rome. It affirmed itself during the rule of Prince Fakhreddin Maan II, who brought Lebanon into contact with the European Renaissance, and developed under Prince Bashir Shehab II, who encouraged foreign Christian missionaries to settle in Lebanon and to establish schools, universities and printing presses.

The Maronite patriarchs and bishops played a great role in fostering this cultural revival. In 1624, Patriarch Yuhanna Makhlouf

7 - Khater, L.,*op. cit.*, p.79
 - Rustom, A., *"Lebanon during the regim of the Mutasarrifiat"* (in arabic), Dar Al-Nahar Publ., Beirut 1973, p.160

8 - Khater, L., *op. cit.*, p.110

Patriarch Yussef Estephan (1766 - 1793)

In 1789, Patriarch Yussef Estephan transformed the monastery of Ain Warka into a clerical school, to preserve the historical authenticity of the Maronite community, which was threatened by the latinizing movement.

The establishment of Ain Warka School did not prevent the promotion of the "village schools" which was recommended by the maronite prelates in letters addressed to their parishioners.

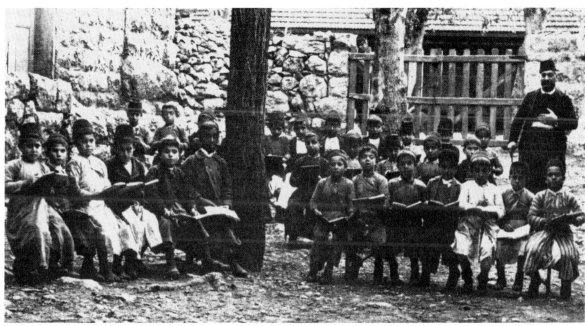

founded the first two schools of higher education, in Hawqa and Bqorqasha. In 1728, Father Boutros Mubaraq, a graduate of Rome, founded the school of Aintoura and placed it under the administration of the Jesuits. In 1834, the administration was given to the Lazarist Fathers.[9] The Synod convened in Louaizeh in 1736 strongly recommended the establishment of schools to help the spread of learning. In 1789, Patriarch Yussef Estephan founded Ain-Warqa Maronite School. Some of the graduates of this institution ranked among the principal leaders of the cultural revival movement in Lebanon in the 19th century. Boutros al-Bustani established the National School in 1863. Bishop Yussef Debs established the Hikmat School (Sagesse) in 1875, and Bishop Yussef Zoghbi established the Lebanese School at Qornet Chehwan in 1883. In 1815, Patriarch Yuhanna el-Helou transformed the monasteries of Kfarhai (1812) and Roumieh (1817) into schools. Patriarch Yussef Hobeish followed suit and transformed the monasteries of Mar Abda Herharya (1830) and Rayfoun (1832) into clerical institutes.

The 19th century witnessed strong competition among foreign missionaries, especially the Catholic and Evangelical Protestants, in establishing schools. Whereas the Maronite Patriarchate supported the Catholic missionaries, it strongly opposed the American Evangelists, especially the Biblicists.[10] When the Americans were unable to establish schools in the

Maronite regions, they moved to the Druze regions; they later established the American University of Beirut in 1866. In their turn, the Jesuits established the Saint Joseph University in 1875.

Schools and Colleges of higher education flourished during the Mutasarrifate period, and Lebanon witnessed an unparalleled increase in the number of scholars, writers and thinkers who were the vanguard of the cultural and literary awakening movement in the Arab world. Among those who stand out were Nassif el-Yazigi, Boutros el-Bustany, Fares el-Shidiac, Yussef el-Asir, Muhamad el-Hut, Gergi Zeidan, Yaacub Sarruf, Fares Nemr, Selim and Beshara Taqla, Rashid Rida, Khalil el-Khoury, Maroun Naccash and many others.[12]

Despite the economic prosperity, Mount Lebanon saw an active emigration, especially among the Maronites, to Egypt, America, West Africa and Australia. This emigration is a manifestation of a fundamental reality in the history of the Lebanese people, i.e. the vital space of the Lebanese is the world at large.

In the cultural field, the Lebanese emigration gave birth to many writers, poets and thinkers, among them Jibran Khalil Jibran, Amin Rihani, Elia Bu Madi, Khalil Mutran, Habib Estephan, Philip Hitti... On the scientific level, we mention Hasan Kamel al-Sabbah, Peter Medawar, and Michael Dabaghi.

9 - Salibi, K., *"Modern History of Lebanon"*, *op. cit.*, p.162

10- Naaman, Ab.B., *"The Patriarch Yussef Hobeish..."* (in arabic), University of the Holy Spirit - Kaslik, Lebanon 1992, p.15

11- Fakhuri, F.H., *"Al Mujaz fi al-Adab al-Arabi"* (in arabic), Vol.IV, Dar el-Jiyl, Beirut 1985, p. 51

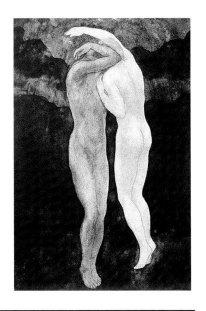

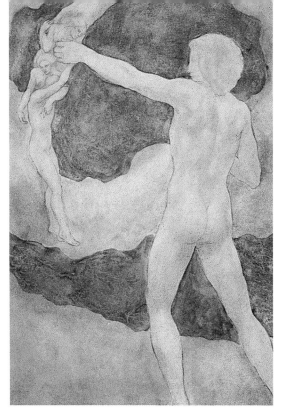

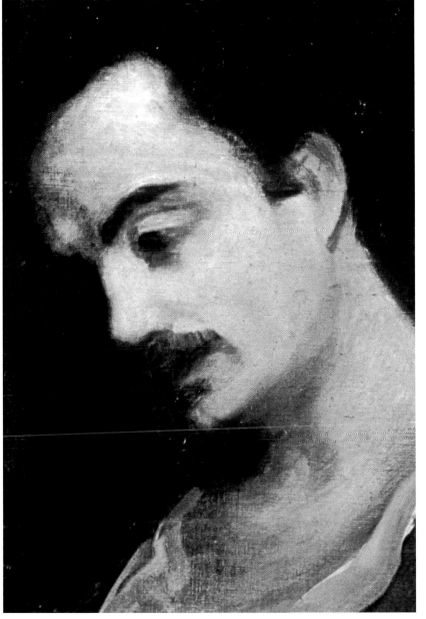

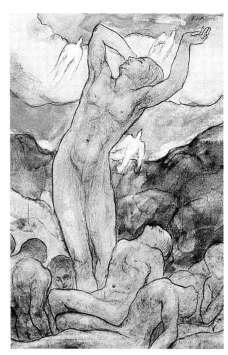

Gibran Khalil Gibran (1883 - 1931)

Poet, philosopher, and artist whose *"power came from some great reservoir of spiritual life, else it could not have been so universal and so potent"* (C. Bragdon).

His books, illustrated with his mystical drawings, are an expression of the deepest impulses of man's heart and mind.

Gibran remains among the most famous and faithful messengers of Lebanon.

As the unrest of 1860 put an end to the *Qaimaqamiat* System, World War I, in which the Ottoman Empire joined Germany and Austria against the Allies, caused the collapse of the *Mutasarrifiat* system in Lebanon. This system had been guaranteed by the major European powers combined.

As soon as the Ottomans entered the war in October 29, 1914, the privileges of the foreign consuls were abolished in all the Vilayets of the Empire. Jamal Pasha, Minister of the Navy and one of the perpetrators of the Armenian genocide, was appointed commander of the Fourth Brigade in the Turkish army. In November 22, 1914, Ottoman troops entered Lebanon via the Zahle road and spread over the regions of Mount Lebanon, thus violating Lebanon's internal autonomy stated in the 1864 protocol. The Ottomans converted the monasteries of Mar Chaya (Brumana), and St. John al-Qalaa into military forts due to their strategic locations.[1] Jamal Pasha made Damascus his headquarters, and Aley his army headquarters for Beirut and Mount Lebanon. He then gave his orders to remove the Armenian Mutasarrif Ohanness Pasha and appointed Ali Munif as military governor. After the defeat inflicted on Jamal Pasha following his invasion of the Suez Canal in November 2, 1915, an intense feeling of humiliation and frustration moved him to take revenge. He imputed this defeat partly to the Lebanese and Syrians

soldiers, who deserted his army, and partly to the lack of cooperation on the part of the country's dignitaries. On March 13, 1915, Jamal Pasha dissolved the Administrative Council of Mount Lebanon and established the Court Martial of Aley. He exiled some of the members of the Council to Anatolia, among whom were the president Habib Pasha Saad, the Maronite Archbishop Boutros Chebli of Beirut, who died in exile, and bishop Germanios Msarrah, Orthodox Metropolitan of Beirut.

In March 16, 1915, the Sultan's Firman which recognized the authority of the Maronite Patriarch Elias Hoayek and those of the bishops over their communities reached Beirut. The Pasha requested the Patriarch to come and receive the firman, but the Patriarch refused to leave his seat, pretending illness. Consequently, the Pasha was obliged to send the firman to Bkerki with his special envoy. Meanwhile, the Turks had broken into the French Consulate in Beirut with the help of one of its employees, Philip Zalzal. They found confidential documents which the Consul had hidden before his departure to France. These documents, which were signed by around forty prominent Lebanese figures, included evidence of their intention to liberate Lebanon from the Turks with the help of France.[2] As a result, the Turks arrested those who had signed and could not leave Lebanon. They were sent to prison, and later tried. Some of them were hanged, others

1 - Hitti, Ph., *"History of Lebanon"* (in arabic), *op. cit.,* p.558

2 - Antonius, G., *"Yaqzat al- Arab"*, Dar al-Ilm, Beirut 1974, p. 235
- Khater, L. *op. cit.,* p. 204

Father Yussef al-Hayek (1869 - 1915)

The Court Martial established by Jamal Pasha issued sentences of exile, life imprisonment or death, on all those who were convicted of conspiracy against the Ottoman State.

In his sentences, Jamal Pasha made no distinction between Christians and Muslims. Great numbers of people were condemned, among whom was Father Yussef al-Hayek, the first Maronite martyr, who was hanged on March 22, 1915.

exiled, and others were sentenced to life imprisonment. Father Yussef al-Hayek, parish priest of Sin el-Fil, was the first Maronite martyr, and was hanged in Damascus on March 22, 1915, because the Turks found a letter addressed to him from Deshanel, the President of the French Parliament[3]. In the trials, Jamal Pasha made no distinction between Christians and Muslims. In August 1915, a total of twenty-five leaders were convicted of high treason because of their connexions with the Allies, and were publicly hanged in Beirut on May 6, 1916 in the square that was later named Martyr's Square.

In addition to the oppression of the Turks, the Lebanese suffered from very difficult economic and social circumstances. The Ottomans confiscated their crops and cattle, and stopped grain from entering Lebanon under the pretense of feeding their army. Prices soared dramatically, and paper currency, which replaced gold, depreciated. Moreover, locusts invaded Lebanon and all agricultural products was destroyed. Thousands of people died of famine and epidemic diseases. At the same time, Jamal Pasha blocked the land and sea routes to aid, cutting off the money sent by emigrants to their families.

Father Boulos Akl, who has been sacred Archbishop and General Vicar for the Maronite Patriarchate in 1919, played a great role in raising funds to help reduce the extent of the calamities. He secretly called the French Governor of Arwad Island, Captain Albert Trabaud, and asked him to report the gravity of the situation in Lebanon to the French government, and provide assistance. Trabaud handed over to the Maronite priest fifty thousand gold francs and sixteen thousand gold sterlings donated by the French government. This sum was very little, so Akl wrote to the Patriarchal Vicar in Egypt, Bishop Yussef Derian, who immediately set about collecting funds from the Lebanese emigrants in Egypt and from all over the world. He managed to collect around two million French gold francs, equivalent to 259 million dollars.[4] These funds were sent to Father Boulos Akl by sea; but some denounced the priest, who fled away after the martial court sentenced him to death *in abstentia*.

In order to alleviate this disaster, the Lebanese Maronite Order, headed by Abbot Ignace Dagher had mortgaged, following the approval of the Apostolic Delegation and the Maronite Patriarchate, all its properties for 1,000,000 gold francs paid by the French Government. The French governor of Arwad Island arranged the mortgage. This sum of money was sent to Lebanon in installments via special routes and distributed to the poor to alleviate the famine, and this, through the Lebanese Maronite Order and a Committee formed by Naoum Bakhos, Yussef Karam, Beshara Bueiri and Yussef Akl.[5]

3 - Khater, L., *op. cit.,* pp.198-199

4 - Hitti, Ph., *op. cit.,* p.591
- Dagher, Mgr. Y.,
"The Maronite Patriarchs"
(in arabic), Imprimerie
Catholique, Beyrouth 1958,
p. 117

5 - Dagher, F.L., *"Al-Muhtaram
al-Tannuri"*, Publ. Awraq
Rahbaniat, Kaslik-Lebanon
1980, pp.102-103
- Bueiri, B., *"Muzaqqarat
Beshara Bueiri"*, Al-Huda
Press, New York, 1922

Archbishop Boulos Akl (1883 - 1959)

He contributed effectively to lessening the suffering of
his Lebanese compatriots during the First World War.
He faced many dangers and was sentenced to death
in abstentia for the efforts he exerted to provide aid to
the Lebanese in need.

When the war was over, the French Government declined to claim the loan or even to confiscate the property of the Lebanese Maronite Order because, as was declared by President Clemenceau, *"the French Government did not want to be less generous than a community of 600 monks".*[6]

Jamal Pacha tried to destroy the Maronite Patriarch Elias Hoayek, who struggled to save his people from the tyrant. Jamal Pacha, hoping to separate the Head (the Patriarch) from the body (the people), summoned the Patriarch to Aley in order to humiliate him, exile him to Syria, and ultimately liquidate him. The news caused great commotion in Lebanon and abroad.

The danger threatening the Maronite Patriarch urged Pope Benedictus XV to ask the Austrian Emperor to intervene with his ally the Ottoman Sultan on behalf of the Patriarch. The Ottoman Sultan ordered Jamal Pacha to stop harassing the Maronite Patriarch. After twenty days of exile, the Patriarch left Bhamdoun and headed to Qornet Chehwan, the episcopal seat for the Cyprus diocese, to pursue his call for a free Lebanon.[7]

6 - Mahfuz, F.Y., *"History of the Maronite Church"* (in arabic) Kaslik 1984, pp. 110-111

7 - Mahfuz, F.Y., *op. cit.*, p. 111

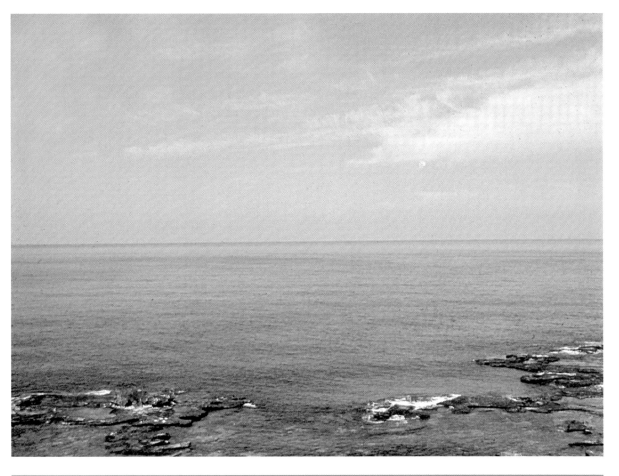

The Lebanese natural environment stimulated the behaviour and reactions of the Lebanese and molded his thinking and imagination.

The rugged mountains provided the Lebanese with protection freedom and seclusion.
It enriched his imagination and endowed his personality with dynamism and vitality.

The continuous call of the sea has been the incentive for the Lebanese to roam, to trade and to meet with other peoples.

The Maronites and the State of Greater Lebanon (1920).

Following the triumph of the Allies in 1918, Lebanon was liberated from the Ottoman hegemony. The four years of war had cost the lives of one third of the Lebanese. The Peace Conference held in Paris on January 18,1919 was supposed to adopt President Wilson's principle of the right of nations into autodetermination. The Lebanese, who had lost important parts of their country, felt that it was the time for them to realize their grand dream of establishing Greater Lebanon.

In the last decades of the nineteenth century, three nationalist political ideas had emerged among the Lebanese. The first idea was that of Lebanese Nationalism. Canvassed by the inhabitants of Mount Lebanon, it called for the establishment of an independent Lebanon, after the incorporation of the Beqaa and the coastal towns. This national homeland would satisfy the aspirations of the Christians, particularly the Maronites, guaranteeing their free existence and rights. The second idea was that of Arab Nationalism, which called for Arab unity on the basis of the Arabic language and cultural heritage. Whereas Christians on the whole wanted this Arab nationalism to be more of a secular nature, Muslims, in particular the Sunnites living in the Lebanese coastal cities (Beirut, Tripoli and Sidon), found in it the much-needed formula to establish a Muslim Arab State on the remains of the Ottoman Empire. The third idea was that of Syrian-Arab

nationalism. It aimed at establishing a united secular country, whose geographical area would stretch over Greater Syria (Syria, Lebanon, Palestine and Iraq), and include Muslims along with Christians.[1]

These three movements shared some common goals, such as opposing Turkish rule, freeing the Arab peoples from Turkish domination, and strengthening the role of the Christian minorities within the Arab regions. However, domestic and external factors triggered clashes between these national movements, especially when British and French troops entered the Levant.

The Administrative Council of Mount Lebanon, which represented all Lebanese sects under the Mutasarrifate System, met on December 9, 1918 and decided to send a delegation to the Peace Conference. The delegation was formed of seven members and headed by Daoud Ammun, the chairman of the Administrative Council. Ammun presented the requests of the Administrative Council to the Conference on February 13, 1919. These requests can be summarized as follows:
First: The restoration of Lebanon as it was known historically and geographically;
Second: Granting Lebanon its independence;
Third: Lebanon should have a parliament whose members were to be elected by the people.
Fourth: France should help Lebanon to attain the

1 - Salibi, K., *"The Modern History of Lebanon"*, Caravan Books Pub., New York 1993, p. 155

2 - Al-Jisr, B., *"Pact of 1943"* (in arabic), Dar AN-Nahar Pub., Beirut 1978, pp. 45-46

Daoud Ammun (1867-1922)

On December 9, 1918, the Administrative Council of Mount Lebanon decided to send the First Lebanese Delegation to the Peace Conference to present the requests of the Lebanese. Daoud Ammun headed this delegation, which included Emile Edde, Mahmud Jumblat, Abdallah el-Khoury, Ibrahim bu-Khater, Tamer Hamadeh, and Abdel Halim al-Hajjar.

above-mentioned aims and should guarantee its independence.[3]

Ammun did not receive a final assurance for the enactment of these demands, for the Allies were manoeuvring, and some American and British milieux were supporting in France the demands of Sharif Faysal, who called for the independence of Lebanon in its administrative affairs within the Syrian Union. At this point, Ammun returned to Lebanon, and on May 20, 1919 summoned the Administrative Council at Baabda, which unanimously issued a proclamation affirming *"the political and administrative independence of Lebanon in its historical and geographical boundaries including the parts previously usurped"*.[4]

On June 16, 1919, the Administrative Council delegated the Maronite Patriarch Elias Hoayek to head a second Lebanese delegation to the Peace Conference. The decision was seconded by requests sent to the patriarchal seat in Bkerki, calling on the Patriarch to represent all Lebanese in the Peace Conference.

The Patriarch left for Italy from the Port of Jounieh aboard a French naval vessel. On October 25, 1919 (the Mandate had already been decided), the Patriarch arrived in Paris and submitted to the Conference a memorandum requesting *"the recognition of Lebanon in its full natural and historical boundaries including the*

regions usurped by Turkey... and for a French Mandate in Lebanon granting the inalienable rights of the Lebanese to ultimate sovereignty".[5] On November 10, 1919, the French Prime Minister Clemenceau wrote to the Patriarch Hoayek confirming France's approval of the demands submitted by the Maronite Patriarch. Upon his return to Lebanon, Patriarch Hoayek was given a hero's welcome.

On March 20, 1920, the General Syrian Convention held in Damascus declared the total independence of Syria in its natural boundaries including Palestine, in the name of "the Arab-Syrian Nation".

Prince Faysal was appointed constitutional King of Syria which was to be administrated in a decentralized way. Subsequently, the national wishes of the Lebanese in administering their districts within the pre-war boundaries, should be respected.[6] Moreover, prominent Muslim Lebanese figures upholding for Arab nationalism participated in the meetings of the General Syrian Conference. They refused the establishment of an "independent Lebanese entity" under French control, separated from Syria. Their stand, in fact, was not a refusal of the boundaries of this entity, as much as it was an expression of the Muslims' political insecurity if an independent Lebanese entity were to be established. "They did not approve a situation whereby they would become a minority in a state governed by

3 - Nawar, A.A., *"Basic Documents for the Modern History of Lebanon 1517-1920"*, Beirut Arab University Beirut 1974, pp. 520 - 522

4 - Nawar, A-A., *op. cit.*, p.528

5 - Nawar, A-A., *op. cit.*, pp. 530 - 531

6 - Nawar, A-A., *op. cit.*, pp. 540 - 541

Patriarch Elias Hoayek (1843 - 1931)

Patriarch Hoayek headed the Second Lebanese Delegation to the Peace Conference. In the name of the Lebanese Administrative Council, and of all Lebanese communities, he submitted to the Conference a memorandum requesting *"the recognition of Lebanon in its full natural and historical boundaries including the regions usurped by Turkey ... and a French Mandate granting the inalienable rights of the Lebanese to ultimate sovereignty".*

7 - Al-Jisr, B., *op. cit.*, p. 54

8 - Zein, Z.N-D., *"The International Conflict in the Middle-East..."* (in arabic), Dar Al-Nahar, Beirut 1971, p. 153
- Mezher, Y., *"General History of Lebanon"* (in arabic), Vol. II, Beirut, p. 916

9 - Zein, Z.N-D., *op. cit.*, p.157

10- Hokayem, A., Bitar, M.C., *"The Ottoman Empire, the Arabs and the Great Powers"* (in arabic), Beirut 1981, Vol. VI, pp. 39 - 41

Christians and foreigners, after having been a majority within a Muslim state. This negative position was based on religious, political, economic and social considerations. The Muslims also viewed the establishment of Greater Lebanon as the defeat of the Arab movement in the face of Christian Europe".[7]

As soon as the Lebanese, who were calling for the establishment of an independent Lebanese entity, knew about the decisions of the General Syrian Conference, protest petitions began to reach the Maronite patriarchal seat from all Lebanese districts. On March 20, 1920, the Lebanese Administrative Council presented a decision to the Peace Conference, rejecting the intervention of the General Syrian Conference in Lebanon's affairs and administration, and considering the decisions of the Syrian Conference a violation of Lebanon's freedom and rights. [8]

On March 22, 1920, a large meeting took place in Baabda in the presence of the Administrative Council members and representatives of the different Christian communities and Druze dignitaries. They declared the independence of Greater Lebanon, and raised the new national flag (the French flag with a Cedar in the middle) on the Serail of Baabda. [9]

On April 25, 1920, the Allied Supreme Council, meeting at San Remo (Italy), offered the Mandate for Syria and Lebanon to France, and for Palestine and Iraq to Britain.

The Lebanese Administrative Council was discontented with the direct French control of the Lebanese administration. Consequently, on July 10, 1920, seven members of the Council took a decision denouncing the principle of the Mandate. However, this decision did not reject the help or friendship of France. It simply reiterated the "total and complete independence of Lebanon", and "its political neutrality". Moreover, this decision reaffirmed the idea of "restoring the former territory of Lebanon by virtue of an agreement signed with the Syrian government". The Council also affirmed that it was exerting every effort to reach an agreement, which would guarantee the mutual interests of the two neighbor countries, Lebanon and Syria.[10] This decision was the outcome of the Administrative Council's support for the Syrian position towards the French Mandate. Accordingly, members of the Council decided to go to Europe to inform the competent parties about their apprehensions. But the French arrested the members of the delegation before they had left the Lebanese territory and exiled them to Arwad, then to Corsica and then to France. On July 13, 1920, General Henri Gouraud, who had arrived in Beirut as French Commander-in-Chief and High Commissioner for Syria and Lebanon, issued a decree dissolving the Administrative Council.

On September 1st, 1920, during a ceremony held in front of the Palais des Pins, General Gouraud proclaimed the "State of Greater Lebanon", in the presence of the Maronite Patriarch Elias Hoayek and the Mufti Mustapha Naja, in addition to other high dignitaries and government officials.

By this proclamation, Lebanon regained its natural and historical boundaries. The Maronites and all the Lebanese who cherished the same aspirations had achieved their great and long-fought-for objective.

Proclamation du Grand Liban, le 1er Septembre 1920

In the summer of 1920, Gouraud took the necessary measures to make the Mandate effective throughout Syria. In July, the French forces, under his command, defeated Faysal's Arab forces at Maysalun Pass, and proceeded to occupy Damascus. On the following day, Faysal left Syria, which was now completely in French hands. On 24 August 1920, Milleran, the French Prime Minister, addressed a letter to Bishop Abdallah al-Khoury, head of the third Lebanese delegation to the Peace Conference, recalling in it the "deep-rooted wishes of the Lebanese people" fulfilled "a few days after the measures which had been taken with the Sharifian government".[11]

In 31 August 1920, General Gouraud applied the decision of the Peace Conference concerning the demands of the Lebanese, by issuing Decree 318, whereby the regions included in Greater Lebanon were defined according to the "wishes of the Lebanese, which were freely expressed in the Peace Conference". This decree stated the restoration of "the natural and historical boundaries of Lebanon". In this context, it is worth noting that the boundaries of Lebanon, as defined in Decree 318, were not those fixed by the Sykes-Picot Agreement signed between France, Britain and Russia on 16 May 1916. By the terms of this agreement, which contradicted the Arabs' wishes for unity, all occupied territories formerly under Turkish rule should be divided among the three countries. However, no boundaries were set for Iraq, Syria, Lebanon, or Palestine. Consequently, the boundaries of these countries, which were set

later, could not be considered as the "result" or the "outcome" of the Sykes-Picot Treaty. [13]

On September 1st, 1920, during a ceremony held in front of the Palais des Pins, the High Commissioner General Gouraud proclaimed the independent "State of Greater Lebanon" under French Mandate, in the presence of the Maronite Patriarch Elias Hoayek, and the Mufti Mustapha Naja, in addition to other high dignitaries and government officials.
On July 24, 1922, the League of Nations confirmed the State of Greater Lebanon after the ratification of the Mandate. The present boundaries of Lebanon were defined and confirmed in Article One of the Lebanese Constitution on May 23, 1926.[13]

What had been achieved on September 1st was not only a physical entity but also a cultural and spiritual one nourished by the Lebanese soil and values. The Maronite Nation's existential commitment to the land has rendered it a Geographical Nation coincident with the Lebanese Nation as a whole.

The Maronite Patriarchate, confirming this intimate relationship between the Maronites and the Lebanese land, adopted the motto: *"The Glory of Lebanon is given unto him"*. This motto, which adorns the entrance of the Patriarchate, is the testimony of faith in Lebanon as a whole, for Lebanon cannot be but a unified and unifying whole. Moreover, the motto is a firm testimony of an everlasting Maronite faith in Lebanon, a land of liberty and values, the Land of Man.

11 - Nawar, A-A., *op. cit.*, pp.547-548

12 - Antonius, G., *"The Arab Awakening"* (in arabic), *op. cit.*, pp. 579-582

13 - *"The Lebanese Constitution"* (in arabic), Sader Press., Al-Majallat al-Qadaiyat, chap. I, 1, p. 6

The Maronite Patriarchate, confirming this intimate relationship between the Maronites and the Lebanese land, adopted the motto:
"The Glory of Lebanon is given unto him".

This motto, which adorns the entrance of the Patriarchate, is the testimony of faith in Lebanon as a whole. Moreover, the motto is a firm testimony of an everlasting Maronite faith in Lebanon, a land of liberty and values, the Land of Man.

CONCLUSION

To end this presentation of the History of the Maronites, we must give a summary of certain of the most important truths and constants that the Maronites have embodied in their intellectual and spiritual heritage:

First: The commitment of the Maronite Church from the very beginning to the Universal Church and especially its firm attachment to the Apostolic See of Rome, with fidelity to the teachings of the early Ecumenical Councils which clearly fixed the apostolic faith. In particular it held to the doctrine of the Council of Chalcedon (451), which affirmed the two perfect natures of Christ in one Divine Person. The Maronites were notable for their application of it in their daily lives.

This affirmation of the Chalcedonian dogma of there being two perfect and distinct natures in the one person of Christ led to positions affecting their whole way of live. They have always been open-minded towards all, for men share with God his divinity as God has shared with mankind its humanity. So the Maronite and the whole of mankind meet in the humanity of Jesus Christ and thus the Maronite is ready to meet with all and no man is a stranger to him.

Second: Because of the ties uniting the Maronites with the Church of Rome, they have always been remarkable for their responsiveness to the West and to the Greco-Roman intellectual heritage. But this acceptance of Western culture has never meant a denial of the oriental Syriac-Aramean heritage in which their past was rooted.

This link with the Universal Church opened to the Maronites world horizons that knew no bounds and gave them sure protection against isolationism of whatever description. "This exceptional contact in culture and in tradition between East and West is something that we owe to the Maronites" (Ch. Malek).

Third: The attachment of the Maronites to their soil, the soil of Lebanon, which has been the very pillar of their existence and of their faith, and has determined their identity.

It was this close tie between the Maronites and the soil of Lebanon which led them strive for the establishment of Greater Lebanon in its clear geographical and historic boundaries as a matter of right, and for the preservation of its independent entity. For the Maronites, the principle of defending Lebanon the Land has always been equivalent to that of defending their doctrine and faith.

Fourth: The attachment of the Maronite to basic human freedom, something that was favoured by the Lebanese terrain with its forested mountains, wild deep valleys and difficult passes. Also, this land has always been a refuge for every rebel against tyranny and a retreat for the hermit seeking union with God. In its distinctive features, the soil nourished the feeling of the Lebanese for freedom, sovereignty and independence. Indeed the whole history of the Maronites is one of unrelenting resistance to oppression whether coming from afar or near.

May a return to the roots, with a global and not merely partial understanding, away from isolationism and prejudices, lead to a true basis for what is in the hearts and minds of the Lebanese, and to a spirit of open understanding between them. So, learning from the harsh trials of the past, may teach them how to protect their existence, their principles and their values, for a people that does not know its past has no future.

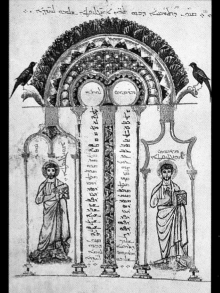

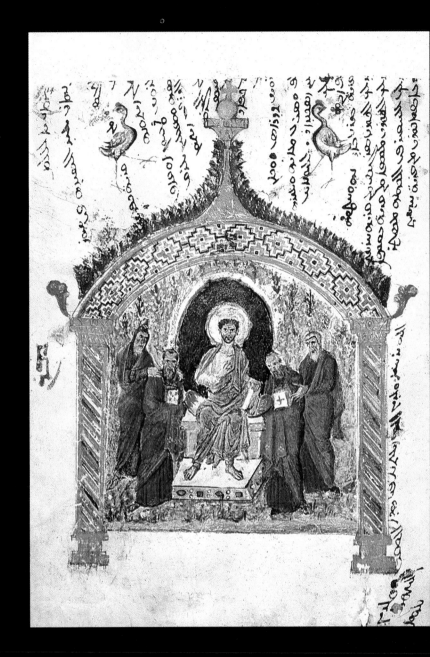

Acknowledgments

Sixteen years ago, I published the first bilingual edition of my book *"The Maronites, History and Constants"*, in French and English, and then a second edition which was followed by a third one in Portuguese and Spanish. In 1998, I published an expanded Arabic edition, and now I am issuing an English edition translated from the Arabic one.

I wish to express my thanks to all those who have contributed either advices or suggestions:

First and foremost, I must express my sincere gratitude to **His Beatitude the Patriarch Cardinal Nasrallah Boutros Sfeir**, who has granted me his paternal benediction and written the foreword of the book.

Thanks also are due to the most **Reverend Abbot Paul Naaman**, who is a distinguished erudite scholar deeply versed in the history and doctrinal developments of the Maronites, who kindly prefaced my book.

I would also like to extend my heartfelt thanks to the very **Reverend Father Boutros Tarabay**, President of Notre Dame University (NDU), who lavished on me encouragement and support, and instructed the Office of Publications to assist me in the translation of the book into English.

I wish also to express my appreciation to **Mr. Kenneth Mortimer**, English editor at NDU, for having gone through the translated text and for his valuable remarks.

Grateful acknowledgement also goes to **Miss. Christine Rayess**, translator at NDU, for having translated the book into English.

I thank also the **Reverend Father Dr. Joseph Ghanem**, Professor of History at the Lebanese University, who has read some chapters of the book and made helpful suggestions, and the **Reverend Father Abdou Badwi**, Director of the Sacred Art Department, at the Holy Spirit University - Kaslik, who furnished me with documents on Maronite Art.

I must not forget **Dr. Boulos Sarru'**, Dean of the Faculty of Humanities at NDU, whose previous translation of the book has been of great help, and **Mrs. Nevine Matar**, Professor of Sociology at the American University of Beirut, who participated in the earlier version.

I would also like to thank Prostyle Group, **Mr. Roy Hajj, Mr. Tony Kfoury**, and particularly **Mrs. Liliane Haddad** for the technical realisation of the book.

Last but not least, I would like to express my thanks to all those who have contributed in one way or another to the publication of this book.

A.K.H.

Beirut, November 2001

BIBLIOGRAPHY

Abdel Massih, G., - "Zeno the Stoic" (in arabic), Beirut 1953.
Abu El-Fida, - "Al-Tawareekh Al-Kadeema...", Flisher Publ., Leipzig 1831.
Abu Shaqra, H.G., - "Al-Harakat fi Lubnan", Aref Abu Shaqra Pub., Beirut 1952.
Akiki, A.D., - "Sawrat wa Fitnat fi Lubnan", Ibrahim Yazbeck Press,
 Beirut 1938.
Al-Amshiti, F. Y., - "The Voyage of Father Jerôme Dandini to Lebanon"
 (in arabic), Beit Shabab 1933.
Al-Balaziri, - "Futuh al-Buldan", Salah Eddin al-Munjid Publ., Cairo 1957.
Al-Jisr, B., - "The Pact of 1943" (in arabic), Dar al-Nahar Publ.,
 Beirut 1978.
Al-Khazen, Ph. and F., - "Al-Moharrarat al-Syasia", Jounieh 1910.
Al-Maqrizi, - "Kitab al-Suluk..." Cairo 1939.
Al-Qalqashandi, - "Sobh el-Aasha...", Cairo 1963.
Al-Shahabi, H., - "Lubnan fi 'Ahed al-Chehabiyin", Publ. Assad Rustom
 - "Al-Ghorar al-Hissan fi Tawarikh al-Zaman", Cairo.
 and Fouad al-Boustany, Beirut 1933.
Al-Shidyaq, - "Akhbar al-Aayan fi tarikh Lubnan", Al-Ourfan Lib.,
 Beirut 1954.
Ammoun, F., - "Le legs des Phéniciens à la Philosophie", Publ. de
 l'Université Libanaise, Beyrouth 1993.
Anaisi, F., - "Collectio Documentarum Maronitarum", Livourne 1926.
Antonios. G., - "The Arab Awakening" (in arabic), Dar al-Ilm, Beirut 1974.
Arab, M., - "Tyre, Metropolis of Phoenicia" (in arabic),
 Dar Al-Mashreq, Beirut 1970.
Beshalani, Est., - "Lebanon and Yussef Bey Karam" (in arabic), Beirut 1925.
Boueiri, B., - "Muzaqqarat Beshara Boueiri", Al-Huda Press,
 New York 1922.
Boulos, J., - "History of Lebanon" (in arabic), Dar al-Nahar, Beirut 1972.
 - "Les Peuples et les Civilisations du Proche-Orient",
 Mouton & Co., Paris 1961, vol. V
Cabrol, F., et Leclercq, H., - "Dictionnaire d'Archéologie Chrétienne", Paris 1925.
Chabot, J.B., - "Chronique de Michel le Syrien", Bruxelles 1963.
Charles-Roux, Fr., - "Les Echelles de Syrie et de Palestine", Paris,
 Paul Geuthner, 1928.
Chebli, M., - "Fakhreddine II Maan", Impr. Catholique, Beyrouth 1946.
Churchill, Ch. H., - "The Druzes and the Maronites under Turkish rule, from
 1840 - 60", London 1862.
Condé, B., - "See Lebanon", Beirut 1960.
Copeland L., Wescombe P., - "Inventory of Stone-Age Sites in Lebanon", dans
 "Mélanges" U.S.J., T. XLI, Fasc. 2, Imprimerie Catholique
 Beyrouth 1965.

Dagher, F.L., - "Al Muhtaram al-Tannuri", Publ. Awraq Rahbaniat",
 Kaslik Lebanon 1980.
Dagher, Y., - "The Maronite Patriarchs" (in arabic), Beirut 1957.
D'Arvieux, L., - "Mémoires", Dar Lahed Khater, Beyrouth 1982, (Col.
 Voyageurs d'Orient - 1).
Dau, B., - "History of the Maronites", Paulist Press, Lebanon 1984.
Debs, Mgr. Y., - "History of Syria" (in arabic), Beirut 1899.
De Pinon, C., - "Voyage en Orient", Paris 1920.
Dib, Mgr. P., - "Histoire de l'Eglise Maronite", Beyrouth 1962.
Diehl et Marçais, - "Le Monde Oriental de 395 à 1081", Paris 1944.
Dionysius of Alexandria
and Archelaus, - "The Works of Gregory Thaumaturgus", tr. S.D.F.
 Salmond, Edinburg, 1871.
Douaihi, Pat. E., - "History of the Maronite Community" (in arabic),
 Rashid al-Shartouni Press, Beirut 1890.
Eusèbe de Césarée, - "Histoire Ecclésiastique" Sources Chrétiennes, Paris 1960.
 - "Onomastica Sacra", Goettinger, 1870.
 - "Life of the Blessed Emperor", London, 1845.
Fahed, Ab. B., - "The Maronite Patriarchs" (in arabic), Dar Lahed Khater,
 Beirut 1985.
Festugière, A. J., - "Antioche Paienne et Chrétienne", éd. de Boccard,
 Paris 1959.
Frayha, A., - "Epics and Legends from Ugarit" (in arabic) 6:3,
 A.U.B. Publications, 1966.
Frazer, J., - "Adonis. Etude des religions orientales comparées",
 in Annales du Musée Guimet, XXIV, Paris 1921.
Gemayel, P.N., - "Les Maronites et l'Education au Liban" ou "Du Collège
 Maronite de Rome au Collège Ayn-Warka", Beyrouth
 1984, 2 vol.
G.E.R.S.L., - "Momies du Liban", Rapport préliminaire sur la découverte
 archéologique de Asi-l-Hadat
 (XIIème siècle)", Edifra 1994.
Goudard, P., - "La Sainte Vierge au Liban", éd. P.H. Jalabert,
 Beyrouth 1995.
Guillaume de Tyr, - "Recueil des Historiens des Croisades", Paris 1844.
Harb, A.K., - "The Name of Lebanon" (in arabic),
 Pub. Lebanese Heritage Foundation,
 Arab Printing Press, Beirut 1979.
Hitti, Ph., - "History of Lebanon" (in arabic), Dar al-Saqafat,
 Beirut 1885.

Hobeika, Arch. B., - "History of Baskinta" (in arabic), Beirut 1946.

Hokayem A., Bitar, M.C., - "The Ottoman Empire, the Arabs and the Great Powers" (in arabic), Beirut 1981.

Hourani, Y., - "Cana of Galilee in Lebanon", Ministry of Tourism, Beirut 1995.

Ibn Abd el-Zaher, - "Tashrif al-ayam wal ousour fi sirat al-Malek Mansour", Cairo 1961.

Ibn Açakir, - "History of Damascus" (in arabic), Al-Raouda Press, Damascus 1329 H.

Ismaïl, A., - "Histoire du Liban", 1955.

Jidejian, N., - "Baalbek", Dar al-Mashreq, Beirut 1975.

John of Ephesus, - "Ecclesiastical History", Part 3, William Cureton (ed.) Oxford, U.P. 1860.

Josephe, Fl., - "Antiquités Judaïques" éd. Leroux, Paris 1900.
- " Guerre des Juifs", éd. Lidis, Paris 1968.

Kaoukabani, B., - "Les Monuments de Wadi Cana", Bulletin du Musée de Beyrouth, t. XXIV, Beyrouth, 1971.

Khater, L., - "The Epoch of the Mutasarrifiat in Lebanon" (in arabic), Lebanese University Public., Beirut 1967.

Kugener, M.A., - "Patrologia Orientalis", Vol. II, "Vie de Sévère", Paris 1907.

Lammens, P.H., - "Notes archéologiques sur le Liban", Beyrouth 1914.
- " La Syrie, Précis Historique", Imp. Catholique, Beyrouth 1921.

Le Quien, - "Oriens Christianus", Paris 1740.

Mahfuz, F. Y., - "History of the Maronite Church" (in arabic), Kaslik 1984.

Makki, M. A., - "Lubnan, min al-Fateh al-Arabi ila al-Fath al-Uthmani", Dar al-Nahar Publ., Beirut 1977.

Mezher, Y., - "General History of Lebanon" (in arabic), Beirut.

Moubarac, Ab. Y., - "Pentalogie Maronite", publ. Cénacle Libanais, 5 tomes, Beyrouth 1984, T.I., "De St. Louis au Général de Gaulle".

Mourad, Arch. N., - "Notice historique sur l'origine de la Nation Maronite et ses rapports avec la France", Paris 1884.

Naaman, Ab. P., - "The Patriarch Yussef Hobeish" (in arabic), University of the Holy Spirit-Kaslik, Lebanon 1992.
- "Theodoret de Cyr et le Monastère de Saint-Maron", Beyrouth, Kaslik, 1971.

Nawar, A.A., - "Basic Documents for the Modern History of Lebanon 1517 - 1920", Beirut Arab University, Beirut 1974.

Qara'ali, B., - "Fakhreddin II" (in arabic), Harissa 1937.

Rabbat, A., - "Documents inédits pour servir à l'histoire du Christianisme en Orient", Paris Leipzig, 1910.

Raphael, P.P., - "Le rôle du Collège Maronite Romain dans l'Orientalisme aux XVII et XVIII siècles", Imprimerie Catholique, Beyrouth, 1950.

Renan, E., - "Mission de Phénicie", Imp. Impériale, Paris 1864.

Rey-Coquais, J.P., - "Inscriptions grecques et latines de la Syrie", VI, "Baalbek et Beqaʾ, B.A.H.LXXVIII, 1967.

Rey, Em. G., - "Les Colonies franques de Syrie aux XII⁰ et XIII⁰ s.", Paris 1883.

Ristlehueber, - "Les Traditions Françaises au Liban", Paris, Lib. Felix Alcan, 1918

Roger, E., - "La Terre Sainte", Paris, A. Berthier,

Rustom, A., - "Lebanon, during the regim of the Mutasarrifiat" (in arabic), Dar al-Nahar Publ., Beirut 1973.

Saade, F.S., - "Al-Fikr al-Marouni fi al-Tarikh", Beirut 1985.

Saleh ben Yahia, - "History of Beirut" (in arabic), Dar Al-Mashreq, Beirut 1967.

Salibi, K., - "Beit bi Manazel Khassirat", ed. Nawfal, Beirut 1990 1667 (2e éd.)
- "The Modern History of Lebanon", Caravan Books, Delmar, New York, 1977.
- "Muntalak tarikh Lubnan", Caravan Books, Delmar, New York, 1979

Strabon, - "Géographie", Trad. G. Aujac, éd. Les Belles Lettres, Paris 1969.

Strauchi, J., - "Dissertatio de Beryto", Brunzvigae, 1662

Taylor, G., - "The Roman temples of Lebanon", Dar Al-Mashreq, Imp. Catholique, Beirut 1971.

Theodoret de Cyr, - "Histoire des Moines de Syrie", P. Cannivet et A. Leroy-Molinghen, éd. du Cerf, Paris 1979.
- "Religiosa Historia", c.XVI, in Migne, P.G.

Thiersch, H., - "Zu den Tempeln und zur Basilika von Baalbek", 1925.

Vigouroux, F., - "Dictionnaire de la Bible", Paris 1899.

Volney, - "Voyage en Syrie et en Egypte", 2e éd., Dugorou,

Yammine, F. Y., - "Cana of Galilee in Lebanon" (in arabic), Ehden 1994.

Zein, Z. N-D., - "The International Struggle in the Middle East..." (in arabic), Dar al-Nahar, Beirut 1971.
Paris 1787.

Layout, Color Seperation by Prostyle s.a.r.l.
Printed by Arab Printing Press s.a.l.
Novembre 2001, Beirut - Lebanon

